·THE·
HOME
BREWER'S
COMPANION

Other Avon Books by
Charlie Papazian

THE NEW COMPLETE JOY OF HOME BREWING

THE HOME BREWER'S COMPANION

CHARLIE PAPAZIAN

AVON BOOKS NEW YORK

THE HOME BREWER'S COMPANION is an original publication of Avon Books. This work has never before appeared in book form.

AVON BOOKS
A division of
The Hearst Corporation
1350 Avenue of the Americas
New York, New York 10019

Copyright © 1994 by Charles N. Papazian
Published by arrangement with the author
Library of Congress Catalog Card Number: 94-1647
ISBN: 0-380-77287-6

Library of Congress Cataloging in Publication Data:

Papazian, Charlie.
 The homebrewer's companion / Charlie Papazian.
 p. cm.
 Includes bibliographical references.
 1. Brewing—Amateurs' manuals. I. Title.
TP570.P285 1994 94-1647
641.8'73—dc20 CIP

First Avon Books Trade Printing: August 1994

AVON TRADEMARK REG. U.S. PAT. OFF. AND IN OTHER COUNTRIES, MARCA REGISTRADA, HECHO EN U.S.A.

Printed in the U.S.A.

OPM 10 9 8 7 6 5 4 3 2 1

The Homebrewer's Companion is dedicated to homebrewers throughout America. They have inspired an American and international renaissance in brewing and a respect for beer.

I especially thank the following people who have helped make this book possible: Chris Miller, my editor of over ten years at Avon Books, for her support and enthusiasm for my work. Michael Jackson as a friend and for his unparalleled dedication, furthering international awareness of beer and brewing and lending me continued insight and assistance. Tracy Loysen as a friend who has helped extract creativity, clarity and insight with my work and with this book. Michael Saunders and Gina Truex for being there as great friends before, during and after my abeyance with writing this book. To my friends and colleagues at the Association of Brewers for putting up with my dispositions while juggling many projects at once. And my parents, Aram and Lucy, who've had the patience to let me stumble into and enjoy whatever I've become and never would've thunk it.

Contents

MAKING BEER: Equipment and Process
103

Boiling the Wort 136

THE
HOME
BREWER'S
COMPANION

Foreword

by Professor Michael J. Lewis*

I have never homebrewed, though I've been around homebrewing a long time. I first seriously observed the sport in the days of Pabst Blue Ribbon malt extract plus four pounds of sugar and baker's yeast. They were rough and ready times. Homebrewers consumed their product, of course, if they got to it before it exploded into the butter, but I'm not sure they could ever "relax and have a homebrew"! In those days—the early 1960s—I was already brewing at the University of California at Davis on a rather sophisticated 5-gallon pilot-scale brewery as part of my teaching and research responsibilities, and I began to use that experience to teach courses about the homebrewing art. I like to think those courses made a difference, and of course, our university extension program has grown hugely since then, but nothing can compare to the sea change in the life of homebrewers wrought by Charlie Papazian and the Association of Brewers and its numerous offshoots, including the American Homebrewers Association and Brewers Publications. This book adds to Charlie's incomparable contribution to the field.

Homebrewers are among my favorite people. They have a passion for beer and brewing that few other groups can match, and a thirst for information that borders on the fanatic. Ideas are rapidly taken up and tried, and stand or fail on their intrinsic value; and information travels quickly. We now teach homebrewing to a very different clientele than formerly: The passion and fascination remain the same, but the level of sophistication is much higher now than before, and so are the expectations for success. So is the willingness to invest in equipment and knowledge and good raw materials, such

* Professor Michael Lewis is an internationally recognized brewing scientist, conducting the program in Brewing Science at the University of California, Davis, since 1963. His graduates are well represented throughout the world. He has been awarded the prestigious Award-of-Merit by the Master Brewers Association of the Americas, and has been elected as a Fellow of the Institute of Brewing (London). He continues to lecture throughout the world and to publish scientific papers on brewing topics as well as maintaining a consulting practice specializing in new product development, brewing processes, brewing sanitation and assessment of research programs.

that there is very little these days the determined homebrewer cannot achieve. Charlie Papazian wrote this book with such homebrewers in mind. Any book is a compendium of what an author knows, what he has read and learned, what his experience has taught him, and how he thinks and what he thinks about. Charlie excels in all of these categories and brings it all to this book.

Homebrewing is a hobby like any other, in which one needs to invest time and money and thought; but that is where similarities end. Homebrewing is not stamp collecting or bird-watching, because there is an actual end product that meets the creative needs of an individual. One might say the same is true of arts or sports hobbyists—but surely amateur musicians or painters or golfers must inevitably fall so far short of satisfying their own expectations that their hobbies must be more frustration than satisfaction. It's different for homebrewers. Homebrewers, perhaps, are more akin to those whose hobby is cooking or quilting or some other useful pastime. But even here the analogy is not exact—after all, one must eat and stay warm whether the meal is from scratch or Stouffer's. A homebrewer (oddly) makes something that can totally satisfy his or her need to create and yet can be entirely done without; it therefore qualifies as an act of love—self-love, perhaps, but love nevertheless.

Is that why the hobby generates the kinds of passions and enthusiasms that it does? Why do people homebrew? Many years ago there was some legitimacy to the argument that one could choose between Budweiser on the one hand, and homebrew or perhaps imports on the other. These days the commercial brewing industry (including the microbrewery and brewpub industry) provides such an extraordinary range of beers that it seems hard to justify homebrewing on the basis that one's sensory expectations cannot be met somewhere between Budweiser and Big Foot. But the naissance of the microbrewing industry, far from preempting the homebrew hobby, seems to have acted as a spur to it. Though more and more people can now enjoy without much effort a wide range of beer products, for some odd reason they want to make these products for themselves or they want to further expand on what is available.

The dollar cost of specialty beers (including microbrewed products) might be some spur to homebrewing, but I don't meet many poor homebrewers. Most homebrewers are clearly in it for fun and pleasure, and saving a buck is of secondary importance—at best a thin disguise akin to a fly fisherman justifying his sport by the price of fish. No! Homebrewers just enjoy making beer, enjoy tasting the beer they make, delight in reaching out through these ancient processes to centuries of craft brewers who went before, are fascinated

by the technology, history and science of the craft, and love to meet others with the same passion. Homebrewing is intriguing and it's fun, and this book will add to both aspects of the hobby.

Making beer at home no longer need be a hit-or-miss operation, and an excellent presentation is not only achievable but expected. All homebrewers should know precisely how they made a beer and exactly what they would do in practical terms to improve or change it. Once a beer has been improved to the point where it satisfies the taste buds of its creator, the brewer should then be able to reproduce that beer at will. Though slavish consistency is not a necessary part of homebrewing, I have never quite understood the point of making a different beer at every brewing. Surely a brewer should work steadily and logically at improving a few beers that each meet a particular desired taste profile; without this logical and developmental approach, every brew is a crapshoot. Though Charlie offers many recipes in this book, they are (or should be) beers *he* likes best; that is a useful starting place for making those *you* like best.

I have never much enjoyed the company of those homebrew aficionados who crave original gravity without good purpose and who worship excessive consumption of alcohol, or those who never tasted a beer they didn't like (except any domestic major) or boast loudly of beer-drinking feats *extraordinaire* in places far away and of products curious. I prefer the company (and usually the beers) of those who realize that beermaking and beer drinking are a matter of taste. It's not a macho thing. It's okay not to like some beers; it's okay to eschew bitterness/blandness; it's okay not to like black beer, or brown or pink; it's okay to know what you like and to say so. It's *not* okay to discount others' preferences, however extreme or peculiar or ordinary they might be. And it's okay not to win prizes. The crucial essence of homebrewing demands you make exactly what you individually like best, and appreciate what you create and have fun while doing both. This puts a premium on information—hence this book.

Homebrewers don't like too much bad beer happening too often—it costs money and time and effort and occasionally damnable pride. In my experience folk can only "relax and have a homebrew" if the beer tastes good and tastes the way the brewer intended. That's why we now teach nine homebrew courses each year, and why I heartily welcome this new book.

Beer Is My Business
and I'm Late for Work

I remember walking over and accepting a taste of beer from my uncle Paul (a family friend), who was sitting in the stiff-backed living room chair. It was Ballantine beer and I liked it. That was in Cranford, New Jersey, 1954. I stood barely belt-buckle tall and I vividly recall liking the stuff. But my parents successfully discouraged any more sips, and as any five-year-old would have done, I went back to playing with my brand-new Lionel train set circling our brightly lit Christmas tree.

I went through the next thirteen years of growing up without a drop of beer. But boy oh boy, I remembered how good it tasted.

I was too young to harbor thoughts of sneaking a bottle or two. Besides, my parents rarely drank beer, and there never seemed to be any around unless my uncle Paul was visiting.

In 1958 we moved to Warren, New Jersey, and I continued my quiet forbearance and led a life of go-carts, cowboys and Indians, touch football, model rockets, airplanes, stamp collecting, Cub Scouts, Little League baseball and secret clubhouse meetings. (We called ourselves the Red Devils. We never did much except dig a secret escape tunnel just in case.)

In 1967 I graduated from Watchung Hills Regional High School. I never ever got higher than a C grade in English, and I recall my English teacher recommended I become a science student; no hope in the liberal arts for me. Anyway, somehow it seemed appropriate to celebrate graduation with beer. My high school buddy, Bob, had a few connections through his older brother, and we found ourselves with a six-pack between the two of us. I don't remember much except that the beer tasted downright awful and that the effect of three cans totally disoriented me at the imperfect moment of climbing over a split-rail fence—headfirst. We spent half the night sleeping off our inebriation in the parking lot of the Union Village Methodist Church.

I don't think my parents ever suspected my illegal indulgences until the time I got Bob arrested along with myself, four other underage rascals and a case of beer. We were all nineteen or twenty at the time. After a $240 fine and the bad taste of beer still lingering, I continued to modestly indulge in store-bought beer during my first

4

few years of nuclear engineering studies at the University of Virginia in Charlottesville.

The truth of the matter was that throughout my early college years I had not enjoyed the taste of beer since I had taken my first sip from Uncle Paul.

Then George walked into my life, or rather came to play marbles at our own Whoop Moffitt Memorial Marbles Tournament. My roommates and I got to know George more and more. After long days of work at his own Arbor Hill Preschool and day-care center, he'd saunter down for a game of Go or dissertations on the state of our lives.

George was a beer drinker, and it wasn't too long before he suggested that we go visit his beermaking neighbor. With little hesitation we found ourselves trying a neighborly brew. The novelty of making one's own beer intrigued me much more than the taste of what I now recall as fizzy, cidery and alcoholic-tasting prohibition-style homebrew.

We found ourselves walking away buzzed, inspired and with the following cryptic recipe:

5 gallons warm water
1 can Premier Blue Ribbon malt (light or dark)
$1\frac{1}{2}$ cans full sugar, white or black, more or less
Mix
Add 1 cake bread yeast when cool
Ferment until bubbling stops (7 days to 5 weeks depending on
 your sugar content and temperature). Best at 45 degrees F.
Tip [sic] bottle.

My first three 10-gallon batches of dump-and-stir (I stirred with a short-handled wooden spoon and my forearm) homebrew kept the sewer rats happy. The stuff was undrinkable. Being somewhat persistent, I managed to discover corn sugar and beer yeast. Consequently, up from the 8-by-8-foot dirt-floored basement of George's preschool emerged many an infamous palatable brew.

I still can't figure out how I managed to enjoy the stuff, but enjoy it, I did. I somehow acquired a taste for those brews, as did most of our acquaintances; even those who disliked commercial beer found "southern pleasure" in every bottle. Perhaps we drank in secret sympathy for those original 30 orphaned gallons.

I continued my education through five years. I abandoned an invitation to continue with the naval ROTC at the beginning of my fourth year but did persist to achieve a bachelor of science in nuclear engineering in 1972.

After graduation and a third consecutive summer in Maine, pure whimsy brought me to Boulder, Colorado, that same year. Nuclear engineering became unclear engineering, and within a year I found myself a preschool teacher and a born-again homebrewer. A kindergarten through eighth grade teacher, I remained through 1981, taking off each summer to hitchhike and backpack across the United States and British Columbia, as well as extended backpacking ventures in the Hawaiian Islands, Fiji, Bali and Central America. And yes, I sampled beer—homebrewed, village-brewed and commercial—whenever I could afford it.

It was in 1973 that I figured I knew enough about making beer (which was hardly anything at all, but the results were legendary) to teach a beer-brewing class through Boulder's Community Free School. It was in these first class sessions that I actually boiled my first wort. I soon discovered many ways to improve on beer and developed a taste for what I'd call quality beer, an experience I had never known before. Yes, I've had my failures and memorable brews; who can forget the original "Goat Scrotum Ale" or "Barkshack Ginger Mead"?

Through those years from 1973 to 1983 I taught over 1,000 people in the Boulder-Denver, Colorado, area how to make and enjoy great beer. My mimeographed six-page class curriculum evolved to a funky but inspirational self-published, self-typed forty-page book titled *The Joy of Brewing* (1976). Four years later I self-published a ninety-page *The New, Revised and More Joy of Brewing* (1980). Three years later I signed a contract with Avon Books to write *The Complete Joy of Home Brewing* (1984) and later revised that book to *The New Complete Joy of Home Brewing* in 1991.

Meanwhile most graduates of my class became avid homebrewers and beer enthusiasts, later inspiring the formation of The American Homebrewers Association (AHA) and its magazine *zymurgy*. In fact, one of my first students, Charlie Matzen, along with a bottle of April Morning Honey Spruce Lager, were the principal catalysts for inspiring the idea of a newsletter for homebrewers. I recall the moment quite vividly. It was Easter Sunday and we had just finished a few bottles of homebrew in the Utah desert in the area surrounding Lake Powell; Colorado River Canyon country. There was a thunderstorm approaching from a distance. Lightning zigzagged across the sky. Curiously, the brightest flash streaked from one cloud to another as the letter Z. The rain never came, but we knew Z stood for zymurgy, the last word in the dictionary, meaning the science and art of yeast fermentation. Later that evening we also saw a vision of the Easter Bunny walk across Lake Powell—but that's another story. Homebrew

has been responsible for many inspirations in my life. *Zymurgy* magazine and the American Homebrewers Association were two of them.

The nonprofit educational association was founded in 1978 with the contribution of three years of volunteer help from dozens of local Boulder homebrewers and myself along with $4,000 in personal loans that eventually got repaid about five years later. In 1981 I left teaching (though I still enjoyed it) to take on the one full-time position at the AHA, drawing and living off a salary of $300 per month. By 1987 the AHA and *zymurgy* evolved to serving as one division of the Association of Brewers, still based in Boulder, Colorado. By the end of 1993 the AHA had over 20,000 members. The other divisions of the Association are the Institute for Brewing Studies and its magazine *The New Brewer*, serving the informational and professional needs of persons interested in small-scale commercial microbrewing. When the Institute was founded in 1983 there were only a dozen microbreweries in North America; ten years later there were over 400. In 1981 it was not homebrew but perfect pints of real ale at the Great British Beer Festival that inspired the first Great American Beer Festival (GABF) in 1982. The first GABF was a small event with 3 microbrewers, 17 large or regional brewers and about 700 Boulder beer enthusiasts. Twelve years later it features 200 American breweries, nearly 1,000 beers and 17,000 festival goers from across America. There was always too much to learn, and Brewers Publications, the book publishing division of the Association of Brewers, was also inspired by many bottles of great homebrew. It publishes five to seven books per year on the subject of beer and/or brewing.

The Association has over thirty full-time employees. As president of the Association of Brewers, I manage, write, edit and travel. Brewing remains a priority and I still continue to brew about twenty batches of beer and mead a year. I'm "on the road" two to three months per year, visiting breweries throughout the world and talking with amateur and professional brewers worldwide (primarily in North America).

When I'm not traveling on business you may find me skiing, cycling, gardening, relaxing in my hammock or somewhere out of the ordinary. I enjoy traveling sight unseen to developing and third world countries to learn more about people, myself and the way we are and have been. Naturally I drink the local beer, but I enjoy just drinking it and not having to talk about it, just like most other beer drinkers.

Through the years I've brewed thousands of gallons of mostly good beer. Thousands of times I've heard first-time homebrew drinkers say, "Hey, this stuff is good." I've heard as many times, "I like this, and I don't usually like beer." I get these responses from men

Keg tossing? Well, whatever I do, I take great care not to spill any beer.

and women, young and old. It almost seems as though no one dislikes well-brewed homebrew and the company of good people. There is something inherently likable about good beer. It's appreciated, and the taste for it naturally develops.

After all these years my high school buddy Bob is still a good buddy. He tried homebrewing for a year or two and now is a bit more choosy about the beer he buys. George's health prevents him from drinking beer any longer, but I visit him every five years or so and thank him for the original inspiration. My cohort Charlie Matzen is still involved as a board member of the Association of Brewers and continues to brew great mead. My uncle Paul . . . well, I'm not so sure about Uncle Paul. It's been over thirty years since I saw him last. Wherever he is, I hope he's found something as good as that 1954 Ballantine Beer.

And me? To this day, though I respect it for what it is, I have yet to regain a preference for Ballantine Beer.

But you'll have to excuse me now . . . I've got to go. . . . Beer is my business and I'm late for work.

Introduction

You've been homebrewing for fifteen years, or five years, or three years. Perhaps you've been brewing for less than a year. Whoa-ho, there are many of you who have been at it for six months and have already brewed over ten batches. Somehow you've found the means, the mind and yourself with this book in hand. You've come to the profound realization that WORK IS WORK . . . PLAY IS PLAY . . . BEER IS BEER . . . BUT HOMEBREW IS THE BEST.

Ladies and gentlemen, you are out of control.

Whether you consider yourself a beginner, intermediate or advanced homebrewer, you've come to realize there are a lot of variables that can influence the character of your beer. You are enjoying beer as you've never enjoyed beer before. You have learned to recognize, respect and appreciate beer in ways you had never imagined. You're a hobbyist at heart, and the art of homebrewing has revealed a means to tap your creative instincts. You've found the results rewarding and worth the distinction of sharing with friends. Mesmerized by bubbles rising from the bottom of your glass of homemade brew, you've dwelled on the mysticism of it all. As brewers have done for 10,000 years, you've sipped, quaffed and conceded thirst for the beers of your creation. A bit of masterfulness creeps into your everyday life. With a bounce in your step you move forward in your daily life knowing that there is a full fermenter in your home brewery, measuring the days with improvement. Bottles condition themselves with the proper effervescence and will soon debut. You've begun to plan for your next batch, while always on the lookout for new ideas, new techniques and new beers.

THE GOLDEN RULE

The Golden Rule of Homebrewing is: "Relax. Don't worry. Have a homebrew." You have strived to Relax. You have pursued the fine art of Not Worrying. And indeed you've had a Homebrew. You often wonder what the world could be like if more individuals brewed their own beer.

You are a brewer. You appreciate quality beer. You have a new book in hand. Have you already jumped to the recipe section in search of a recipe for your favorite kind of beer? Perhaps you thumbed through the ingredient section investigating whether there was anything new to enliven your curiosity. What does this book say about lagering? you wonder, having flipped to the index (ah yes, there is an index!) in search of techniques that enable one to brew beers like those you'd be willing to pay money for.

After all of this you find yourself at the beginning of another book on brewing. What worthy advice might this writing offer? Yes, "Relax. Don't worry. Have a homebrew" is still the Golden Rule of Homebrewing. Yet another quite profound truth of brewing beer is

that it is an art. Beer is fashioned with the tools of knowledge and experience. Science is a valuable tool, but the art form of brewing cannot be reduced to a scientific process. Beware of the scientification of brewing.

Science is rule and order. It is a set of laws and statements about phenomena that we have observed and verified repeatedly. Throughout history science agrees on sets of rules for relatively short periods of time. Then we change the rules and laws, because someone else has observed new and different things, and new rules are based on more current experience. Scientific knowledge can help us make better beer.

But science alone can never create the experience of producing fine beer. Our own experiences will always be necessary. Your heart, mind and soul become part of the beers you create. Your senses are your most valuable tool. Taste your ingredients, your fermentation and your premature beer. Watch it ferment. Note the aromas. The difference in the sound that bubbles make in hot water and cold water tells you something.

Brewing is not just a recipe and a set of important procedures and measurements in your brewing logbook. You must observe your beer and note what it is telling you. The development of the art of brewing takes time. For all of us who brew, it continues. The purpose of this book is to help enhance the spirit of creativity, to discover new tools for brewing, and above all to be a companion through the wonderful journey of brewing.

The Homebrewer's Companion is not about how to chill your wort—it is about how heat moves. It's not about trub separation—it is about the behavior of liquids. It's not about reactions in brewing—it is about the dances of enzymes and ions. It is not about culturing yeast—it is about creating life and soul. It is not about beer styles—it is about people. It is not about maximum yields and efficiencies—it is about personal priorities.

The Homebrewer's Companion is not about homebrewed beer—it is about yourself.

THE HOMEBREWER'S COMPANION

Work is work. Play is play. Beer is beer. Homebrew is the best.

The *Homebrewers Companion* is for beginning, intermediate and advanced homebrewers. Before getting into a somewhat orderly presentation of brewing ingredients, process, equipment and style, this first chapter offers some helpful hints that may make some very significant improvements in the quality of your beer. These choice pearls are noteworthy for their simplicity and effectiveness—you may find that one of them is worth the price you paid for this book. That will make the rest of the book a continuing companion and a bonus, full of resources to help you discover even more ways to brew the kind of beer you want.

AN IMPORTANT REMINDER

Without a doubt the single and most dramatically significant thing that can spoil the taste of your beer is . . . worrying. Remember that whenever you brew or enjoy a glass of beer: Relax. Don't worry. Have a homebrew. This is the Golden Rule of Homebrewing.

CHOOSING AND USING INGREDIENTS: SIMPLE IMPROVEMENTS

BOILING

Malt, hops, yeast and water—that is what it all boils down to, and boil, you must. Many beer kits do not advise boiling the ingredients with water at all. Others advise boiling for only 10 to 15 minutes. Ignore that advice. Some beginning brewers minimize boiling times in an attempt to simplify or shorten the brewing process. Please don't. By avoiding or reducing boiling times, you are eliminating time to relax and have a homebrew.

Boil your wort for a minimum of 60 minutes. An active and rolling boil will help stabilize the flavor of your beer once it has reached its peak. The chemical reactions taking place between hops and malt

during a good rolling boil will help clarify your beer and reduce chill haze (that tasteless haze that forms when you chill your beer). It will also help minimize the possibility of contamination from microorganisms that can detrimentally affect the character of your beer.

A good rolling boil of hops, malt and water is essential for fully utilizing hops and helping to predict bitterness.

In some cases a short or no-boil regime can result in a sweet cornlike flavor and aroma in beer that, when evident, usually detracts from your enjoyment.

YOUR STOVE

It may seem inconsequential to consider your stove as a contributor to your beer's character, but it is. If you use an electric stove and your brewpot is in direct contact with the burner element, then you are scorching malt sugars onto the inside bottom of the pot. Have you noticed that your light ales and light lagers haven't been as light as you anticipated? Perhaps some of your brews have a discernible burnt flavor.

When the hot element of your electric stove (an electric immersion-type heater will also create the same effect) is in direct contact with your pot, it caramelizes sugars during the boil. Caramelizing takes place during any kind of boil, but is exaggerated by the high temperatures of red-hot electric stoves.

There is an easy, simple and inexpensive solution. Buy a wire "trivet" and place it between the pot and the stove coil. You also can fashion a simple triangular trivet from a nonlacquered coat hanger. This will greatly reduce the caramelization of your boiling wort.

SUGAR AND KIT INSTRUCTIONS

Beer kits, packaged in cans with all manner of beer styles to choose from, are a welcome introduction to homebrewing for many. They are simple to use and require minimal processing. They are designed so that they do not intimidate a new homebrewer with overwhelming procedures or concerns. A good beer can be made from many of them.

However, if you want to make better beer or you want to help others improve upon their own kit beers, here's some advice that will result in major improvements in beer flavor.

Whenever a beer kit calls for the addition of sugar in a recipe, substitute light dry malt extract (except where it calls for sugar for

priming carbonation). You will end up with a beer that tastes like something you would want to pay money for.

CHANGING YOUR YEAST

Have you ever had a fermentation that seems to take forever? Is there a flavor in your beer that is reminiscent of bananas or plastic Band-Aid strips? If so, then change your yeast, especially if you are using dried yeast. Choose a name-brand dried yeast that you or your homebrew supply shop owner trusts to have consistency and a dependable supply. If you are brewing from kit beers and haven't been quite satisfied, then avoid using the nameless and labelless yeast package provided with the kit. Yeast strains vary tremendously. Some will produce flavors you don't prefer because they are a particular strain, while others will produce strange plasticlike flavors or long, slow fermentations because of wild yeast contamination of the cultured yeast. When yeast is packaged in a simple white foiled or paper envelope, you never can depend on it. If your results have been inconsistent or consistently frustrating, progress from one name brand of yeast to another until you find one that suits your preference.

ENHANCING YOUR YEAST'S PERFORMANCE

Homebrewers have access to both dried cultures of yeast and active liquid cultures of yeast. Starting your fermentation with a good healthy crop of yeast will certainly help improve the quality of your beer.

Rather than simply adding dried yeast directly into the wort, enhance its performance by rehydrating it in hot water (100 degrees F [38 degrees C]) for 15 minutes. Use boiled water that has been allowed to cool in a sanitized jar. Cover the jar with a clean unused piece of aluminum foil during the rehydration period.

Can liquid yeast cultures make a positive difference in the quality of your beer? The answer is clearly yes, assuming that you have a clean culture. The quality of most liquid yeast cultures currently available through homebrew supply stores is excellent. If they are handled properly, they can markedly improve the quality of your beer.

Liquid cultures are more expensive to purchase and require some understanding of how they should be handled. Despite the added risk of anxiety (don't worry), your investment and patience will certainly be rewarded. For beginners, follow the instructions that

are printed on the package of yeast. Keep in mind that when using liquid cultures, it is essential to thoroughly aerate your wort before introducing active liquid cultures. Not doing so will result in long, sluggish fermentations. Aerate your unfermented wort thoroughly by shaking or agitating your sealed fermenter.

GERMAN STYLES, ENGLISH STYLES, AMERICAN STYLES. GETTING TO YES

If you're like most homebrewers, you have had quite a variety of beer experiences, both homebrewed and commercially made. Sometimes there is a desire to duplicate a world classic or, more generally, the quality of beer from Germany, Holland, Belgium, England, Canada or even the United States. Specific beer qualities derive from the artful blending of ingredients and the skilled execution of process. There are dozens of important variables that need to be considered.

If you are a malt extract brewer, one of the easiest variables to look at is your choice of malt extract. When brewing German-style beers, use extracts produced in Germany; likewise, if you wish for a more authentic character in your British-style ales, use extracts of British origin. Homebrew supply shops offer varieties of malt extract naturally produced from no fewer than the following countries: Australia, Belgium, Canada, Germany, England, Ireland, the Netherlands, New Zealand, Scotland and the United States. It would be too simplistic to attribute all of the final character of your beer to the origin of the malt extract used, but different barley varieties and malting techniques do have an influence on beer's character. Purchasing malt extract made in the same country as the beer you are trying to match will be a step in the right direction.

The same principle holds true for those who brew from grains. It is easier to make an authentic-tasting English-style pale ale when you use English-made pale ale malt. Make German lagers with German malts, Belgian ales with Belgian malt, and American lagers with American lager malt. The proper processing of malts of known origin is but one option towards achieving the finesse many all-grain brewers eventually strive for.

DON'T BLAME IT ON THE MALT

For all-grain brewers or those who utilize a partial mash in their formulations, getting a good yield from grains is an important endeavor. Getting a good yield means getting a fair amount of fermentable

sugars and other character-building carbohydrates from the grain. When good yields are not achieved and subsequent original gravities fall below expectations, brewers have a tendency to blame the ingredients and not the process. I've read many all-grain recipes, noting low yields. I have four simple suggestions for helping enhance your yields.

1) Test your efficiency by finely grinding (almost to flour) one pound of malt. Mash at 158 degrees F (70 degrees C) for 30 minutes to yield one gallon of sweet extract. Then follow the same procedure using your ordinary grind of malt. Note the difference in specific gravity. For homebrewing systems the regular grind should produce at least 80 percent of the fine-grind gravity. If yours is less, you should not blame your low yields on the malt, but rather on the nature of your grind.

2) Visit a brewery you have confidence in and ask if you can observe what properly ground malt looks like. There is no substitute for seeing this with your own eyes.

3) For greater extraction and yield, hold the mash at 158 degrees F (70 degrees C) for at least 10 minutes during the final mashing regime.

4) Investigate the hardness and pH of your water. If your pH is in the high 7s or higher and your hardness is more than 100 ppm, the water is responsible for helping reduce your yield. You will need to learn more about water before you can remedy the situation.

Admittedly these are four very simplistic approaches to improving your grain yields. They are meant to produce results with the least amount of hassle or in-depth scientific involvement on your part. At worst they are meant to be inspirational beginning steps towards improved yields. Yes you can. Just brew it.

IMPROVE YOUR WATER. IMPROVE YOUR BEER

If you are using a municipal water source, there is one simple thing you can do that can help improve the quality of your beer. Purchase and install a sink-top bacteriostatic activated-carbon water filter. It's simple to install, and you can configure it so that you only use it for water that you consume. Your investment will range from about $50 to $200, but over the long haul it runs about 2 cents per gallon. Unlike

boiling, activated charcoal will remove chlorine and chloroamines from your water supply. These chemicals combine with organic compounds to create harsh, undesirable flavors, barely perceptible to some but annoying to others. The advantages of filtering are twofold: It is simple to do and it will markedly improve the taste of your water.

KIT BEERS: SIMPLE FINESSE WITH HOPS

The use of fresh whole or pelletized hops in a knowledgeable manner can immensely improve the quality of your beers. It is relatively inexpensive, and the procedures are virtually worry-free.

Most kit beers are designed to have relatively low bitterness. Many are flavored with hop extract, which contributes bitterness but none of the other often desirable hop characteristics to beer. Along with substituting light dried malt extract for the sugar that many kit instructions call for, adding a small amount of bittering hops will help balance and enhance the flavor. For a 5-gallon (19 l.) batch, a half ounce (14 g.) of low- to medium-bitter hops such as Hallertauer, Cascade, Goldings or Willamette boiled for a full 60 minutes will make a positive and noticeable contribution to your kit beers. Adding half an ounce of low- to medium-bitter hops that are noted for their flavor during the final 15 to 20 minutes of the boil will contribute a complex hop flavor that will otherwise always be lacking if hop extract is listed as an ingredient of the kit. Fuggles, Willamette, Hallertauer, Mt. Hood, Cascade, Goldings, Tettnanger and Saaz are among the more popular aroma and flavor hops. Finally, to add aromatic finesse to any beer, add half an ounce of aroma hops during the final two minutes of the boil, then immediately strain, sparge and transfer to the fermenter. By including this step in your brewing process, you will create a balance, complexity and depth of character in your beer that is missing from most kit beers.

For those who choose to continue their brewing endeavors with simple kit beers, these three hop infusions may provide the complexity and satisfaction you have been seeking in your homebrewed beer.

SIPHONING SENSE

Transferring beer from one container to another is an essential step for every homebrewer. There are many ways and means to simplify this process, but there is one principle that must be kept in mind whenever handling fermented beer. Avoid aerating the beer once it has finished fermentation. The introduction of oxygen to finished

beer will accelerate the staling process and render beer oxidized and unpalatable.

Preventing the spoilage of good finished beer is easy. Avoid splashing the beer when siphoning by placing the outspout of the siphon at the bottom of the receiving vessel. This is a simple and very important principle you can keep in mind to help maintain beer freshness.

DO YOU HAVE A PROBLEM?

It tastes funny, but you're not quite sure why. Was it the ingredients, the yeast, the process, the temperature, the bottles? For a new brewer, it can be quite frustrating knowing that your beer isn't exactly what you would like it to be, but not knowing why.

There's one simple observation you can make that will almost always indicate whether or not you have a bacterial contamination that has affected the flavor of your beer. Hold a bottle of beer up to a bright light and carefully examine the fill line in the bottle's neck or any part of the surface where beer and glass are in contact. Is there a deposit adhering to the glass in the form of a ring or small dots? If so, you can be 100 percent certain that you have a bacterial contamination, whether you like it or not and even whether you like the beer or not. It's time to investigate your sanitizing process and get out the household bleach. At least now you know what kind of problem you have and you can seek advice on how best to get back to clean brewing. Don't give up. Don't worry. Every brewer confronts this problem several times a lifetime. And solves it.

SANITIZING CONTAMINATORS

Many homebrewers use a wire mesh strainer to strain hot wort from spent grains. Due to their weave, wire mesh strainers are impossible to sanitize with chemical solutions such as bleach and water. Bacteria and other contaminating microorganisms evade chemical solutions by lodging themselves in the microscopic world of nooks and crannies. For the price of a paper clip and a bit of forethought, one can use the brewpot and the boiling wort to heat and sanitize the strainer. Immerse the strainer in the boiling wort during the final 15 minutes of boiling. Configure a paper clip as a handle-hook and hook it on the lip of the pot to prevent the strainer from falling completely into the boiling liquid.

Do you use a saucepan to ladle hot wort from the brewpot into

your fermenter? Does the saucepan have seams that hide and protect bacteria? If so, your saucepan needs a heat treatment as well. This might best be done directly on your stove top.

WASH YOUR HANDS

Didn't your mother tell you this? Before handling equipment coming into contact with wort or fermenting beer, wash your hands with soap and water. But please don't get overly compulsive about this. Have a homebrew and think about the sense it makes.

CHEAP SANITATION

At less than $1 per gallon, household chlorine bleach is about as cheap a sanitizer as you can get. It will make over 300 gallons of

sanitizing solution. It works well and, with a few hours of soaking, even removes stains and bacterial deposits on the inside of contaminated beer bottles. One ounce of bleach mixed with 4 gallons (15 l.) of cold water will last for weeks in a cool environment. It is easily rinsed with hot tap water. (For brewing purposes, hot tap water is essentially sanitized water, so no need to worry here.) It works on plastic hoses, funnels, fermenters, glass; there is really no justification for contaminated beer because of ineffective sanitizing solutions.

TASTE IT

It takes a lot of practice, but taste your beer. Taste your unfermented wort. Taste it while it is fermenting and at bottling time. Taste your malt ingredients. Chew every kind of grain. Crush, squeeze and feel hops between your fingers. Smell the perfume they emit. Slowly learn the difference between fresh ingredients and stale ingredients, between fresh beer and old beer.

Use your senses of sight, smell, touch, taste and hearing to experience your ingredients, your beer and the brewing process. If you take the time to do this, you will learn the art of brewing in a way no book or technical measuring instrument can convey.

Participate in beer evaluations as a learning apprentice or a judge or for fun. In the company of others there is a lot to learn about beer, yours and those you buy.

Ingredients, Process and Equipment—and Beer!

Malt, hops, yeast and water; these are the basic ingredients of beer. But ingredients alone do not beer make. The manner in which the ingredients are processed and the kind of equipment used to process the ingredients are as essential as the ingredients themselves.

- Ingredients
- Process
- Equipment

These are the fundamental denominators that provide the basis for structure from chaos. The chaos of a thousand variables, all harmonizing into dynamic relationships resulting in the final character of beer. Ingredients, process, equipment; they are variable beyond your wildest imaginations. They affect one another in ways mysterious and obvious. Their dynamics inspire an appreciation for things created.

The art of brewing is about appreciating these relationships and appreciating the necessity of being master of ingredients, process and equipment; the substance, action and tools.

The brewmaster is one who may observe and understand or who observes and does not understand—but observes nonetheless and is willing to learn. An open mind, flexibility, intuitiveness and the willingness to adapt are all essential in achieving the final expression:

- Beer

Read about ingredients. Read about process. Read about equipment. Know that only when they are conceived and respected as a whole can beer be made by a brewmaster.

Malt

MALT EXTRACT

Most homebrewers owe the success of their brewing hobby to the satisfaction of having made their first batch of beer from malt extract. Over 90 percent of homebrewers continue to use malt extracts for their brewing endeavors. Malt-extract brewing clearly has its advantages over more time-consuming (and more rewarding for many) all-grain full-mash brewing. In less than 2 hours a homebrewer can easily brew 5 gallons (19 l.) of quality beer using a minimal amount of equipment.

As the hobby has matured and become more popular, malt-extract brewing has become more rewarding and has increased its ability to match the qualities all-grain brewers seek with their beers.

Beer made from malt extract syrups or powder has often been considered less appealing than beer made from all grains. This difference may be due not to extract versus all grain factors, but rather to other important brewing variables.

In the mid-1980s England's Campaign for Real Ale (CAMRA, a watchdog organization for Great Britain's consumer beer interests) taste-tested three different beers made from the same full-grain mash. One was made from wort drawn directly off the mash. Another was made from malt extract syrup that had been processed from that mash with tap water added. The third was made from the same malt extract syrup with distilled water added. Being proponents of full-grain mashing, the CAMRA panel members admitted to being biased against extract-brewed beer. But they found in a blind tasting that they preferred the malt-extract-and-tap-water-based beer over the distilled-water-based brew and found no characters in the full-grain brew to solicit a preference for or against the extract-based brew.

Yet the panel and other participants in this experiment still real-

ized that many extract-based beers brewed in the pubs left something to be desired. They could not identify what it was other than describing homemade pub-brewed extract beer as "nearly always having a characteristic (and indifferent) flavor that we think of as 'malt extract.'"

The panel concluded:

1) Freshness of product was one factor contributing to the excellent quality of the beers they tasted in this experiment.
2) The quality of yeast used in the experiment was thought to be a significant factor.
3) A knowledgeable and well-trained brewer brewed the experimental beers under controlled conditions. This may have been a factor in the overall good quality of all the beers.

Their conclusions were astute and bear remarkable insight as to what was to transpire almost ten years later in the American homebrewing hobby.

DOES FRESHNESS REALLY MAKE A DIFFERENCE?

Today in America the popularity of the hobby clearly is an advantage to homebrewers because they can be more assured of fresher malt extracts. This is particularly important with malt extract syrups, less so with dried extracts. While malt extracts in their package will not spoil, syrups tend to get darker with age and develop flavors that are contrary to the fresh flavor we expect in beer. Lighter malt extract syrups are more sensitive to these changes.

Dried malt extract, whether bought in bulk or in typical 3-pound (1.4 kg.) packages, can be conveniently stored and measured. Store unused dried malt extract in double plastic bags in a cool, dry place. If you don't, you will create a unique product called "rock malt." Rock malt is best processed with a homebrew in one hand and a hammer in the other. The smashed pebbles can be dissolved in cold water overnight and then brought to a boil in the brewing process. But enough about rock malt.

The growing popularity of homebrewing has helped to move products on and off the shelves more quickly. Currently it is rare to find stock that has been sitting for over one year on the shelves.

KNOWLEDGE IS YEAST? YEAST IS KNOWLEDGE?

The quality of the yeast used in the CAMRA experiment was thought to be a significant factor. In the late 1980s American homebrewers were introduced to a wide variety of liquid yeast cultures. The variety and availability of these cultures continue to increase, and their quality continues to improve. Quality yeast has definitely improved the quality of beer made from malt extracts. American homebrewers now have access to the same quality of yeast that the CAMRA experimenters had, and these yeasts are much better than what was previously available to homebrewers.

KNOWLEDGEABLE BREWING

The knowledge that American homebrewers have and the information they have access to are unsurpassed in the history of homebrewing. Magazines, journals, newsletters, judging groups and knowledgeable homebrew shop personnel have guided hundreds of thousands of homebrewers in the right direction, avoiding what were common pitfalls only a decade ago.

Malt extract always is the first thing to be wrongly (usually) blamed for low-quality beer. In commercial settings, such as pub breweries, there is an inclination to believe that with malt extract one does not need to know as much about brewing. This gross misconception has led to the demise of several pub breweries. In some cases it may take an even more knowledgeable and trained brewer to assure that the extract produces beer comparable to that made with full-grain mashes.

THE WELL-ATTENUATED BODY

The popularity of homebrewing has inspired an absolutely astounding and bewildering array of malt extract products. Hop-flavored specially formulated malt extracts with yeast are sold as kits intended to brew specific kinds of beer. Then there are malt extract syrups and dry powdered malt extracts. There are hundreds of malt extract products to choose from, produced principally in Australia, Belgium, Canada, Germany, England, Ireland, the Netherlands, New Zealand, Scotland and the United States. It isn't by accident that these malts are produced in nations that have a great brewing tradition.

Choosing the color of malt extract for a desired style of beer is a relatively easy exercise, but choosing a type of malt extract that will result in a beer with the correct fullness or thinness of body is

not quite so simple. If you want a light-bodied Pilsener, then a malt extract should be used that is known to attenuate well, that is, be more fermentable, thus leaving less full-bodied carbohydrates such as dextrin. If you seek a full-bodied sweet brown ale or "chewy" stout, a malt extract that does not ferment as completely should be your choice. Brands of plain malt extract are generally consistent in their fermentability. Experiment with the dozens of brands to determine for yourself which brands are more or less fermentable. Keep good notes and don't forget to drink the beer. Two malt extracts that are currently considered on the high end of fermentability are Munton and Fison's (England) light *dried* malt extract powder and Alexander's (U.S.) pale malt extract syrup. Two quality extracts considered to result in more full-bodied beers because of their lower fermentability are John Bull (England) malt extracts and Laaglander (The Netherlands) *dried* malt extract powder.

RECIPE CONVERSIONS

Recipes are starting points for all homebrewing formulations. They can be followed exactly as presented, knowledgeably varied, or altered because you have no choice. You will often be faced with the forced choice of another ingredient because of the unavailability, temporary or otherwise, of desired ingredients.

One of the simplest substitutions that can be made is malt syrup for dried malt and vice versa. Most malt syrup is about 80 to 85 percent solids and 15 to 20 percent water. For simplicity, use an 85 percent conversion factor when substituting dried malt for syrup. Thus, if 1 pound of malt syrup is called for in a recipe, you can substitute 0.85 pound of dried malt. Likewise approximately 1.2 pounds of syrup will substitute for 1 pound of dried extract. Specific malt extracts will contribute specific characteristics to a beer. Substituting dried extract for syrup or vice versa will result in a variation of the beer's intended final character, but it will be a close approximation and may be a desired discovery (and another recipe worth repeating).

Malt extract brewers are often introduced to beers brewed by others and consequently inspired to brew themselves. But sometimes you may discover that that great taste of homebrew was based on a recipe calling for mashing grains. Good-quality malt extract can be substituted for grain malt in any recipe, giving results that can resemble (but not duplicate) the original beer. If you wish to convert an all-grain recipe to an extract recipe, you can substitute 0.7 pound of light dried malt extract or 0.9 pound of light malt extract syrup for

every pound of pale malt (malted barley grain). If the grain recipe calls for lager malt (a lighter type of pale malted barley), try choosing an extralight or extrapale malt extract made from lager malt.

Some specialty malts such as crystal (sometimes referred to as carastan or caramel), chocolate and other roasted black malts and roasted barley do not need to be processed through mashing. They offer extract brewers a simple option for enhancing a beer's flavor and color. Extract brewers who choose not to use any grains in their recipes can substitute colored malt extracts such as amber, dark and extradark malt extract for specialty grains and produce similar effects. Here is a chart for simple conversions:

Specialty malts are crushed, and 1 cup (237 ml.) equals approximately $\frac{1}{4}$ lb. (113 g.)

5 lbs. (2.27 kg.) amber
 malt extract = 5 lbs. (2.27 kg.) light malt extract + 2 cups (474 ml.) crystal = 5 lbs. (2.27 kg.) light malt extract + 1/2 cup (119 ml.) black, roasted or chocolate malt

5 lbs. (2.27 kg.) medium brown
 malt extract = 5 lbs. (2.27 kg.) light or amber malt extract + 1 cup (237 ml.) black, roasted or chocolate malt + (optional) 1 or 2 cups (237 or 474 ml.) crystal malt

5 lbs. (2.27 kg.) very dark
 malt extract = 5 lbs. (2.27 kg.) light or amber malt extract + 2–3 cups (474–711 ml.) roasted, black or chocolate malt

The versatility of light malt becomes apparent when you realize that you can combine it with different specialty malts to produce malt extract of any color.

GRAIN MALTS

A lot has changed on the American brewing scene in the last decade, and there is every indication that these progressive trends will continue. These changes were inspired by the grass-roots enthusiasm of homebrewers and their appreciation for diversity and quality in beer. But much of the change has been economically driven by the commercial microbrewers and pub brewers throughout America who created a market for specialty beers—beer styles other than typical light American-style lager beers. Several hundred small breweries have created a demand for a wide variety of specially malted grains. Their demand has resulted in an industry that actively produces special malts in America and imports special malts from around the world.

Homebrewers have always been second-tier customers of the malt companies. The distribution system for homebrewing supplies picks and chooses the malts it makes available to the hobby from the larger production batches of malts made for the commercial industry.

With the boom in small brewery specialty products and the growing popularity of homebrewing, the homebrewer wins, especially the all-grain brewer. Homebrewers also benefit from the commercial brewing industry's research and development efforts to grow better barley for brewing purposes.

Pale malted barley (pale malt) is a generic tag used to designate many types of very light-colored malted barley, which usually makes up the majority of the grist (total amount of crushed grains, malted or otherwise). The term *specialty malt* refers to types of malt that usually are not the major portion of the grist but are added in relatively small quantities to influence the character of a beer's aroma, flavor, color, head retention or mouth feel. But you can't always use the specialty malt designation as such. There are exceptions, sure as there are homebrewers enjoying one of their own homebrews right this very moment as you read or reread this paragraph. There are some beer formulations whose grist will take on a major proportion of specialty malts. In these cases usually the lighter specialty malts are utilized. So please don't take exception. Relax. I already have (both taken exception and relaxed and maybe had a homebrew as well).

USING SPECIALTY MALTS WITHOUT MASHING

Many specialty malts must be fully mashed with the rest of the grist, but there are exceptions. Black malt (sometimes referred to as black patent malt, named after an eighteenth-century process of roasting

malt patented as British patent number 4112), chocolate malt, brown malt, various crystal and caramel malts and roasted barley are the principal malts available to homebrewers that do not require a mashing regime to convert nonfermentable carbohydrates to fermentable carbohydrates. These malts can contribute color, roasted flavor and some degree of stability to the character of beer. Crystal and caramel malts also can contribute to the perception of final unfermentable sweetness.

For ideal extraction of the favorable qualities of any malt, the crushed grain should never be brought to a boil. Some recipes and procedures guide beginning brewers to bring these specialty malts just to a boil and quickly remove them from the heat source. This is a simple procedure designed to encourage their use by beginning brewers. For those who desire to improve the quality of their beers with a small additional investment in time and attention, the grains should never be steeped in water whose temperature exceeds 170 degrees F (77 degrees C). The extraction of undesirable tannin and astringent characters is minimized with a lower-temperature steep.

A procedure that works very well is to mix the crushed grains with water at 150 degrees F (66 degrees C) and hold this temperature for 30 minutes. The grains and water should be mixed in a ratio of 1 pound (.45 kg.) to $\frac{1}{2}$ gallon (1.9 l.). Add the liquid strained and extracted from this "steep" to malt extract and continue the brewing process with a vigorous boil, adding hops and more water as needed.

THE ESSENTIAL KERNEL: ALL ABOUT MALT

If you've ever wondered why there isn't one book that neatly and concisely compiles all you'd ever want to know about malted barley, then you've never done any real research yourself. There is good reason why a comprehensive overview does not exist. The diversity of information and of individual brewers' needs is enough to drive you to making your own homebrew with whatever ingredients are available and coming to the conclusion that yours is some of the best you've ever had.

Almost all of the dependable information on malt originates from professional literature. Commercial brewers' needs are diverse. The equipment, the recipe formulations, the processes, vary tremendously to adapt to *whatever type of malted barley the brewer can get.*

Two-row, six-row, highly modified, undermodified, high-enzyme, low-enzyme, lager malt, ale malt—they have all been quite thoroughly explained in several books, including *The New Complete Joy of*

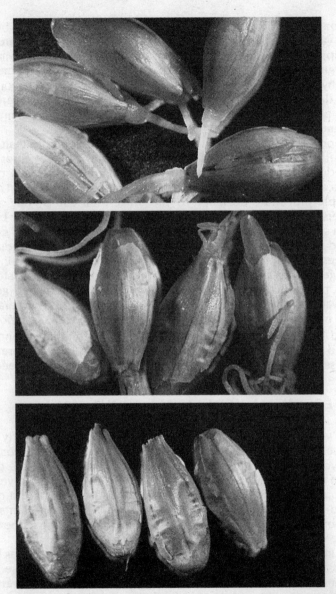

After an initial 48-hour water steep, barley kernels sprouting rootlets while growing acrospire emerge from beneath husk. Sprouted and dried barley kernels become malt. From top: rootlet development after one day of germination; rootlets begin to wither after five days of germination and acrospire length is about full length; kilned and cleaned malt.

Home Brewing. The best advice I can offer to someone who wishes to understand "all about malt" is to read no fewer than ten authors/ resources/books about malt and its influence on beer. Stock your refrigerator with several of your own beers in order to maintain contact with reality. Take notes. Do take notes! Divide them into two groups. Make a list of points that every source usually agrees on and generally trust those rules, facts, statements and opinions. Also make a list of the points that either contradict or don't match other sources. Then seek out discussions with "experts" and begin to understand why these sources disagree or facts don't match. When you are through drinking all of your beer and have completed this research, *you* will be an expert.

How can the subject of "all about malt" be approached in a book such as this with limited scope? The question was duly considered. After much perusal of literature and a 6-ounce bottle of six-year-old homebrewed honey weizen steam-style barley wine lager, I arrived at an answer: Get practical. What are some of the more common problems or challenges homebrewers might face when all-grain brewing—particularly when brewing light lagers or pale ales, when the choice of malt can be influential? Let's examine some practical information about the characters of malt.

A KEY TO UNDERSTANDING MALT

There are many specifications by which malt is measured. These include but are not limited to:

Percent moisture
Extract
 Coarse-grind extract (dry basis)
 Fine-grind extract (dry basis)
 Coarse-grind–Fine grind difference
Diastatic power
 Alpha amylase activity
Beta-glucan
Viscosity
Color of wort
Clarity
Growth of acrospire
Sieve (size) assortment

Protein
 Percent total protein
 Percent soluble protein
 Percent soluble/total protein ratio

Percent Moisture—Pale malts are usually 2 to 4.5 percent moisture. Roasted and mild malts have less moisture. If moisture gets too high, storability decreases.

Extract—a measure of the soluble carbohydrates that can be extracted by the mashing process. It is measured by the ratio of the weight (dried) of the soluble material to the initial weight of the malt and is expressed as a percentage. For example, one year's crop of typical two-row lager malt coarse-grind extract may be about 79 percent, while a six-row lager malt may be 75 percent. This number can help estimate the total weight of solubles in a given volume of water, thus making it possible to calculate degrees Balling or specific gravity.

 Coarse-grind extract (dry basis)—imitates typical mash conditions.

 Fine-grind extract (dry basis)—gives an idea of maximum yield given certain conditions.

 Coarse grind–fine grind difference—partial indication of degree of modification. Larger differences indicate less modification; greater differences, more modification. How it works is that fine grind will tend to give a maximum yield regardless of modification, while coarse grind/brewery grind yields will be influenced by degree of modification.

Diastatic Power (Includes Alpha Amylase Activity)—a measure of potential enzyme "energy" that a malt has. We can be assured that all pale and lager malts have more than adequate enzyme power to convert their own soluble carbohydrates to fermentable carbohydrates plus about 10 percent adjunct starch. High-enzyme malts such as many varieties of American six-row have a surplus of power, allowing them to convert 40 percent extra adjuncts. Diastatic power is measured in degrees Lintner. A typical high-enzyme American six-row will be 150 degrees L, while an American two-row may be about 120 degrees L and some European lager-type malts will be about 90 degrees L. European units of diastatic power are expressed in degrees W-K. Degrees (W-K) = $(3.5 \times$ degrees Lintner$)$ = 16.

Beta-glucan—a gumlike substance that causes commercial brewers problems with stuck runoffs and wort filtration if their level is too high. From 75 to 150 ppm is a range that is acceptable for malted barley.

Viscosity, Color of Wort and Clarity—These are other data provided in specification.

Growth of Acrospire—A measure of the growth of the acrospire inside the outer husk layer of malt, indicating degree of modification of the malt. If the acrospire is less than half the length of the kernel, the malt is undermodified. If it is three-quarters of the length up to the full length, it is considered normally modified. Overmodified malt has an acrospire that sometimes grows the full length of the kernel or more. The degree of modification helps indicate the protein character of malt. More modification increases soluble proteins.

Sieve Assortment—A measurement of the uniformity of the malt kernel size. This is important when setting malt mills to grind a consistent and uniform grist for maximum yield of extract.

Protein—Excellent beer can be made from less than ideally ground malt, low- or high-enzyme malt, undermodified or highly modified malt, and malt of varying color and viscosity, but when your protein goes haywire you may have problems unless you compensate for it in your brewing process. But first you've got to know what is not ideal and begin to understand its impact on the character of your beer.

Total protein content is expressed as a percentage of the total weight of the malt. Almost all of the nitrogen content of malt is bound in protein. Nitrogen is about 16 percent of the total weight of protein. Analysts measure the weight of the total nitrogen in malt (% N) and multiply by (100/16), which is equal to 6.25, to get total percent protein. Got it? Total percent protein = 6.25 × % N and is usually expressed as total percent protein. A range of 9 to 11 percent would be considered ideal by many brewers, but 6-row malts of this type are rarely available. Eleven to 12 percent is typical for American two-row, and 12 to 13 percent is typical for American 6-row. High protein contents must be carefully considered in the brewing process. If not compensated for, they may create problems in the character of the beer.

Soluble protein is a measure of proteins that act as a yeast nutrient. Solubility is a measure of the protein that can be expected to dissolve in the final wort. It is also an indication of proteolytic enzyme activity since this activity helps break down some proteins into solution.

If, as a practicing homebrewer, you have reason to care or be concerned about malt quality (don't worry, please), then the single most telling and useful specification is that of soluble protein con-

tent. While the entire brewing process and other ingredients must be considered, protein content of malt can have a significant impact on many qualities of beer. The key words here are *can have*, because the malt you used and how you handled it may or may not have been crucial to your individual beer's character.

Sluggish fermentation, poor head retention, excessive diacetyl production, excessive chill haze, collodial haze (a permanent haze) and unstable beer (beer whose freshness deteriorates) can all be the result of out-of-bounds soluble protein content or improper handling of malt.

The study of proteins is a very complex and involved science. At the risk of oversimplifying their involvement in the brewing process, I'll explain some basic principles. Proteins in malt start out as very long chains of molecules. These long chains are made up of building blocks called amino acids. Amino acids are the smallest of the proteins. The longest chains of proteins are susceptible to breaking apart into medium-sized chains of proteins. Certain enzymes at specific temperature ranges break the longest chains to medium-sized chains: Then there are other types of enzymes that work at another temperature range to break the medium-sized proteins into the smallest amino acids. (If this sounds similar to mashing and breaking down long chains of carbohydrates into their constituent glucose molecules through the use of diastatic enzymes, you're right—and you deserve a homebrew.)

It is desirable to degrade proteins to varying degrees with the aid of protease enzymes that are in the malt. If the longest chains of soluble and insoluble proteins are carried over into the beer in excessive amounts, their presence will result in turbidity, destruction of head retention and flavor instability. The medium-length chains of protein are born from the first breakdown of long chains. A certain amount of these medium-chain proteins is desirable for good head retention and mouth feel. Finally, the smallest chains or building-block proteins are the result of the breakdown of medium-chain proteins. They are terrific yeast nutrients and essential, in proper proportion, for healthy fermentation and good attenuation.

In summary, about 50 percent of the original long-chain proteins must be removed or broken down to create a reasonable balance of other types of proteins in order to optimize head retention, clarity, attenuation, healthy fermentation and flavor stability.

Here are some additional generalizations you can consider. Six-row malts generally have higher protein contents. Higher protein con-

tents are an indication of higher enzymatic power. Higher protein contents coincide with lower extract yields from the malt.

It is worth noting that high-protein, high-enzyme malts are often used with 20 to 40 percent starch adjuncts such as corn and rice. With 30 percent adjuncts in the grist and a 13.5 percent total protein malt, the total grist has an effective total protein of 9.5 percent. This effectively reduces the overall wort protein content to a level that does not create the same problems that would arise if these malts were used when brewing all-malt beer.

What is the relationship of soluble protein produced in highly modified malts and yeast nutrition? Fully or highly modified malts such as English two-row pale malt have had adequate yeast nutrients (amino acids) created during the malting process so the wort is not as dependent on the mashing process for these nutrients. Some brewers argue that English two-row malts benefit from a protein-degrading regime, creating better head retention and beer stability.

Here are a few other beer characters that all-malt homebrewers may relate to.

Some brewing researchers claim diacetyl levels in the final beer can be influenced by protein content and mashing procedures. When brewing all-malt beers and using normally modified malts (less soluble protein) with an infusion mash, there is a greater likelihood of excessive diacetyl (butterscotch flavor/aroma) in the final beer. Highly modified malts (more soluble protein) in an infusion mash tend to result in comparatively less diacetyl in the final beer.

Dimethyl sulfide (DMS) is a sulfur compound that smells and tastes like cooked sweet corn. When noticed, its impact on the character of beer is satiating and almost always undesirable. When DMS is evident in beer, it is the result of either bacterial contamination or the way the malt was processed. Lager malts are the lightest of malts due to their low kilning temperature. This process inherently leaves behind compounds in the malt that are precursors to DMS. If the malt is not properly processed with a vigorous one- to two-hour wort boil and rapid chilling before fermentation, detectable levels of DMS can form. English pale ale malts are kilned slightly darker than lager malts; consequently, as with other colored malts, the precursor compounds are "driven" off, thus offering little risk of DMS character contributed by the malt.

Get the picture? How you can deal with all of this information and make at least some small improvements without risking anxiety will be explained in the section on mashing and boiling the wort.

SPECIALTY MALT FRENZY

Have you ever visited a full-service homebrew supply shop? They'll often carry over twenty different kinds of grain malts. Thanks again to the popularity of specialty beers in America, many choices now are available to homebrewers. But what about all of these malts? What flavors will they contribute to beer? What kind of extract can one anticipate? If a certain color of beer is sought, how will one know how much to use?

The challenge seems quite bewildering at first. Relax. Remember you're a homebrewer. You have the opportunity to play around with these malts in relatively small amounts and get a genuine feel for what games they will play with beer character, flavor and aroma.

All malt is made by allowing barley to go through a series of water steeping and draining to allow moisture uptake by the barley seed. The barley is then allowed to germinate under controlled conditions to a specified degree. The amount that the barley is allowed to sprout is called *modification*. This process is quite similar for all malts up to this point. It is during the drying process that malts take on their special character. All commercially available malt is dried in kilns. The character of the malt is determined by three main variables: the moisture content of the malt, the temperature at which the malt is kilned, and the time the malt spends at any given temperature. Some malts will be processed through a series of time and temperature kilnings to create their unique appearance, color, flavor and aroma character.

Touch the malt. Examine its appearance. Are the grains more or less uniform in size? Are they plump or wrinkled? Break open a grain. Does it appear glassy (an indication of undermodification), or mealy or floury (an indication of well-modified malt)? Does the endosperm appear white, orange, light brown, reddish, dark brown or black? Chew it. Taste it. Is it hard or "steely" (indicating possible kilning irregularities)? Is it friable (crunches easily)? Does it taste mildly sweet and malty? Does it have a toasted malt character? Is it caramel-like? Perhaps it's flavorless. What is the aroma like? Does it have a smoky, caramel-like, roasted, biscuitlike or toasted aroma that may contribute to the aromatic character of the beer it is used in?

Using your senses as a tool to assess malt is an essential first step in understanding the character of beer made from malts. With practice you will develop your own data bank of information, more valuable than anyone else's assessment.

Experimentation is the most enjoyable way of discovering the character of these malts and what they contribute to beer, and you'll

have plenty of great beer to share with friends. Alas, your resources of time and money may crimp this style of discovery. So, presented later in this section is a table of malt data and specifications. This essential information will be the foundation for reasonably calculating the color and original gravity of any beer that uses grain malt or malt extract in its recipe formulation.

COLOR

Color of beer is expressed as SRM (Standard Reference Method). SRM is very close to the old degrees Lovibond method, and for practical purposes they are interchangeable. Predicting the final color of beer is a tricky endeavor. Using data that indicate the original color of the malts used is at best a reasonable approximation. Malt color is not the only variable that affects the final color of beer. Wort boiling promotes some degree of caramelization, darkening the beer. Water with high pH (high alkaline) can extract more than usual color from malt grains. Filtering beer can remove some color. Oxidation can increase beer color. Commercial brewers are much more sensitive to these influences and resulting variations because they are trying to produce a beer whose color is identical from batch to batch. For homebrewers the priorities are entirely different. Even if you are trying to match a color for a certain style of beer, there is variation within the style to allow at least plus or minus 1 to 2 degrees SRM. Homebrewers can get good results when blending different malts to achieve a given character and color if they use malt color as the sole factor in predicting beer color.

Each malt is assigned a color rating expressed in degrees Lovibond. In America these color ratings correspond with the color that 1 pound (.454 kg.) of a malt will contribute to 1 U.S. gallon (3.8 l.) of beer. For example, if we have a Vienna malt rated at 5 degrees L and we use 5 pounds (2.3 kg.) in 5 gallons (19 l.), the predicted color of the beer will be about 5 degrees Lovibond:

$$\frac{(5 \text{ degrees L} \times 5 \text{ lbs.})}{5 \text{ gallons}} = 5 \text{ degrees L or SRM}$$

If 10 pounds (4.54 kg.) are used in 5 gallons (19 l.), then:

$$\frac{(5 \text{ degrees L} \times 10 \text{ lbs.})}{5 \text{ gallons}} = 10 \text{ degrees L or SRM}$$

The beer will have 10 degrees color.

If one were to use metric units to calculate color of beer from colored malt, the formula would be:

Degrees Lovibond malt \times (kg. malt/liters of beer) \times 8.36 = color of beer

When different malts are combined in a recipe, the formula is extended as such:

$$\frac{[(°L\,malt_1 \times lbs.\,malt_1) + (°L\,malt_2 \times lbs.\,malt_2) + (°L\,malt_3 \times lbs.\,malt_3)]}{gallons\,of\,beer} = color\,of\,beer$$

PREDICTING EXTRACT AND ORIGINAL GRAVITY

Extract potential of malt is indicative of the maximum amount of sugars and unfermentable carbohydrates a brewer can expect to extract from malt. A key point to understand is that the figures given in malt analysis specifications or the following table is the maximum you can achieve. What really is achieved is dependent on the efficiency of your mashing system and other processes. Inevitably there will be extract left behind in the lautering system, during trub removal after boiling the wort, and even during the sparge of hops. And, oh yes, what about boilovers? Let's not even consider this for now. The point is that most homebrewers can predict what kind of final extract they will achieve by factoring about 70 to 90 percent efficiency. This is dependent on your system, and you will be able to figure your efficiency rating by calculating a predicted extract based on 100 percent efficiency and comparing it to the actual. For example, if 100 percent efficiency predicts an extract resulting in an original specific gravity of 1.048 (12 B) and your actual reading is 1.036 (9 B), then the efficiency of your system is:

$$\frac{Actual\,original\,gravity}{Maximum\,predicted\,gravity} \times 100$$

or

$$\frac{36}{48} \times 100 = 75\,percent$$

(assuming your targeted volume is achieved)

There are three ways in which extract potential is expressed. If you read a specification sheet from a maltster, you will note that extract is expressed as a percentage indicating the ratio of dried soluble extract to the total original weight of the malt. As explained earlier in this section, this percentage can be converted to degrees Balling and thus specific gravity in a given volume of wort.

One degree Balling (or Plato) is equal to 1 pound of extract dissolved in 100 pounds of liquid (or 1 kg. dissolved in 100 kg.). If extract is expressed as 75 percent, this means that 1 pound of malt will yield 0.75 pound of extract. Dissolving this into 1 gallon of water will result in about 8.5 degrees Balling because the weight of the water plus extract will weigh about 8.6 lbs.:

$$\frac{0.75 \text{ lb.}}{8.6 \text{ lbs.}} = .087$$

Multiply by 100 and we get 8.7 degrees Balling

or

\times 4 = abbreviated specific gravity 35 more accurately expressed as 1.035

The preceding conversion from percent (expressed as a whole number) to degrees Balling or specific gravity is expressed:

(Percent extract \div 8.6) = degrees Balling for 1 gallon

or

(Percent extract \div 8.6) \times 4 = specific gravity (shorthand)

The above degrees Balling or specific gravity is referred to as "extract potential"

Converting these expressions into useful formulas for estimating potential initial specific gravities for given volumes of beer gets simplified to:

$$\frac{\text{Pounds of malt} \times (\text{percent extract} \div 8.6)}{\text{volume of beer in gallons}} = \text{potential degrees Balling}$$

or

$$\frac{\text{Pounds of malt} \times (\text{percent extract} \div 8.6)}{\text{volume of beer in gallons} \times 4} = \text{potential specific gravity (shorthand)}$$

The metric equivalent is:

$$\frac{\text{Kilograms of malt} \times (\text{percent extract} \div 1.03)}{\text{volume of beer in liters}} = \text{potential degrees Balling}$$

or

$$\frac{\text{Kilograms of malt} \times (\text{percent extract} \div 1.03)}{\text{volume of beer in liters} \times 4} = \text{potential specific gravity (shorthand)}$$

When we know the extract potential (EP, either in degrees Balling or specific gravity shorthand) for a variety of malts, and these malts are combined in the formulation of recipes, estimating the maximum potential gravity of the beer is as simple as:

$$\frac{(\text{lbs. of malt}_1 \times EP_1) + (\text{lbs. of malt}_2 \times EP_2) + (\text{lbs. of malt}_3 \times EP_3)}{\text{gallons of beer}} = \text{potential original gravity}$$

If you were to use:
5 lbs. of lager malt rated at 35
1 lb. of crystal malt rated at 20
1 lb. of dried malt extract rated at 45

you would calculate:

$$\frac{(5 \times 35) + (1 \times 20) + (1 \times 45)}{5 \text{ gallons}} = 48 \text{ or } 1.048 \text{ maximum potential gravity}$$

When you know the efficiency of your system, simply multiply that percentage by the maximum potential to arrive at the actual expected gravity. For example, if your calculated maximum potential is 48 or 1.048 and the efficiency of your system is 80 percent, then: $.80 \times 48 = 38.4$ or 1.038 predicted actual gravity.

Refer to the Malt Table on pages 44–47 and have at it.

STORAGE OF MALT

The best way to store malt is to combine it with water, hops and yeast, ferment and then bottle it.

But if you must find short-term alternative means, you should consider that moisture, insects, heat and age are the primary factors that will cause malt to become unusable.

Moisture will cause spoilage by promoting molding. This type of spoilage is characterized by a musty aroma and flavor as well as a gray, dusty appearance.

Insects will eat the grain, bore holes throughout, lay eggs and defecate in the malt. Appearance will be obvious. Aroma can be cheeselike and the flavor ugly.

Age will make malt progressively more rancid. Heat will accelerate this process. This is essentially oxidation. Malts with higher moisture content are more susceptible to this problem. Malts such as crystal or dark malts are drier and don't show signs of this effect for quite some time.

Properly stored malt can last for a few years. Store in a cool, dry, airtight environment. Use two food-grade plastic trash bags if prolonged storage is anticipated. If you live in an area where insects are a problem, malt should be stored in an airtight plastic bucket. If insect contamination is suspected, place a piece of dry ice in the bottom of the container of malt. Make an allowance to vent the carbon dioxide as it evaporates from the dry ice. This will create an oxygen-free environment that will kill or at least seriously inhibit insects and their larvae.

Keep your storage area free of crumbs, spills and malt dust. Be tidy, relax, don't worry and have a homebrew.

MALT TABLE

Malt	Dias. Power = degrees Lintner	Percent Protein = Total dry basis	Percent Yield = Coarse grind dry basis (or fine grind)	Degrees Balling	Specific Gravity	Color SRM (EBC)	Character/Suggested Upper Limit Percent
Light Pale Malts							
American 6-row[1]	150	13%	76	8.8	1.035	1.8	≤100%
American 2-row[1]	140	12.3	79	9.2	1.037	1.8	Higher protease activity; more soluble protein than English 2-row; ≤100%
American Klages 2-row[3]	120	12	79	9.2	1.037	—	≤100%
English 2-row Pils[4]	60	10	78	9.1	1.036	1–2.5	≤100%
English 2-row lager[6]	75	9.7	81	9.4	1.038	1.4 (2.5)	≤100%
English 2-row pale	45	10.1	81	9.4	1.038	2–3 (5–6)	≤100%
German 2-row Pils[5]	110	11	81	9.4	1.038	1.6 (3.0)	≤100%
Belgian pale ale[2]	60	10.5	80	9.3	1.037	3.2	≤100%
Belgian Pilsener[2]	105	10.5	79	9.2	1.037	1.8	≤100%

Extract Potential 1 lb. in 1 gal.

Light-Colored Specialty Malts

English mild[6]	53	10.6	80	9.3	1.037	3–4 (≤6.5)	≤100%
English wheat malt[4]	70	12.5	80	9.3	1.037	1.5–3	≤80%
Pacific Northwest wheat[3]	160	12	87	10	1.040	4.0	≤80%
Midwest wheat malt[1]	155	NA	79	9.2	1.037	2	≤80%
German wheat malt[5]	95	12.5	84	9.8	1.039	1.8 (3.5)	≤80%
Belgian wheat malt[2]	74	11.5	81	9.4	1.038	1.8	≤80%
Rye malt	75	10.23	63	7.3	1.029	4.7	≤15%
American Vienna[1]	130	13	75	8.7	1.035	4	≤90%
German Vienna[5]	95	11	80	9.3	1.037	2.7 (6)	≤90%
English 2-row Vienna[4]	50	11	78	9.1	1.036	3–4	≤90%
American Cara-Pils/Dextrine[1]	0	13.2	72 (FG)	8.1*	1.033*	1.5	for added foam and head retention; ≤20%
German light crystal[5]	20	—	80	9.3	1.037	2.5 (5.5)	for added foam and head retention; ≤20%
Belgian Cara-Pils[2]	9	11.5	77 (FG)	8.5*	1.034*	7.8 (15)	≤80%
American Munich[1]	50	13	77 (FG)	8.6*	1.034*	8–12	≤60%
German Munich[5]	72	11.5	80	9.3	1.037	7.8–10 (15–20)	≤80%
English 2-row Munich[4]	40	10	80	9.3	1.037	4–8	≤80%
Belgian Munich[2]	50	10.4	81	9.4	1.038	7.8 (15)	≤80%

(continued)

MALT TABLE (*continued*)

Extract Potential
1 lb. in 1 gal.

Malt	Dias. Power = degrees Lintner	Percent Protein = Total dry basis	Percent Yield = Coarse grind dry basis (or fine grind)	Degrees Balling	Specific Gravity	Color SRM (EBC)	Character/Suggested Upper Limit Percent
Crystal, Caramel, Carastan Malts							
American caramel – 10[1]	0	13.2	75	8.7	1.035	10	≤20%
American caramel – 20[1]	0	13.2	75	8.7	1.035	20	≤20%
American caramel – 40[1]	0	13.2	74	8.6	1.034	40	≤20%
American caramel – 60[1]	0	13.2	74	8.6	1.034	80	≤20%
American caramel – 80[1]	0	13.2	74	8.6	1.034	80	≤20%
American caramel – 120[1]	0	NA	72	8.4	1.033	120	≤20%
English crystal/Caramel[4]	0	13.4	75*	8.7*	1.035*	50–200	≤20%
English carastan/Caramalt[4]	0	12.6	75*	8.7*	1.035*	10–37	≤20%
German dark crystal[5]	0	0	80	9.3	1.037	65 (100)	≤20%
Belgian caramel Munich[2]	0	11.2	76 (FG)	8.3*	1.033*	72 (115)	≤10%
Belgian Caravienne[2]	8	9.6	78 (FG)	8.6*	1.034*	22 (45)	≤10%

Dark-Colored Specialty Malts

American Victory[1]	50	13.2	73	8.5	1.034	20–30	toasted; ≤15%
Belgian Biscuit[2]	6	10.5	79 (FG)	8.7*	1.035*	23 (55)	≤10%
Belgian "Aromatic" malt[2]	29	11.8	78	9.1	1.036	26 (55)	≤10%
English Brown/Amber[4]	0	10.5	72 (FG)	8.1*	1.032*	65	≤10%
Belgian Special "B"[2]	0	10.4	69 (FG)	7.6*	1.030*	221 (500)	≤10%
American Chocolate[1]	0	13.2	50–60	5.8–7.0	1.023–28	325–375	≤10%
English Chocolate[4]	0	10.5	73 (FG)	8.5	1.034	450–500	≤10%
Belgian Chocolate[2]	0	11.1	68 (FG)	7.4*	1.030*	500 (1,100)	≤10%
American Black Roast[1]	0	13.2	50–60	5.8–7.0	1.023–28	475–525	≤7%
English Black Roast[4]	0	9.8	50–65	5.8–7.6	1.023–30	500–550	≤7%
Belgian Black Roast[2]	0	11.1	68 (FG)	7.4	1.030	600 (1,400)	≤7%

Unusual Specialties

Black Roasted Barley[1] (unmalted)	0	13.2	50–60	5.8–7.0	1.023–28	500–550	≤7%
Roasted Barley[1]	0	13.2	50–60	5.8–7.0	1.023–28	300–325	≤7%
German smoked[7]	NA	11.5	80	9.3	1.037	6–12 (15–30)	≤100%

Malt Extract

Dried malt extract	varies	varies	97	11	1.045	varies	≤100%
Malt extract syrup	varies	varies	80	9.3	1.037	varies	≤100%

NOTES: Diastatic Power is approximated within the following ranges: very high, >130; high, 85 to 130; medium, 50 to 85; low, 10 to 50; none, <10. The values for diastatic power, protein and yield may vary from year to year and batch to batch. The values in this chart are represented from actual or average data available in mid-1993.

[1] Briess Malting Company, Chilton, Wisconsin [2] De-Wolf-Cosyns Maltings, Belgium [3] Great Western Malting Co., Vancouver, Washington [4] Hugh Baird & Sons, England [5] Ireks Arkedy, Germany [6] Muntona, England [7] Liberty Malt Supply, Seattle, Washington * Estimated data based on information provided

Fermentable Adjuncts

In the early and mid-1970s there was a distinct reason why Americans became interested in brewing their own beer. Virtually all the beer that was available was a typically light-flavored American-style adjunct lager. Heineken, Becks and the occasional Guinness Stout were the hard-to-find alternatives. Homebrewers were primarily interested in fuller-flavored all-malt beers. If you wanted one, you had to make it.

The hobby has changed dramatically since 1974. Hobbyists have become more diverse in the interest of creating an unending variety of beers. As homebrewers have continued to acquire knowledge through reading and experience, they have developed a great deal of respect for the brewing process. Who would have guessed in the mid-1970s that there would be significant numbers of homebrewers who respect the character of light-flavored adjunct beers? Curiously, commercial brewers of those light-flavored adjunct beers have also developed a great deal of respect for fuller-flavored all-malt beers.

With a greater understanding of the brewing process and with the availability of quality lager yeasts, the skilled homebrewer can brew quality light adjunct beers. Grain adjuncts contribute some distinctive and positive characters to beer. They are worth experimenting with for producing very traditional American light lager-style beers or to see what unusual contributions they make to typically fuller-flavored ales and lagers. Finally there are unusual reasons to use cereal grains other than barley in brewing beer, such as duplicating indigenous beers from other parts of the world or substituting other grains in order to circumvent allergic reactions to specific grains.

A thorough discussion regarding the processing and use of unmalted grains in beer is available in *The New Complete Joy of Home Brewing.* Formulating recipes with unmalted grains can be done more easily with the additional information supplied in the table on page 49.

BEER AND ALLERGIES

Buckwheat, amaranth and quinoa are unique among common cereal grains in that they are not of the grass family. Persons with allergic reactions to grass cereals may find that alternative beers may be

FERMENTABLE GRAIN ADJUNCTS EXTRACT TABLE

Adjunct	Total Protein	Percent Yield	Degrees Balling	Extract Potential 1 lb. in 1 gal. Specific Gravity	Character
Barley, raw or flaked	13%	65–74	7.5	30–34	High in haze-producing protein. Soluble protein is about a third that of malted barley. Protein rest in mash recommended for lighter beers. Helps head retention.
Corn/maize, grits	9–12%	80	9.3	37	Very low soluble protein content. Grainy cornlike flavor.
Corn/maize, flaked	9–12%	84	9.8	39	Very soluble low protein. Pleasant mildly cornlike flavor.
Wheat, raw or flaked	13–15%	77	9.0	36	No husk, therefore no contribution as husk astringency. Foam-promoting proteins available. Protein rest recommended.
Rice, raw or flaked	9%	82	9.5	38	Very low protein. Neutral flavor.
Millet/sorghum, raw	8–11%	80	9.3	37	Very low soluble protein.
Rye, raw or flaked	11.3%	77	9.0	36	Small contribution to robust flavor. Finished crisp, clean. Protein rest recommended.
Oats, raw or flaked	9%	70	8.1	33	Adds fullness to mouth feel. Promotes good head retention. Protein rest recommended.

Tef, Dinkel (Spelt), Kamut, buckwheat, amaranth and quinoa are other grains worth considering as brewing adjuncts, but brewing-related data are not available, and little is known regarding their contribution to beer character.

brewed from these grains. Another potential alternative for persons with allergies to cereal grains is "heirloom wheats" called spelt (also known as dinkel, *triticum astivum spelta*) or kamut (*triticum polonicum*). Spelt and kamut are ancient wheats that have not been hybridized. A significant percentage of persons normally allergic to wheat-based foods could use spelt as an alternative. Spelt may be malted just as any other wheat and subsequently used as the basis for beer. Spelt is about 30 percent higher in protein than modern wheat. Kamut is higher in lipids. (See recipe and procedures page 275.) Consult your physician before experimenting.

Malting Your Own Grains:
A Basic Procedure for Survival

Malt is simply a grain that has been allowed to germinate and then has been dried. The process degrades proteins into more desirable types of proteins and develops starch-to-sugar converting enzymes, soluble starch and some sugar.

When malting individual varieties of grain, some experimentation will be necessary to approach optimal results. But adhering to these basic procedures will allow you to brew the simplest beers next time you find yourself on an extended sojourn to a remote village in the Himalayas, the Andes, the African bush or an island without beer.

Clean the grain by rinsing and soaking in water, removing the chaff and other material that floats to the surface. Soak the grains in five to seven changes of water over a period of 30 to 40 hours or until the grains take on 40 to 45 percent moisture. (They'll weigh 40 percent more than dry weight.) Germinate in a relatively cool area (ideally at 55 to 65 degrees F [13 to 18 degrees C]) until the growing acrospire is about three-quarters or equal to the full length of the grain. (Ideal length will vary with different types of grain.) You will need to mix the germinating grains and rinse them with fresh water to prevent molding. This process generally will take two to six days.

Dry the malt by any means you have available—dry roof in the sun, low-temperature oven. Of particular convenience for brewers at home is a clothes dryer. Tie the malt into a large pillowcase or sack, set the heat on delicates or permanent press and tumble dry. The ideal temperature for your basic pale lager barley malt is about 122 degrees F (50 degrees C) and upward to 221 degrees F (105 degrees C) for more strongly-flavored malts. Good luck and may we share a brew in Leh someday.

OTHER FERMENTABLE ADJUNCTS EXTRACT TABLE

Extract Potential
1 lb. in 1 gal. total volume

Adjunct	Percent Yield	Degrees Balling	Specific Gravity	Character
Cane sugar	100	11.5	46	Lightens flavor and body when substituted for malt. Can contribute to apple- or ciderlike character, especially when not cold-fermented.
Belgian candy sugar	100	11.5	36	Lightens flavor and body. Will contribute to ciderlike character in lighter beers. Usually used in full-flavored ales to lighten or enhance character and drinkability.
Corn sugar, dextrose	80	9.2	37	Approximately 20% of weight tied up as water molecules.
Honey	65–75	7.6–8.8	30–35	Approximately 25% to 35% of weight tied up as water. Nearly 100 percent fermentable. Can lighten flavor and body when substituted for malt.
Maple sap	2–3	0.2	1.009	Sap is 1.009 ± .003 (0.2 ± .05 B), pH 6.8, hardness 250 ppm.[1]
Maple syrup	65	7.5	30	Will vary with type.
Corn syrup	—	—	—	Extract varies considerably depending on type. Avoid those with preservatives.
Molasses	77	9	1.036	Can contribute strong butterlike and winelike flavors if added in excess. One cup or 1/2 pound per 5 gallons noticeably affects character.
Rice extract	73	8.5	1.034	Excellent adjunct to lighten flavor of extract beers. Neutral in flavor.

[1] "How to Make Maple Sap Beer," by Morgan Wright, *zymurgy* magazine, winter 1988.

Recipes in this book using adjuncts:

FRUITS, HERBS, SPICES, ROOTS AND THE GALAXY

Fruit. Fruit in beer? Originally discussed in *The New Complete Joy of Home Brewing* as perhaps an oddity, fruit remains an unusual ingredi-

ent in beer, but is no longer considered an oddity. Wonderfully refreshing beers can be brewed with the addition of fruit, its juice or extract.

Generally speaking, the intent of adding fruit to beer is to have its flavor evident in the beer character. Fruit flavors are usually enhanced in beer when the bitterness levels are kept very low and are accompanied by a degree of residual sweetness and body. Fruits have their own natural sugars. We are most accustomed to fruit flavors with the support of sweetness. Without some sweetness, the fruit flavor is not familiar to most people and, as such, is usually not preferred.

The addition of crystal and dextrinous malts will contribute sweetness and body. High-gravity brews or high-temperature mashes will also elevate sweetness and body.

Let your own preference be your guide. If you disagree with the preceding, hey, no problemo. That's why you're a homebrewer—to brew the kind of beer you prefer.

Boiling fruit will set pectins and result in a pectin haze that is sometimes slow in clearing. One method of preparing fruit as an ingredient for beer is to pasteurize it at about 140 degrees F (60 degrees C) for 20 to 30 minutes. This can easily be accomplished by turning the heat off and adding the crushed fruit to boiled wort from which the majority of hops have been removed by scooping with a strainer. Pasteurizing fruit helps assure the brewer that most wild yeasts and other uninvited microorganisms will not reach the fermenter alive. Usually some microorganisms survive, but with the introduction of a healthy yeast culture, their influence is minimal. They are often evident as a light film on the surface of bottled beer and are relatively harmless.

Heating and then fermenting the fruit during primary fermentation will drive off some of the more delicate fruit flavors and aromas. (Caution: if you are using glass carboys as fermenters, the total volume of wort should not exceed 75 percent of fermenter capacity.) Heat reduces some flavors, and carbon dioxide gas "scrubs" or "bubbles" desirable fruit volatiles out of the wort.

An option that works well with relatively clean fruit, juice, wine concentrates and naturally made concentrated extract is to add the crushed fruit or juice (in whatever form) to the secondary stage of fermentation. You will inevitably be introducing some bacteria and wild yeast if using fresh or frozen fruit, but they will be greatly inhibited at this stage by the influence of alcohol, low pH and hops. Brewers using this method who are able to relax and not worry will find a greater degree of desired fruit character in the finished beer. As

an option you may add the crushed fruit to a small amount of water and pasteurize the mush at 140 degrees F (60 degrees C) for 15 to 20 minutes to minimize contamination before adding the fruit to the secondary. After the addition, fermentation will become active once more. The fruit will become impregnated with carbon dioxide and float to the surface, where most of it will stay. The skilled home-brewer-siphoner *extraordinaire* will be able to siphon mostly beer from just below the floating fruit while transferring it to another vessel for further storage, lagering or bottling. About one week in contact with the fruit is adequate. Certainly don't worry.

The skins of dark fruits will add color to the beer. Juice alone does not affect color as much. More often than not, edible fruit skin will have a good deal of tannin, which can contribute an astringency if left in contact with the beer too long. The astringency will decrease with age.

When using fruits whose skins will make only a minimal contribution to color, removing the skin of the fruit will be to your advantage. Unbruised fruit is almost sterile under the skin. The skins from such fruits as apricots and peaches are very easily slipped off if the fruit is immersed in boiling water for 15 to 30 seconds. It can be frozen in unused freezer bags or used immediately.

Fresh fruits usually must be crushed or mashed before adding to the ferment. Thawed frozen fruit will not require mashing because the action of freezing and thawing has already ruptured the skin, allowing the juices to flow out and the yeast to get in.

Related Recipes: The Horse You Rode in On Apricot-Coriander Ale (see page 292), Unspoken Passion Raspberry Imperial Stout (see page 302), Ruby Hooker Red Raspberry Mead (see page 366), Prickly Pear Cactus Fruit Mead (see page 360) and Waialeale Chablis Mead (see page 357).

Vegetables. While beers made with vegetable adjuncts are not quite as popular, there is certainly one worth mentioning because of its place in American history. The pumpkin was used by early settlers as a base for "beer" when other more typical ingredients were not available. The pumpkin beer recipe in this book is a wonderfully palateful brew that deserves serious consideration.

Related Recipe: Cucurbito Pepo (Pumpkin Ale) (see page 315).

Herbs, Spices and Roots. This list could go on forever. There are several popular herbs and spices discussed in *The New Complete Joy of Homebrewing*. Whenever possible, use fresh or freshly ground dried whole herbs, spices and roots. Preground herbs, spices and roots

should only be considered as a very last resort; the difference is quite significant.

Freshly ground with a mortar and pestle, coffee grinder or blender, these ingredients can be added during the boil, to the secondary fermenter or at bottling time. Just as with fruit, some of the more delicate volatiles of herbs and spices are lost if boiled or heated too long. This will vary with each type of spice. An effective way to enhance beer with spices is to add half during the final 5 to 10 minutes of boiling (or steep) and half to the secondary. But it is very difficult to generalize as the optimum method of extraction for each herb essence is different.

If you wish to experiment and are not quite sure what effect a new idea will have on your beer, don't sacrifice an entire batch of beer. Teas can be made by boiling water and allowing the herbs to steep. Dose a glass of beer that you happen to be enjoying and see how the flavor will influence the beer. Remember the flavor of the herbs in water will not be similar to the flavor of herbs added to beer. This is an important point to keep in mind. You can add a desired amount of cooled (but not reaerated) herbal tea (concentrated teas are recommended) to a portion of beer you wish to bottle with that flavor. This is the cautious method and allows some reassurance on your part that everything will be okay. We know it would anyway, but what the hey.

Here are a few new ideas that warrant consideration.

Cardamom Seed. A unique and strongly aromatic herb often used in East Indian cooking and tea. Bought as a dried pod with dark seeds or as podless seeds. The preground seed has a different character, possibly attributable to age and oxidation. A half teaspoon (2 g.) of podless seed boiled in wort for the entire boil will contribute a very subtle flavor to a 5-gallon batch of beer. The subtle flavor is reminis-

cent of the character of Pepsi-Cola. Two grams ($\frac{1}{2}$ tsp.) freshly crushed and added to the secondary fermentation will contribute a strong aromatic character to the beer.

Coriander Seed. This flowery and aromatic spice is commonly used in certain styles of Belgian ale. The coriander plant is also known as cilantro or Chinese parsley and is used in Oriental and Latin American cooking. The flavor of the seed is very different from the root and plants. Obtain whole seeds and crush them as you need them. Add 1 to 2 ounces (28 to 57 g.) of the freshly crushed seed to the final 10 minutes of the wort boil for a 5-gallon (19 l.) recipe. This will create an assertive and distinctive flavor and aroma. An additional $\frac{1}{2}$ ounce (14.2 g.) added to the secondary stage of fermentation, allowed to steep for at least one week, will have an equally intense but more delicate effect. Hop bitterness of medium to low intensities are recommended for coriander beers.

Related Recipes: "You'll See" Coriander Amber Ale (see page 290) and The Horse You Rode in On Apricot-Coriander Ale (see page 292).

Cubeb Berries. Like small peppercorns with stems in appearance, these berries contribute an unusual eucalyptuslike character to brews in the smallest of doses. One gram in 5 gallons crushed and added to the secondary fermentation will do nicely.

Ginseng. You've got to enjoy the flavor of this as a tea if you are going to consider it for your brew. The very expensive root can be made into a tea, or extract can be used. Ginseng has a bitter character, so it may be wise to reduce the hop level and increase the sweetness of the beer by using caramel or crystal malts. Consider combining it with other things such as ginger root. The combination may prove to be synergistic.

Star Anise. About the size of an American quarter, these attractive seed pods contribute a licoricelike character to beer. Two to 3 ounces (57 to 85 g.) of whole pods and seeds can be added to the wort for at least a 30-minute boil. The pods are woody in nature, so a longer boiling time is required to extract their essence. The licoricelike aroma is intense in the wort, but mellows out in the character of the final beer. Crystal or caramel malts added for sweetness will positively balance the flavor of star anise. For more subtle character $\frac{1}{2}$ to 1 ounce (14.2 to 28.4 g.) is recommended. Do not grind.

Related Recipe: Tim's Topple Over Anisethetic Brown Ale (see page 311).

Szechuan Peppercorns. These are NOT the same as Szechuan chile peppers. These peppercorns are a combination of pods and seeds that have an extremely unusual mouth-numbing menthol-like hot-

ness. They are available at Oriental food supply specialty stores. A half ounce to 2 ounces (14.2 to 57 g.) of freshly ground Szechuan peppercorn will absolutely create conversation and some converts at your next beer tasting.

Related Recipes: Mr. *Kelly's Coconut Curry Hefeweizen (see page 314), Slanting Annie's Chocolate Porter (see page 296) and Love's Vision—Honey and Pepper Mead (see page 363).*

MISCELLANEOUS ODDS AND ENDS

Smoked Malt. Unusual enough to include in this section. Smoked flavor in beer can be a wonderful complement if you don't overdo it and you enjoy smoked foods. If smoked malt is not easily purchased, it is a relatively simple matter to make your own. You will need to add the homemade smoked malt to the recipe formulations in amounts of 10 to 15 percent of the total fermentables.

You will need a kettle-type barbecue grill (such as a Weber) and a clean brass screen to fit over the grill. Soak whole pale malted barley in cool water for five minutes. Start a fire with a small amount of charcoal briquettes and burn all of the grease from the grill. Clean with a wire brush. Place apple, maple, hickory, alder, pear, cherry, mesquite or other desirable smoking wood on the hot charcoal. Replace the grill. Lay the screen atop the grill and spread the grain over the screen. Cover securely with the lid and open vents to allow maximum smoking. Inspect every 5 to 10 minutes and stir frequently. Remove grains when dried. A cooler fire will prevent darkening of the malt. This is a hot-smoke method of smoking grains. A cool smoke method uses cool smoke in contact with malt in a chamber somewhat removed from the heat of the fire.

Low bitterness levels and high malty character are recommended for beers brewed with smoke-flavored grains. Full-bodied malty porters and Oktoberfest styles work exceptionally well.

Related Recipe: Curly Whisper Rauchbier (see page 341).

Artificial Sweeteners? Personally my advice would be to forget it. Aspartame, sorbitol and saccharine contribute the peculiar character and aftertaste of artificial sweeteners to beer as well as soft drinks. Furthermore, some concoctions made from these artificial sweeteners such as Equal (contains Nutrasweet [which is aspartame] and dextrose, among other things) are fermentable. I've tasted beer brewed with artificial sweetener. The brewer loved it and so did others, but count me out.

Hops

Finesse. Exotic, complex, subtle, whimsical, boisterous, evocative. The small, wondrous flowerlike hop cone impassions many a brewer and beer enthusiast with so very little. At 8 milligrams (.00028 oz.!) per bottle of beer, the "stuff" of hops imparts all the wondrous character that beer enthusiasts have come to appreciate.

We know that hops contribute bitterness, flavor, aroma and stability to the beer and a calming effect to the beer drinker, though it appears that this calming effect is sometimes counteracted by an excitement about all things beer. Hopheads and lupomaniacs are often known to discuss life in terms of "the lupulin effect."

If there is one principle to remember about hops and their use, it is that their freshness should always be considered. Fresh means that the hop has not gone stale, or become old or oxidized to a degree that negatively impacts the character of beer. Minimal oxidation or staling is desired of bittering hops. They are best at their freshest. However, some degree of aging and oxidation is essential for the best-quality aroma hops. Flavor-active components of the essential oils of aroma hops are low for fresh aroma hops. These flavors and aromas increase with about three to six months' aging after harvest at ambient to cool conditions. There is some deterioration of bittering resin during this time, but a balance is determined and achieved by the skilled hop merchant.

Fresh does not imply freshly picked, nor does it imply whole hops rather than hop pellets. Fresh simply means that the hops, whatever dried form they are in, have been maintained and stored with care and have not deteriorated to an unusable degree. The entire art of using hops cannot get any more essential than this. Have a homebrew and think about this.

While you're contemplating, let's sneak in one other significant

point. Bitterness and hop flavor are relative. When discussing hop bitterness and flavor we must always bear in mind that we are referring to bitterness and flavor *in beer*. While this may seem to be a trivial point, many a brewer has gone temporarily astray by making comparisons of hop bitterness and flavor in other aqueous solutions, such as teas, hot, cold or otherwise. Assessments of hop teas, though of limited instructional value, cannot, should not and must not be seriously correlated to predictive characters in beer. It just ain't the same.

BED HOPPING

Before getting into a serious discussion about hop anatomy, it is worth noting that hops have been used for things other than beer. Call it the lupulin effect if you wish, but regardless of what you name it, hops do have a calming effect on the nerves, so much so that herbalists will recommend hop tea as a remedy for insomnia. More strangely, the smell of hops is said to help induce sleep. Usually hops and other herbs are combined as ingredient stuffing to make a "dream pillow." When slept with, the pillow not only induces deeper sleep but promotes vivid dreams. Most people are skeptics about this effect, but I have found through personal experimentation that these dream pillows work very well. So, for all the lupomaniacs and hopheads, here is a recipe for making a dream pillow.[2]

[2] Recipe by Barbara Wakshul, taken from the summer 1980 issue of *zymurgy* magazine.

The following mixed ingredients will stuff two 8-inch-by-6-inch pillows

 2 oz. (56.8 g.) of your favorite dried whole hops
 2 oz. (56.8 g.) dried chamomile flowers
 2 oz. (56.8 g.) dried rosebuds, crushed
 1 oz. (28.4 g.) dried mugwort
 1 oz. (28.4 g.) dried lemongrass
 $\frac{1}{2}$ oz. (14.2 g.) benzoin (this is a natural preservative)

Bag this mix in double-layered cheesecloth. Sew together an outer pillow from material that is attractive and tightly woven. Sleep with this dream pillow near your bed pillows, and be warned that your dreams may be so intense that you may decide to go back to having a beer before bedtime instead.

HOP VARIETY: IT DOES MATTER

Knowing that some hops are more bitter than others and that a long boil extracts and introduces only bitterness to beer, many homebrewers are misled to think that if bitterness is all you want from hops, then it doesn't matter what kind of hops you use. Not true. The kind of hops you use as bittering hops does indeed influence the character of beer. One only has to sample the empty bitterness of a homebrew formulated from a kit made with hop extract. These brews lack complexity and depth of flavor.

Another example to illustrate this point is to compare two beers, 1 boiled 1 hour with 2 ounces (57 g.) of 5 percent alpha-acid-rated Goldings hops, and the other boiled 1 hour with 1 ounce (28 g.) of 10 percent alpha-rated Eroica hops. Bitterness will be theoretically equal, but the resulting beers will be notably different in character. One is often led to believe that hop flavor comes only from the very volatile oil components of hops and is completely lost if the hops are boiled for 30 minutes or longer. While it is true that nearly all flavors from hop oils are lost during short periods of boiling, distinct flavor characters from bitter hop resins will remain with the beer.

Having some degree of knowledge about hop "anatomy" will help in developing an understanding of how many different ways hops can contribute to the bitter, flavor and aromatic character of beer.

HOP ANATOMY. WARNING: THIS MAY GET UGLY

The female hop plant produces flowerlike hop "cones." These can be seedless or seeded, depending on the variety of hop and whether

the character the seeds contribute is desirable. The hop cone consists of petal-like "leaves." At the base of the leaves are tiny yellow glands called lupulin glands. The leaves contribute some tannin during the wort boil and help facilitate the precipitation of malt proteins out of the wort. The lupulin glands contain waxes, oils and resins.

Resins. There are two kinds of resins: hard and soft. Hard resins are believed by hop scientists to contribute very little, if anything, to the character of beer. Soft resins are primarily responsible for bitterness and some flavor character.

The soft resins are categorized into three groups: alpha acids, beta acids and "other." When alpha and beta acids oxidize they fall into the "other" group. When hops are fresh the "other" resins do not contribute significantly to the character of beer. Beta acid's principal components are lupulone, colupulone and adlupulone, none of which is very soluble. With fresh hops, beta acids do not contribute significantly to the bitter character of beer. Some hop analysts estimate that beta acids are one tenth as bitter as alpha acids—when they are soluble. Beta acids become soluble with age and oxidation. Very old hops, besides having a host of other undesirable characters, will have little if any bitterness contribution from the principally bittering

alpha acid. The bitterness old hops contribute is derived mostly from oxidized beta acids.

Life is not simple, nor is how beta acids influence the bitter character of beer. Beta acids do indeed contribute to the bitterness of beer. Research has shown that their contribution can be positively perceived by the beer drinker as a preferred milder-type bitterness. This effect is more pronounced with the use of aroma-type hops because the ratio of the beta fraction to alpha acids is higher in aroma hops. For example, if two beers had identical amounts of bittering units, but one beer's bitterness units were contributed to by a higher amount of beta acids, the bitterness character of that beer may be preferred over the beer whose bitterness contribution came more from alpha acids. Even though their bitterness units were equal.

Alpha acids' principal components are humulone, cohumulone and adhumulone. These are the hummers that most significantly contribute bitter character to beer. They are insoluble except when treated to the vigor of a boiling wort. Then they become partially soluble and some of the alpha acids go through a chemical change called isomerization. Milligram for milligram, isomerized alpha acids (iso-alpha acids) are more bitter than alpha acids. But nonisomerized alpha acids do not dissolve or, shall we say, "melt" into the flavor of the beer. So we can only count bitterness contributed by isomerized alpha acids. (If you're not on your second glass of beer by now, you might want to consider making a move to the refrigerator right now. I warned you it may get ugly.)

Let's get back to the three components of alpha acid. The proportions of humulone, cohumulone and adhumulone vary among hop varieties and with the yearly harvest. Hop scientists continue to investigate their proportional relationships and what they contribute to the flavor of beer. One discovery that is generally observed is that hop varieties with a greater proportion of cohumulone tend to manifest harsher or more robust bitterness in beer. Brewers Gold, Bullion, Cluster, Nugget, Northern Brewer and Eroica are a few hops that are considered to have relatively higher levels of cohumulone. Tettnanger, Hallertauer, Fuggles, Hersbrucker and Saaz are hop varieties with lower levels of cohumulone. Because of the lower levels of cohumulone, an equivalent amount of bitterness from these hops would be expressed a bit more softly. Neither type has a general advantage over the other. The choice of hops is dependent on the style you wish to brew and, more important, your preference. Any brewer who has used the hops listed can appreciate the fact that the character of bitterness is different as cohumulone varies.

Hop oils. Hop oils are the principal contributors to hop flavor and aroma in beer. Many of the more volatile components evaporate completely within about 20 minutes' boiling time. Some components remain behind despite boiling. There are many different types of oils that are present in varying proportion, depending on the variety of hop and the particular harvest. Two significant oils worth mentioning in this discussion are humulene and myrcene. Hop scientists tell us hops with a higher proportion of myrcene contribute a harsher and more unpleasant aroma and flavor. Bullion and Cluster are good examples. These types of hops generally are avoided as flavor or aroma hops. Hops with relatively higher levels of humulene are preferred as aroma and flavor hops because of their subjectively pleasant character. Hops such as Hallertauer, Tettnanger and Saaz fall into this classification. Very interestingly, a certain amount of slow, low-temperature oxidation of humulene oils enhances the desirability of these types of hops as flavor and aroma hops. This oxidation could be considered a type of maturation or aging process.

HOP OILS: COMPARISON OF TYPICAL COHUMULONE, MYRCENE, HUMULENE PROPORTIONS IN AROMA AND BITTER VARIETIES OF HOPS

Hops Type	(Resin) Cohumulone	(Oils)	
		Myrcene	Humulene
Higher-Alpha-Acid Bittering Varieties			
Northern Brewer (German)	30%	36%	31%
Brewers Gold (German)	45%	39%	30%
Nugget (German)	28%	29%	38%
Chinook (American)	32%	37%	23%
Cluster (American)	39%	50%	17%
Galena (American)	37%	57%	17%
Lower-Alpha-Acid Aroma/Flavor Varieties			
Hallertauer Tradition (German)	26–28%	21%	40–48%
Hallertauer (American)	21%	39%	34%
Mt. Hood (American)	23%	60%	20%
Hersbrucker Pure (German)	26%	23%	27%
Tettnanger (German)	27%	20%	25%
Tettnanger (American)	23%	40%	21%

One cannot have an American discussion of hop oils without at least mentioning what makes Cascade hops a unique hop. Geraniol and linalool (they sound like two characters from *The Hobbit*, don't they?) are primarily responsible for the citrusy and floral character found in Cascade hops. The Cascade hop is a poor storing hop and ages quickly. These compounds occur at high levels soon after harvest.

LOVE AND HATE TO THE BITTER END

All those good resins, and it's all a brewer can do to get hold of 30 percent of them. It's a struggle every step of the beermaking way. The bitter hop resins are not only stubbornly soluble, they have a tendency to go by the wayside during the beermaking process. For simplicity many brewers take into account a kettle/wort boil utilization factor, but there are many other factors, though of lesser significance, that determine how much of the bitter stuff finally gets into beer. Though this subject is often discussed in basic books on brewing, it is worthwhile to review and list some of the more significant considerations that determine the development and utilization of hop bitterness.

In the kettle

- Hop utilization decreases with an increase of wort gravity (see *Hop Utilization Chart* on page 281). This is somewhat analogous to dissolving sugar in water; as the solution approaches saturation, it takes longer for the sugar to dissolve. Recall that alpha acids must be dissolved before they can become isomerized and affect beer bitterness.
- Hop utilization decreases with an increase of hop rate; the more hops added to the wort, the lower the utilization. Some brewers will choose to add bittering hops in stages to maximize their bitterness yield. (This also is a way of controlling or influencing oil component loss.)
- The same amount of hop pellets will be more utilized than whole hops. As an example, whole hops might be 28 percent utilized while, given the same conditions, hop pellets might be 33 percent utilized. While the difference in utilization is 5 percent, what this really indicates is that one must use 18 percent more whole hops than pellets if the recipe was designed for hop pellets, and one must use 15 percent less hop pellets if a recipe was designed for whole hops.

- Hop utilization increases with longer boilings up to about $1\frac{1}{2}$ hours for normal worts and up to $2\frac{1}{2}$ hours for very high gravity worts.
- Hop utilization levels off with excessive boils. The iso-alpha acids you've worked so hard to create begin to break down. The loss is about equal to the gain.

Stages elsewhere in the process that affect the overall hop utilization factor

- Some hop bitterness can be lost during the fine filtration of finished beer.
- The loss of hop bitterness increases as fermentation temperatures increase. You will lose a higher percentage of hop bitterness with more bitter beers.
- Some hop bitterness can be lost to trub, hot and cold break material.
- Some hop bitterness can be lost to fermentation kraeusen foam expelled from the fermenter or adhering to the walls of the fermenter.
- Some hop bitterness can be lost to yeast sediment.
- Professional brewers have indicated that when increasing batch sizes dramatically, let's say from 5-gallon test batches to 10-barrel production batches, hop utilization usually increases. Proportionally less hops are needed for the same amount of bitterness. At first this may seem as though the kettle configuration affects utilization, but by reviewing many of the preceding points, a crafty brewer should realize that there are many other factors that have changed along the wort's way to beer.

If all of this weren't enough to consider, think about this next factoid before taking another sip of your favorite brew. Water hardness and certain minerals can affect the *perception* of bitterness. Increased hardness will create a relatively harsher sensation of bitterness. Within reason, this is neither good nor bad. The unique bitter character of world-class beers such as Bass Ale can be attributed partly to the hardness of the brewing water. It is worth noting that classic Czechoslovakian Pilseners are brewed with extremely soft water with very few minerals present. Their bittering rates and formulations would lead one to anticipate an extremely bitter beer, but the softness of the water helps create palatability, allowing these

Pilsener beers to be highly hopped. Highly hopped, their flavor and aroma are enhanced by the combination of soft water and high hopping rate, though the perception of bitterness is kept palatable.

IBU, BU, AAU, HBU. WHAT'S GOING ON HERE?

There are several ways to express bitterness and bitterness potential. International Bitterness Units (IBUs) refer to the same scale as Bitterness Units (BUs). One BU is equal to 1 milligram of isomerized alpha acid in 1 liter of wort or beer. This is a system of measuring bitterness devised by brewing scientists and is an accepted standard throughout the world.

Homebrew Bitterness Units (HBUs) are the same as Alpha Acid Units (AAUs), the system first devised by the late British homebrew author and pioneer Dave Line. One HBU is equal to a 1 percent alpha acid rating of 1 ounce (28.4 g.) of hops. HBUs are calculated by multiplying the percent of alpha acid in the hop by the number of ounces of hops. Ten HBUs could be equal to 2 ounces (57 g.) of a 5 percent alpha-acid-rated hop or 1 ounce (28.4 g.) of a 10 percent alpha-acid-rated hop. Contrary to what BUs represent, HBUs or AAUs are not a measure of bitterness in beer. They are simply an indication of the amount of alpha acid called for in a recipe, which is a first step in figuring how much bitterness could end up in your beer.

Infrequently you may come across a professional recipe that specifies the amounts of bittering hops in terms of milligrams alpha acids/liter. This is not an indication of how bitter the beer is or of its BUs. It is used to devise a recipe for any given volume of beer. If the bittering hop amount is given in terms of mg./l. alpha acid, first you must determine how many liters you are going to brew and multiply that amount times mg./l. to determine how many total milligrams of alpha acid will be needed for the recipe. Alpha acid rating of hops is expressed as a percentage of the total weight of the hop. For example, if you have 1 ounce (28.4 g.) of 5 percent alpha acid hop, then you have .05 ounce of alpha acid. Multiply .05 times 28.35 to convert to 1.418 grams or 1,418 milligrams. Working the other way, you can determine that if you need 200 mg./l. alpha acids and you wish to make a 19-liter (5-gal.) batch, then:

$$19 \text{ liters} \times 200 \text{ mg./l.} = 3,800 \text{ mg. of alpha acids} = 3.8 \text{ grams}$$

If a 5 percent alpha acid hop were used, then:

$$\frac{3.8 \text{ grams}}{.05} = 76 \text{ grams (2.68 oz.) of hops}$$

Lupomaniacs and Freshly Picked Hops

Those who grow their own hops can't help but wonder if there is a secret advantage to using freshly picked hops (i.e., fresh off the vine and sun-dried) in brewing. Unfortunately encouragement can't be offered. There are a lot of undesirable chlorophyll-like grassy flavors that evaporate along with moisture when hops are dried. It's likely that those "fresh green" flavors would not enhance the character of your beer. But if you wish to experiment, here are some guidelines. Freshly picked hops are about 80 percent moisture. When dried they are reduced to about 8 percent moisture. Given this ratio, you would use by weight about ten times more undried hops than dried hops called for in a recipe.

Here's a hopbit: Interesting results were found by German hop researchers when they tested the stability of frozen undried hops. They found that the undried hops, when frozen, were significantly more stable than dried hops stored under identical conditions. Practically speaking, freezing ten times more water and dealing with increased volumes does not make this procedure commercially viable. But then, there are homebrewers. . . .

BITTERNESS, FLAVOR AND AROMA

FINESSE, FLAVOR AND AROMA

Having already noted that volatile hop oils are the principal contributors to beer's hop flavor and aroma, logically their infusion should come during the final 20 minutes or 2 to 5 minutes, respectively, of the wort boil. If the boil is stopped and the wort cooled as quickly as possible, volatile oils contributing to late hop flavor and aroma will be preserved through to the final product.

DRY HOPPING

Dry hopping is another means to infuse hop flavor and aroma into beer. British brewers use this method to give a special hop character to selected ales. The process involves adding selected aromatic vari-

General Guide for Imparting Maximum and Minimum Potential Hop Aroma, Flavor and Bitternes

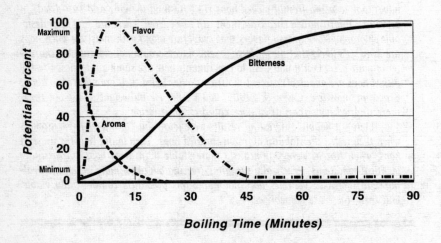

Boiling Time (Minutes)

eties of hops to beer in cold storage, during the stage of final maturation. In Great Britain hops were traditionally added directly into the serving cask, where the hop oils were allowed to meld with the overall beer character.

Homebrewers can consider this traditional method of infusion, but must plan to deal with the potential of loose hops in the tapping system. A more practical approach for most homebrewers would be to add aroma hops at a general rate of $\frac{1}{4}$ to 1 ounce (7 to 28 g.) to secondary fermentation during the final one or two weeks before bottling or kegging. Separate the spent hops by carefully siphoning.

This procedure often brings to question the risk of contaminating the beer with undesirable microorganisms. There are several reasons why this risk is not as great as it may appear. Dry hopping should be done in the secondary or lagering vessel and absolutely avoided during primary fermentation. By the time beer is in the secondary, the alcohol, lower pH (higher acidity) and lack of oxygen in the beer serve to inhibit bacteria that might be introduced at this point. Beer spoilage organisms are not as likely to choose hops as a resting place, because hops themselves have an antiseptic property.

Cleanly packaged hops should be sought. Hop pellets can be used with great effect. Their use will minimize risk of serious contamination, though experienced brewers will argue both the pros and cons of the character they contribute compared to whole hops.

Lupomaniac immersed in a mountain of hops becomes momentarily dazed before becoming a brewer for life.

If you are at the brink of worrying, don't. There may be other alternatives worth considering that perhaps will result in more controllable results. Make a concentrated hop tea and add it to the finished beer. You might even consider making a cold tea by soaking hops in a jar of water, sealed and refrigerated for a week. Add these teas in amounts that suit your taste at bottling time. When making any tea that will be added to the finished beer, be sure to use deaerated water. This can be accomplished by boiling.

A final 2-minute steep of aroma hops in the wort boil, or the addition during secondary: Which is better? Some brewers claim that dry hopping results in more stability of the sought-after character. You're a homebrewer. Try both methods.

HOP MADNESS. HMMMM

Now that we've come this far, you have two choices. You could become obsessed and try to do something about everything that affects hop utilization or you could get practical and have a homebrew.

Yes, you now have a feeling and an understanding of what the art of using hops is all about. You don't just have to believe what someone else tells you, but rather you can consider it from your knowledgeable perspective and decide what to do. If and when you change brewing equipment or procedures, you'll have an idea of what to expect. Or maybe you'll be surprised, but then you'll be able to recover easily.

Practically speaking and from one homebrewer to another, don't get bogged down in obsessive details. After all, the very truth of the matter is that no matter how fresh your hops are, they are going to vary as much as 20 percent (i.e., plus or minus 10 percent) from the alpha acid rating you've been told they are. (Note: That's plus or minus 10 percent difference, not plus or minus 10 percent alpha acid weight.) Why? Because a hop plant grown on one side of the ditch may have received more water than a hop plant grown on the other. Perhaps the sample bale that the hop company based their analysis on was the one in the middle of the room and not the one you got your hops from (which was stored up against the wall). Maybe your hop cones were harvested on a Tuesday and the analyzed sample was harvested on Friday. Perhaps the shipment to your shop took eight days rather than three days.

To put things in a clearer and more practical perspective, consider for example that a 0.5 percent difference in an alleged 5 percent

alpha-acid-rated hop is 10 percent. Now what? Establish your own procedures and determine your own overall utilization factor. Be consistent, and the law of averages and the errors of misplaced precision will be in your favor.

EXTRACT BREWERS' TIP

Be careful when converting all-grain recipes to extract recipes that use a concentrated wort boil. Remember, hop utilization decreases with concentrated wort boils. While a 60- to 90-minute boil of an all-grain recipe may get 30 percent utilization, the same boiling time of 6 pounds (2.7 kg.) of extract boiled in 2 gallons (7.6 l.) of water will result in a 23 percent utilization. Do a little math and you will realize the necessity of adding 25 percent more hops to have the same contribution to bitterness.

Likewise, if extract brewers wish to convert their boiling procedures to full wort boils (see page 280), the reverse of this principle applies; you need to consider reducing bittering hops by 25 percent.

Converting from a concentrated wort boil to a full wort boil (or vice versa) and substituting hop pellets for whole hops (or vice versa) can lead to as much as a 30 to 40 percent difference in the amount of bittering hops called for in a recipe in order to match what the recipe formulator intended. That's quite startling if you've never considered it before.

STORAGE OF HOPS

There's not much to say here, but what there is to say is absolutely essential. Keep the hops cold, at or around freezing. Keep them double-plastic-bagged or in an airtight container or jar. Many brewers do not appreciate the importance of sealed containers and minimizing contact with air. Compressed hops, sealed in a jar with minimal air and stored in the freezer, will keep for years. Slow oxidation of some aroma-type hops will even enhance their character.

Interestingly, the more prized the hop, the poorer stability it has at room temperature. This is particularly true with the aroma-type (sometimes referred to as Noble) hops such as Hallertauer, Tettnanger, Saaz, and their hybrids such as Mt. Hood.

Time for a beer? You betcha!

ADDITIONAL REFERENCES

zymurgy magazine 1990, volume 13, number 4, special "Hops and Beer" issue. Articles include "History of Hops," "Development of Hop Varieties," "Hop Varieties and Qualities," "Assessing Hop Quality," "Processing Hops into Bales and Pellets," "Hop Products," "Hop Oil: Aroma and Flavor," "Growing Hops at Home," "Propagating Hops," "Factors Influencing Hop Utilization," "Calculating Hop Bitterness," "Matching Hops with Beer Styles."

Hops, by R. A. Neve, Chapman and Hall, 1991. Comprehensive book on hop cultivation.

Homegrown Hops, by David Beach, David R. Beach, 1988. Practical advice and procedures for home cultivation.

Water

As a freshman in college at the University of Virginia in 1967, I aspired to become a chemical engineer, that is, until I took a course in chemistry. Every science and art has its own language and ways of explaining reality. I never could quite comprehend the logic of chemistry. That is why I switched into the university's nuclear engineering program, and five years later, after a lot of seemingly more logical math, physics, mechanics, thermodynamics and a smattering of what seemed to be science fiction (the required electrical engineering courses were part of another science I couldn't quite fully grasp and barely escaped with passes), I received my B.S. degree in nuclear engineering.

Researching this chapter on water, I couldn't help but reflect on the struggles I had with chemistry in college. If only the introduction to college chemistry had been approached by relating it to some reality, such as beer and water chemistry, perhaps the lives of college freshmen could be more meaningful. As a freshman, I had no knowledge whatsoever about the qualities of beer and beer styles, but college should be inspiring, shouldn't it? Beer and water—how much more profound can chemistry be?

With limited knowledge of chemistry and microbiology, brewers over a century ago developed beer styles indigenous to their regions. Perhaps the single most influential factor in determining the style of beer brewed in an area was the mineral quality of the water. The unique bitterness quality of the pale ales and bitters of Burton-on-Trent (home of Bass Ale) was profoundly influenced by the high concentration of calcium sulfate in the water. The sweeter milds of Northern England were brewed with water with relatively higher concentrations of sodium and chlorides (sodium chloride). The porters of the south of England, the stouts of Ireland and the dark beers of Munich resulted from having to brew with water high in carbonate.

73

The qualities of the famous light Pilsener beers from the town of Pilzen, Czechoslovakia, were only possible because of the very soft mineral-free water of that area.

Dissolved minerals in water and the chemical reactions during the beermaking process are two of the principal driving forces determining beer's quality. Minerals in water influence the flavor, aroma, color, head retention, clarity, alcohol content and stability of beer.

If water is suitable for drinking, then good beer can be brewed with it, but there are exceptions. Knowing the influence that water and mineral chemistry can have on beer engenders a more artistic approach to the beermaking process, even when the brewer chooses to do little about adjusting water. With a bit of knowledge and understanding, you give yourself a choice and are better able to brew the kind of beer *you* like.

With regard to the mineral content of water, it can be grossly generalized that naturally occurring soft water low in minerals is the most versatile of all brewing water. Not only will it allow one to brew a reasonable rendition of most beer styles, its mineral content can be supplemented with relative ease. Very hard water, high in permanent hardness, high alkalinity and usually having a pH in the mid 7s, is the most frustrating to use. It is best suited for dark beers because of the neutralizing effect of the more acidic dark malts. If not used for dark beers, it is best not used at all.

Water with temporary hardness is salvageable and can be relatively easy to adjust. It can be used for accurately brewing most styles of beer. By their nature, bicarbonates can be easily precipitated out of temporarily hard water by boiling and decanting off the softer water. This is as simplified as mineral and water chemistry gets.

Malt extract brewers do not have to be as concerned about minerals as all-grain brewers do. However, permanently hard water can have an effect on healthy yeast fermentation, hop utilization and the flavor character of hop bitterness. Malt extract brewers would always do better to avoid the use of very hard (permanent type), carbonate water and boil temporarily hard, bicarbonate water to remove the calcium carbonate precipitate.

Now it's time for a homebrew and a brief review of chlorinated water treatment and nitrates before we delve into the details of water chemistry and its influence on the brewing process and beer character.

NOTE: In the context of brewing, water chemistry parts per million (ppm) is considered to be nearly equivalent to milligrams per liter (mg./l.). Water analyses will often express content in mg./l. rather than ppm.

CHLORINE, CHLORINE, NASTIEST STUFF YOU MIGHT HAVE EVER SEEN

Added to virtually all municipal water supplies in minute amounts, chlorine is a necessary evil that helps assure that municipal water sources are free from other, more dangerous health-threatening microorganisms. The dose of chlorine in water supplies will vary with seasons and other circumstances to prevent the risk of contamination.

This very powerful disinfectant can combine with the organic ingredients in beer to form very powerful flavor compounds called chlorophenols. They can be detected as threshold flavors and aromas by many people at concentrations of a few parts per billion. If your beer is affected by this reaction and you can perceive it and you wish to do something about it, you can.

Boiling water can remove some of the chlorine compounds. It does not remove them all. The most efficient means of removing chlorine is to pass all of the brewing water through an activated charcoal (carbon) filter. Simple sink-top versions should be bacteriostatically rated. (There is a silver compound included with the carbon that prevents bacteria from surviving within the filter when not in use.) Filters cost from about $50 to over $200, but over its life a filter will produce water at a cost of about 2 cents per gallon. And it does make your drinking water taste remarkably better.

When using household chlorine bleach to sanitize equipment, be careful when the sanitizing solution concentration exceeds 10 ppm. Prolonged contact with metal will cause corrosion.

NITRATES AND NITRITES

As the use of nitrogen-based fertilizers has increased, so have nitrates in water supplies. In some areas the problem is much more serious than in others. With regard to their effect in beer, some research has indicated that nitrates (NO_3) themselves do not affect the beermaking process. However, when nitrates are metabolized by some types of bacteria, either prior to or during the beermaking process, then nitrites (NO_2) are produced. Experiments have shown that they have a negative effect on the fermentation process at levels as low as 25 ppm.

MINERALS MATTER!

Mineral salts, when they have not been dissolved in water, have shape, form and substance. They are easily quantifiable, measurable

and visually real. However, when they are dissolved in water their ion components dissociate or separate from one another. These ions are charged either positively or negatively and attract one another when not in solution to become compound salts. Minerals in brewing water are dissociated ions floating in solution, ready to react with other matter given the right opportunity and conditions. Their reaction with this other matter is what the brewer is concerned about. The "other matter" is malt, yeast, hops and our taste buds.

PRIMARY IONS

There are seven ions that have a substantial influence on the beer-making process. As you will soon realize, their influence must be understood as a whole; they have a complex relationship with one another and with the beermaking process.

Calcium (Ca^{+2}). This is perhaps the single most important ion. It reacts with phosphates naturally present in malt to acidify the mash. The acidification is a crucial step in creating an environment in which protein-reducing (proteolytic) enzymes and starch-reducing (diastatic) enzymes work best. The reaction of calcium ions with phosphate compounds releases hydrogen ions (H$^+$) into solution, thus increasing acidity, corresponding to a decrease in pH.[3] An absence of calcium ions would also detrimentally result in the precipitation of oxalate salts in the finished beer, causing haze and gushing. Sparge water with an appropriate amount of calcium helps inhibit color increase (for light beers), decreases pickup of tannins (tannins contribute to chill haze and astringent phenolic flavor) and helps maximize the amount of sugar extract that can be rinsed or sparged out from mashed grain. The presence of calcium during the boil enhances protein coagulation. Its presence during fermentation enhances yeast health. An ideal concentration of calcium ion in the brewing water is in the range of 50 to 100 ppm. The calcium ion dissociates from calcium sulfate (CaSO$_4$), calcium chloride (CaCl$_2$) or calcium carbonate (CaCO$_3$) when these compounds are added to brewing water.

Sulfate (SO$_4$$^{-2}$). Sulfate does not participate in any important brewing reactions but makes more of a stylistic contribution to the end flavor character of beer. It draws increased bitterness from the hop during boiling and contributes a drying bitterness to the beer flavor. Sulfate is a source of sulfur if yeast or bacteria are given the opportunity to produce hydrogen sulfide (H$_2$S). In excess of about 450 to 550

[3] See explanation of pH in glossary, *The New Complete Joy of Home Brewing*.

ppm, sulfates promote undesirable types of bitterness sensation. When added to brewing water, calcium sulfate ($CaSO_4$) or magnesium sulfate ($MgSO_4$) will dissociate, providing a source of sulfate ions.

Magnesium (Mg^{+2}). The magnesium ion promotes reactions similar to calcium but to a much lesser degree. In limited amounts (malt has it) it is beneficial to yeast metabolism. Its presence should never exceed 30 ppm. In excess it will contribute a sour-bitter-salty sensation.

Chloride (Cl^{-1}). Chloride's contribution is stylistic—it contributes a fullness to the flavor of beer, accentuating the malty character. It does not participate in any important brewing reactions. It has a synergistic effect with sodium (Na). Chloride's effect on flavor becomes evident at about 200 to 250 ppm.

Sodium (Na^{+1}). This ion has no chemical benefit in beermaking, though in conjunction with chloride, it accentuates a malty-sweet fullness in beer. Its effect can be stylistically desirable when concentrations are between 70 and 150 ppm. Above this amount, a salty character begins to interfere with the overall desirability of the beer.

Water softeners reduce hardness in water, but in doing so, they replace calcium ions with sodium ions, usually in amounts unsuitable for brewing.

Carbonate (CO_3^{-2}). Carbonate inhibits crucial chemical reactions in the beermaking process as well as secondarily influencing beer character. It is alkaline in nature and neutralizes acids. In doing so, it counteracts the beneficial and necessary effects of calcium. When calcium mash reactions are inhibited by carbonates, malt yields are lowered during the mashing process. Carbonates contribute to an increase in color extraction during sparging (undesirable for light-colored beers). Carbonates also contribute a harsh character to the flavor of beer by extracting excessive tannins from grain husks. A beer with high pH is less stable and more susceptible to spoilage organisms. Carbonate concentrations in excess of 50 ppm will begin to create undesirable brewing conditions. However, dark-roasted malts, because of their acidity, help neutralize some of the effect of carbonate; thus, high carbonate water can successfully be used to brew dark beer. Sulfates also help to neutralize carbonates. If carbonates exceed 200 ppm, then only dark beers should be brewed.

Bicarbonate 2(HCO_3^{-1}). By way of reacting with carbon dioxide (CO_2) and water (H_2O), a carbonate ion can add a hydrogen ion to produce a bicarbonate ion. In normal mashes, ion-for-ion bicarbonate has twice the buffering capacity of carbonate. What this means is that a concentration of 50 ppm of bicarbonate has the same neutralizing power as 100 ppm carbonate and the same effects as described for

carbonate. But although bicarbonate is a stronger alkaline, it is less stable and can be removed from water by simply boiling water and aerating. Boiling brings on a chemical reaction that liberates carbon dioxide (CO_2) and steals some calcium ions to combine with carbonate ions to form a compound that precipitates out as a solid. The water, now more suitable for brewing, is decanted off of the sediment. Because of the instability of bicarbonate, its contribution to water is called *temporary hardness*. If not dealt with, then bicarbonates will have the same effect as carbonates, only twice as powerful.

SECONDARY IONS

There are several ions that are often involved in brewing matters, though they are usually present in amounts that do not significantly contribute to beer flavor and aroma. If maximum amounts are exceeded, however, they can create havoc.

Iron (Fe^{+1} or Fe^{+2}). Its presence in water must be kept below .05 ppm or a bloodlike, metallic flavor will dominate the flavor of beer.

Copper (Cu^{+1}). A very small amount is needed for proper yeast metabolism. Professional texts cite trace amounts of about .01 ppm and recommend that levels be kept below 0.1 ppm. Ten ppm will prove toxic to yeast. It is best to avoid even approaching the theoretical "bang you're dead" limit. If copper kettles and beer equipment have been properly passivated by a weak acid solution, there will be very little copper pickup during the brewing process (see section on copper equipment).

Silicate (SiO_3^{-2}). This is present in very small amounts in almost all water. It really does not interfere with the brewing process, but does appear as scale on the inside of commercial brewing kettles and requires removal at regular intervals.

Zinc (Zn^{+2}). As a trace element, zinc is essential for proper yeast metabolism. Amounts should not exceed 0.2 ppm. In excess it will impart a metallic flavor to beer.

Manganese (Mn^{+2}). Trace amounts less than 0.2 ppm are desirable for proper yeast metabolism. Amounts greater than this should be avoided.

MINERAL SALTS

A variety of mineral salts is commonly utilized by brewers to add desired ions to the brewing water. The accompanying table lists them with concentration information. In salt form, magnesium sulfate and

calcium sulfate have water molecules attached to them, which affect weight, percentage and ppm calculations. This has been taken into consideration for the data in the table.

MINERAL TABLE

Mineral Salt	Ion Composition Percent by Weight	1 Gram Salt in 1 Gallon (3.8 liters)	1 Gram Salt in 5 Gallons (19 liters)
Calcium Sulfate ($CaSO_4 \cdot 2H_2O$)			
Common name: Gypsum			
calcium (Ca^{+2})	23%	62 ppm	12 ppm
sulfate (SO_4^{-2})	56%	148 ppm	30 ppm
Calcium Chloride ($CaCl_2 \cdot 2H_2O$)			
calcium (Ca^{+2})	27%	72 ppm	14 ppm
chloride (Cl^{-1})	48%	127 ppm	26 ppm
Magnesium Sulfate ($MgSO_4 \cdot 7H_2O$)			
Common name: Epsom Salt			
magnesium (Mg^{+2})	10%	26 ppm	5 ppm
sulfate (SO_4^{-2})	39%	103 ppm	21 ppm
Sodium Chloride (NaCl)			
Common name: Table Salt			
sodium (Na^{+1})	39%	104 ppm	21 ppm
chloride (Cl^{-1})	61%	160 ppm	32 ppm
Calcium Carbonate ($CaCO_3$)			
Common Name: Chalk			
calcium (Ca^{+2})	40%	106 ppm	21 ppm
carbonate (CO_3^{-2})	60%	159 ppm	32 ppm

NOTE: Numerical data are rounded off to the nearest whole number.

GETTING IT! PH, ALKALINITY AND HARDNESS

This is where water analysis can get hopelessly confusing for those who do not abide by the Golden Rule of Homebrewing. Get a homebrew and reread the section on bicarbonates once again.

Now that you're back, consider what follows.

In the United States water hardness is expressed as parts per million calcium carbonate ($CaCO_3$). Calcium is a main source of permanent hardness (in the old days "hardness" was an indication of how easily soap lathered), and magnesium is usually a secondary source.

An important point to remember here is that ppm hardness is expressed *as if it were* calcium carbonate, not that it really is. Well then, if calcium indicates permanent hardness, so does sulfate, because it is usually associated with calcium in the form of calcium sulfate. Then what does carbonate indicate? Alkalinity? Yes, the amount of carbonate is related to alkalinity. As we've discussed earlier, bicarbonates are an even more powerful indicator of alkalinity. But bicarbonate is also a measure of temporary hardness, because when it is boiled it reduces hardness by combining with calcium and precipitating out as calcium carbonate. As calcium carbonate precipitates out, alkalinity is also reduced because carbonate is leaving solution.

As a curious homebrewer, you should obtain an analysis of your water and determine its suitability for brewing beer. If it is soft water with hardness less than 50 ppm and pH of near 7.0, consider yourself fortunate. You can brew just about any type of beer, using easy adjustments if called for. For beer styles that call for brewing water with increased minerals, it is a relatively simple matter to add mineral salts to increase hardness to the desired levels.

If your water is high in hardness and pH is near a normal 7.0, you have lots of permanent hardness. Referring to the mineral needs of certain beer styles, you will be doomed to brew styles of beer such as classic Burton-style ale or Dortmund-style export. There is nothing to prevent you from formulating a Pilsener style of beer, but the results will have the characters that sulfates, sodium, chloride and magnesium contribute to the overall character of the beer. A practical alternative is to find another, more appropriate water source for those styles or blend deionized, mineral-free water with yours in appropriate proportions.

When parts per million hardness increases and pH also increases, homebrewers will need to employ increasingly difficult procedures in order to make their water suitable for the style of beer they wish to brew.

Water with 150 to 250 ppm hardness and pH in the 7.2 and higher range will have quite a bit of detrimental carbonate temporary hardness, but boiling and the addition of some gypsum will remedy the situation to a great degree.

A pH higher than 7.5 and hardness greater than 250 ppm indicate that the water has a lot of temporary carbonate/bicarbonate hardness. Only some of it will precipitate out with boiling because there won't be enough calcium to combine with the carbonates to form calcium carbonate as a precipitate. Furthermore, there won't be enough calcium left for necessary reactions during the mash. In this case brewers usually calculate how much food-grade acid (such as sulfuric acid,

phosphoric acid or lactic acid) to add to the wort in order to neutralize the carbonates without sacrificing excessive calcium. In some cases calcium sulfate may need to be added.

There is another alternative used by those who wish to brew more naturally and without additives. A portion of the mash is acidified by mashing at a temperature of 120 degrees F (49 degrees C) for one or two days. At these temperatures lactic acid is formed by naturally present *Lactobacillus* bacteria. Using principles of brewing chemistry, the acidity is measured and the correct proportion of this mash is added to the full mash in order to neutralize alkalinity created by carbonates. For those homebrewers who do not wish to deal with this in-depth chemistry, finding another source for water is the best alternative.

Excellent beginning references to a more thorough discussion of water chemistry and brewing science are *Principles of Brewing Science*, by George Fix (Brewers Publications, Boulder, Colorado, 1989); and *Brewing Lager Beers*, by Gregory Noonan (Brewers Publications, Boulder, Colorado, 1986).

MINERALS AND BEER STYLES

There are certain characters that each mineral may contribute to the final character of beer. The presence of some minerals makes it impossible to brew certain types of beers having desired characters. We can surmise this from the information already presented in this section. What are the typical water qualities of certain styles? The Ionic Concentration Chart that follows is a listing of what could be a typical water supply analysis from many of the great brewing areas of the world. Here is an important point that is easily overlooked: Before brewing chemistry was fully understood, brewing centers in the world were by and large stuck with the water they were able to get. Deionization and sophisticated treatment were not known. These brewing areas brewed types of beer that suited their water source. Munich, Dublin, Pilzen, Burton-on-Trent and Dortmund are but a few examples of areas that developed certain styles primarily based on their water source. But the present-day situation is quite different.

APPROXIMATE IONIC CONCENTRATIONS (IN PPM) OF CLASSIC BREWING WATERS. VARIATIONS CAN BE EXPECTED TO BE ±25% IN MANY CASES, AND SOMETIMES MORE.

Brewing Area	Ca^{+2}	Mg^{+2}	Na^{+1}	Cl^{-1}	SO_4^{+2}	HCO_3^{-1}	Hardness
Style of beer typifying heritage							
Pilzen	7	2	2	5	5	15	30
Light-colored lagers, zealously hopped							
Burton-on-Trent	295	45	55	25	725	300	850
Amber pale ales with distinctive sulfate-influenced hop character							
Dublin	115	4	12	19	55	200	300
Dark, malty ales with medium bitterness							
Edinburgh	120	25	55	20	140	225	350
Dark, malty, strong ales with low bitterness							
Dortmund	250	25	70	100	280	550	750
Strong, well-hopped amber lagers with full malty palate contributed to by sodium and chloride, and sulfate-influenced hop character							
Munich	75	20	10	2	10	200	250
Dark, malty lagers							
Vienna	200	60	8	12	125	120	750
Amber to brown malt-accented lagers with sulfate-influenced hop character							

Water chemistry at its best. Ultimately the character of the water really does affect the degree of enjoyment you'll find in every bottle of homebrew.

For example, Munich brewers, using water with high carbonate concentrations, evolved a type of beer that was necessarily dark and malty. Now, with sophisticated acidification of the mash (lactic acid sour mashes), they can reduce the carbonate level low enough to allow the brewing of lighter lagers, so the dark malts are no longer necessary to acidify the mash. A brewer wanting to brew a Münchner Helles style of lager should seek a noncarbonate, soft water, just as Munich brewers do.

In Dublin the famed Guinness Stout continues to be made with water similar to what was used a century ago. But brewers also make light lagers and ales. When an area brews a style of beer that does not typify its heritage, it is almost certain that the water is being treated in order to match a beer's profile.

Homebrewers who wish to adjust their water to match water from traditional brewing cities can simply subtract the ionic amounts in their own water from the desired amounts. The differences represent the amounts of ions that need to be added (or subtracted; not possible in some cases). Brewers with soft or distilled water are at a distinct advantage. Here is how a typical worksheet might be prepared:

	Desired Water (Munich Type) (ppm)	Your Water (ppm)	Difference (ppm)
Ca	75	35	40
Mg	20	11	9
SO₄	10	18	−8
Cl	2	5	−3
Na	10	3	7
HCO₃	200	14	186

From the Mineral Table one can pick and choose what minerals to add in order to approximate the indicated additions (the "Difference" above) and come reasonably close to achieving the desired water character.

Yeast

In the high country of the Andes Mountains in Peru, local tribes continue the centuries-old tradition of brewing beer with available ingredients such as corn. The corn is not malted, but is chewed by the women of the village. Enzymes in the mouth are diastatic and break down carbohydrates to fermentable sugar. The "spittoon" is filled with "mouth mash" and allowed to ferment with indigenous yeast. The yeast is, you might say, very uniquely cultured. I have been told by a very dedicated researcher of indigenous old-world American fermentations that the special yeast culture is derived from the feces of unweaned infants. Tests of the culture have indicated that it was nearly a pure culture of *Saccharomyces cerevisiae*, or brewer's ale yeast. A bit startling? Relax. Don't worry. Have a, ahh, umm, er . . . home-poo . . . er . . . homebrew.

Fermentation opportunities for the American homebrewer are limitless. Most choose to ferment in a more traditional manner with more traditional yeast cultures. Malt (and other fermentables), hops and water are all crucial to the character of a beer's profile. Yeast is an equal partner with its own unique influences on the qualities of beer. With the accessibility of dozens of yeast strains, the homebrewer can develop even greater flexibility in brewing.

Information, guidelines, techniques and data are extremely helpful in developing one's brewing skills. The role that experience and experimentation have in helping develop the art of using and choosing yeast is absolutely essential. As with most homebrewing, the information and products available are of high enough quality that it is very unusual for an experiment or new endeavor to yield a brew that is anything less than drinkable.

NAMES AND STRAINS

Technically speaking, all single-celled fungi yeasts are classified by genus, species and strain. The primary genus used by brewers is *Saccharomyces*, though other genera are used for some specialty beers. Of the *Saccharomyces* genus, there are two species principally used. They are *cerevisiae* and *uvarum* (sometimes called *carlsbergensis*). *Saccharomyces cerevisiae* is commonly known as ale yeast. *Saccharomyces uvarum* is lager yeast.

The strain of brewer's yeast used is perhaps a most critical consideration for the practical homebrewer. Strains of yeast are designated by any manner of names or numbers and are distinguished from one another by variations in their behavior. Different strains of yeast, whether they are ale yeast or lager yeast, will behave differently in some ways and similarly in others. The behavior of yeasts will affect wort attenuation, ester production, phenol production, fusel alcohols, diacetyl (butterscotch character) levels, flocculation of yeast, alcohol production and mutability. Different strains of yeast are more or less susceptible to the influence of temperature, alcohol levels, mineral content, nutritional balance, atmospheric and osmotic pressure and other factors.

It is quite obvious that choosing your yeast by strain is crucial to the final character of the beer you wish to produce.

DRIED AND LIQUID YEASTS

Yeasts are available for use by the homebrewer in dried granulated form and various liquid forms.

Dried Yeast

By a long shot, dried packaged yeasts are the simplest to use. When a source of quality dried yeast is found, the brewer is doing well to consistently use it. A quality yeast is one that the brewer is pleased with, giving desired results. Unfortunately only ale yeasts are dependably available in dried form. If the package claims that it is a lager yeast, its behavior will be similar to ale yeasts, and for all intents and purposes, it is an ale yeast.

It is not uncommon for dried yeasts to be contaminated with bacteria and/or wild yeasts. The contaminations usually manifest themselves as undesirable bananalike (esters) and phenolic (characteristic of plastic Band-Aids or clovelike) flavors and aromas. They also produce long, drawn-out fermentations (wild yeasts ferment carbohydrates usually not fermentable by pure strains of common beer

A mother of all beers! Two Saccharomyces cerevisiae yeast cells imaged by a scanning electron microscope depict the top cell with bud scars. The center scar is about 2 microns in diameter. It would take a string of over 5,000 yeast cells to equal an inch (2.54 cm.).

yeasts) and sometimes a slight film on the surface of the finished beer (wild yeast or bacteria).

Good beer can be made with dried yeast, but this takes an effort and knowledge of the characters that are the result of poor yeast.

For the hobbyist, dried yeast usually comes in 3.5-, 7- or sometimes 14-gram packages. For a 5-gallon (19 l.) batch, the addition of 7 to 14 grams of active dried yeast is recommended. Prior to pitching, rehydrate in $\frac{1}{2}$ to 1 cup (118 to 237 ml.) sterile water at about 100 degrees F (38 degrees C) for 15 minutes to activate viable yeast cells. The rehydrated slurry can be added directly to the wort at temperatures generally below 75 degrees F (24 C).

When the yeast is introduced to the wort, it is crucial to oxygenate the wort to provide the yeast sufficient oxygen for its initial metabolic phases. During this lag phase yeast cells take up the oxygen and nutrients required for later growth and fermentation. When using dried yeast the lag phase is not as crucial because the dried yeast has gone through the lag phase during culturing and so already possesses stores of oxygen and nutrients when it is packaged. This is one reason why dried yeast seems to "take off" within an hour or two when intro-

Not *your beer—you hope!* As seen through a laboratory microscope one yeast cell is about 5 to 7 microns in diameter. Saccharomyces cerevisiae *yeast cells are depicted here among rod-shaped* Lactobacillus *bacteria; bacteria you do not want in your beer* (Lambic *styles excepted*).

duced to fresh wort. It jumps right into the growth and fermentation stages much more quickly.

Wet or Liquid Yeast

Using liquid cultures does not in any manner assure or increase the odds that the culture is clean and not contaminated. Actually, liquid yeasts are more susceptible to contamination than dried yeasts once they are handled by the brewer. Care must always be a top priority when using liquid cultures to help assure a maximum degree of purity. Yes, you still may abide by the Golden Rule of Homebrewing, but an elevated degree of respect for the process of handling must be considered—while you are relaxing, not worrying and having a homebrew. Remember, worrying can influence the flavor of beer more than anything else. It can influence the quality of yeast as well.

There are a few essential factors that must be considered when propagating or using liquid yeasts. They require a proper wort environment in order to successfully grow, thrive and ferment. They need proper nutrition. This should never be a problem if the propagating medium or wort is all malt. If using over 30 percent adjuncts such as refined sugar, corn, rice or other unmalted adjuncts, you will need to determine whether the nutrition requirements have been met. An equally important consideration is the requirement of oxygen. Whenever propagating yeast in any amount of sterile wort, it *must* be adequately aerated. Aeration by vigorous agitation in a sealed sterile container is often adequate. Temperature of propagation is another consideration that influences timely yeast growth and activity. You may find yourself in a situation propagating yeast at slightly higher temperatures than you'd normally expect to have during beer fermentation. This is okay when there is no alternative, but it may influence the behavior of the yeast.

Liquid yeasts can be derived from three principal methods or procedures: from fermentation sediment, from agar slants or from dormant yeast suspended or sedimented in small amounts of beer or fermented wort.

REUSING YEAST SEDIMENT

Active yeast can be collected from the sediment from either the primary or secondary fermenter and added directly to fresh wort. Theoretically the best part of the yeast sediment to use is the middle layer of lighter, straw-colored yeast. This sits above trub and other organic material such as hop particulates. It is the most viable.

Four to 8 fluid ounces (125 to 250 ml.) of yeast slurry should be used for pitching into 5 gallons (19 l.) of wort, the upper limit being optimal. The practical homebrewer more often than not has less than ideal circumstances to work with. If the brewer is assured that the finished fermentation is not contaminated, excellent results are usually obtained with a mixed slurry of yeast sediment poured out of a fermenter. Care should be taken to sanitize the mouth of the carboy by swabbing with disinfecting alcohol (preferably grain alcohol or 150-proof cheap vodka) and flaming with a butane cigarette lighter.

Another source of yeast sediment is your friendly microbrewery or pub brewery. While most do not appreciate being bothered at the spur of the moment, many will accommodate the needs of local homebrewers if a regular schedule can be developed and there is one homebrewer contact or homebrew shop contact that will deal with the exchange. Use your imagination as a homebrewer when you reciprocate the favor, but keep in mind a professional brewer is not lacking for free beer.

If a slurry is taken and contained in a sterile jar, it can be kept relatively fresh and active for two to five days in the refrigerator. Don't seal the container. Fermentation can continue creating gas and dangerous pressure in a sealed container. The yeast's storability will depend on the strain.

CULTURING DORMANT YEAST IN SUSPENSION

A very practical means for culturing and storing yeast is the method outlined on pages 275 to 282 of *The New Complete Joy of Home Brewing*. It is a simple method requiring very little specialized equipment and is accessible to virtually all homebrewers. It essentially cultures active yeast in mini fermenters: beer bottles affixed with a fermentation lock. The yeast is cultured with real wort and is stored as a sediment under fermented wort, conditions most natural to beer yeast. Highly bittered wort is usually made in advance and stored in sterile jars or bottles. The highly bittered wort is an inhibitor of bacterial activity.

Using this method, yeast may be cultured from any source. A yeast bank can be maintained easily. Yeast will remain viable for months at refrigerated temperatures. (I have had experience with a yeast that survived one and a half years "under beer" and was recultured to brew an excellent light lager.) These cultures more quickly grow to suitable amounts for pitching 5 gallons of wort than slants do.

Expose yourself to culture. Culturing yeast in sterile-prepared wort is quite a simple process, requiring only a few precautions. Swabbing pouring surfaces with grain alcohol-soaked cotton swabs helps reduce risk of contamination. Flaming surfaces with butane lighter further minimizes contamination.

Commercial cultures are available to homebrewers as yeast suspended in sterile compartmentalized foil packages. These yeast cultures need to be cultured up to amounts sufficient for pitching into your volume of wort. Instructions are included with the packaging.

Practical homebrewers often find themselves pitching a less than ideal quantity of slurry (1 cup [237 ml.]) for 5 gallons (19 l.). Don't worry; it will work. You can enhance the results and accelerate the growth of yeast in your pitched wort by holding the temperature of your wort at about 70 to 75 degrees F (21 to 24 C) until yeast activity is observed (usually within 24 hours), then cooling to desired temperatures. The trade-off here is that you may be encouraging some degree of undesirable fruitiness at these warmer temperatures for lager yeasts, but this is reasonable considering the more deleterious effects of extended lag times, which allow bacteria populations to gain a foothold in the wort before the yeast cells sufficiently outnumber the bacteria and inhibit them by increasing the acidity of the wort.

For homebrewers able to culture 1 cup (250 ml.) of slurry, yeast can be pitched into more appropriately cooled worts (50 to 55 de-

grees F [9 to 13 degrees C] for lager) with normal lag times and growth phases.

YEAST TYPES AVAILABLE

A sampling of a few types of liquid yeasts available to homebrew shops throughout the United States, Canada and Australia

Ale Yeasts

German ale (Alt-type) yeast
American ale yeast (often referred to as Chico or Sierra Nevada ale yeast)
Irish ale (Guinness Stout–type yeast)
British ale (from Whitbread brewery)
European ale
London ale
Bavarian wheat ale (50% *Saccharomyces delbrueckii*, 50% *Saccharomyces cerevisiae*)
Belgian ale
Canadian ale
Australian ale

Lager Yeasts

Pilsen
Danish
Bavarian
Munich
American
Bohemian (Czechoslovakian origin)

CULTURING AND STORING

Though it requires more equipment, training and practice, culturing yeast from slants is the preferred method of maintaining purity when storing yeast over long periods of time. Essentially, slants are test tubes with a small amount of gelatinized wort in them. Before the gelatinlike substance cools and solidifies, the test tube is tilted to allow the nutrient-rich wort to solidify with a greater surface area. The surface of the culturing medium is slanted relative to the tube. All

procedures must be done under extremely sanitary conditions, using pressure cookers and high heat to sanitize everything that comes into contact with active surfaces.

Amounts of yeast invisible to the naked eye can be carefully transferred to the surface of these slants, usually with a sterilized wire that has been in contact with the yeast source. Within days the yeast will multiply under appropriate conditions and grow on the surface of the wort-gelatin, where they will remain dormant or slowly active for many months if kept refrigerated.

There are many excellent resources that explain in detail the process of making slants and similar petri dish mediums for the culturing, purifying and storage of yeast. They are listed at the end of this section.

If you are using liquid yeasts from various sources, the opportunity will inevitably present itself when another brewer will give you a slant culture of a yeast that you'd love to try. The process of culturing from a slant is a lot simpler than making and maintaining slants. Relax. Don't worry, and have a homebrew AFTER you've transferred the yeast from the slant to the initial culture.

Here's how. You will need a test tube, sterile cotton (from the supermarket), an inoculating wire, butane torch and material you already have for propagating liquid yeast. Sanitize the test tube by boiling in water for 10 minutes. Cool and add about 3 to 5 milliliters (about 0.1 fl. oz.) of sterile, aerated, clear and cooled wort, preferably at a specific gravity between 1.025 and 1.030 (6 and 7.5 B). Temporarily cover with a sanitized piece of aluminum foil and set aside.

Working in a dust-free, draft-free (that's not draft beer) environment, heat the wire to red-hot, burning off microorganisms. Cool the wire by touching the tip to the surface of slant media containing no yeast or dip into a small cap full of alcohol. (Note: WARNING! Alcohol is very flammable. Do not immerse red-hot wire into a large container of alcohol.) Sanitize the mouth of the test tube slant and test tube of wort by swabbing with an alcohol-soaked Q-tip. If you are using glass test tubes, you can briefly flame the opening with the butane torch. Hold your breath (seriously), open the slant and use the sterilized wire loop to scrape off a bit of yeast from the surface of the slant. Immediately cap the slant, then open the wort-containing test tube and immerse the wire into the wort. Jiggle, remove the wire and temporarily cover the tube with foil. Resume breathing and carefully replace the foil with a wad of sterile cotton. Place the test tube in an environment that is suitable for propagating yeast, upright at 60 to 70 degrees F (16 to 21 degrees C).

Within 48 hours you should notice that the clear wort has a light

Step it up. Torched and sterile wire loop is used to scrape yeast cells grown on agar slant. These few yeast cells are introduced to a very small amount of sterile wort (small tube, left foreground) and allowed to ferment for two to four days. Doubling the amount, more sterile wort is introduced to feed the yeast to continue fermentation. Beaker (right) of fermenting wort represents third step of "culturing up" yeast.

sediment of yeast. Using similar procedures you will propagate the yeast by doubling the volume of wort in successive steps until you have a pint of fermenting wort, at which time you may consider pitching the sediment or the high kraeusen activity into your awaiting freshly brewed wort.

When is the appropriate time to pitch the propagation? You may do so at high kraeusen (when the yeast activity has created a foamy surface "kraeusen") or within 24 hours after the yeast has sedimented. Each method has its advantages and works well. The high kraeusen method seems to result in much quicker activity in the freshly pitched wort. The disadvantage is that you are pitching, along with the active yeast, 1 pint to 1 quart (about 500 to 1000 ml.) of fermenting wort

that may not match the carefully designed character of your freshly brewed wort.

For those who use highly bittered worts to propagate their yeast, pitching the sediment is preferred. The relatively clear fermented wort is poured off and only the yeast slurry and a small amount of propagating wort are introduced to the freshly brewed wort.

A note on sterile cotton: Handled with care, a wad of sterile cotton is an effective barrier to contaminating microorganisms. It is useful when actively propagating yeast. However, when storing yeast cultures, cotton is obviously not an effective barrier to evaporation or the oxidizing effects of air. Air locks should be utilized for long-term storage. A small piece of sterile cotton can be placed into the lower end of the lock to help assure that airborne contamination does not enter the stored culture if the water in the air lock inadvertently evaporates.

OTHER REASONS TO PROPAGATE YEAST

Introducing propagated yeast for primary fermentation is but one reason to propagate yeast.

KRAEUSENING

Kraeusening is the process of introducing a measured amount of freshly fermenting wort into finished beer in order to carbonate or condition it. True kraeusening methods rely on an introduction of wort that has just reached the kraeusen stage of metabolism/fermentation. This is usually just after the respiration cycle, when most of the fermentable carbohydrates have not yet been fermented. The yeast has passed through the lag phase, and uptake of energy-providing nutrients and oxygen is complete. At this point the yeast can be introduced into oxygen-free finished beer and be expected to complete the fermentation of the added wort.

Other, simpler methods of kraeusening work but are less than optimal. The addition of a measured amount of yeastless wort or malt extract at packaging time (bottling time) will provide fermentables, but a deficiency of oxygen will result in slow refermentation and long carbonation periods.

If corn sugar is added as a primer, the yeast cells are not sluggish,

because the oxygen requirement for metabolizing corn sugar is minimal.

CHARGING EXTENDED LAGER

When homebrewers lager their beers for extended times (one to three months), the resulting beer is extremely clear. The reduced yeast count is a disadvantage if bottle-conditioning methods will be used to carbonate the beer. Culturing up a small amount of fresh yeast and adding it to the finished beer just prior to bottling will help carbonate the beer in a more reasonable amount of time.

OUT WITH ONE AND IN WITH ANOTHER

Classic Bavarian-style wheat beer is a great example of a beer brewed with two different yeasts, one of which is introduced at bottling time. Typically the fresh original wort is fermented with a unique ale yeast that does not sediment well. When the fermentation is complete, Bavarian brewmasters and American homebrewers actually filter out the ale yeast, providing clear beer for bottling. Bavarian wheat beer is traditionally bottle-conditioned, and this is why well-flocculating/sedimenting lager yeast is propagated and added to the finished, filtered beer as a kraeusen.

YEAST PROFILING

There is quite a bit of printed information on the qualities that various yeast strains contribute to the character of beer. They are at best marginally helpful. It is difficult to generalize, because a particular strain of yeast will behave differently and produce different characters when used with individual brewing systems and different types of wort. For example, if a description of a yeast strain claims that it is well-attenuating, it may be—compared to other yeasts—but it most certainly will not be well-attenuating if proper nutrition hasn't been provided or a high-temperature mash has been used. Yeast can also differ from its stated description if mineral content varies from one wort to another.

You're a homebrewer. Take your homebrew in hand. Appreciate and note the variations of each brew. The best behavioral descriptions of yeasts are the ones you have made after using them in your brewery.

After all that, I can say that in general the Irish ale and London ale liquid cultures tend to work best at high fermentation temperatures such as those experienced in warmer climates. Both produce a lesser amount of the esters and phenolic character that usually typify beer fermented at high temperatures. (So can't I be a bit contrary now and then?)

TRULY STRANGE YEASTS

I've already primed you with the legendary account of high-altitude Peruvian diaper beer. Here are a few more interesting anomalies worth noting.

BRETTANOMYCES

Yeast of the genus *Brettanomyces* is utilized in the production of certain beer styles, especially in Belgium. *Brettanomyces bruxellensis* and *Brettanomyces lambicus* are two yeasts that help produce the very estery-

fruity character of Belgian lambics. Alone they do not produce sourness; acetic acid can be produced, but it is very volatile and is not present in any great amounts in the finished beer. These cultures are available to homebrewers through various homebrew computer networks and homebrew club yeast banks. When stored on slants, they must be cultured on wort that contains about 0.5 percent calcium carbonate. The yeasts produce acidity while in storage that will eventually kill them when excessive levels are reached. The calcium carbonate neutralizes the acids.

Homebrewers can obtain very good results with these yeasts if a propagated culture is introduced during or after primary fermentation with normal ale or lager yeast. The *Brettanomyces* will ferment carbohydrates not normally fermentable by *Saccharomyces cerevisiae* or *uvarum* yeasts. They are slow fermenters, but produce a great deal of perceptible esters typifying their character.

"SCHIZO" YEAST

Not all yeasts reproduce by budding. There is one unusual yeast called *Schizosaccharomyces pombe* (S. *pombe* for short). It is the only yeast in the world that reproduces by fission, rather than budding. This means the yeast cell reproduces by dividing its body into two or more parts, each growing into its own entity. All other yeasts reproduce by producing lots of buds that grow onto themselves.

The sample that I was given was cultured from African millet beer brewed in the bush. It produced a beer from an all-malt recipe that resembled the estery character of beers brewed by some Belgian monasteries. Further discussion with brewing colleagues revealed that this yeast is dry-cultured for some of the wine industry. Evidently it has the ability to make passable wine from less than desirable grapes. The yeast tends to deteriorate (autolyze) rather quickly. If beer or wine made from this yeast is not racked off the primary in a short time, the autolyzed yeast imparts certain characters to the beer. I refrain from saying these characters are undesirable, because my experiment was not racked off and produced a product that resembled certain kinds of Belgian ales that are desirable to many.

MORE INDIGENOUS YEAST

An experiment worth trying would be to brew a beer similar in nature to the beers first brewed by the Egyptians and Sumerians 5,000 years ago. They used barley or wheat along with available yeasts. There

are heirloom wheats currently available at some specialty natural food stores. They are called spelt, kamut or dinkel and are ancestors of our hybridized modern wheat. Primitive malting and mashing procedures would produce a wort that may be very similar to the worts of 5,000 years past. This brew would not be authentic without heirloom yeast. Even this can be acquired. There is a company called World Sourdoughs from Antiquity (P.O. Box 1440, Cascade, Idaho 83611 U.S.A.), specializing in culturing and packaging sourdough yeast cultures from around the world. These yeast cultures are sure to include unique strains of *Lactobacillus* bacteria and wild yeast, but this is likely what ancient brewers used. One of the nine varieties offered is Egyptian Red Sea Culture, said to be from one of the oldest ethnic bakeries in Egypt. It was found in the village of Hurghada on the shore of the Red Sea. The bread was actually placed on the village street to rise. It is one of the fastest cultures to rise and has a mild sourdough flavor. Another variety, Egyptian Giza culture, is said to be found in a bakery in the shadow of the Sphinx in the town of Giza. The bakery dates back to antiquity.

Brewing a batch? Use your imagination and drink while still fermenting, as likely did the ancients. The art of brewing will certainly be more meaningful, and if you stand in the sunshine with your second glass of homebrew and you cast a shadow of a sphinx . . .

AND DID YOU EVER NOTICE

I have sometimes noticed with curiosity a dusting of yeast adhering to one or perhaps all sides of a bottle of bottle-conditioned beer. It was a total mystery to me until I came across a summary of some research Belgian brewers had undertaken to unravel this aberrant behavior. They found that yeast is electrically charged the same as glass and is usually repelled. Sometimes if the yeast is deficient in certain nutrients, it will take on a different charge and become attracted to the sides of the bottle. Only the Belgians with their admirably wonderful world of unusual beers would undertake such research. A recent study proposes research dealing with the influence of transport conditions on adhesion of yeast to the bottom of the bottle. They say, "Further studies of these aspects under zero gravity conditions are planned for the next Eurospace mission [1994]." Furthermore they conclude that these considerations of transport conditions "will be required to solve this important national problem." Right on! Perhaps homebrewers might consider these questions as well. I believe they should.

ADDITIONAL REFERENCES

zymurgy magazine 1989, volume 12, number 4, special "Yeast and Beer" issue. Table of contents includes "Homebrew Starter Cultures," "Yeast Biology and Beer Fermentation," "Wild Yeast," "Yeast Nutrients in Brewing," "Commercial Production of Dried Yeast," "Yeast Stock Maintenance and Starter Culture Production," "A Sterile Transfer Technique for Pure Culturing," "Collecting Yeast While Traveling," "Collecting and Reusing Live Brewer's Yeast," "Isolation and Culture of Yeast from Bottle-Conditioned Beers," "Running a Yeast Test," "Analysis and Evaluation of Commercial Brewer's Yeast," "Of Yeasts and Beer Styles," "Fleischmann's [aka Budweiser] Yeast," "Lambic: A Unique Combination of Yeasts and Bacteria," "The Hybrid Styles [of Beer]: Some Notes on Their Fermentation and Formulation."

Yeast Technology, by Gerald Reed and Tilak W. Nagodawithana, Van Nostrand Reinhold, 1991. Up-to-date developments in yeast genetics, analytical techniques. Sections on flocculation, nutrition, fermentation, wild yeast, killer yeast and more.

Yeast Culturing for the Homebrewer, by Roger Leistad, G. W. Kent, 1983. How to culture and grow yeast at home in an easy-to-follow format.

Making Beer: Equipment and Process

EQUIPMENT

Are there other hobbies besides homebrewing that inspire so many innovations? Whether you consider yourself a beginner, intermediate or advanced brewer, the means to your end begins by choosing ingredients and follows with choosing the process and equipment. There are hundreds of options along the way. Many can be bought ready to go and off the shelf of your homebrew supply shop, or you may find yourself fashioning a brewery of your own design.

Throughout your homebrewing endeavors there is much likelihood that you will continue to learn and consider new ways of brewing; revising, upgrading, simplifying, diversifying and having a homebrew at every step of the way. It's the nature of homebrewing

Out of control? Got the bug? How many batches of beer have you brewed in the last year?

to create and to care about quality. It is also the nature of homebrewers to increase their respect and enjoyment of beer.

There are no perfect systems for homebrewing. Individual needs will vary from one home to another. An apartment in New York City, a suburban home in Missouri, a houseboat in Florida or Seattle, a ranch in Texas, a farmhouse in Colorado, a condominium in Michigan and a mobile home traveling on the interstate all present unique circumstances. Financial resources and leisure time are also factors to consider when choosing and designing the homebrewery.

Whatever your current system, keep your mind open to new ideas and innovations. Change when you envision an improvement and your resources allow you to make it happen. Relax. Don't worry. Have a homebrew, and perhaps do something different just for the plain fun of it!

THE PROCESS

In the end you will be holding a glass of the best beer in the world—yours. Getting there involves a number of steps. For beginners the process is often reduced to a very unintimidating simple one, with very few choices to consider. Do you remember your first batch? Be honest. It was probably like going on your first starship mission through Wort-5 hyperspace—into the unknown. Nervous and not quite confident, you probably appreciated the beginning simplicity and few choices. Now you know better. Making beer? Hah. No problem. Let's brew. And brew, you have, becoming more confident and less intimidated with every new batch of great beer. You have learned to abide by the Golden Rule of Homebrewing.

So now you're ready to consider all manner of processes, equipment, ideas, ingredients and gadgets. Perhaps you can pick up a few tips here and there without changing things too much and really improve your beer. But you pause because you thought it could never get any better than the one in your hand right now. Maybe . . . Thirsty? Have a homebrew.

Let's have a look at the principles of the beermaking process and consider some equipment utilized to achieve your end: the best beer possible in your privileged situation as a homebrewer.

AN OUTLINE OF THE BEERMAKING PROCESS

MALTING BARLEY

Let's face it—most of the grain malt you'll use to make homebrew will be bought from your local homebrew supply store. The dependability and the quality of grain malt is as good as that available to commercial breweries. You can make your own, but the malting process is an extension of the hobby most don't consider, for reasons of inconsistency of product and loss of time to relax with a homebrew. (Hmmm . . . but it does take four to five days to sprout barley.)

However, someday you may be in a situation that forces you to develop your malting skills. The situation is called survival. Unfortunately there are a number of people who find themselves in that mode because they are allergic to barley, wheat, rice, corn and other grains normally used in beer. Malting your own grains may give you an alternative.

Before considering any alternative grain-based beer, you should consult with your physician. Many persons who are allergic to cereals such as barley, rice, oats, corn, millet, rye or teff, all from the grass family, may find hope in pseudocereals such as buckwheat, amaranth or quinoa. Another serious possibility is a triticum grain called spelt (also called kamut or dinkel). Spelt is an "heirloom" wheat or an ancient wheat that has not been hybridized. More often than not, persons who find themselves allergic to wheat are not allergic to spelt.

Buckwheat, amaranth, quinoa and spelt all have starchy endosperms that are ultimately fermentable if reduced by enzymes. One

way to make these grains fermentable is to process them as though they were barley: malt them and mash them.

Malting is the simple process of germinating grain and then drying it: voilà malt. Practically speaking, soak grains for 24 to 40 hours (depending on the grain), changing the water about every 8 hours. Let the grain sprout until the growing acrospire is about the full length of the grain (this will vary depending on the grain) and then dry it.

Drying is exceptionally easy. Put the wet "green malt" in a pillow-case. Tie it securely shut and throw it in the clothes dryer until dry. Your lingerie setting will probably produce the lightest malt. Drying at a forced-air temperature of 180 to 220 degrees F (82 to 104 C) will produce malt similar to lager and pale malted barleys. Sounds outrageous? But hot damn—it really does work. When done, spread the malt on a flat surface and use a fan to blow away the dried rootlets and shriveled acrospires. You've got malt to experiment with. If you do this on a regular basis, you'll want to take careful notes of times and temperatures throughout the process to determine what gives optimal results.

If you want to make darker beers, simply roast a small portion of your homemade light malt in your oven at temperatures between 350 and 450 F (186 to 232 C), depending on the degree of roastiness you want.

Survival: Remember that sometimes your objective is not to get good yields, but simply to make good beer—any beer!!!

See related recipe: Speltbrau, page 318.

MILLING: CRUSHING YOUR GRAINS

If you use any kind of malted grain in your brewing formulations, the first place you'll have to make a decision will be at the malt mill. Whether you are using crystal or roasted malts to jazz your extract brews or you are about to make an all-grain beer, you'll need to crush malt in order to get the good stuff out of the grain.

There are two points to consider when crushing grain. One is to grind the grain in a manner that optimizes the extract yield, and the other is to grind the grain in a form that will cause the developed sugars to flow and rinse easily from the grains and into the brewpot. If you don't crush at all, you get virtually no yield but terrific flow. If

you crush into a flour, you get a most excellent yield, but a clogged glutinous (no) flow. There's a balance somewhere in between as sure as there should be a glass of beer in your hand right now.

A good balance is achieved if you can crush the grains in a manner that removes the husk relatively intact. The milled husk should still look like it was a husk. The remaining endosperm should be about 50 percent grits and 50 percent rough to fine flour. Certainly the best way to learn what a good grind looks like is to examine freshly milled malt firsthand at an operating commercial brewery or get a sample from a brewery. Mix the crushed malt before taking a handful. Don't simply observe a pile of crushed malt. It will give false impressions of composition since the lighter husks will tend to migrate to the top of the pile, and the flour to the bottom.

The best type of mill to grind grains through is a roller type. With this type of mill the grains are drawn through a very precisely measured gap between two rotating metal cylinders. The cylinders are about 8 to 12 inches (20 to 30 cm.) in diameter and can be set to accommodate different size grains and different grind requirements. These are very expensive to buy and beyond the resources of most homebrewers. For about $200 in supplies and a lot of mechanical know-how and skills, homemade roller mills can be built.[4] There are some small roller mills that have recently become available to homebrewers.

The advantage of these roller mills is usually a few percentage points of yield or a little less lautering/sparging time. Sacrificing a few minutes or 50 cents worth of yield is the option most brewers choose when they grind grains with the much more affordable "corona"-type grain-flour mill. These grain mills are designed so that the malt is forced between two plates rotating against each other by the action of a large hand-turned screw. The distance between the plates can be set so close together that they turn the grain into flour or set so wide that the grains pass through uncrushed. The action of the plates can certainly crush the grain adequately. The disadvantage is that the husks have to pass a greater distance through this measured gap, so they begin to break down into smaller husk particles. Relax. Don't worry. Have a homebrew. Your beer will turn out terrific. But compared to grain ground with a good roller mill, the physical composition of the grist produced by a corona mill will cause a slower runoff during the mashing/lautering process and a little bit less yield. You

[4] See "Building a Roller Grain Mill," by Wayne Greenway and Russ Wigglesworth, *zymurgy* magazine special issue 1992, published by the American Homebrewers Association, Boulder, Colorado.

UNI
BICYCLE DRIVEN
GRAIN MILL.

can do two things to help this situation: (1) buy an additional 25 to 50 cents worth of grain to make up for the yield difference and (2) have another homebrew during the additional leisure time you've just created. Pretty nifty, eh?

Now, regarding those plates on the corona-type mill or the cylinder gap on your envy-of-the-neighborhood roller mill, you will need to adjust the spacing depending on the malt you use. The best grind often is achieved by only a quarter or half turn on an adjusting screw. There can be big size differences that you will see and feel between raw grains, pale malts, two-row and six-row, crystal and black malts. Be sure to put your hand under the mill as the crushed grain flows out. Examine the handful to determine whether more adjustments are needed. Don't examine the pile; remember, the husks tend to "float" to the top and give a false impression.

You can turn your mill by hand, and that works fine if you're only grinding 2 or 3 pounds (about 1 or $1\frac{1}{2}$ kg.) at a time. But with all-grain 5-gallon (19 l.) batches, most of you will figure out a way to harness your electric drill, spare bicycle or spare electric motor by means of pulleys and reducing gears to power your grinder. In order to deter-

mine what to do, have a homebrew and contemplate your mill from a distance of about 3 feet. If that doesn't work, invite a mechanically minded friend over, give him or her a homebrew and let this person observe the situation as you have. It works.

In summary, remember that you are a homebrewer and are usually brewing 5- to 10-gallon (19 to 38 l.) batches of beer, not 3,000 gallons (11,400 l.). Your grain bed will be 6 to 18 inches (15 to 46 cm.) deep, not 4 feet (1.4 m.) deep. Having less than optimal yields will cost you an extra 25 to 99 cents a batch, not hundreds of thousands of dollars a year. When used properly, roller mills are the best for optimizing yield and runoff. If you have access to one of them, that's terrific, but a properly used good old corona-type flour mill will always make terrific beer.

Coffee grinders, food processors, rolling pins and blenders should be avoided because the pulverizing effect of the grind is exaggerated, causing frustration during the mashing process and disappointment in the quality of the beer.

MASHING

Master brewers have been combining art, science, skill and experience for over 5,000 years. Perhaps nowhere in the brewing process is the delineation between art and science less certain than in the mashing process. Experience and a feeling for ingredients serve the brewer well for fine-tuning the end results. As in any stage of the brewing process, however, novices with the desire and time should be thoroughly encouraged to just brew it. All-grain mashing may seem intimidating at first, but brewing on a small scale in your home is very forgiving. Homebrewers have a lot of latitude during this process. Very good beer can certainly be made despite the theoretical demands of grain mashing. Just brew it.

For extract brewers desiring to add additional qualities and diversity to their brewing endeavors, a combination of mashed grains and extract offers most of the simplicity of extract brewing with a limited amount of mashing. The basic principles of all-grain mashing (and mash-extract brewing) can be found in *The New Complete Joy of Home Brewing*. The following discussion will assume basic knowledge of these principles. But as a quick reminder: The purpose of mashing is to dissolve carbohydrates and activate various enzymes into solution in order to achieve a desired balance of various carbohydrates and prepare the wort for optimal fermentation.

ENZYME ACTIVITY DURING THE MASHING PROCESS

Enzyme	Effective Range in Mash	Approximate Temperature Range for Maximum Activity	Best Practical Utilization in Mash	Typical pH Range
Phytase	86–128 F (30–53 C)	pH dependent	95 F (35 C)	5.2–5.3
Peptidase*	113–122 F (45–50 C)	45 F (113 C) at pH = 4.2	122 F (50 C)	4.2–5.3
Protease	122–140 F (50–60 C)	122–131 F (50–55 C) at pH 4.6 to 5.0	122 F (50 C)	4.2–5.3
Protease primarily for head retention		130–140 F (54–60 C) at pH 4.6–5.0	130–140 F (54–60 C)	4.2–5.3
Beta glucanase**	95–140 F (35–60 C)	104–113 F (40–45 C) and at 140 F (60 C)	122–130 F (50–54 C)	4.5–4.8
Beta amylase	126–144 F (52–62 C)	140–149 F (60–65 C)	145–157 F (63–69 C)	5.2–5.7
Alpha amylase	149–158 F (65–70 C)	155–158 F (68–70 C)	145–157 F (63–69 C)	5.2–5.7

* NOTE: When brewing all malt beer, the peptidase rest may be bypassed in favor of developing better foam- and head-related proteins at higher temperatures. (There is adequate protein nutrient developed at slightly higher temperatures.)

** NOTE: Seventy-four percent of glucanase activity is related to endo beta glucanase$_{1-4}$ at an optimum temperature range of 104–113 F (40–45 C), and 26 percent of glucanase activity is related to endo beta glucanase$_{1-3}$ at an optimum temperature range of 140 F (60 C).

PHYTASE AND THE ACID REST

Acidification of the mash is essential in order to optimize diastatic (alpha and beta amylase) and proteolytic (peptidase and protease) enzymatic activity. When water contains an adequate amount of calcium ions (50 to 100 ppm) and the pH of the water is below 7.2, acidification occurs at virtually any mash-in temperature by the reaction of the calcium ions with phosphates from the malt.

However, if very soft water is used, calcium is lacking in the water. The brewer may choose not to add calcium salt "additives." If this is the case, then acidification can be achieved by mashing in at 95 degrees F (35 C). At this temperature phytase enyzmes are optimally activated and convert malt phosphate compounds to acidic compounds, thereby acidifying the mash. The process takes 2 to 3 hours.

If the water is high in carbonates, development of acidity with this method will not be adequate, and alternative lactic acid mashes (discussed elsewhere) need be considered.

PROTEASE, PEPTIDASE AND THE PROTEIN REST

(See page 35 for discussion of proteins and malt and their effect on beer.) The protein-degrading enzyme rests are a bit of an enigma. The degradation of long-chained proteins into medium-chained proteins occurs best at higher temperatures than are optimum for degradation of medium-chained proteins to the simple proteins. If we used optimum temperatures for long-chain degradation, we would deactivate the enzymes that are needed in the next step. Consequently 122 degrees F (50 C) is a compromise temperature where there is both protease and peptidase activity. (Protease breaks down soluble albumins and insoluble globulins into peptones and polypeptides, both important for foam stability. The reduction of albumins and globulin is important for reducing haze. Peptidase breaks down medium-chained peptones and polypeptides to peptides and amino acids, both important yeast nutrients.)

The protein rest is not necessary when using fully modified malts and especially overmodified English pale ale malts. The proteins in these malts are already adequately degraded.

The peptidase protein rest becomes essential for mashes with over 10 percent starch adjuncts in order to develop necessary protein-based yeast nutrients, absent in starch adjuncts.

During proteolytic activity the soluble protein albumin and insoluble protein can be acted upon by protease to help reduce chill

haze in beer. The secondary protein products resulting from this degradation help foam stability. If yeast nutrition is of secondary importance (especially when all-malt beers are being made, since more than adequate nutrition is available even without a protein rest), then the protein rest can occur at about 130 to 135 degrees F (54–57 C) in order to maximize the foam-enhancing activity and reduce haze.

BETA GLUCANASE AND GUMS

The degradation of filter-clogging gums is usually not an issue for most homebrewers. Commercial brewers who filter the mash or have deep grain filter beds may have problems with gum content of low-temperature-kilned lager malts. The mash may be held at a special temperature for a beta glucan rest. A beta glucan rest is often monitored and considered during protein rests or a rest at a slightly higher temperature. Homebrewers should simply relax, not worry and have a homebrew while a commercial brewer worries with furrowed brow about glucans.

DIASTASE AND MAKING SUGARS

The objective in choosing mash temperatures for diastatic activity is to achieve the best yield of desired fermentable sugars and dextrins. Compromises in temperature choices must be made due to the fact that alpha amylase produces the best yield at different temperatures than beta amylase. The activity of both is necessary to achieve the brewer's desired end.

Another important fact that the brewer must consider is that although maximum activity of diastatic enzymes is achieved at the upper limit of their temperature ranges, the activity is short-lived and does not produce the highest extract. When mashing at higher temperatures for fuller-bodied, dextrinous beers, you can expect a little less extract.

Highest fermentable yield is achieved at 149 degrees F (65 C). Highest extract is achieved between 149 and 155 degrees F (65–68 C). Highest dextrinous yield is achieved between 155 and 158 degrees F (68–70 C).

Assuming proper acidification of your mash, you can approximately expect:

A mash at 158 degrees F (70 C) complete in 20 minutes
A mash at 150 degrees F (66 C) complete in 45 to 60 minutes
A mash at 145 degrees F (63 C) complete in 90 to 120 minutes

A thinner mash will increase extract yields by increasing the viability of the enzymes and the speed at which conversion takes place. (Note: mashes that are too dilute will inhibit proteolytic enzyme activity.)

TYPES OF MASHING PROCEDURES

With the availability of quality commercial malts, any type of mashing procedure will most likely produce very good beer. Then why choose one mashing procedure over another? You may have to use a certain procedure because of the limitations of your brewing space and equipment. If your ingredients are substandard, the yields and the final product could be improved by your choice of procedure. Mashing offers the homebrewer flexibility and more control over the quality of the beer.

There is a lot of potential for mashing terminology to be confusing, so let's begin by defining our terms. *Infusion* is the act of steeping one ingredient in another; in the case of mashing, it is malt in water. *Decoction* is the process of extracting by boiling.

There are various steps the brewer may choose to implement in processing the mash. These options are a low-temperature acidification step, a protein rest and a starch conversion.

Brewers will raise the temperature of the mash through various steps by (1) applying heat to the mash, (2) adding (infusing) hot water to the mash or (3) bringing a portion of the mash to a boil (decoction) and adding it back into the main mash. Applying heat directly to the mash to achieve large temperature gains is usually avoided due to the time it takes to get from one temperature to another. It is desirable to reach diastatic conversion from the previous stage as quickly as possible. That is one reason why infusion and decoction methods are employed. Heating the mash directly is a method often used when making fine temperature adjustments during starch conversion or when mashing out at 167 degrees F (75 C) to halt all enzyme activity. Mashing out is a step that is not essential but does stabilize the balance of fermentable and nonfermentable carbohydrates achieved during carefully monitored mash periods. It is an assumed step, so even though mash-out is utilized with all mash schedules, it is often not reflected in the number of steps the mash schedule is named after.

As you can see, it's time for a homebrew. Go get one.

There are many options, but the ones most utilized by brewers are:

The one-step infusion mash
The two-step infusion mash
The two- or three-step decoction mash

THE ONE-STEP INFUSION MASH

Crushed malt is infused with hot water at a temperature calculated to reach a desired equilibrium temperature when mixed with the malt. The mash bypasses the protein rests, achieving starch-converting temperatures immediately. This mash is best suited for highly modified and ideally crushed malts. English pale malts are particularly well suited for this system.

One-step infusion mashes can be used with mash-tuns (mashing vessels) that also serve as lauter-tuns (straining vessels). If you cannot apply heat directly to your mash vessel, one-step infusion mashes are a necessary convenience. In order to stop enzyme activity with

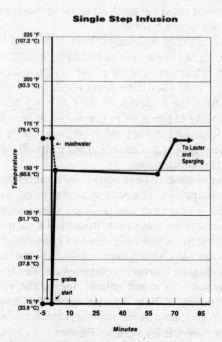

Single Step Infusion

this system, the initial 25 percent of the sparge water can be at 180 degrees F (82 C) to raise the temperature of the grain bed above 167 degrees F (75 C). The remainder of the sparge water should be about 170 degrees F (77 C), an occurrence that is reached naturally with homebrewing systems whereby a pot of water gradually cools at room temperature.

Step-by-step procedures for infusion mashes are provided in *The New Complete Joy of Home Brewing*.

TWO- OR THREE-STEP INFUSION MASH

The two-step mash goes through a protein rest and starch conversion and is particularly well suited to the music of Dwight Yoakam. Temperatures are raised with an infusion of hot water at calculated temperatures to reach desired equilibrium in the ranges of proteolytic and diastatic activity. Heat may need to be applied to the mashing vessel to adjust temperatures. If necessary, a third step may be added to this mashing schedule as an acid rest preceding the protein rest. In this case heat must be applied to raise the temperature from the acid rest to the protein rest.

The two-step infusion mashing schedule should be used if your malts tend to be higher in protein or not fully modified and you wish to improve head retention, reduce potential for chill haze and help assure development of adequate yeast nutrients. If your malt is less than ideally crushed, the added soak time at lower temperatures will help assure solubility of the malt in the water. As you increase starch adjuncts in your formulation, step infusion procedures will be increasingly critical in developing necessary yeast nutrients during the peptonizing part of the protein rest.

This mashing regime is best suited for a lautering system separate from the mashing vessel because of the need to apply heat to the mash vessel. A stovetop and a large stainless steel pot work very well. Without any insulation (at household room temperatures) a stainless steel brewpot will hold a mash containing 8 pounds (3.6 kg.) of malt and water at conversion temperatures for 60 minutes with no more than a 2-degree F drop in temperature. For all-grain, 5-gallon (19 l.) batches, insulation is not critical due to the volumes you are working with. If necessary, heat may be applied at any point in time.

Step-by-step procedures for two-step infusion mashes are provided in *The New Complete Joy of Home Brewing*.

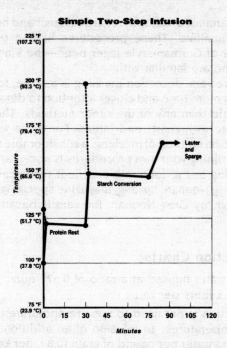

Simple Two-Step Infusion

TWO- OR THREE-STEP DECOCTION MASH

In decoction mashing, a portion of the mash is removed, brought to a boil and returned to the main mash to achieve temperature increases. Boiling water is added to achieve temperature for the initial acid rest and to maintain temperature during the diastatic rest.

Decoction mashing achieves a better yield from ingredients that are less than ideal quality. With decoction mashing, undermodified malt or poorly ground malt will offer better yields than with infusion-type mashes. Boiling part of the malt mash increases yields by gelatinizing and bursting starch particles, making them available for diastatic conversion. Boiling also helps reduce chill haze by breaking down protein gums not otherwise affected by enzyme activity.

Decoction mashing schedules are common among German brewing companies. The tradition dates back to when undermodified malt was common and the thermometer was not yet invented. Decoctions served to develop consistency in methods. Germans use thermometers these days and their malt is of improved quality; however, decoction is still the preferred method of mashing. With regard to yields,

the necessity is arguable, but with regard to flavor and beer character, the method is justified. These procedures have a positive effect on the character of German-style lager beer—the kind of character you can taste and are familiar with.

For homebrewers, decoction mashing is a chore, to say the very least. It involves more time and closer attention to details during the mashing schedule than any of the other methods. The procedures are outlined here with charts and tables. For those who choose to employ a decoction method of mashing, a considerable investment in research and outlining your own procedures is necessary. You should begin by referring to the following excellent resources: "Decoction Mashing," by Greg Noonan, *zymurgy* magazine special issue 1985, and *Brewing Lager Beer*, by Greg Noonan, Brewers Publications, Boulder, Colorado, 1986.

Key to Decoction Charts

A) Boiling water infused at a ratio of 0.625 quart per pound of grain (1.3 liters per kg.).

B) If decoction is not used to raise temperature to the protein rest temperatures, an infusion of an additional 0.375 quart of boiling water per pound of grain (0.8 l. per kg.) will accomplish the same.

C) About one-third of the mash or about 0.4 quart per pound of malt (about 0.8 l. per kg.) is decocted. The thickest part of the mash should be removed for this decoction. Liquid should be left behind in the main mash. Vigorous stirring is required.

D) About 0.5 quart per pound of malt (about 1.0 l. per kg.) is decocted. Again the thickest part of the mash should be removed for the decoction.

E) Up to a total of 1 quart of boiling water per pound of malt (2.1 l. per kg.) can be added during any infusions to maintain diastatic conversion temperatures.

F) About one-third of the mash (a fifty-fifty blend of thick mash and liquid) is removed for this decoction.

G) If the acid rest is bypassed altogether, then adding 1 quart of water at 130 degrees F (54 C) per pound of grain (2.1 l. per kg.) will raise the mash temperature to 122 degrees F (50 C).

Three Step Decoction Mash with Acid, Protein and Starch Conversion Rests

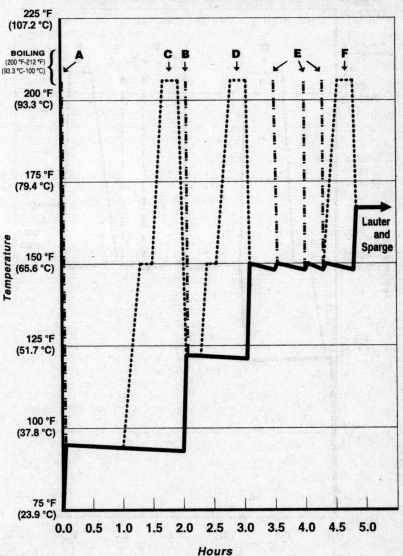

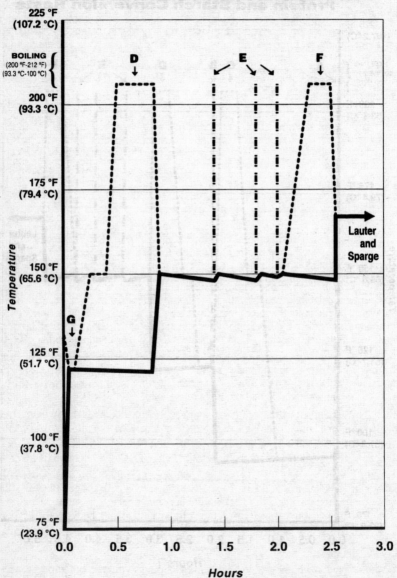

Two Step Decoction Mash
with Protein and Starch Conversion Rests

225 °F
(107.2 °C)

BOILING
(200 °F-212 °F)
(93.3 °C-100 °C)

D

E

F

200 °F
(93.3 °C)

175 °F
(79.4 °C)

Lauter
and
Sparge

150 °F
(65.6 °C)

Temperature

G

125 °F
(51.7 °C)

100 °F
(37.8 °C)

75 °F
(23.9 °C)

0.0 0.5 1.0 1.5 2.0 2.5 3.0

Hours

OPTIMIZING? WHAT ARE WE TALKING ABOUT HERE?

So what if we have reasonably good ingredients and we want to consider different methods of mashing to increase our extract yield or make our wort more fermentable (greater wort attenuation)? To what degree are we going to benefit? Let's refer to some research that has been done by professionals[5] and put things into perspective for the homebrewer.

Experiments were done using undermodified malt and well-modified malt in four different mashing procedures: two-step decoction, three-step decoction, one-step infusion and three-step infusion.

The greatest difference in extract yield was between the well-modified malt mashed with a three-step decoction, yielding a high of 79.3 percent extract, and undermodified malt mashed with a one-step infusion, yielding a low of 76.2 percent extract. That is only a 3.1 percent difference in yield. That is equal to .0014 point specific gravity (0.38 B) per pound of malt in one gallon of water (0.12 kg. per l.). If you were running a 10,000-barrel (11,700-hectoliter) brewery, your need for extra grains for the year would run about 15,500 pounds (7,032 kg.). For a million barrels (1.17 million hectoliters), your needs would be an additional 1.55 million pounds (703,075 kg.) of malt. But let's talk in homebrewing terms and consider a 5-gallon (19 l.) batch of homebrew using 8 pounds (3.6 kg.) of malt. You could make up the difference by adding 0.25 pound (.11 kg.) of malt. That's about 25 to 40 cents worth of malt. The 3.1 percent difference represents a loss of about 0.6 quart (0.6 l.); let's just call it a pint of beer. Consider all of the other places you might lose one pint of beer: in sediment, during trub removal, through siphon waste, through hydrometer readings.

The greatest difference in wort attentuation was between the well-modified malt mashed with a one-step infusion, yielding a high of 67.5 percent wort attenuation, and undermodified malt mashed with a three-step decoction, yielding a low of 63.4 percent wort attenuation. That is only a 4 percent maximum difference. A 4 percent difference in attenuation is equivalent to about .002 point of specific gravity (0.5 B) in a 1.048 (12 B) wort.

For better yield and better attenuation, homebrewers must ask the question: Is it worth it? Perhaps a more justifiable reason to con-

[5] *Malting and Brewing Science*, by Briggs and Hough, volume 1, Chapman and Hall, 1971, page 287.

sider different mashing schedules and procedures is the taste of the beer. Do different mashing processes affect the flavor and character of the beer? Of course they do, in various ways and to various degrees. The art of brewing is not simply considering numbers and statistics on paper. It is a blend of the science and the tasted results. Your tastes and your perceptions are an important individual factor. Remember, you're a homebrewer. Keep this in perspective.

MASHING VESSEL—THE MASH-TUN

The purpose of your mash-tun is very simple. It contains the grains and liquids during the mash and helps maintain heat. Other considerations are durability, cleanability and cost.

THE MASH-TUN/BREWPOT

The brewpot doubling as a mash-tun is the simplest system to consider. Although cost may be a factor, stainless steel is the most versa-

tile and durable. A 10-gallon (38-l.) pot is required for 5- to 7-gallon (19- to 26.5-l.) batches. Four- or 5-gallon (15- or 19-l.) brewpots can be used for mashing 8 pounds (3.6 kg.) of grain or less for full wort boils of 4 gallons (15 l.) or less.

Advantages: Simple. No extra cost if you already have one as a brewpot. Heat can be added to the mash if necessary. Can be used for any kind of mashing schedule. Holds heat well without insulation for up to an hour for mashes containing 10 pounds (4.54 kg.) of grain or more.

Disadvantages: Loses heat with mashes of less than 10 pounds; needs monitoring every 15 minutes for mashes containing 5 pounds of grain or less. Need to transfer mash to a lauter-tun (straining vessel to separate grains from liquid).

Types of mash: Well suited for any mashing schedule.

THE COOLERS

Food-grade insulated heat-resistant "picnic" coolers are popular choices for use as mash-tuns. Be sure they are heat-resistant. You will have material as hot as 180 degrees F in them. The cooler should have a drain for versatility as a lauter-tun.

Advantages: Maintains near constant temperature. Can be fitted with a straining system and double as a lauter-tun, eliminating the need for transferring the mash.

Disadvantages: Heat cannot be applied directly to the mash-tun. Less margin of error allowed when infusing water or decocting mash to raise temperatures. Difficult to mash out at 167 degrees F (75 C).

Types of mash: Very good for one-step infusion mashes. Can be used for two-step infusion or three-step decoction mashes if water and decoction temperatures and amounts are determined precisely.

PLASTIC BUCKETS

Five- and 6-gallon (19- and 23-l.) white buckets used in the food industry are usable as mash-tuns. To prevent heat loss, they can be easily insulated with a variety of materials, including blankets, Styrofoam shipping containers and sleeping bags.

Advantages: Inexpensive. Easy to work with and can be fitted with spigots and straining systems.

Disadvantages: Needs some insulating material to help maintain heat during mashing process. Also see "Disadvantages" for coolers.

MASH TIPS

- The capacity of a 5-gallon (19-l.) vessel for a mash is about 12 pounds (about 5.5 kg.) of grain and necessary water. For thicker mashes the amount of grain can be increased somewhat.

- Tincture of iodine is used as an indicator of starch conversion. If the iodine turns purple-black, it is an indication of the presence of starch and incomplete conversion. If the color of the iodine remains unchanged, conversion is considered complete. When removing mash liquid for testing, place about a tablespoon of liquid on a cool large white plate. Swirl the liquid so that it cools. The test must be done to cooled liquid to give an accurate indication of conversion. An additional test can be pursued to indicate how complete the conversion is by removing a teaspoon of grains and squeezing the liquid out. Testing this liquid indicates how much of the soluble starches has been brought out of the grain into solution and converted. Large, poorly ground chunks of malt will take longer for extraction and conversion.

- Take care not to aerate the hot mash. Oxygenation of the mash is detrimental to the final quality of the beer. Mash oxidation occurs quite rapidly at hot mash temperatures. Oxidation forms precursor compounds contributing to accelerated staling in finished beer. Don't worry. Simply keep this in mind. Avoid whipping up a froth when adding infusion water or making transfers. Oxidation in the mash stage can also darken the color of beer.

- Here's a little gem that will help reduce chill haze and reduce some harshness: Add about 1 ounce (28 g.) of finely crushed black malt to your light beers at the end of the mash. The addition will not affect color significantly but will adsorb some of the polyphenols, tannins and long-chained proteins that cause chill haze and astringent character in beers. Some of the largest brewing companies in the United States use this method for some of the lightest of their beers. You may have already noticed that chill haze is less of a problem—even nonexistent—in dark beers. Aha.

LAUTERING AND SPARGING

You've made all of this good wort, on its way to becoming the next best beer you've ever made. Now it's time to separate the good

liquid from the grains we extracted it from. The straining process is called *lautering*, and the vessel it is done in is called the *lauter-tun*. There's a lot of good stuff as well as some undesirable stuff impregnating these grains. The good stuff needs to be rinsed away during the process called *sparging*. There are many points to be considered in order to get the most good stuff extracted and the least amount of the undesirable stuff left behind.

TEMPERATURE

The temperature of the mash at mash-out should be 167 degrees F (75 C). This halts enzyme activity and allows dissolved sugars to flow more freely from the grain.

FOUNDATION

If not already atop a straining device, the hot mash must be transferred into the lauter-tun. However, before this is done, foundation water must be added to the lauter-tun to a level visibly above the straining "plate" or device. The water should be between 170 and 175 degrees F (77–79 C). This water provides a foundation upon which the mash can be suspended onto the straining interface. This prevents compacting of the grain bed and a clogged system.

FILTER BED

A polyposturepedic fully sprung mattress is best utilized for maximum somnambulism. Back up. Start over. Score one for me if I had you. If you didn't bite, then have a homebrew.

The broken and spent grains serve as a filtering medium for most of the particulate and insoluble material not wanted in the extract. When the flow of extract from the lauter-tun is begun, the first runoff will be cloudy and contain quite a bit of particulate matter. This initial runoff should be recirculated by gently pouring it back onto the top of the grain bed. After a few minutes or a few quarts, the extract will run clear.

COLLECTING THE EXTRACT

The extract is drawn from the lauter-tun and directed to the brewpot by means of a hose. The hose should reach to the bottom of the brewpot so that aeration of the hot extract is minimized.

BEGIN SPARGING

At least $\frac{1}{4}$ inch to $\frac{1}{2}$ inch (6–13 mm.) of liquid should be maintained on the surface of the grain bed during the lautering, as long as the supply of premeasured sparge water lasts. Sparge water should be maintained at 170 degrees F (77 C) and sprinkled evenly onto the grain surface as necessary. The formation of the grain bed should be disturbed as little as possible, though it is not critical at the top 2 to 3 inches (5–8 cm.). The hot sparge water percolates through the grains and carries with it extract from the grains.

WHEN TO STOP

The quality of the extract changes as it trickles from the lauter-tun. The concentration of sugar decreases as the sparge water dilutes the runoff. Consequently the specific gravity of the runoff decreases. At the same time the pH of the runoff increases. When this occurs, undesirable compounds such as harsh-tasting polyphenols and tannins, haze-forming starch and insoluble proteins, are more easily extracted and brought out of the grain bed and into the extract.

Experiments by professional brewers and researchers provide information that gives us some indication of what the optimal point of ending the runoff might be.

For beers requiring a delicate and smooth finish, stop the runoff when the specific gravity falls below 1.008 (2 B) or pH is greater than 6.0 to 6.1, whichever comes first.

For more robust beers or beers not requiring extreme finesse, stop the runoff when the specific gravity falls below 1.002 to 1.004 (0.5–1 B) or pH becomes greater than 6.2 to 6.4, whichever comes first.

Generally the pH and the amount of undesirable materials begin increasing dramatically when the runoff is between 1.004 and 1.008 specific gravity. They really zoom when specific gravity drops below 1.004 (1 B).

By monitoring the pH and/or the specific gravity of the runoff, you can determine when to stop the lautering process. As head brewmaster, you should also be tasting the runoff at various stages to get a sense of what all these numbers mean.

These guidelines all assume sparge water of low calcium hardness (0–50 ppm). Experiments have shown[6] that when the calcium

[6] "The Importance of pH Control During Fermentation," by David Taylor, MBAA *Technical Quarterly*, vol 27, 1990.

content of sparge water is increased, the tendency of the late runoff to increase in pH is greatly inhibited. Additions of calcium to levels of 50 to 200 ppm will have dramatic effects, enabling the brewer to collect extract from a prolonged runoff. However, the increased calcium levels may alter the flavor profile and perceived bitterness of the hops if calcium sulfate is added to achieve these higher calcium levels.

Higher levels (50–200 ppm) of calcium in the mash also inhibit the increase in runoff pH, but the difference is not as great as the effect when adding calcium to sparge water.

SOME PRACTICAL CONSIDERATIONS

MEASURING THE RUNOFF

pH and specific gravity measurements must be done with extract between 60 and 70 degrees F (15–21 C). A half cup (118 ml.) of extract is all that is needed to fill the hydrometer flask and take a reading. A simple way of cooling the hot extract is to add it to a saucepan and immerse the saucepan in cold water. Simply swirl for 10 seconds to cool to appropriate temperature. pH is conveniently measured with pH paper strips rated for the range between 5.0 and 6.6 or thereabouts. More accurate pH measurements can be done with expensive pH meters. The choice is yours.

HOW FAST THE RUNOFF?

Lautering, sparging and collecting the extract from an 8-pound (3.6-kg.) mash will take about 20 to 30 minutes, but that doesn't mean lautering ten times the amount of grain will take ten times as long. The runoff is influenced by how deep the grain bed is and how quickly the dissolved sugar takes to migrate out from inside the saturated grain. To get the good stuff out takes patience because there is little a homebrewer can do to speed it along.

It requires patience because there is a limit imposed by the nature of the grain on how fast lautering can go, but you don't want it to be too fast anyway because you'll get a stuck runoff.

STUCK RUNOFF

Just as sure as you've had a boilover, you will also experience the occasional stuck runoff, set mash and the aggravation that comes with

it. Stuck runoffs occur when the grain bed clogs the strainer interface or the filter bed compacts, thus restricting flow. The most common direct and controllable cause of a homebrewer's stuck runoff is impatience and allowing the flow from the lauter-tun to be faster than extract can percolate through the filter bed and strainer interface. When you remove more extract below the strainer than can be replaced by percolation, an air space is created below the strainer. Without the foundation water suspending the grains above the strainer, *whamo*—the grain compacts onto itself, enhanced by the slight vacuum below. Neither the situation nor the brewer is a pretty sight at this point.

Other factors that increase the potential for a stuck runoff are gums from malt or grains such as oatmeal, rye or wheat. Take great care in regulating the outflow. A glass of homebrew and patience are essential ingredients for this process. Every lautering system has its own tolerance. You will learn with experience.

Sometimes a gray "mud" will form on the surface of the grain bed. This insoluble material can form a barrier, preventing flow. The remedy for this is quite simple. Take a barbecue skewer or fork and break this barrier by "raking" the surface to a depth of about 1 inch (2.5 cm.).

What to do if a stuck mash happens? First try making a wish. If that doesn't work, then sometimes "underletting" will help alleviate the situation. By forcing hot water back through the system in reverse, sometimes the compacted grains can be pushed away from the strainer grate. Let it sit for a while and slowly begin the flow again. Another option is to underlet with water and simply stir the mash, creating a new beginning for the filter bed and flow of extract. You'll have to recirculate the cloudy first-running extract once again to set up the filter. A last resort is to scoop out all the grains and start the lautering process all over again. It isn't a pretty sight, but very good beer can be salvaged from these unfortunate circumstances. Keep in mind that it happens to the best of us.

HOW MUCH SPARGE WATER?

The total volume of sparge water will vary with beer styles and mashing processes. Generally sparge water will equal about three-quarters to just over the total volume of water necessary for the mash process. It is better to have more than necessary and stop the runoff when indicated by pH, specific gravity or your taste experience.

It is sometimes the case that the total volume of extract wort is

less than the total volume of beer anticipated. If the gravity of the collected extract is greater than expected, it is better to add water to make up the volume than it would be to continue the runoff. On the other hand, if the volume and gravity are less than anticipated, you have found yourself brewing less beer than you figured you would. Have a homebrew, cry a little, but don't let the teardrops fall into your brew—they will add sodium and chloride.

The mineral composition of the sparge water should be slightly acidic, containing 50 to 100 ppm calcium and not exceeding 100 ppm carbonates. Alkaline water high in carbonates will extract excessive color and the undesirable characters discussed previously.

SPARGING AND LAUTERING EQUIPMENT—YOUR SYSTEM

PLASTIC BUCKET SYSTEMS

The "Zapap" lauter-tun system discussed in *The New Complete Joy of Brewing* is one of the most inexpensive and effective methods of lautering. This system has been improved with some additional equipment commercially available at homebrew supply shops. The system relies on the Zapap principles and integrates miniaturized elements of the sparging equipment used by commercial breweries. It is not only fun to use, but impressive to observe. Manufactured by Listermann Manufacturing Company of Norwood, Ohio, one system uses a concave disk perforated with holes to replace the strainer bucket of the Zapap system. The advantage of this system is that it requires recirculation of only about 1 quart (1 l.) of extract rather than 4 to 6 quarts (3.8–5.7 l.) to clarify the runoff. Also because less foundation water is needed, the grain capacity of the 5-gallon (19 l.) bucket is greater than with the Zapap system.

The sparging apparatus is the gem of the Listermann system. Fed by a gravity siphon or direct flow, hot sparge water enters a sparge arm that rotates under the power of water exiting the holes. The holes are precisely drilled and spaced so that the water covers the maximum area atop the grain bed. Flow can be regulated with a hose clamp. The system requires that the sparge water reservoir be about 3 feet (1 m.) higher than the sparging arm's outflow. This system really allows a lot of time to enjoy a homebrew.

Flow of hot sparge water may be regulated with clamp or by positioning container of sparge water higher above lautering vessel and sparge arm outflow.

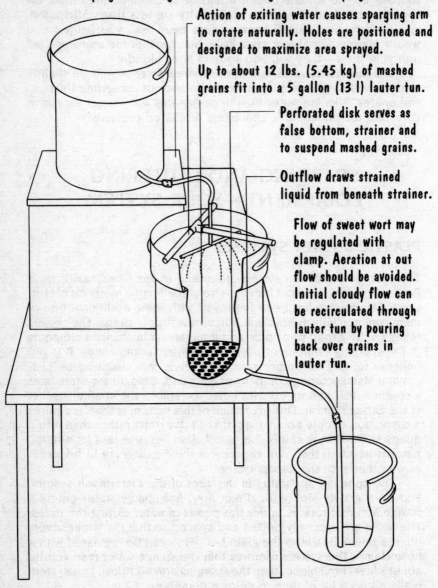

Action of exiting water causes sparging arm to rotate naturally. Holes are positioned and designed to maximize area sprayed.

Up to about 12 lbs. (5.45 kg) of mashed grains fit into a 5 gallon (13 l) lauter tun.

Perforated disk serves as false bottom, strainer and to suspend mashed grains.

Outflow draws strained liquid from beneath strainer.

Flow of sweet wort may be regulated with clamp. Aeration at out flow should be avoided. Initial cloudy flow can be recirculated through lauter tun by pouring back over grains in lauter tun.

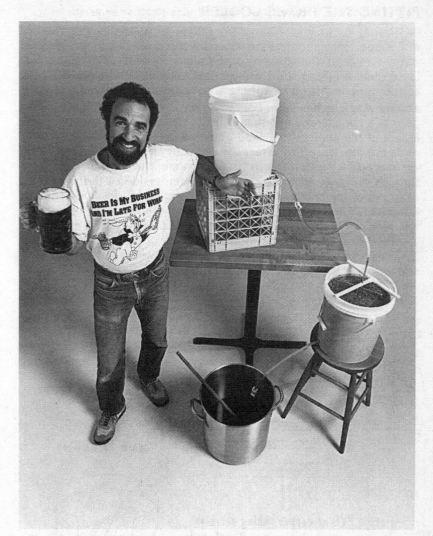

This ain't my kitchen, but you get the picture. One of many user-friendly commercially available lautering and sparging systems specially designed for all-grain homebrewing. Note leisure time to relax, not worry and have a homebrew. (System courtesy of Listermann Mfg., Norwood, Ohio, and T-shirt courtesy of BrewCo, Boone, North Carolina.

FITTING THE PICNIC COOLER

Box-shaped picnic coolers are not easily fitted with a perforated false bottom. Instead, the straining and draining systems of picnic cooler lauter-tuns are fabricated with slotted piping. Food-grade PVC or copper pipe is slotted by cutting about one-third of the way through about every $\frac{1}{2}$ inch (13 mm.) of the pipe's length. The pipe is assembled in a configuration so that it lies in three or four rows along the length of the cooler. The dead ends are capped and the opposite ends are junctioned to direct the flow out of the cooler. The slots are placed facing downwards. In this manner the extract percolates through the grain into the slots on the underside of the pipe and flows out of the cooler. The pipe matrix should be designed so that it is removable for easy cleaning. Various methods of sprinkling hot sparge water onto the surface are employed. One of these is drilling a series of tiny holes in a capped-off length of pipe. As water flows by gravity into and through the pipe, the water is sprayed in tiny streams over the surface of the grain bed.

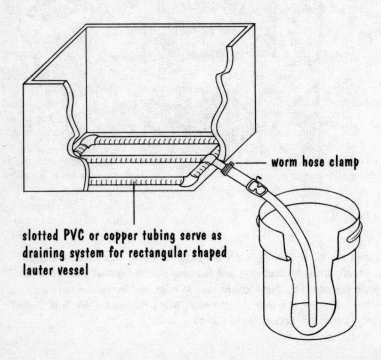

worm hose clamp

slotted PVC or copper tubing serve as draining system for rectangular shaped lauter vessel

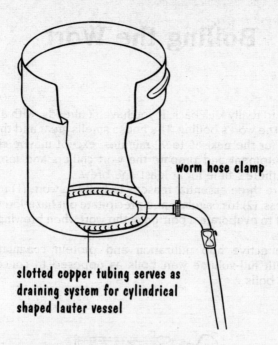

worm hose clamp

slotted copper tubing serves as draining system for cylindrical shaped lauter vessel

STAINLESS STEEL LAUTER-TUNS

A homebrewer with the right resources and friends in good places can fashion a lauter-tun from a stainless steel brewpot or a discarded stainless steel keg. These vessels are fitted with an "out" spout on the side near the bottom, from which extract can flow. Because of the cylindrical configuration of the vessel, straining and draining matrixes can be configured from slotted bent copper tubing in the same manner as described for the picnic cooler configuration, or with a perforated false bottom, similar to the plastic bucket system.

These systems are the most durable and are often fabricated by homebrewers who wish to make 10-gallon batches or who brew more often.

Boiling the Wort

It's the time to really kick back, if you haven't already, with a favorite homebrew. The wort's boiling. The house smells great and there isn't much to do for the next 60 to 90 minutes, except maybe clean the mashing equipment and prepare the wort chillers and fermenters. Regardless, there's time for at least one brew.

There are three essential reasons to boil the wort: (1) to extract hop bitterness, (2) to coagulate and precipitate out haze-forming proteins and (3) to evaporate a portion of the wort when brewing higher-gravity beers.

More effective hop utilization and protein coagulation are achieved with full-volume wort boils as opposed to concentrated malt extract boils.

EXTRACTING HOP BITTERNESS

In order to impart a stable bitter flavor to beer, hop resins must be boiled to dissolve them and facilitate a chemical reaction called *isomerization* that enhances stable hop bitterness in beer. For optimal utilization of hops, the process takes at least 60 to 90 minutes with a vigorous full-wort boil. (Refer to pages 64–65, hop utilization in the kettle.)

The importance of a vigorous, rolling boil for maximum hop utilization cannot be emphasized enough.

PROTEIN COAGULATION

Certain types of proteins can be coagulated by boiling the wort. These coagulable proteins are primarily responsible for haze formation in the finished beer. However, boiling temperatures alone will not coagulate the proteins. It takes the action of the bubbles formed by vigorous boiling for both coagulation and precipitation to occur. Because these proteins are electrically charged molecules, providing a substance that is of opposite charge will enhance the coagulation. Irish moss (carragheen) is a seaweed that, when added in small amounts during the final 10 to 15 minutes of a rolling boil, helps attract coagulated proteins into clumps. About $\frac{1}{4}$ teaspoon (1 g.) of Irish moss is adequate for a 5-gallon batch.

The importance of a vigorous, rolling boil for protein coagulation cannot be emphasized enough.

EVAPORATION OF WORT

The 60 to 90 minutes of boiling will typically evaporate 10 percent of the initial volume. If necessary, this volume can be made up with the addition of water prior to fermentation. Brewers of all-grain strong ales and lagers, however, may need to reduce the volume of the wort by evaporation to achieve targeted initial high gravities.

Evaporation also makes the house smell good to most sensible people.

BOILOVERS

No, the purpose of boiling is not to have boilovers! But they do occur every so often. Watched pots never boil, but unwatched pots boil

over. Watch it and watch out. Care should be taken to *always* leave the lid ajar to reduce the risk of boilover. Never cover a boiling wort with a lid.

CATCH THE HEAT—
BOILING EQUIPMENT

Homebrewers use one of three types of heat sources to boil their wort.

STOVE-TOP BOILING, GAS AND ELECTRIC

Natural gas heating is the most friendly towards homebrewing. It is hot yet does not scorch the malt. Furthermore, because the pot is raised an adequate distance above the flame, the stove is less apt to be damaged by inadequate heat dispersal.

Electric stoves work well for volumes of 4 gallons or less. Wire trivets should be placed between the electric coil and brewpot to prevent direct contact with red-hot coils. The trivet will reduce scorching, caramelization and darkening of the wort. For larger volumes and larger brewpots, use caution: Heat may not disperse into the pot of wort quickly enough, thereby overheating the coils and damaging the stove.

OUTDOOR PROPANE COOKERS

These outdoor burners are ideal for bringing large volumes of liquid to a quick boil. Fire one of these hummers up and you can bring 6 gallons (23 l.) of wort to a boil in less than 15 minutes. Sometimes referred to as "Cajun cookers," these burners are rated as high as 200,000 BTUs and are available at many homebrew supply shops. Less powerful models rated at 25,000 to 35,000 are ideal for more casual firing up of the brewpot and are available at hardware stores.

These burners are also convenient for keeping the heat of cooking out of the house during warm summer days. Because they are fueled by propane, they must be used outside. Propane is heavier than air, and if there are leaks, the gas will migrate to lower areas of homes (like basement open-flame furnaces or water heaters) and

add to the danger of indoor use. The surface upon which the cooker sits must be nonflammable and heat-resistant.

For the more resourceful homebrewer, the heating unit from a discarded water heater makes an effective heat source for brewing. A stand must be built, and the fittings sometimes need to be converted from natural gas to propane.

Extreme care should be taken to keep children away from these cookers. Boilovers are more likely if not carefully monitored during the onset of boiling.

IMMERSION HEATERS

A less than desirable option for efficient wort boiling, these heaters should only be used when convenience dictates or other sources are not available. Electric immersion coils are placed in the wort. Caramelization of the wort and insipid boiling are common with most models.

BREWING KETTLES

A good brewpot is a joy to work with. It contains the wort during a rolling boil, is easy to clean, is affordable and lasts a lifetime. Unfortunately all these attributes don't always find themselves in harmony.

ENAMELED BREWPOTS

This is the kind of brewpot that most beginning brewers use for their first wort. They are enamel-glazed steel pots more commonly used for canning and other lightweight kitchen uses. The enamel is essentially inert and does not react with the acidic wort. However, if these pots develop chips or cracks, the steel is exposed. Wort will react with the exposed metal, contributing to undesirable flavors. With proper care they can last through quite a few brews, but a lifetime? Not. Every few years you will need to buy another. After going through three or four pots, you will have paid the same as if you had bought a stainless steel brewpot—once.

STAINLESS STEEL

Once you've bought one stainless brewpot, you'll never have to buy another, unless you want more of them. Sizes up to 3 gallons (11.5 l.)

are relatively inexpensive and can be quite affordable at homebrew supply shops or department stores. However, when you get to the 5- and 10-gallon (19- and 38-l.) sizes, you're breaking the $100 barrier. For brewing 5-gallon (19-l.) all-grain batches, a 10-gallon (38-l.) stainless brewpot is essential.

A discarded stainless steel brewery keg can sometimes be salvaged and fashioned into a large brewpot. This is a job for your friendly neighborhood welder. Cutting off the top with special saws is no simple home project. Perhaps for a few dollars or a few bottles of beer in trade, you can get yourself a brewpot with handles safely and dependably welded onto the sides, and a lid thrown in for good measure.

Homebrew will get you through times with little money better than money will get you through times with no homebrew.

COPPER

Copper has been used for centuries as a material for fashioning brew kettles. There is often concern expressed that copper will react with wort and taint the beer with toxic amounts of copper. The dangers of using copper to prepare food products lie in alkaline food coming in contact with the metal, which causes copper ions to be leached into food. However, grain mashes, wort and beer are all very acidic in nature. The acidity serves to "passivate" the copper, coating the metal with a thin protective covering of oxide almost immediately.

If copper is ever scrubbed brightly clean, it should be passivated with a weak acid solution before using. Brewers will notice that when wort comes in contact with copper wort chillers, the surface becomes brighter. This brighter copper still has a protective oxide coating and in comparison is nowhere near as shiny as a brand-new copper penny.

Now, where are you going to find a copper kettle that is not soldered with lead-based solder? Beats me. But if you do find one, use it if you wish.

ALUMINUM AND OTHER METALS

Aluminum is rarely used in commercial brewhouse equipment. There are some logical reasons. Structurally, aluminum is not as strong as stainless steel. Caustic cleaning solutions (used in commercial breweries) must never be used to clean aluminum. A chemical reaction producing explosive hydrogen gas will result.

There is no reason why a homebrewer should avoid using an

aluminum brewpot. The effect aluminum metal ions could have on the flavor and character of beer is negligible if it exists at all. The link of aluminum with Alzheimer's disease is inconclusive at this writing. If this risk is a personal concern, you should use your own better judgment.

Cast iron and mild steel should not be used in the brewing and fermenting processes. Iron compounds will create a variety of ill effects on the character of beer.

IMMERSION-TYPE ELECTRIC KETTLES

Available at homebrew supply shops are plastic buckets that are fitted with electric immersion heaters, either 110 or 220 volts. If you have a choice, get the 220-volt model; it will bring your wort to a boil in a reasonable amount of time. The drawback with both models is that they tend to caramelize the wort sugars, which darkens the beer and contributes a related flavor. If you're never going to be brewing really light-colored or delicately flavored beers, these "brew-heats" are easy to use.

Trub and Hop Removal

Both extract and all-grain brewers must remove spent hops before fermentation. Trub removal, on the other hand, is an option many homebrewers overlook. Hops are relatively easy to remove. For homebrewers, the removal of proteinaceous trub is not quite so simple and the relative benefits are debatable, but the potential for improving your homebrew makes it worthy of consideration.

REMOVING HOPS

Hops could simply be removed from the wort by passing the hot wort through a strainer on its immediate way to the fermenter, but simple straining is perhaps wasting an opportunity to remove the trub. More on this subject later.

A convenient method for infusing additional hop aroma and some flavor into the wort is to pass the hot wort and spent hops through a basketlike device to which fresh hops have been added. The basket, called a hop-back, also serves as a straining device for the spent hops. The effect of this configuration is to "hot-wort-rinse" hop oils from these hops. The aroma-producing oils find their way directly into the fermenter, where they add aroma to the finished beer.

TRUB AND ITS REMOVAL

Trub (pronounced *troob*) is mostly a tannin (polyphenol)–protein compound precipitated out of solution during the vigorous boiling of wort or cooling of the wort. Its formation is the direct result of boiling malt (with its proteins) and hops (with its tannins, though malt has some tannins too). The heat and the vigorous boiling action cause precipitation. The trub formed during the boil is called the *hot break*, and trub formed at cooler temperatures, the *cold break*.

There is about three times more hot break than cold break formed, but amounts can vary considerably. About half of the trub is composed of protein. The rest is bittering substances (some hop bitterness is lost to trub), polyphenols (tannins), fatty acids and carbohydrates.

HOW MUCH TRUB?

The amount of trub that will precipitate out of wort is influenced by quite a few factors. In the boil it is desirable to precipitate out as much trub as possible. In all the brewing processes prior to the boil it is desirable to choose ingredients and processes that can minimize trub, whenever the advantages outweigh the disadvantages. Factors that can minimize the potential for trub in wort are: malt quality (poorly modified malt will increase trub), mash filtration (oversparging and pH contribute more polyphenols from the grain husks), grind and mill setting and mash process (decoction mashing will reduce trub in boiling by formation and removal of trub during decoction boiling and mash filtration).

Factors that can maximize trub formation during the boil are: time of boil, density of boiled wort, amount of hops, use of Irish moss, degree of agitation and pH of wort. After boiling, how quickly wort is chilled influences the amount of cold break that precipitates out.

Remember, if the compounds are in solution to begin with and the brewer does not take steps to precipitate them out, the compounds remain in the wort during fermentation and will affect the character of the beer to some degree.

TRUB: ITS INFLUENCE ON FERMENTATION AND FLAVOR

There has been no shortage of research and experiments performed by the commercial brewing industry and brewing schools. Their concerns have addressed the needs of commercial interests and their large-scale (larger than homebrewing) brewing systems and attention to fine differences. More on this perspective later, but for now, let's take a look at some of the conclusions reached.

Fatty acids in trub appear to serve as nutrients for vigorous yeast activity, increasing the rate of fermentation. The presence of trub decreases ester production, but increases fusel oil (higher alcohols) production by yeast. Trub can contribute negative flavor character to beer, darken the color of beer, decrease foam stability and contribute polyphenols that can combine with other compounds to create staling. Trub can also interfere with or suffocate yeast activity when yeast is harvested for reuse, causing slower fermentation.

Interestingly, it was found by researchers at Coors Brewing Company that oxygen had the same positive effect on fermentation rate as trub. When filtered trubless wort was fermented with a normal

amount of oxygen, it took 30 percent longer to complete fermentation than the wort with trub and normal amounts of oxygen. Furthermore, it was found that filtered trubless wort with high oxygen fermented equally as well as trubed wort with low oxygen. From these and other observations the researchers partially concluded that the fatty acids (lipids in particular) in the trub provided the same type of nutrient energy as the oxygen effectively did in the filtered wort.

So what's a homebrewer to do? On one hand trub seems to enhance fermentation, which is just what we want, but it also seems to negatively impact the flavor of the beer. Relax. Don't worry. Have a homebrew. Trub's influence is a relatively minor consideration. Keep in mind that there are many other steps in the homebrewing process that can enhance or inhibit the same effects—to a much greater degree. Keep things in perspective, and when you have the other process variables under control, consider trub and its removal more seriously. Don't worry about it, yet know you can continue to improve and fine-tune the quality of your homebrew.

The consensus in brewing literature encourages the removal of trub. With a homebrewer's needs and considerations kept in perspective, one would be doing very well to remove 60 to 80 percent of the trub. This can be achieved with some fairly simple techniques.

TRUB: HOW TO REMOVE IT

There are three principal methods that the homebrewer can employ to remove trub: settling, filtration and whirlpooling.

Settling of the trub will occur if the wort, hot or cool, is allowed to sit quietly. The settling can be observed in a quiet brewpot or in a 5-gallon (19-l.) glass fermenter of cooled wort. Transfer the top clear layer of wort to another container to separate it from the trub. Maintain sanitary conditions when dealing with cooled wort.

A major problem with transferring clear cooled wort by siphoning or other means is that there is quite a bit of wasted wort, as much as 10 to 15 percent, because even though the trub has settled to the bottom, it is still suspended in fermentable wort. There are other alternatives, so please read on.

Filtration offers a very good means for removing most of the hot break if whole hops are used in the brew kettle. When used as a filter bed through which all of the hot wort must pass, the hops offer a natural means to catch much of the trub. When employing whole hops as a filtration bed in this manner, they mustn't be disturbed once the flow of wort through them has commenced. A simple strainer

doesn't offer a very effective means to collect the hops and utilize them as a filter. The ambitious homebrewer will need to fashion a hop-back. A lauter-tun can serve as a hop-back, but care must be taken to minimize aeration of the hot wort during transfer and to maintain sanitation during the entire process as the wort flows from the hop-back to the fermenters. As an assurance of sanitation, one could bring the filtered wort back to a boil before transferring it to the fermenter.

If you are using hop pellets, this method won't work, but the next one will.

Whirlpooling sets the hot wort into a circular whirlpool motion in a container. The heavier hop and trub particles will migrate to the center of the container because of the forces involved. Take a cup of tea with tea leaves in it and stir the cup in a swirling motion. Observe the tea leaves as they migrate to the center and into a conelike pile. This is exactly what happens to trub and hops in a whirlpool effect.

Commercial brewers and homebrewers with more sophisticated equipment will apply this principle to their brewpot or another tank and remove the wort from the side of the tank through an outlet.

TRUB, WHIRLPOOLS AND EQUIPMENT

With a little ingenuity, homebrewers can use all three principles—settling, filtration and whirlpooling—to their advantage with no more than a minimal amount of simply fashioned equipment. You will need a 3-foot (about 1-m.) length of copper or stainless steel tubing. Bend one end so that it forms a cane shape. Tie on a copper-mesh cleaning pad to the straight end of the tube with some string or twine. This will serve as a partial filter and prevent clogging of the siphon tube-hose you are fabricating. Attach a 4-foot length of siphon hose to the crooked cane end of the tube. Your siphon equipment is ready.

Stir your boiled wort in a vigorous circular motion, taking care to minimize aeration. This will take about 5 to 10 seconds. Replace the lid on the pot and let it sit for 5 to 10 minutes. The wort will partially clear and the hop and trub particles will tend to accumulate in a cone at the center and bottom of the pot. Fill your siphon hose completely with tap water and, while holding your thumb over the end of the hose, carefully place the copper-padded end of the tube in the bottom and side of the brewpot. Let 'er rip. Start the flow of the hot wort into an awaiting other brewpot or two. Be careful to minimize aeration.

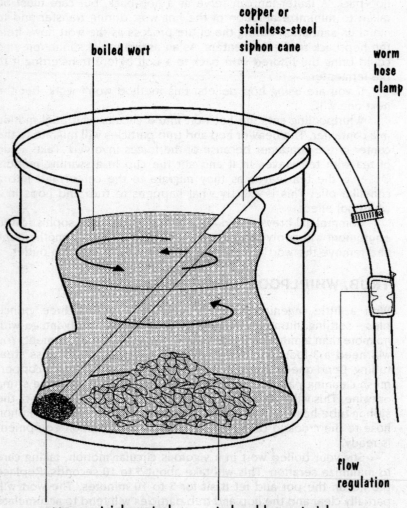

boiled wort

copper or
stainless-steel
siphon cane

worm
hose
clamp

flow
regulation

copper or stainless-steel
kitchen scrub pad tied onto
and of siphon cane prevents
most hops and other material
from exiting

trub and hop material
gather in a cone-like pile
from action of stirred
wort-whirlpooling

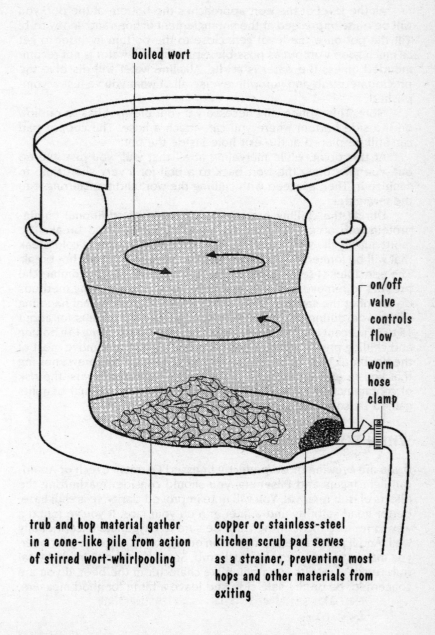

boiled wort

on/off valve controls flow

worm hose clamp

trub and hop material gather in a cone-like pile from action of stirred wort-whirlpooling

copper or stainless-steel kitchen scrub pad serves as a strainer, preventing most hops and other materials from exiting

As the level of the wort approaches the bottom of the pot, you will be quite impressed at the entanglement of hops and gooey trub. Tilt the pot once the level gets close to the bottom in order to get as much good wort out as possible. Sparging with water is not recommended unless the water is acidic. Alkaline water will dissolve the precipitated trub and you will reverse all of what you've just accomplished.

Note: This siphon isn't necessary if your brewpot has an outflow on the side bottom where you can attach a hose. The copper pad can still be placed at the exit hole inside the pot.

At this point, while marveling at all that stuff you just filtered out, you may bring the wort back to a boil for a very short time to sanitize it. Then proceed with chilling the wort and transferring it to the fermenter.

During the chilling process precipitation of additional tannin-protein trub occurs. The precipitate is called the cold break. The more quickly the wort is chilled, the greater the amount of cold break that will be formed. It will be about 10 to 30 percent of the hot break. The principles of settling and whirlpooling are utilized by commercial brewers to remove the trub. However, most homebrewing methods do not offer the sanitary conditions required for additional handling of the wort during cold trub removal. Cold break accounts for about 15 to 30 percent of all the trub material precipitated during the boiling and chilling processes. If efforts have been made to remove most of the hot break trub, then you can relax and have a homebrew knowing that you've eliminated most of the trub. For homebrewers, the risk of contamination may not be worth the relatively minimal benefits gained by cold break removal.

WHEN TO GO THE DISTANCE

If you are brewing those perfectly finessed German, Czech or American light lagers and Pilseners, you should consider maximizing the effects of trub removal. You will note improved clarity, less chill haze, better head stability and a finer grin on your face. If you've found a way to remove most of the trub, be sure to oxygenate exceptionally well. And if perchance you notice an onionlike character in your beer, you may have removed too much trub. Some brewers claim that total trub removal results in an onionlike character in the beer. If you are concerned, be on the safe side and leave a bit in for good measure.

Transferring Extract and Wort

There are several methods of getting the sweet extract or hopped wort from one place to another. Gravity or electric pumps can serve as the power. Hoses, coils, valves and spigots can serve as conveyance. Whatever the methods, there are two very important considerations to always keep in mind. Minimize aeration of hot extract or hot wort. Sanitation of all equipment that comes into contact with cooled wort is of sacred importance.

GRAVITY AND PUMPS

The natural and preferred way to move any liquid in the beermaking process is with gravity. It's cheap and quite dependable. It should be used whenever possible. However, with some brewing systems an electric pump is a preferred alternative for moving liquid from one place to another. The prime considerations for using small pumps in a homebrewing system are that the pump is heat-resistant, that it does not infuse any air or oils into the flow and that its internal components are made of food-grade materials.

SPIGOTS AND VALVES

After hassling with lively and misbehaving siphon hoses, one may be inclined to thoughtfully eye a container, homebrew in hand, and imagine, "Wouldn't it be nice if I could just cut a hole in the side and attach a spigot?" Well, yes, this can work rather nicely, but one must take into consideration a few things.

A spigot does not eliminate the need for hoses. Remember, you must avoid aeration of the hot wort. Once the hot extract or wort exits the spigot, it needs to be guided to the bottom of whatever container it's headed for with a length of hose. The hose's inside diameter should not be so large that it creates bubbles in the flow. As the liquid flows through the tube, it should fill the tube.

Spigots, their accompanying valves and attached hoses are dandy for directing mash runoffs. The flow can be regulated, and concern for sanitation is minimal at this point since the extract has not yet been boiled. If a spigot and valve are to be used to help

Priming a siphon? Not exactly what I had in mind, but it is effective in getting one thing done.

transfer cooled wort or hot wort on its way to be chilled, herein lies a problem. Extreme care must be taken to sanitize the spigot and valve. Passing sanitizer and hot boiling water through them can greatly reduce the risk of contamination, but to minimize the risk even more, the valve and spigot should be disassembled and sanitized thoroughly. Sugars and bacteria from the last time you used the system are enjoying their dormancy in the crevices and interfaces within the valve. Plastic valves offer more of a challenge in that they are prone to scratching and scuffing. Don't underestimate the tenacity of beer-spoiling microorganisms. They want to get at your beer every bit as much as you do. You can relate to that, can't you?

THE SIMPLE HOSE

Hoses used as siphons equipped with external hose clamps are inexpensive and, with practice (more practice = more homebrew; oh, the price of getting it right), easy to use.

Siphoning cooled liquid offers few problems. Siphoning hot liquid requires some creativity as the hose will lose its rigidity, buckle, and pinch the flow of liquid. When siphoning hot liquid or using

a thin-walled hose it's necessary to use a heat-resistant racking or siphoning tube. This is usually a $2\frac{1}{2}$- to 3-foot (0.75- to 1-m.) length of copper or stainless tubing bent to resemble a cane. The hose is attached (a clamp may be necessary for a watertight fit) and you are on your way.

How to start a siphon? Cheese and crackers, there must be a million ways. Here's one simple way. Wash your hands. Sanitize both the outer and inner surfaces of the hose. Coil the hose so that you can hold and control it all with one hand (your left one if you are right-handed). Rinse off the outside of the hose with warm tap water. Fill the hose completely with warm tap water and hold your thumbs on each end. Move away from the sink and uncoil the hose by un-twisting it while keeping your thumbs on the ends. Empty about 12 inches (30 cm.) of liquid from one end of the hose. Insert that end into the wort or beer and start the siphon by directing water into a bucket. When beer starts flowing, temporarily stop flow and direct it to the secondary vessel. This all takes about 37 seconds and elim-inates the need for gargling with vodka and sucking on the hose.

There's a little trick for starting a siphon with a hose and cane. Attach the hose to the cane. Coil the hose. Point the tube straight up and then begin to fill the hose and cane with water. With careful guidance, the water will flow upwards into the cane, overflow and rinse the sanitizer off the outer surface of the cane and hose below. With your thumb on the end of the hose, keep the filled cane pointed upward and, when ready, quickly tip (don't get obsessive about the quickness; relax) and insert it into the hot wort (or beer if you're using a racking cane) and start the flow. If you don't hold the cane upward while filling with water, you will have air bubbles residing in the tube and hose.

Chilling Effects:
Cooling Your Wort

Whether you are a malt-extract, mash-extract or all-grain brewer, the task of cooling boiling-hot wort down to yeast-pitching fermentation temperatures presents itself as an exercise in expediency. The methods range from simple, requiring no additional equipment, to complex, employing sophisticated equipment requiring an initial onetime investment of time and resources and great attention to sanitation. The method chosen depends on whether a full wort boil or concentrated wort boil is employed and whether the brewer has access to water cold enough to facilitate adequate cooling.

THE PRINCIPLES OF WORT CHILLING: WHY AND HOW

The primary reason for cooling wort is to reduce the temperature for optimal yeast activity and fermentation.

It is desirable to cool the wort as quickly as possible to minimize the time the wort is susceptible to contamination. Once the temperature of the wort falls below about 140 degrees F (60 C), the risk of contamination by spoilage microorganisms greatly increases. At temperatures between about 80 and 130 degrees F (27–54 C), most wort- and beer-spoiling bacteria thrive.

Also, a wort cooled slowly over more than an hour may develop compounds that will later result in excessive levels of DMS (dimethyl sulfide), undesirable flavor compounds reminiscent of the taste and aroma of sweet cooked corn. This is a factor when lager malt is used. English pale-type malt and other similarly higher-temperature-kilned malts do not present this problem.

Various methods, techniques and equipment may be used to cool wort. They all employ various means of heat exchange, that is to say, taking the heat away. Let's briefly examine the principles of heat exchange in order to more fully appreciate what's going on and to allow yourself the opportunity for further creativity.

THE PRINCIPLES OF HEAT EXCHANGE

Time for a homebrew. Heat is a form of energy, and your hot wort has a lot of it. You can't make energy disappear, but you can convert

heat energy to a different form of energy, remove it or "dilute" it. Consider heat as an entity. It can travel. ("Cold" does not travel; only heat does.) In order for heat energy to be removed, it must be carried away. Cold water passing through the hot wort by means of pipes or tubes, or surrounding a hot pot of wort, will carry heat away. The cooler water must be moving away; otherwise, the heat removal will stop when that cool water is no longer cooler than the hot wort, because there's no reason for the heat to leave the wort. Got it?

There has to be movement to carry the heat away. It has to go somewhere. Now consider this: The greater the differential (that means "the difference" to nontechy types) between the hot wort and the cooling water, the *faster* the heat will leave your wort. Eventually the hot wort will reach "equilibrium" temperature with whatever it is in contact with. But remember, the greater the difference, the faster the cooling. That's why boiling-hot water will freeze faster than (or as fast as) room-temperature water given the same cooling conditions; and vice versa for ice water and warm water brought to a boil. "No way," you say? Well, try it yourself before you make any conclusions about my sanity. But just to give you an example, 3 cups of 120-degree F (49 C) water will increase 15 degrees F in the same time 3 cups of 65-degree F (18 C) water will increase about 35 degrees F using identical heat sources. (I just did it!)

Commercial breweries use many different systems to cool wort. Some utilize large, shallow "pans" called cool-ships, where the wort fills to a depth of about 1 foot (0.3 m.). These cool-ship rooms are ventilated with sterile air systems. The hot break settles out of the hot wort while cooling to about 160 degrees F (71 C). Leaving the trub behind, the wort is drained and piped to counterflow-type (heat exchanger) wort chillers (discussed below) for cooling to fermentation temperatures. Other breweries will employ whirlpool tanks to receive the hot wort and then direct the hot flow out to a counterflow wort chiller. The system is completely enclosed and requires diligent cleaning and sanitation.

Homebrewers are little people making big beers. Their wort-chilling techniques are home adaptations of the commercial systems.

EQUIPMENT AND TECHNIQUES FOR EXTRACT AND MASH EXTRACT HOMEBREWERS

Sanitary procedures are essential through the 80–130 degree F (27–54 C) temperature range and until the yeast is pitched and begins

to create an environment that inhibits the few microorganisms that find their way into the wort. (Absolute sterilization is impractical and highly improbable.)

CHILLING CONCENTRATED WORTS

For those employing brewing methods that boil concentrated worts, the process of chilling the wort is instantaneous and simple. Hot concentrated wort is passed through a sanitized strainer (sanitize the strainer by immersing it in the boiling wort during the final 15 minutes of boiling) to a fermenter containing adequate cold foundation water to reach fermentation temperature. In warmer climates the natural water source may not be cold enough to facilitate adequate cooling. In this case there are a few options for the homebrewer to consider.

Chill the foundation water in sanitized gallon jugs in your refrigerator. Utilize the cool-ship principle by immersing your covered brewpot of hot wort in cold water for 10 to 20 minutes. This will cool the wort to about 150 to 170 degrees F (66–77 C) within 10 to 20 minutes. It isn't essential to create a flow of water to carry the heat away, though it will speed up the process. Between the two procedures of chilling the foundation water and/or partially cooling the wort, fermentation temperatures can easily be achieved.

FULL WORT BOILS: EXTRACT AND ALL-GRAIN BREWING

With a 5-gallon (19-l.) batch you have all 5 gallons of boiling hot wort to chill. You want to chill it as quickly as possible and give careful consideration to sanitation. Let's consider the simplest ways first.

POT-IMMERSION METHOD

The pot-immersion method requires an investment in a long-handled stainless steel spoon. Use stainless steel because it can be effectively sanitized. Never use a wooden or plastic spoon. You will immerse your brewpot in a flow of cold water, cooling the wort by the principle of heat exchange. Recall that the heat must be carried away. The flow of cold water facilitates this. As well, the hot wort must be stirred constantly for best results; stirring carries the hot wort from the center of the pot to the cooler sides, where the heat is actually exiting through the walls of the pot.

The room where this is done must be draft- and dust-free. Roll up the sleeves of your shirt and wash your hands and arms before hovering over your pot while stirring. You don't need to create turbulent rapids. With careful wort agitation, a slow flow of adequately cold water will drop the temperature to yeast-pitching level within 30 minutes.

The cooled wort may be transferred to the fermenter by ladling with a sanitized saucepan, through a strainer and funnel if necessary. The strainer will remove spent hops (if still present). Aerate the cooled wort well as it splashes into the fermenter or after it is in the fermenter.

USING ICE

If you live in a climate where tap water isn't cold enough to chill your wort adequately, then sanitary methods of cooling with ice during the final temperature drop can be used. Never add ice directly to your wort. Water exposed to the air in your freezer will be contaminated. Add 3 quarts (2.8 l.) of water to an unused one-gallon-size (3.8-l.) Ziploc-type heavy-duty freezer bag. Employ sanitary procedures by double-bagging, inserting one bag inside another in order to protect the surface of the inner bag containing the water. Place the double-bagged water in a paper bag before placing in the freezer to reduce the risk of nicking and puncturing the plastic. Freeze the water solid. When you have reduced the wort temperature to about 80 to 85 degrees F (27–29 C), add the bagged ice. Carefully remove the inner bag of ice from its protective outer bag. Immerse in the warm wort and let sit. Stir occasionally, but take great care to avoid puncturing the bag. Two one-gallon-size bags, each containing 3 quarts of 0- to −5-degree F (−18 to −21 C) ice, should reduce the wort temperature to 70 degrees F (21 C) with the greatest of ease.

If the ice bag method doesn't suit your fancy, you can add 80-degree F (27 C) wort to the fermenter and facilitate further cooling by wrapping the fermenter with a wet towel or large T-shirt. This works particularly well in drier climates and can reduce the temperature of the wort 10 degrees F (about 5 C) below room temperature. It takes a few hours, but a clean wort will wait without suffering too much.

COIL IMMERSION

The next simplest method of wort chilling involves immersing a coil of copper (or stainless steel) tubing into the hot wort. Cold water

flows in one end and out the other end of the coil. The heat of the wort travels through the copper coiling and into the cold water and is carried away.

Copper is easier and less expensive to work with than stainless steel. About 15 to 20 feet (4.5–6 m.) of $\frac{3}{8}$- to $\frac{1}{2}$-inch (0.95- to 1.27-cm.) outside-diameter copper tubing is required. Form a coil by rolling the tubing in an 8- to 10-inch diameter (20- to 25-cm.) cylinder of some kind. (Stainless steel soda canisters [see sections on "fermenters," p. 174, and "kegging," p. 194] work well.) To reduce the risk of crimping the copper tubing while fashioning the coil, you can fill the copper tubing with water and temporarily seal the ends. When the coil is immersed in the brewpot, the ends of the coil must extend up and out of the pot. Bend the ends downwards in a U shape to prevent the attached plastic hoses from crimping. Attach hoses to both ends and secure with hose clamps. You will need to adapt the end of your "in with the cold water" hose to be able to connect with your water source. Adaptors will vary, but you can figure that out.

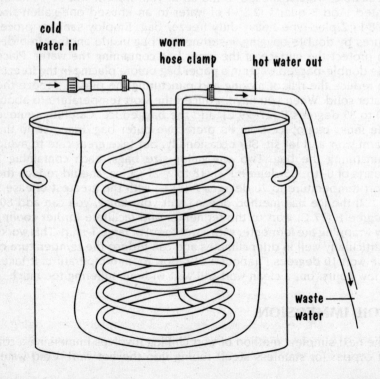

cold water in

worm

hose clamp

hot water out

waste water

When using the coil-immersion method, care must be taken to minimize contamination. Immerse the washed, clean coil and stainless steel stirring spoon in the boiling wort during the final 15 minutes of boiling. This will sanitize the surface. Don't worry about the shinier appearance of the coil; everything is still copacetic.

Place the pot near your sink. Air drafts and dust should be minimal in the room. Roll up your sleeves. Wash your hands and arms thoroughly. Attach the in-hose to your source of cold water. Begin flow, stir the wort constantly and don't sneeze into the wort or scratch your beard (or your nose) while peering into the stuff that will soon be beer. Aerate the wort with agitated stirring once temperatures fall below 110 degrees F (43 C). Monitor the temperature and quit once you've reached 60 to 70 degrees F (16–21 C). Carefully transfer the wort (and spent hops if still in the wort) through a sanitized strainer (sanitize the strainer by immersing in boiling wort during the final 15 minutes of boiling) to the fermenter.

For those living in warmer climates, ice bags or wet towels as explained in the preceding section may be employed to finish reducing the temperature.

COUNTERFLOW SYSTEMS

Requiring more time and/or expense in fabrication, the counterflow chilling system has advantages and disadvantages. This heat exchanger is designed so that hot wort passes through the *inside* of the coils (copper or stainless), while cold water bathes the outside of the coils and flows in the opposite direction of the wort (counterflow), carrying the heat away. Because the wort travels inside the coil, the care, cleaning and sanitation of the coils must be given tremendous attention. Sanitizing solutions are often corrosive, so they cannot be in contact with the copper or stainless for any length of time. The coils, connections and fittings require thorough rinsing with very hot or near-boiling water and must be cleaned before and after each use. It has an advantage in that it is a closed system. If the system is sanitary to begin with, there is virtually no risk of contamination. The system requires that all of the spent hops be removed before the wort enters the system. Gravity (or a pump) can be utilized to siphon hot wort into the counterflow device and out directly into the fermenter.

There are several designs employed by homebrewers, using all types of fittings, adapters, tubes and clamps. Two configurations are presented to seed your mind for more thorough development. The

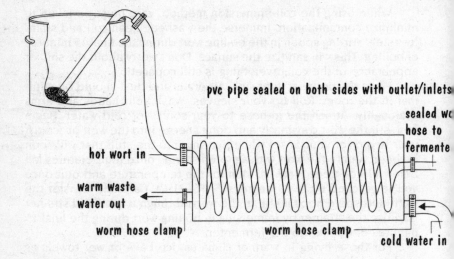

pvc pipe sealed on both sides with outlet/inlets

sealed wo
hose to
fermente

hot wort in

warm waste
water out

worm hose clamp

worm hose clamp

cold water in

copper tubing usually used for these systems is about $\frac{1}{4}$ inch (0.64 cm.) inside diameter.

The garden hose system calls for an approximately 15- to 20-foot (4.5- to 6-m.) length of copper tubing to be inserted into a hose of slightly shorter length. The copper tubing's diameter is smaller than the inside diameter of the hose in order to allow water to flow through the hose and around the tubing. The tubing protrudes 3 to 5 inches (7.5–13 cm.) out either side of the hose ends. The hose-tube is coiled for convenience. Additional short lengths of plastic tubing, T connectors and hose clamps are configured at the ends to allow wort from the brewpot to flow into the copper tubing and exit to the fermenter, while cold water flows in the opposite direction into the hose and out as warm water that can be collected for cleaning or directed down the drain.

Another simple method utilizes ice chilling and is ideal for use in warmer climates where tap water is warm at best. Quite simply, hot wort passes into a coil of copper tubing that is immersed into a bucket or container of ice and water. The water-ice mixture is stirred constantly until the temperature of the cooled exiting wort reaches 70 degrees F (21 C). The flow of wort is temporarily stopped while fresh ice and cold water replace the increasingly warmer water.

Be sure to clean, sanitize, hot-water-rinse and drain these systems before storage. Place a piece of foil over each end to deter homeless spiders and roaches from loitering.

Detail--Attachment to Garden Hose

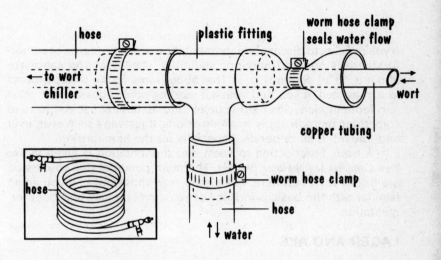

Fermentation

If you're going to discuss beer fermentation with any degree of authority, there is one and only one definitive statement you can make about it: "It all depends. . . . " That about sums up the whole process in a yeast cell. If you find yourself reading other books about yeast and fermentation, don't kid yourself into assuming that you've read something that will apply to all situations. It just ain't so. Never, ever and forever. It all depends. Especially for the homebrewer.

A basic introduction to yeast and fermentation is given in *The New Complete Joy of Home Brewing*. The main points of that discussion are briefly reviewed here, but please read those pages if you aren't familiar with the basic principles of yeast metabolism and beer fermentation.

LAGER AND ALE

Whether you are using ale or lager yeast, the principal factors influencing yeast behavior are:

- The strain of yeast
- Their physical environment
 temperature
 pH
 osmotic pressure (i.e., density of liquid)
 head pressure
- Nutrients and food
- Oxygen
- Good initial health

There is no one perfect "schedule" of fermentation. The variables listed above are only some of the many that influence the life cycle of yeast, how yeast behaves, what compounds it consumes and what compounds it creates on its mission of transforming wort to beer.

BEFORE YEAST METABOLISM BEGINS

There are a number of conditions that will evolve in the wort and with the yeast. Brewers have some control over this evolution, but

160

it is the homebrewer's first task to take a moment or two to have a homebrew and begin to appreciate the essential fact that yeast cells are living organisms and that they are in some ways more evolved than human beings. They can live in beer!

Only after developing this respect for yeast should the homebrewer proceed to consider what can be done to enhance conditions for the happiest and best fermentation.

CHOOSING THE YEAST STRAIN

It all depends . . . on the beer you're making and the fermentation conditions you anticipate. Of the hundreds of flavor-related compounds created during yeast metabolism, most are arrangements of carbon, hydrogen and oxygen atoms. Remember, the food the yeast will convert to beer flavor is sugar, itself chains of carbon, hydrogen and oxygen atoms. The yeast metabolize and rearrange these atoms into hundreds of other carbon, hydrogen and oxygen chains, some of which are classified as

- Esters
- Alcohols (including fusel alcohols or fusel "oils")
- Diketones (including diacetyl)
- Aldehydes
- Organic acids
- Phenols
- Sulfur compounds (not strictly carbon, hydrogen and oxygen atoms)

Every strain of yeast will behave differently and produce varying amounts of these products. And each one is also influenced by the conditions in the wort during fermentations. To highlight only one example out of thousands, studies have shown that the ester level of beer can be influenced by the presence of carbon dioxide during fermentation. The pressure at the bottom of a very tall fermenter is significantly greater than in a small fermenter; the more pressure, the more carbon dioxide remains in solution, thus affecting ester levels. Here's another gem. Research by brewers at Guinness Brewery in Dublin indicates that prior to fermentation, ester levels can be affected by certain situations during lautering. For example, the amount of ethyl acetate esters can be influenced by the degree of filter bed compaction during lautering. Cutting the bed with rakes serves to loosen the bed, releasing more lipids into the wort and consequently suppressing ester formation during fermentation. On the other hand, long, clear runoffs from a compacted grain filter bed will reduce the amount of lipids (all relatively speaking, remember) making their way to the wort and thus tending to encourage ester production during fermentation. "It depends . . . " is an understatement.

There is often concern by homebrewers that some of the above-listed compounds are toxic. Aldehydes, some sulfur compounds, some types of alcohols (fusel alcohols) and esters can indeed be toxic. But toxicity is best defined by dose rather than by substance. The amounts of these compounds that can be naturally produced in homebrewed beer are at very low levels of concentration. One would have to drink two or three gallons of beer having high levels of the compounds every day to even have the remotest effect of toxicity. The "clean" alcohol (ethanol) would have more of an unhealthful effect on your body than any other trace compounds. Besides, any beers having perceptible levels of these compounds are most likely NOT going to be something you'll want to drink a lot of anyway. Much bigger problems can occur with moonshine. The distilling process

concentrates these compounds, raising their levels thousands to millions of times higher than what you'd naturally find in homebrewed beer. By the way, high levels of esters, aldehydes and fusel alcohols are the culprits responsible for headaches and hangovers. Some people are more sensitive than others, and we all are certainly sensitive to abuse by overindulgence.

ADEQUATE YEAST

Too little or too much yeast can affect fermentation. The beginning and intermediate homebrewer should consider the negative effects of underpitching, but certainly not worry about the effects of overpitching. The homebrewer striving for finesse will gain some advantage from knowing a few basics.

If inadequate amounts are used, the respiration cycle will be prolonged, and more reproductive cycles will need to occur to reach optimal yeast population.

If too much yeast is added, there won't be enough oxygen for all of them and on the average they will all be oxygen-deficient, resulting in some negative side effects.

How much is enough? If introducing liquid live yeast, about 6 fluid ounces (177 ml.) of yeast slurry that is the consistency of a thick cream chowder is ideal for a 5-gallon (19-l.) batch. There is little doubt that quality beer can be made if more or less yeast is pitched. Ask any practical homebrewer. But the possibility of making the best beer is increased if proper amounts of yeast are introduced.

AERATION

Once the wort has been cooled, it is essential that it be aerated in order to dissolve oxygen. Yeast must have oxygen to carry out the many tasks expected of it. But the amount of oxygen required varies. . . . It all depends. Generally speaking, though, the required concentration will range somewhere between 4 and 14 mg./l. (ppm). Recall the discussion of trub—you could conclude that if you are removing all of the trub or most of it, then your oxygen requirement will be on the high end of this range. If your trub is carried over into fermentation, then fatty acid/lipids will provide the yeast with compounds that it can synthesize into the energy it would have received from oxygen. Thus your oxygen requirement will be less. These are only two variables to consider. Oxygen requirements will

also vary with yeast strain. If insufficient oxygen is provided, a sluggish fermentation may be observed.

There is a downside to adding too much oxygen. Yeast tends to remain in the respiration cycle for a longer period and continues to reproduce, using more of the fermentable carbohydrates. There may be more undesirable flavor compounds that are produced during the respiration cycle in the finished beer. If the addition of oxygen is continued while the yeast is in the wort, there will be a tendency for the yeast to remain in the respiration stage (or even revert to the respiration stage if oxygen is added during fermentation), reproducing, and producing no alcohol. The flavor compounds resulting from this unnatural process are less than desirable. Some yeast strains do better at this than others, but so far, none have been found that will produce a good-tasting nonalcoholic beer using this process—yet.

When saturated with air at about 60 degrees F (16 C) by shaking, splashing or spraying, wort will pick up enough air to saturate to 8 mg./l. of oxygen. This is usually adequate, especially considering that most homebrewers will not remove every bit of trub. If additional oxygen is desired, then sterile pure oxygen can be introduced to the wort to reach a maximum saturation of 40 mg./l. of oxygen. (This will vary somewhat with wort density. Remember, it depends.) This amount is far in excess of proper levels. It is interesting to note that water at 60 degrees F (16 C) will hold more saturated air than wort at the same temperature, so it is possible to boost the levels of oxygen to some degree (but certainly not to an excessive degree) by adding cold water to the wort. This would be primarily a factor for malt extract brewers to consider. But don't get swell-headed and think you've found salvation. Just have a homebrew and appreciate it for what little it's worth.

YEAST METABOLISM AND FERMENTATION

Once yeast is added to the prepared wort, metabolic activity begins. There are dozens of different cycles that yeast can enter during their residency in wort and beer. There are several excellent references that go into much greater detail than this discussion does.[7] Remember all of these activities and flavor compounds that are produced

[7] Two excellent references are: *Principles of Brewing Science*, by George Fix, Brewers Publications, Boulder, Colorado, 1989; and *zymurgy* special yeast issue 1989, American Homebrewers Association, Boulder, Colorado.

are influenced by the type and strain of yeast as well as the condition of the wort and beer before and during the fermentation process. The general phases of yeast metabolism are:

1) *Lag Time*—A period of a few hours when yeast cells take up oxygen and nitrogen-based nutrients (protein amino acids) from the wort. This period is sometimes considered part of the respiration cycle.

2) *Respiration*—The period when reproduction occurs. Carbon dioxide, water and flavor-related compounds are produced. No alcohol is produced.

3) *Fermentation*—The population of yeast is optimal and the metabolic cycles begin, whereby carbohydrates are converted to heat, alcohols, carbon dioxide and other flavor compounds.

4) *Sedimentation*—Most of the conversion of fermentable carbohydrates is complete. Yeast enter a dormant life-preserving metabolic cycle and fall as sediment.

5) *Aging*—While not an actual yeast cycle, the aging process is a period in which flavor compounds produced by yeast can transform into other compounds, many considered favorable.

SINGLE-STAGE FERMENTATION OR TWO-STAGE FERMENTATION: WHICH IS BEST? AGAIN, IT ALL DEPENDS

Even though one-stage fermentation is the simplest, it should be considered only when the yeast strain you use does not autolyze quickly and impart yeast-bite flavors. Note that cooler fermentation temperatures can reduce the autolyzation process. Choose your yeast strains and fermentation conditions carefully if using single-stage fermentation. Generally if beer can be lagered or aged for short periods (less than three weeks) at below 60 degrees F (16 C), the single-stage homebrewer may be able to brew excellent beer without removing the beer from the primary fermentation yeast sediment. However, if warmer temperatures, longer aging times or sensitive yeast strains are used, two-stage fermentation is needed to optimize the quality of your homebrew.

The two-stage process removes the beer from prolonged contact with the primary fermentation sediment. Long, cold lagering and postfermentation aging require that the beer be moved off any sediment for optimal quality development.

STUCK FERMENTATION

"My beer stopped fermenting before it was supposed to." This is a frantic statement best dealt with by having a homebrew and relaxing. Reading a recipe and assuming things are "supposed to" happen a certain way is not really homebrewing. Homebrewing is what you do and how your beer behaves. And it usually behaves the way *it* is supposed to, not the way a recipe concludes it should. Remember all of the variables. It all depends Most of the time when a fermentation is apparently stuck, it is the result of a wort that is high in unfermentable carbohydrates. If you don't want a beer with such a high finishing gravity, you will have to look at all the variables you can change—the next time.

Sometimes a lack of oxygen or nutrients will result in a stuck, or more likely very slow, fermentation. Starting a new culture of yeast, waiting until it reaches high kraeusen (that is the phase when all the oxygen and nutrients have been taken up, the yeast is energized and the wort is frothy with foam), then pitching it into the stuck fermentation will help, if anything can.

Be careful of foam-over, which occurs if the fermentation is cool and there is quite a bit of dissolved carbon dioxide in the stuck beer. Adding sugar or new fermenting beer with agitation may cause a sudden and messy release of carbon dioxide. Be prepared and cautious.

Some homebrewers will create conditions whereby complete fermentation will occur within 24 hours. It's possible, and you may be fooled into thinking that it prematurely stopped. A hydrometer reading will indicate the status of your brew.

POSTFERMENTATION

A period of cold storage often referred to as lagering enhances the qualities of bottom-fermented lager beers. Cold storage of ales is not as critical a factor in flavor development.

Lagering and Cold Storage

A period of two weeks to several months can improve the quality of lager beers. The temperatures at which beers should be lagered will vary with different styles of beer and with different strains of yeast, though in general the temperature should begin at about 45

degrees F (7 C) and be slowly reduced to 32 degrees F (0 C). During this time several things happen.

1) Remaining yeast cells continue to break down fermentable carbohydrates.

2) The evolution of carbon dioxide purges (scrubs out) volatile undesirable flavor compounds such as hydrogen sulfide (H_2S) and dimethyl sulfide (DMS).

3) Yeast activity can reduce diacetyl levels.

4) Esterification (i.e., more esters are produced) occurs by the combination of organic acids and alcohols. Esterification during lagering is activated by enzymes produced by yeast. (Remember, "it depends"—different strains of yeast will produce different enzymes in various amounts.)

5) Oxygen-reduction reactions occur, affecting the flavor of the beer.

6) Yeast continues to settle out, clarifying the beer.

7) Chill haze is formed at very low temperatures. When beer is lagered for long periods, much of the haze will precipitate and sediment out. Commercial brewers have 10- to 50-foot-high tanks of cold beer for haze to fall out of. They can't wait *that* long, so many of these brewers filter. A 5-gallon fermenter of homebrew at near freezing temperatures can drop out its chill haze in a reasonable time, resulting in clear beer.

An alternative to cold storage for long periods of time would be to bubble carbon dioxide gas through "green" beer for a period. The bubbling will purge many of the green flavors from the beer by scrubbing out the undesirable volatiles quickly. The disadvantage here is not being able to naturally minimize chill haze by allowing adequate time for precipitation and sedimentation.

Ales and Settling Time

Cold lagering is not as necessary with ales. The warm-temperature fermentation will accelerate the evolution and dissipation of undesirable volatiles from the beer. Chill haze is not as serious a consideration if ales are served at their traditional temperatures (about 55 to 60 degrees F [13–16 C]).

Traditional English ale-brewing practices accelerate yeast sedimentation with the addition of isinglass finings. The beer is often served at its best within two weeks from brew day.

Fermentation Equipment for the Homebrewer

One of the most innovative fermentation systems I have ever heard of included the use of a large, 10-foot-deep swimming pool. Tucson, Arizona, is not known for its coolness. In the summer daytime temperatures regularly exceed 100 degrees F (38 C), and during the winter one can count on daytime heat in excess of 80 degrees F (27 C). Going underground is not an option. The geological formations of underlying hardpan rock prevent basements from being a standard home inclusion. Nonetheless, there are many homebrewers in Arizona. Cold beer goes down quite easy among the cactus, mountains and good company.

Air conditioning is quite common, but for some it cannot satisfy the requirements of homebrewing. The logical conclusion for one homebrewer was to don a bathing suit and immerse the fermenting beer in the swimming pool. Carboy, fermentation lock and beer were gently placed under 10 feet (3 m.) of cool water. The brewer reported that checking the fermentation was a pleasure and the rising bubbles were very comforting. A natural Jacuzzi?

AERATORS

Yeast needs oxygen prior to fermentation. An adequate amount of dissolved oxygen is usually introduced into cooled wort as it enters the fermenter, with agitated shaking of the wort (in closed fermenters) or with the addition of cold tap water. However, some circumstances, such as high-gravity brewing, may warrant mechanical introduction of additional oxygen to help assure adequate levels of dissolved oxygen. Pumping ambient air into the cooled wort and allowing it to bubble through is a versatile and economic means of introducing oxygen into wort.

An aquarium (fish tank) aerator-bubbler is a simple and readily available piece of equipment that may be employed for this purpose. The air pumped through this system can be purified by utilizing sterilized cotton as an air filtration medium. Insert a wad of sterile cotton into the tubing through which air flows from the air pump. Commercial filters can also be bought and attached to the system. The sterile cotton may be purchased wherever basic home medical supplies are sold.

To help disperse air into the wort, an aquarium aeration stone can be attached to the hose outlet. Employing tubes and hoses is a convenient way of extending the system into the wort. Whatever method you use, it is absolutely essential that all pieces of equipment be sanitized before being immersed into the cooled wort. For porous material and fixtures with joints, disassembly and heat sanitation with boiling water is the best method to help minimize contamination.

Thirty to 60 minutes of aeration will be adequate to introduce the required oxygen into solution. Never introduce air once fermentation has begun.

FERMENTERS

Brewers use wood, plastic, glass and stainless steel vessels to ferment beer.

Wood. The use of wood has a long tradition in brewing, though it is rarely used today. Older breweries, offering unique products, are usually the exception. For homebrewers, wood should be considered only in the most desperate of situations, such as being stranded on an island in the South Pacific with a supply of water and a pallet of homebrew kits. No one would begrudge you fermenting in wooden barrels. Traditionally speaking, when beer is fermented in wood it

does not usually come in direct contact with the surface of the wood. Brewer's pitch, a tasteless resin, is applied to the inner surface of fermenters, and with a great deal of care, is maintained every few months or as necessary. Fermenting beer in uncoated barrels should only be considered for some of the wilder Belgian styles of beer. Homebrewers have been known to brew excellent Flanders-style sour brown ales and masterfully made lambic-style beers in old sherry casks.[8]

Plastic. Food-grade plastic fermenters are economical and offer the homebrewer ease in handling and cleaning. But their disadvantages eventually leave the homebrewer seeking a replacement after a fair amount of usage. Plastic stains and scratches easily and is more prone to abuse such as being used as a storage container for homebrewery equipment. Scratches, whether visible or invisible to the naked eye, will harbor bacteria and other undesirable microorganisms partly responsible for beer spoilage. However, if plastic is well sanitized (scratches and all) and a good healthy dose of yeast is added under optimal fermentation conditions, the cultured yeast will vastly outnumber any small bacterial populations hanging out in the cracks and crevices in the fermenter. Therefore, one should suspect less-than-ideal procedures when confronted with a spoiled beer that was fermented in plastic.

Open fermentation should never be considered for the homebrewer. The home environment is much more contaminated with spoilage organisms than a clean brewery. In a word: don't. Plastic fermenters should be sealed with an airtight snap-fitting lid. Never, ever use a piece of plastic or towel as a cover. It is a 100 percent guarantee of contaminating the beer. Fermentation locks should be placed in a prebored hole in the lid. The lid should be sanitized, and nothing should come in contact with the fermentation except the hose or racking tube you will use to transfer the beer into its prebottling vessel. Drafty rooms, dusty environments, careless breathing and mucking about, must be avoided whenever the fermentation is exposed to the outside air for transferring or bottling purposes.

When using plastic, single-stage fermentation is recommended to minimize handling. Bottle when visually evident activity has

[8] For further reading see: "Scratch Brewing the Belgian Way," by Michael Matucheski, *Brew Free or Die*, Brewers Publications, Boulder, Colorado, 1991; "The Legend of Wild and Dirty Rose," by Michael Matucheski, *Just Brew It*, Brewers Publications, Boulder, Colorado, 1992; "Scratch Brewing the Belgian Browns," by Michael Matucheski, *zymurgy* magazine, summer 1989.

stopped or after assessing the activity with a hydrometer. Because of the risk of oxidation, the beer should not be kept in plastic for more than a few days after fermentation is completed.

In summary, plastic requires more attention, care and timing during the fermentation process, but can give consistently adequate results for homebrewers who prefer this alternative for one reason or another.

Glass. Glass is one of the most preferred fermenter materials. One-gallon jugs and 2-, 3-, 5- and $6\frac{1}{2}$-gallon (7.5-, 11.4-, 19- and 25-l.) glass carboys offer a number of advantages to the homebrewer. The inner surface is not susceptible to scratching, is chemically resistant to most substances and can be cleaned relatively easily. Perhaps one of the nicest advantages of glass is that you can watch the beer's fermentation activity. Glass is unsafe if handled improperly. Always lift with dry hands. Breakage can cause severe injury. Procedures to avoid pressure buildup in a glass carboy must be taken into consideration. Glass will break if subjected to drastic changes in temperature. Boiling wort should never be added to an empty, cool carboy.

Cleaning a glass carboy is a simple process of filling with cold water and 2 ounces (60 ml.) of household bleach and allowing it to soak overnight. A light brushing with a bottle brush will then remove all fermentation residues. A bottle washer of the type that screws onto your faucet and directs a stream of water upwards is a useful gadget for rinsing glass fermenters.

With experience you will be able to determine when to bottle your beer by simply observing the fermentation activity through the clear glass. As a rule, when fermentation does not produce any surface bubbles and the beer begins to clear and appear darker, it is ready to bottle. The procedure for measuring specific gravity to assure completion of fermentation becomes unnecessary.

Whenever a blow-off fermentation system is employed, it is essential that all particulate material be strained out of the wort before it enters the fermenter. Large-diameter hoses (approximately $1\frac{1}{8}$-inch [2.86-cm.] outside diameter) can be affixed to the opening of the glass fermenter in order to minimize the risk of clogging, pressure buildup and bursting. A simple option to consider when using glass fermenters is to completely eliminate the risk of pressure buildup in a carboy due to a clogged blow-off tube by only filling the fermenter to three-fourths of its capacity. This is essential if fermenting fruit beers in carboys. You may choose to top up to the full volume after fermentation is complete, but do so only with deaerated and sanitized water (boiled and then cooled).

Shove it in. Large-diameter hoses can be affixed to the opening of glass fermenters in order to expel kraeuseing fermentation and minimize the risk of clogging, pressure buildup and bursting more probable with smaller diameter hoses.

Small glass carboys and one-gallon glass jugs offer convenience when brewing small batches or experimental brews. Be especially aware that fermentation activity and possible beer character can be significantly affected by the size and shape of the fermenter. Large commercial operations must consider these variables when scaling recipes and procedures up or down. Perhaps two of the most significant considerations for the homebrewer are the effects of convectionlike circulation currents during fermentation and the effects of heat retention and dispersal during fermentation.

Heat is generated by yeast activity and is dispersed from the fermentation through the walls of the fermenter. Heat transfers to and from the brew in the fermentation room. The efficiency and speed of heat transfer are a function of the ratio of volume to fermenter surface area. What this means is that for smaller one-gallon fermenters, heat

will travel in or out of the brew much more quickly. Detrimental temperature fluctuations are more likely to affect smaller brews, a factor particularly worth considering in homebrewing areas that are prone to temperature changes.

Stronger circulatory currents are set up in larger containers by the action of carbon dioxide production. These actions can affect flocculation, suspension and other activities of the yeast, thus affecting the character of the beer.

The best course of action here is to relax and have a homebrew. Remember—you are a homebrewer, and your beer much more often than not comes out great. Don't worry. Appreciate the many factors that *can* have an effect on the character of your fermentation and the flavor of your beer. Enjoy this diversity and the challenge of considering all this stuff while enjoying the results of your latest efforts. A homebrew in hand is quite helpful in keeping a perspective on your brewing endeavors.

The 200-Year-Old Burton Union "Blow-off" System

World-class top-fermented pale ale has been brewed in the Burton-on-Trent area of England for centuries. A combination of water quality, brewing technique and yeast handling has helped one ale in particular achieve international recognition. Bass Ale, considered by many beer enthusiasts as a world classic, has been brewed with the same yeast for over 200 years. What makes this brew even more distinctive is the method employed for propagating the yeast, known as the "Burton Union System." Not all Bass Ale these days is produced using this method, but modern upgrades to the brewery employ this system in some of its production.

Simply put, the Burton Union System directs the yeast kraeusen-head produced during the initial stages of primary fermentation from the fermenters through a blow-off system into collecting troughs. The very flocculent top-fermenting ale yeast is collected from these troughs and repitched batch after batch, year after year. As the fermenting head is blown off and collected in the system, there are three "phases" of brew that separate in the system. Some of the fermenting wort is allowed to flow back into the fermenters, while the settled yeast is collected by selective channeling of the liquid. The foamy head maintains itself in the "open" system and serves as a barrier between the ambient air (full of contaminants) and the pure yeast below.

The brewers at Bass have determined that yeast harvested from the Union System is not only the purest but also the most healthy and viable. Yeast sedimented out of the fermenters is discarded or processed into other food products.

The Burton Union System is unique and is particularly well suited to the particular strain of yeast that makes Bass Ale.

Not your typical homebrew setup. The same yeast and the same system are still used in some of Bass Ale's breweries, though wooden fermenters are no longer used and modern upgrades to equipment are employed. The Burton Union system is unique and crucial to the survival and purity of the original yeast.

Commercial brewers often have to consider the effect of pressure on the behavior of yeast and fermentation when fermenting in tall two- to four-story-high fermenters. The effect of pressure in small-scale brewing is virtually none.

Stainless Steel. Used by commercial brewers the world over, stainless steel is the preferred material for fermenters. On a homebrewing scale the only serious disadvantage is cost—stainless can be expensive. Stainless vessels do require adaptation before they can be used in the household brewery. Also, care needs to be taken when sanitizing with solutions of household bleach and water as any solutions can cause corrosion.

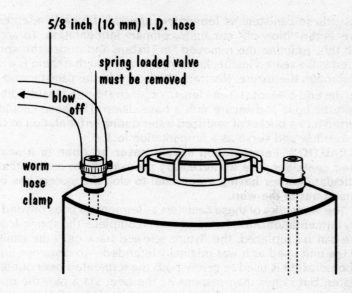

5/8 inch (16 mm) I.D. hose

spring loaded valve
must be removed

blow
off

worm
hose
clamp

Practically speaking, the only reasonable means for employing stainless steel as a homebrewing fermenter is to adapt 2-, 3- and 5-gallon (7.5-, 11.4-, and 19-l.) stainless steel soda canisters for the job. The opening is large enough to allow easy cleaning. There are two fittings on the tops of these canisters. Usually marked "in" and "out," they normally dispense "out" soda (or beer) and take "in" carbon dioxide pressure to push the soda (or beer) out. (Using these canisters as homebrew kegs is discussed in the kegging section.) In order

to use these canisters as fermenters, the "in" fitting is adapted to serve as the "blow-off" stream for primary fermentation. To accomplish this, examine the removed "in" fixture and notice the spring-loaded valve seated inside. Remove this valve so that there is a clear way through the fixture. Reattach the fixture to the canister and slip onto the end a 4-foot (1.3-m.) length of $\frac{5}{8}$-inch (16-mm.) inside-diameter plastic hose and secure with a hose clamp. The hose should be inserted into a bucket of sanitized water during fermentation to catch the overflow and serve as a fermentation lock.

CAUTION: Fermentation should never be done in a sealed, closed container. Use all necessary precautions to assure that all particulate matter having a potential to clog the system has been strained out of the wort.

The versatility of these canisters as fermenters goes beyond primary fermentation. After fermentation is complete, the spring-loaded valve can be replaced, the fixture screwed back onto the canister, and the unit used as it was originally intended—to dispense liquid. Carbon dioxide is used to gently push the fermented beer out of the canister, but rather than dispensing the beer via a tap, the end of the "out" hose is fixed onto the "out" fixture of a secondary canister fermenter. In this manner the beer is pushed from one tank into another, leaving behind most of the sediment. One tip worth considering is to purge the air from the receiving fermenter and minimize oxygenating the beer during transfer by injecting about 10 seconds worth of carbon dioxide. (Carbon dioxide is heavier than air/oxygen.)

In fashioning this transfer system, you may have to shorten the long "out" tube by cutting with a hacksaw. The principles are simple, but there are additional considerations that the brewer must deal with to get the system to work properly. A tank of carbon dioxide with regulators and hoses is necessary, along with extra hose to connect fixtures. Sanitation of all fixtures, tubes, hoses and anything whatsoever that comes into contact with the beer is essential.

If all this weren't enough, you can take the whole system one step further by transferring once again into a final "keg" of beer (more on that later).

CONTROLLING FERMENTATION AND LAGERING TEMPERATURE

Don't immediately assume this discussion is only about maintaining cool lagering temperatures. Some homebrewers need to keep their fermenters from getting too cold.

Whether your goal is to keep your fermentation warm or cold, the essence of dependable, carefree temperature control is a thermostatic device that senses temperature and reacts by switching electricity on or off. These thermostats, complete with sensing probe and switches, are readily available. Devices adequate for homebrewers will generally run from $25 to $50.

KEEPING IT WARM

For homebrewers brewing in Alaska or through a cruel New England or Midwest winter, maintaining warmer ale fermentation temperatures or keeping your lager from freezing can best be accomplished by storing your fermenter in an enclosed insulated area. The heat source can be as simple as a 100-watt light bulb for small areas or an electric heater for a closet space. Shield your fermentation from direct light. Connect your light bulb or heater to a thermostatically controlled device that switches on whenever the temperature drops below a certain point. A spare closet or a large cardboard box lined with sheets of insulating Styrofoam will work quite well, while an unplugged refrigerator can also serve the same purpose while doubling as a cold lagering box in the warmer months.

Recall that fermentation produces heat. To a certain degree a very well-insulated and sealed compartment can hold heat created by vigorous primary fermentation to help maintain ale-fermenting temperatures in extremely cold environments.

Heat tapes used to help prevent pipes from freezing can be wrapped around carboys. Electric blankets or heating pads can also be employed, but be very aware that a more sensitve thermostatic device should be interfaced with the tapes, pads or blankets to regulate when they turn on and off. Fermenters should not be placed on top of pads or blankets for safety reasons. Rather these heat sources should be draped around the area of the fermenters in a manner that easily allows the heat to escape from the pad or blanket.

The temperature of the air is not always indicative of the temperature of the brew. Once you have your system established, take temperatures of the fermentation and the air. Note the difference and adjust your thermostatic controls accordingly.

KEEPING IT COOL

For homebrewers living in more temperate climates, an extra refrigerator will serve perfectly to lager or ferment your homebrew at con-

trolled temperatures. A thermostatic device is simply plugged into the wall. The refrigerator is plugged into its switching device, and the temperature-sensing probe is placed inside the refrigerator. The device can be set for any temperature. Some more sophisticated thermostats can be programmed for a variety of temperatures over extended periods.

Another way to cool your fermentation is to employ the principles of evaporative cooling. This works well in particularly dry climates. When water passes from the liquid stage to an evaporated gas stage, it literally takes a lot of heat energy with it. (That's why when water vapor gas turns to liquid [rain] in a storm, there is a lot of heat energy reversibly released. That in part is what makes a storm.) Homebrewers can employ this principle by wrapping a wet towel (or heavy cotton T-shirt) around a fermenter and letting water evaporate from it. Keep the towel wet and your beer will be no fewer than 10 degrees F cooler than the air temperature. The effect can be exaggerated by blowing air on the wet-toweled fermenters with a small fan.

Wetness can be maintained by fashioning a means of dripping water on the towels or by placing the fermenter and towel in a shallow pan of water. The towel will wick water up as it evaporates.

SUCK-BACK AND FERMENTATION LOCKS

When a fermenter is moved to a lagering environment, temperatures are often drastically reduced. If there is any signficant amount of air space in the fermenter, a vacuum effect will be created as the air in the fermenter is cooled and reduced in volume. If there is not sufficient fermentation gas still being produced by the yeast, then outside air can be sucked into the fermenter. This can create problems if contaminated air is brought into the fermenter or if contaminated water from the fermentation lock is sucked into the brew.

To minimize the risk of contamination by fermentation lock liquid, the liquid can be reduced to a level that cannot be sucked into the brew by the reverse action of the vacuum. The liquid can be replaced with neutral sterile spirits such as vodka just in case there's suck-back. Sterile dry cotton can be stuffed into the fermentation lock passages to act as a filter barrier. If this method is used, it is imperative that the cotton not become wet, otherwise the barrier

will become a wet bullet sucked into the brew. For this reason the fermentation lock should be dry for 24 hours. As equilibrium is reached, pour liquid back into the lock.

With a good lager yeast and proper timing, lagering will continue to produce some carbon dioxide. This will purge any air from the vessel that was introduced through suck-back.

TRANSFERRING BEER FROM HERE TO THERE

There are many reasons to move beer from one place to another. The most important and most obvious transfer is the one from your glass to your lips. But that's the end of the journey. There are several transfers made during the fermenting, aging and bottling (or kegging) process to help assure that the beer's final character is the best.

Usually beer is transferred from one vessel to another to remove it from sedimented yeast and other matter or to move it to a special environmentally controlled container such as a lagering tank. In some breweries and perhaps sophisticated homebrew systems a "uni-tank" system is employed whereby, rather than moving the beer off of sediment, the sediment is removed from the temperature-controlled tank. The bottoms of these tanks are usually conically shaped so that yeast removal is easier. The tanks themselves are jacketed with refrigerant.

Most homebrewers will find themselves transferring beer from one vessel to another. There are three important factors to consider with any transfer system you employ: (1) Avoid the introduction of oxygen during transfer, (2) maintain sanitary conditions throughout the process and (3) avoid sudden and drastic temperature changes in the environment.

Small electric pumps can be used by homebrewers, but as with any equipment, they must be maintained in sanitary condition at all times. The pump should be of the type that will not aerate or introduce air into the stream.

Using a hose siphon is the easiest and cheapest means to transfer liquid from one container to another (see page 150). It is powered by gravity and requires little maintenance other than sanitizing the hose or occasionally replacing it with a new one. There are as many ways to start a siphon as there are homebrewers. Before any method

is used, the number one step that must be taken is to thoroughly wash and rinse your hands before handling the siphon hose. Soap and water and a good rinse will be adequate for homebrewers' purposes.

The outflow from the transferring hose should be directed to the very bottom of the receiving fermenter so that splashing is minimized. The effects of splashing can be virtually eliminated by adding a layer of carbon dioxide to the receiving fermenter. Homebrewers with a carbon dioxide dispensing system can easily add about a 15-second stream of regulated carbon dioxide gas into the fermenter. Carbon dioxide is heavier than air and will layer itself on the bottom of the receiving fermenter. Any splashing will only aerate the brew with harmless carbon dioxide. This method can also be used when transferring beer into kegs. Hey—relax and don't worry if you can't add a layer of carbon dioxide to your receiving fermenters and kegs. Have a homebrew—there are plenty of more important things you can attend to that will make more of a difference.

Carbonation, Conditioning and other Gaseous Matters

PRIMERS

Natural conditioning with the addition of a measured amount of fermentable sugar prior to bottling or kegging is the most common method employed by homebrewers to carbonate beer. Three-quarters of a cup (178 ml.) of dextrose (corn sugar) added to 5 gallons (19 l.) of fully fermented beer will adequately carbonate bottled beer. For kegged brew and draft beer, about $\frac{1}{3}$ cup (79 ml.) of dextrose per 5 gallons (19 l.) will create appropriate carbonation.

All-malt enthusiasts may substitute dried malt extract for dextrose. In this case, the process is called kraeusening. Use $1\frac{1}{4}$ cups (296 ml.) of dried malt extract for bottling or $\frac{1}{2}$ cup (118 ml.) for kegging. Whether dextrose or dried malt is used, priming sugar should be dissolved and boiled for 5 minutes in about 1 cup (237 ml.) of water before adding to the beer prior to bottling.

Malt extract will take comparatively longer to carbonate beer than corn sugar. There is a solid theoretical basis for this phenomenon. Yeast does not require dissolved oxygen to metabolize dextrose, but does require dissolved oxygen or the development of nutritional equivalents to metabolize most of the sugars in malt extract. Neither the fully fermented beer nor the added priming solution contains dissolved oxygen, thus time is needed to develop nutritional equivalents, resulting in slow carbonation. Patience and time are the easiest remedies, but it is perhaps truer to the tradition of kraeusening to expedite a normal bottle fermentation by introducing yeast to a well-aerated malt extract solution and letting it metabolize oxygen for 4 to 6 hours before adding it as priming. An alternative for those using dried yeast would be to simply add some fresh dried yeast to the batch along with the malt extract solution. Dried yeast has its oxygen requirement stored, having taken it up prior to being suspended in its dried state.

BATCH VS. BOTTLE PRIMING

Each has its advantages and disadvantages, though batch-priming methods help assure consistent and contamination-free results.

Batch primers rack (transfer) the finished beer off of any sediment to another vessel to which all of the priming sugar is added and evenly mixed. Bottle primers attempt to add a carefully measured amount of priming sugar to each bottle and bypass the extra transfer.

There are two significant problems that are likely to be encountered with bottle priming: (1) Without being dissolved and boiled in water, granulated dextrose may contain beer-spoiling microorganisms, and (2) a 10 to 20 percent difference would not be visually noticeable, but can have drastic effects resulting in under- or overcarbonation. Until someone produces sanitarily packaged, premeasured dextrose pellets for bottle priming, batch priming is a preferred means of priming.

Other fermentable sugars may be used as priming. Some will contribute unique flavor. The following table shows equivalents.

SUGARS FOR PRIMING: VOLUME MEASUREMENTS OF VARIOUS SUGARS FOR BATCH PRIMING 5 GALLONS (19 L.)

Sugar Type	Bottles	Draft/Keg
dextrose	$\frac{3}{4}$ c. (180 ml.)	$\frac{1}{3}$ c. (80 ml.)
honey	1 c. (240 ml.)	$<\frac{1}{2}$ c. (100 ml.)
maple syrup	$1\frac{1}{4}$ c. (300 ml.)	$\frac{5}{8}$ c. (130 ml.)
molasses	1 c. (240 ml.)	$<\frac{1}{2}$ c. (100 ml.)
brown sugar	$\frac{2}{3}$ c. (155 ml.)	$<\frac{1}{3}$ c. (70 ml.)
cane or beet sugar	$\frac{2}{3}$ c. (155 ml.)	$<\frac{1}{3}$ c. (70 ml.)
dried malt extract	$1\frac{1}{4}$ c. (300 ml.)	$\frac{5}{8}$ c. (130 ml.)

NOTE: Milliliter equivalents are rounded off to the nearest whole number divisible by 5.

FLAT BEER?

If you brew enough, you may encounter the rare batch of beer that does not carbonate. You did add sugar. You did rinse out the sanitizer properly. You did everything correctly. But your beer never carbonated. Without ever finding an explanation, you can salvage your flat beer. You could blend it with carbonated beers at your next party. But more seriously, each bottle can be uncapped and a pinch of dried yeast or a drop or two of rehydrated dry yeast can be added.

Quickly recap and briefly agitate the bottle, store for another few weeks, and in most cases the beer will carbonate.

When particularly strong beers do not carbonate, it may be the result of the yeast's intolerance to alcohol. In these special circumstances wine or champagne yeast can be used to salvage carbonation, if wine yeast was not used for initial fermentation.

"ARTIFICIAL" CARBONATION

Just as some breweries inject carbon dioxide gas into flat beer right before it is packaged, homebrewers with scaled-down techniques can also artificially carbonate their beer prior to or after the beer is packaged. This method is particularly convenient when you need 5 gallons of homebrew tomorrow and you only have 5 gallons of unbottled yet fully fermented, clear beer in your carboy.

To artificially introduce carbon dioxide into your homebrew, you will need a carbon dioxide draft system complete with fixtures. The principle one takes advantage of is that carbon dioxide gas will dissolve into a liquid solution when introduced under pressure. The amount of carbon dioxide that can be dissolved into beer and the level of carbonation that will result are determined by the pressure applied and the temperature of the liquid. Average carbonation levels for most German, American or British styles of beer fall into a range of 2.0 to 2.7 volumes of carbon dioxide. British styles are on the low end of this range, German styles in the middle, and American styles on the high end. By referring to the *Carbon Dioxide Volume Table*, one can choose a desired amount of carbon dioxide and then determine the temperature of the beer and required carbon dioxide pressure.

In practice, after chilling your flat beer, the desired pressure is applied to the keg through the regulator, and the keg is shaken until equilibrium is achieved. If time is short, an extra few pounds of pressure can be applied for quicker dissolution of the gas into the beer. If time is on your side, the correct pressure can be applied and the keg left to sit over a period of a day or two with occasional agitation until equilibrium is reached; i.e., no more gas is heard moving into the cold beer when it is shaken.

Artificially carbonated bottled beer is within the means of the homebrewer who wishes sediment-free or quickly carbonated bottled beer, but the methods are significantly more complex. The beer must be fully carbonated before it is transferred to the bottle. The conditioning method may be natural or artificial. Homebrewers will

Volumes of Carbon Dioxide (CO$_2$)

Pounds per square inch (psi)

Beer Temperature (°F)	0	1	2	3	4	5	6	7	8	9	10	11	12	13	14	15	16	17	18	19	20	21	22	23	24	25	26	27	28	29	30
30	1.82	1.92	2.03	2.14	2.23	2.36	2.48	2.60	2.70	2.82	2.93	3.02																			
31	1.78	1.88	2.00	2.10	2.20	2.31	2.42	2.54	2.65	2.76	2.86	2.96																			
32	1.75	1.85	1.95	2.05	2.16	2.27	2.38	2.48	2.59	2.70	2.80	2.90	3.01																		
33		1.81	1.91	2.01	2.12	2.23	2.33	2.43	2.53	2.63	2.74	2.84	2.96																		
34		1.78	1.86	1.97	2.07	2.18	2.28	2.38	2.48	2.58	2.68	2.79	2.89	3.00																	
35			1.83	1.93	2.03	2.14	2.24	2.34	2.43	2.52	2.62	2.73	2.83	2.93	3.02																
36			1.79	1.88	1.99	2.09	2.20	2.29	2.39	2.47	2.57	2.67	2.77	2.86	2.96																
37				1.84	1.94	2.04	2.15	2.24	2.34	2.42	2.52	2.62	2.72	2.80	2.90	3.00															
38				1.80	1.90	2.00	2.10	2.20	2.29	2.38	2.47	2.57	2.67	2.75	2.85	2.94															
39					1.86	1.96	2.05	2.15	2.25	2.34	2.43	2.52	2.61	2.70	2.80	2.89	2.98														
40					1.82	1.92	2.01	2.10	2.20	2.30	2.39	2.47	2.56	2.65	2.75	2.84	2.93														
41						1.87	1.97	2.06	2.16	2.25	2.35	2.43	2.52	2.60	2.70	2.79	2.87	2.96													
42						1.83	1.93	2.02	2.12	2.21	2.30	2.39	2.47	2.56	2.65	2.74	2.82	2.91	3.01												
43						1.80	1.90	1.99	2.08	2.17	2.25	2.34	2.43	2.52	2.60	2.69	2.78	2.86	2.96												
44							1.86	1.95	2.04	2.13	2.21	2.30	2.39	2.47	2.56	2.64	2.73	2.81	2.90	2.99											
45							1.82	1.91	2.00	2.08	2.17	2.26	2.34	2.42	2.51	2.60	2.68	2.77	2.85	2.94											
46								1.88	1.96	2.04	2.13	2.22	2.30	2.38	2.47	2.55	2.63	2.72	2.80	2.89	2.98										
47								1.84	1.92	2.00	2.09	2.18	2.25	2.34	2.42	2.50	2.59	2.67	2.75	2.84	2.93	3.02									
48								1.80	1.88	1.96	2.05	2.14	2.21	2.30	2.38	2.46	2.55	2.62	2.70	2.79	2.87	2.96									
49									1.85	1.93	2.01	2.10	2.18	2.25	2.34	2.42	2.50	2.58	2.66	2.75	2.83	2.91	2.99								
50									1.82	1.90	1.98	2.06	2.14	2.21	2.30	2.38	2.45	2.54	2.62	2.70	2.78	2.86	2.94	3.02							
51										1.87	1.95	2.02	2.10	2.18	2.25	2.34	2.41	2.49	2.57	2.65	2.73	2.81	2.89	2.97							
52										1.84	1.91	1.99	2.06	2.14	2.22	2.30	2.37	2.45	2.54	2.61	2.69	2.76	2.84	2.93	3.00						
53										1.80	1.88	1.96	2.03	2.10	2.18	2.26	2.33	2.41	2.48	2.57	2.64	2.72	2.80	2.88	2.95	3.03					
54											1.85	1.93	2.00	2.07	2.15	2.22	2.29	2.37	2.44	2.52	2.60	2.67	2.75	2.83	2.90	2.98					
55											1.82	1.89	1.97	2.04	2.11	2.19	2.25	2.33	2.40	2.47	2.55	2.63	2.70	2.78	2.85	2.93	3.01				
56												1.86	1.93	2.00	2.07	2.15	2.21	2.29	2.36	2.43	2.50	2.58	2.65	2.73	2.80	2.88	2.96				
57												1.83	1.90	1.97	2.04	2.11	2.18	2.25	2.33	2.40	2.47	2.54	2.61	2.69	2.76	2.84	2.91	2.99			
58												1.80	1.86	1.94	2.00	2.07	2.14	2.21	2.29	2.36	2.43	2.50	2.57	2.64	2.72	2.80	2.86	2.94	3.01		
59													1.83	1.90	1.97	2.04	2.11	2.18	2.25	2.32	2.39	2.46	2.53	2.60	2.67	2.75	2.81	2.89	2.96	3.03	
60													1.80	1.87	1.94	2.01	2.08	2.14	2.21	2.28	2.35	2.42	2.49	2.56	2.63	2.70	2.77	2.84	2.91	2.98	3.03

Draw a line straight across from the temperature of the beer to the desired volumes of CO$_2$ then straight up to find the correct psi of your regulator.

begin with a kegged container of chilled and fully carbonated beer and then transfer the beer to bottles under pressure. Pressure is maintained throughout the transfer system of hoses, tubes and the "counterpressure" bottling gadget so that the carbonated beer will not release any of its dissolved carbon dioxide. The system is referred to as a counterpressure system because the gas pressure exerted by the carbon dioxide in the beer is countered by artificial carbon dioxide pressure from a regulated carbon dioxide source.

The counterpressure bottling device is first placed atop a sanitized bottle, temporarily sealing it with a rubberlike stopper through which gas or liquid can enter or escape. The first step after temporarily sealing the bottle is to purge air out of the bottle by allowing carbon dioxide to flow in and displace the original air by exhausting it. This is accomplished by opening and closing different valves. After the air has been evacuated from the bottle, a valve is shut and carbon dioxide is allowed to continue entering the bottle under a pressure equal to that of the kegged beer, thus pressurizing the bottle at a pressure equal to the pressure of the kegged beer. Next a valve is opened, allowing beer to flow into the bottle, but because of equal pressure in the bottle and keg, there can be no flow until the carbon dioxide in the bottle is slowly evacuated (as the original air was) by opening a valve. Beer slowly flows into the bottle to the desired level. The vent and beer flow valves are shut, the device is removed and the bottle is quickly capped.

The operation is much simplified when four hands are employed. Safety glasses should always be worn when operating this device because of the risk of an imperfect bottle bursting under pressure.

If you have time to consume, an idle mind and the hankering to try something different, counterpressure bottling may suit your homebrewing hobby. Hand-operated counterpressure devices can be purchased for as little as $40.

THE ZEN OF BOTTLING

Most homebrewers consider themselves slaves to bottling when it comes time to package homebrew. Bottling can be a time-consuming chore, requiring extensive preparation time and scheduling, but it doesn't need to be. It can be a procedure as spontaneous as having another beer, taking less than an hour of your time.

When to Bottle

Until you feel in touch with your fermentation, the trusted hydrometer will continue to give you a true indication of when to bottle. If you've

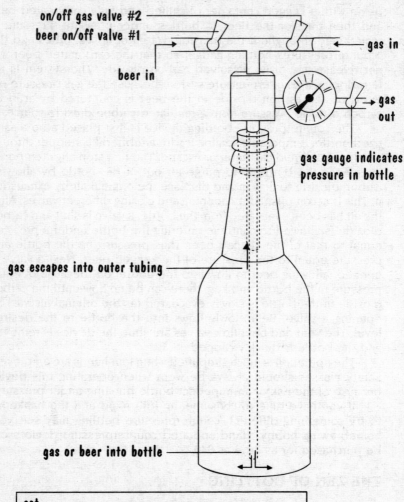

on/off gas valve #2

beer on/off valve #1

gas in

beer in

gas out

gas gauge indicates
pressure in bottle

gas escapes into outer tubing

gas or beer into bottle

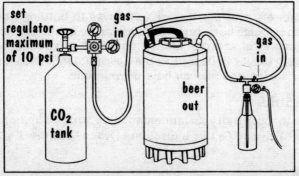

set
regulator
maximum
of 10 psi

gas
in

gas
in

beer
out

CO_2
tank

brewed and bottled enough times, you will begin to realize that beer is ready to bottle when it appears a certain way. Easily observable in glass fermenters, an apparent darkening of the brew brought on by clarification and the cessation of bubbles are accurate indications that your beer is ready to bottle (or cold lager). Hydrometer readings should be taken and recorded during the bottling process, but visual observation can serve well to indicate when the brew is ready to bottle. Practice and confirm with regular hydrometer readings until you are confident about making these judgments.

Preparing the Bottles

Contrary to the methods you may have been employing, all of your empty bottles should be ready to be filled with beer within a few moments' notice. How can this possibly be?

Between batches of beer, while the beer is fermenting and you have leisure time, take the opportunity to immerse your beer bottles in a 10- to 15-gallon (38- to 57-l.) clean plastic trash can to which about $\frac{1}{3}$ cup (79 ml.) of household bleach and nearly a total volume of cold tap water have been added. It's a mindless task perfect for soothing a stressed mind numbed from a day's work. It will take all of 5 minutes to totally immerse two to four cases of empties in the sanitizing solution. Let soak overnight or until you are in the mood to take the next step. This could be days or weeks later. Take about 15 minutes to drain each bottle (do not rinse) and affix a piece of aluminum foil atop it. Place the bottles in their boxes and store for weeks, months or years until ready to use. Meanwhile immerse another round of empties in the pail and repeat only when you're good and ready. You'll find that the bottles will be sparkling clean, with stubborn stains vanished. If a particular bottle doesn't come clean, discard the bottle as it isn't worth your valued time. Rubber gloves should be considered to protect your hands from the drying effects of the bleach solution.

When you've decided to bottle, simply remove the foil and give the bottle a quick rinse with hot tap water. A homebrew-type bottle rinser will complete this step in 3 seconds, enabling you to prepare and bottle 5 gallons (19 l.) of beer as well as clean up within one hour.

Dishwashers are not recommended for cleaning because they are comparatively high energy users and may not remove stains and bacterial deposits inside the bottles. There are other sanitizing chemicals that can be substituted for bleach, but they should be tested

against the stain-removing capabilities of a dilute household bleach solution.

Iodine-based sanitizers are available and commonly used in the dairy industry and by many breweries. They are effective sanitizers. When diluted with water in proper proportions, they may be used to sanitize equipment without subsequent rinsing. However, the correct sanitizing proportion of $12\frac{1}{2}$ parts per million (titratable iodine) represents very low concentrations and must be carefully measured. If concentrations exceed the recommended limit, the iodine residue will give beer an undesirable iodine flavor and will be toxic to yeast. A drawback of iodine-based sanitizers is that they stain equipment a yellow-orange color very easily, a stain that's almost impossible to remove.

Moving the Beer and Air Space

As discussed earlier, care should be taken to minimize aeration and oxygen uptake whenever transferring beer. To minimize the detrimental effects of oxidation in bottled beer, reduce the air space, which will reduce the amount of oxygen in the bottle. A half-inch (13-mm.) air space is perfectly all right for all bottled beer.

The magical 1- to $1\frac{1}{2}$-inch (25- to 38-mm.) air space that we've become so accustomed to seeing in commercially bottled beer is little more than the space dictated by high-speed counterpressure bottling machines. As commercial beer undergoes the counterpressure process of bottle filling, there is a brief moment in the assembly line when a filled bottle of beer is open to the air. It is during those split seconds that a needle-thin stream of sterile water is injected into the bottle. The agitated beer foams over perfectly, evacuating the space with carbon dioxide gas released from the beer. A light tap on a bottle can produce the same effect. The bottle is capped as the "fob" barely oozes over the lip. When the foam subsides, there is "that air space."

A small amount of air space is required for proper bottle conditioning, while excessive air space increases the risk of the explosive effect of overcarbonated bursting bottles.

Bottles and Bottling Equipment

Green, brown or white, long-neck, stubby, returnable, not returnable, twist-off or not, champagne, glass or plastic, capable or swing-top. There you have it. Are these variables worth considering, and will they affect the character of your beer?

BOTTLE COLOR

Your choices will be brown, green or white (clear). Brown bottles are the only type of bottle that offers any reasonable amount of protection from damaging strong light. When beer is allowed to sit in direct sunlight, a photochemical reaction takes place among the bitter-flavored hop molecules. It happens in less than a minute, and it smells and tastes like a skunk (polecat) smells. It isn't toxic, but it does detract from the flavor, for most people. Commercial brewers cannot control how their beer is handled, and if it sits on a store shelf among the artificial lights for extended periods of time, the beer will become affected. Green bottles and clear bottles do not afford any protection whatsoever against damaging light.

As a homebrewer, you have the choice of relaxing, not worrying and having skunk-free homebrew—from any colored glass bottle. There is no reason to even think about getting paranoid during the bottling process. Artificial light takes days and sometimes weeks to have an effect, if any at all. From your carboy into your bottles and into closed boxes in the quiet of your basement, storeroom, garage or domestic cave, you've got complete control from bottle to glass. Don't hesitate to use whatever is convenient in terms of colored glass. Only if you plan on entering your beer into competitions should you consider bottling exclusively in brown bottles.

SIZES, SHAPES AND LIFE-STYLE

With proper batch priming, virtually any kind of bottle that has already had beer in it is fair pickings for recycling with homebrew. It is possible to use twist-off glass beer bottles, but one should seek

twist-off-type caps to cap them. These special caps may not look much different, but they are thinner, and the more malleable metal is able to conform to the top of the bottle more easily. Regular caps work all right, though the occasional poor seal may result. The action of your bottlecapper will seal either cap to the extent that you probably won't be able to twist off the cap of your homebrewed beer.

Certain types of champagne bottles are well suited for homebrewed beer. All champagne bottles are usable, but some of the more expensive types require a larger bottlecap than is readily available in America. You can always wire down a plastic champagne cork at considerably more expense than a bottlecap, but if you can afford that kind of champagne, then the expense shouldn't matter.

PLASTIC

A very convenient alternative for homebrewers is plastic PET bottles (the kind soft drinks are commonly packaged in). Commonly available in Canada, these bottles are "capped" with a reusable (a few times) plastic screw-on top, bypassing the need for a bottlecapper. The plastic is food-grade, light, easily sanitized, unbreakable and particularly well suited for traveling. Over time, oxygen will slowly permeate through the plastic into the beer, but one to three months at cool temperatures with homebrewed care seems to have very little effect on the stability of beer. Aged barley wines and doppelbocks would do better in glass.

There are many laws of this universe. One of them is Boyle's Law, which has to do with the observation that gases will seek equilibrium in the environment they are capable of inhabiting. What this all means to a PET bottler (and to bottlecappers as well) is that though there is pressure in a bottle of beer and it seems that because of that outward pressure, no air would ingress into the beer, it doesn't happen that way. Why? Because the outward pressure is created by only carbon dioxide gas. There is no oxygen gas inside the beer pushing outward; consequently, it's as though the oxygen sees a void and thus it makes its way in, slowly. There is a very small amount of air ingress through the seal of a bottlecap as well.

But don't worry.

SWING TOPS

Commonly referred to as "Grolsch-type" bottles, these wired porcelain swing-top beer bottles are a great convenience for homebrewers.

Swing top bottles are particularly convenient while driving elephants through the deepest of jungles. During my research and over rougher parts of the trail I found that bottles could be sealed without spilling a drop. Warning: Don't feed the elephants.

The caps are outlawed in some states, including California, due to the detrimental effect porcelain has on the glass recycling kilns. The porcelain tops are being replaced with molded plastic, and happily, swing tops are still available.

These bottles must be sanitized just as any beer bottle, with special care to assure that the gasket-seal is in good condition and sanitized as well. Removal and sanitation of the gasket is added insurance against contamination, though usually not necessary if the bottles are immersed in sanitizing solution for any length of time.

BOTTLECAPS

There are several types of bottlecaps available on the market. They all may be used for homebrewing with complete confidence. All are

lined with a plastic material to help assure a proper seal. The lighter-gauged twist-off caps already discussed help assure better seals on twist-off bottles. There is one special type of cap worth considering called a Pure-Seal[tm] Cap. Its advanced inner liner creates a better seal against air ingress and also absorbs oxygen in the bottle. It is activated by moisture and best stored in a cool, dry environment. It seems especially perfect for those potentially old barley wines, strong ales and doppelbocks. Their cost is more than regular caps, but at least you have the choice.

CORKS

The bottlecap was invented a mere 100 years ago. Closures such as the swing top and cork were most often used. Some commercially available traditional French and Belgian ales are still corked to this day. Wine corks and hand-operated "corkers" are available through most homebrew and winemaking supply stores. Corks can be sanitized to some degree in grain alcohol or high-proof vodka, though because of their porous nature, alien characters may develop in your beer. A musty, earthen, cellarlike character will often develop in corked beer. This may be desirable or undesirable depending on your personal preference. (I find it to add a wonderful and desirable complexity to strong ales.) A well-brewed, clean beer should not be otherwise drastically affected.

Because of pressure, corks should be wired down with bottle wires available at many home wine- and beermaking supply stores. Champagne bottles are best suited for corking. It is also helpful to drip hot melted wax on the crown of the cork, once inserted. This will help prevent the cork from drying out and losing its seal. For those beers you intend to age, you can still affix a bottlecap over the cork.

BOTTLECAPPERS

There are all manner of bottlecappers. Usually the more expensive they are, the more you are likely to enjoy the process of bottlecapping. Though more affordable than bench-style cappers, two-handed lever cappers are sometimes awkward to use and are prone to snapping the tops off of bottles, especially thin-walled bottles.

Hammercappers should be used as a last resort. If you don't know what I'm talking about, good—you don't need to know.

When choosing a good bench capper, you are investing in a lot of

hassle-free bottling sessions and more time to enjoy your homebrew. Choose one that adjusts easily to all sizes of beer bottles and your standard champagne bottle. Though not as easy to find and in short supply, the antique models often found at flea markets are some of the best-designed cappers available. Keep your eye out for that perfect capper.

Kegging and Draft Equipment

The most obvious advantage that kegging has over bottling beer is that there aren't any bottles to wash. An additional, not quite as obvious, advantage is that properly kegged beer is less prone to oxidation. The air-space-to-beer-volume ratio is much smaller, reducing the effects of oxidation. Kegged beer—if stored properly—will keep its fresh character for a longer period.

Kegged beer and draft systems are a real treat for those with the resources of space and money to assemble all the necessary equipment to make it happen.

A few disadvantages are worth considering. It is far easier to take a few bottles of assorted homebrew to your friend's party or dinner event. Giving bottled beer as a gift is easier to cope with than giving kegs! Then there's the cost of setting the system up, but if that is not an obstacle, there are several convenient and pleasurable options available to homebrewers. The most common systems (brewery kegs, soda canisters and plastic "beer balls") are reviewed in *The New Complete Joy of Home Brewing*.

SOME SAFETY AND QUALITY-ASSURANCE CONSIDERATIONS

Before disassembing any beer keg for cleaning, *always* take great care to release all pressure from within the keg. If you are sure you've already done this, check and do it once again. The explosive force of flying keg parts as they are loosened can be lethal. If there is any beer or sediment left over along with pressure, you could also be a prime target for a full-body beer soaking, never mind having to repaint the walls.

The majority of stainless beer kegs and soda canisters used by homebrewers are secondhand. Valves, seals and gaskets wear out and fail. To help assure yourself of a perfectly conditioned keg of beer, check all seals, valves and gaskets by adding 5 pounds of carbon dioxide pressure to the just-primed and kegged beer. Work up a good lather of soap and water and smear this lather over all seals

and joints. As if you were looking for a leak in a bicycle inner tube, look for air bubbles. The smallest pinhole will result in flat, uncarbonated beer. If you do discover a leak, release all the pressure and attempt to reseat the fixture or seal. Reapply pressure and check again. Keep spare parts on hand to replace worn-out fixtures.

SEDIMENT-FREE DRAFT BEER

There are times when sediment-free draft beer is an option of choice, particularly when you will be traveling into the wilderness for days with only draft homebrew to sustain the spirits.

Sediment-free draft beer can be achieved in two ways, one of which was explained in the section dealing with artificial carbonation. A more natural method is not only very simple but inexpensive. A naturally conditioned sedimented keg of beer can be chilled (the closer to freezing, the better) and transferred from one keg to another by means of attaching the outflow fixture to the outflow fixture of an empty keg. Before the transfer, the empty keg is sanitized and purged of air by running carbon dioxide gas into the "out" valve. The tube inside will direct the gas flow to the bottom of the keg. As you release pressure from the "in" valve, air is evacuated and replaced with carbon dioxide. Similarly beer is pushed out of the full keg with carbon dioxide and into the "out" valve to the bottom of the awaiting keg. Releasing pressure from the "in" valve or safety release will allow the flow of sediment-free beer into your new keg. All that is required is an extra short hose and one extra valve fixture.

"ON DRAFT"—DISPENSING BEER

Having to walk to where your keg of beer is located is good exercise. It'll help keep you in shape. Now, why would I mention something like that? If you really get swept away with this hobby of homebrewing, things are likely to get a bit out of hand. It wouldn't surprise me if there is someone, somewhere out there, who has all his or her cold beer stashed in the basement with beer hoses running from a draft system to a bedroom headboard, a bathtub or shower stall, the kitchen, the living room, dining room and patio. It's all quite possible, and whenever homebrewers and possibilities intermingle, well . . . Need I say more?

Yes, much is possible, but when your beer lines are long, you'll need to be a bit more scientific and understand how keg pressure can be compromised with flow resistance, gains or losses in elevation,

Canoe Brew? Sediment-free three-gallon stainless steel kegs are perfect for wilderness canoeing and those long portages. Using a hand pump to dispense the beer, I found that Canoe Brew made evenings perfect even when the fish weren't biting. Pack it in and pack it out—they're ecologically smart, watertight, and float when empty!

temperature changes and a lot more. If you keep your beer lines short and dispense your beer within 3 feet (1 m.) of the source, then the dynamics of pressure, flow and resistance need not be seriously considered. But here are a few tidbits of information to prime your thoughts if you ever consider putting together an elaborate draft system that runs throughout your castle, or if you want to appreciate the problems a tavern or bar has to deal with when installing a draft system.

- The hose through which beer flows will create varying resistance to flow depending on the inside diameter, hose material and length. Increased resistance requires more pressure to push the beer from the keg through the hose and into your glass.
- An increase in elevation from the keg to the tap will create resistance to flow and require additional pressure to push the beer through the lines.
- When the pressure required to push the beer through the beer lines is more than the ambient pressure within the keg, then additional carbon dioxide is forced into the beer. The beer gains carbonation. Beer can lose carbonation if the reverse is true.
- The ambient pressure inside the keg is affected by how cold the beer is (refer to the Carbon Dioxide Volumes table on page 184).
- If the beer lines are long and not insulated, beer can be warmed on its journey to the tap. Warmer beer releases carbon dioxide much more quickly and becomes overcarbonated or foamy.
- Unfortunately relaxing and drinking lots of homebrew will not help you figure out how to put together a sophisticated system, but referring to other sources of information and doing a little scientific homework will. Here are several references that go into greater detail: "Setting Up Your Home Draft System," by Dave Miller, *Just Brew It!*, Brewers Publications, Boulder, Colorado, 1992; "Principles and Characteristics of Beer Dispensing," by Elton Gould, *The New Brewer*, volume 5, number 4.

The simplest of home draft systems requires a spare refrigerator, a carbon dioxide system (tank and regulator), a gas line with a fixture to attach to the keg, and a beer hose with a tap on one end and a

fixture to attach to the keg. Holes can be drilled through the walls of the refrigerator to accommodate hoses carrying pressurized carbon dioxide in and beer hoses out to a tap.

A less sophisticated method requires no adaptation of the refrigerator. Carbon dioxide can be applied only as needed to dispense a desired amount of beer. Simply open the refrigerator door, connect the tap line to the keg and serve yourself. Add carbon dioxide if necessary. When you are using this method and are finished pouring for the day, top off your keg with about 10 pounds of pressure so that carbon dioxide is not lost from the beer when it attempts to equalize pressure in the air space in the keg.

If you have several kegs of homebrew on tap, a carbon dioxide manifold is a handy device to employ. It allows you to split the gas lines and direct carbon dioxide from one tank to several kegs of beer at one time.

Serving cold beer from a warm keg can be done by means of a "jockey box." It allows you to chill only the beer that is actually being poured, saving energy or allowing for a quick and immediate chill. From a room-temperature keg, beer is pushed with carbon dioxide through a hose leading into an insulated box or chest. (Picnic-type coolers work well.) Inside the chest the hose is connected to a length of coiled copper or stainless steel from which the beer flows into a beer tap emerging from the side. Beer is chilled by means of ice and water inside the chest and surrounding the coils. Instant cold beer. Replace ice as needed.

Whenever using carbon dioxide gas for dispensing, *always use a properly functioning regulator*. Unregulated pressure can blow a keg and cause fatal injury. As a safety precaution always turn the gas source off when it is not in use. Leaks can create their own hazards; carbon dioxide is heavier than air and can snuff pilot flames in water heaters and cause asphyxiation.

How long will a keg of beer last? If you dispense with carbon dioxide and have brewed a clean beer, homebrewed beer can last for several months and even a year, but only if you don't consume it in a hurry. The carbon dioxide does not hasten the deterioration of the beer, though with time the beer will naturally age and flavor character will change. For some styles of beer this may be desirable, while for others it may not.

If a carbon dioxide system is not practical or available, draft beer can still be enjoyed by pushing the beer out of the keg with a hand pump. Air is forced into the keg, and beer forced out. This method of dispensing beer is completely adequate as long as the beer is properly chilled and you plan on finishing the keg within the day.

Beer will not maintain proper carbonation or its freshness when air is introduced. Air contains spoilage organisms that will eventually turn the beer sour over a matter of a few warm days. But prior to spoilage, much of the carbonation will be lost. Why? Even though you are putting a lot of air pressure into the keg to push the beer out, the beer does not "see" much carbon dioxide gas in the air. There is no carbon dioxide pressure being forced onto the beer and forcing the carbonation to stay in the beer. Even though there is pressure to force beer out, the beer's carbonation "instincts" see no pressure, so it equalizes the dissolved carbon dioxide pressure with the gas carbon dioxide pressure and slowly loses carbonation as the air space gets larger and you and your friends drink more homebrew. Hand-pumped homebrew is best served at colder temperatures.

AT THE TAP

When dispensing beer from a home tapping system, pull the "throttle" out full, even if your beer tends to be overcarbonated. Opening the tap partway only serves to agitate and spray the beer out, and much carbonation is lost. Pouring flat beer from an overcarbonated keg seems contrary, but it happens if you choke the throttle. You're better off pouring a full pitcher at full throttle and letting the foam subside. If you encounter an overcarbonated keg, you can reduce the carbonation by releasing carbon dioxide gas pressure from the safety release (on some kegs) or from the "gas in" valve. Release pressure every few hours or once a day until you can dispense beer with a reasonable amount of carbonation.

Five to 15 pounds per square inch of pressure is a normal range of regulated carbon dioxide pressure with which to dispense beer. Applying more than that may create overcarbonation or too vigorous a flow from the tap.

Your beer hoses and taps should be cleaned regularly. Run hot water and sanitizing solution through them. A perfectly good keg of beer can pick up moldy and sour flavors from its quick trip through dirty beer lines.

WHAT ABOUT THAT CREAMY GUINNESS HEAD?

It's the gas! For those of you who have ever had the pleasure of draft Guinness Stout, you can appreciate what a thick, creamy head really can be. Almost whipped cream or meringuelike, the head on draft Guinness Stout is created by injecting a mixture of nitrogen (N_2) and

carbon dioxide gas into the dispensing system. Nitrogen gas, when mixed with beer and agitated, creates very tiny bubbles. Because of the laws of physics, molecular behavior and surface tensions, these bubbles of nitrogen and carbon dioxide break down very slowly, hence the long-lasting, dense head on draft Guinness.

Homebrewers can duplicate the Guinness effect to some degree by using the simplest of methods. You will need a tank of nitrogen gas and a special regulator for high-pressure gas. (These are not cheap.) Prime your stout (or other beer) at a rate of $\frac{1}{4}$ cup (60 ml.) of dextrose per 5 gallons (19 l.). Apply 20 to 25 pounds pressure of nitrogen to the keg. Note that nitrogen does not dissolve very readily into beer, but it doesn't take very much to create a dense, creamy head. Because nitrogen does not dissolve into beer in great amounts, it is still necessary to carbonate with carbon dioxide.

When the beer is conditioned and chilled, serve as you normally would, but use mostly nitrogen to dispense the beer. Add some carbon dioxide to help maintain carbonation levels. The beer will be dispensed quite forcibly at 20 to 25 pounds pressure, but if served cold, once the foam has settled, you will get the head you've been looking for and the typically mild carbonation of a proper draft Guinness.

Another option is to simply purchase a Guinness tap. It comes designed with a flow restrictor for dispensing stout just like your favorite source of draft Guinness.

Sure—you can try this with any type of beer.

WHAT ABOUT THE LONG-LASTING, DENSE HEAD OF GERMAN DRAFT PILSENER?

If you ever go to Germany and intend to have more than one glass of Pils, order your second beer as soon as you get your first. You'll wait perhaps 5 to 10 minutes for the first round.

Classic German draft Pilsener is a slow pour. It takes time for the dense, rich head of foam to subside and the barkeep to top off your glass with a fair serving of beer.

Very cold fermentation, hopping with quality "noble"-type aroma/flavor hops, and decoction mashing help build the character of German draft Pilsener. The tapping system and regulation of pressure also have much to do with the quality of the head and carbonation. Pilsener is fully carbonated and dispensed with more than the usual amount of pressure. This practice creates a lot of foam in the glass. The foam is allowed to settle for a few minutes, then the glass is

topped off with more beer. It is allowed to settle and then topped off again and again until the portion is correct. Draft Pils is not excessively carbonated, but it has a pleasingly stubborn head that forms patterns of lace on the sides of your glass as you seek the bottom.

And while we're on the subject of head retention . . . as indicated above, cold fermentation enhances the ability of beer to maintain a head of foam. Warmer fermentations are more likely to create fusel oils (alcohols), which can have a negative impact on head retention.

Clear Beer with Filtration

The average beer drinker has been led to believe that crystal-clear beer is better beer. The clarity of beer can be an indication of its character, but it is not always true that the clearest beer will be the beer of preference. There are clear advantages and disadvantages of filtering beer. Knowing what they are and understanding the basic process will help you decide for yourself to what degree you want to clarify your brew.

You've brewed a batch and have observed its fermentation. With time the yeast has settled to the bottom of your fermenters, kegs or bottles. And if you cold-lagered your brew for a good length of time, you've observed the formation of chill haze and its eventual settling out. You pour yourself a chilled bottle of clear enough beer, leaving most of the sediment behind in the bottle. You are a perfectly happy homebrewer. You've had a homebrew. You're relaxed. You're not worrying. Why bother with filtering? If this scenario has been your experience, read further with the intent of just knowing what clarity and filtration are about. You needn't read with the avid intent of designing your filtration system or considering the turn of every word as it flies off this page into your brain.

However, if you think it might be great to filter your beer, then consider the following with interest, but not necessarily commitment—yet. Have a homebrew.

Why bother? There are three main reasons why a beer might be filtered.

1) To make it visually more appealing (a subjective preference).
2) To make the beer more quickly suitable for consumption.
3) To help stabilize the character of the beer in some situations.

Brewers are most concerned with removing yeast, bacteria and/or chill haze. Yeasts are the largest in size, bacteria smaller and precipitated protein-tannin molecules (chill haze) the smallest. But in the process of removal, other beer characters can be affected. Depending on the circumstances and the brewer's filtration skill, color,

hop flavor and bitterness, body (mouth feel) and head retention all may be reduced. Oxygen or unwanted characters contributed by the filtration material or process can weasel their way into a perfectly brewed and fermented beer.

Beer undergoes filtration as it is forced through a porous surface. The porosity or size of the holes that the beer passes through determines what remains behind and what is allowed through. "Rough" filtration or relatively more porous material may filter out yeast, but allow bacteria, chill haze and most of the beer's other character to pass through. As the porosity decreases, the filtration is referred to as being "tighter," and smaller matter will be filtered out of the beer.

If you simply want to make clear, sediment-free beer, then filtration allows you to achieve this. However, if you are bottling filtered beer, you are bottling a beer without yeast. Without yeast, you cannot naturally carbonate beer in the bottle. You may add yeast (perhaps a different strain, as Bavarian wheat beer brewers do), prime and referment in the bottle, but you will still have sediment. If sediment-free is the way to be, then you have two choices: (1) Artificially carbonate and counterpressure in the bottle or (2) naturally carbonate your beer in a keg *before* filtration, though the entire filtration process must be done under counterpressure, complicating the process beyond most homebrewers' means, tolerance and relaxedness.

If your beer has been properly brewed and matured in the fermenter, but the yeast has not had adequate time to settle out, filtration can clarify the beer and allow for artificial carbonation and ready-to-drink beer within hours. However, the temptation for many brewers is to filter and make beer ready before it has properly matured. There are dramatic flavor changes that occur over time with any beer. Some styles of beer will take less than a week to mature, while others may need months. If beer is filtered prematurely, you may indeed produce a clear, yeastless and bacteria-free beer, but the "greenness" and immature character may be a real turnoff.

The principal reasons why commercial brewers filter their beer are to make it more visually appealing and to help stabilize the character of the beer. *Stabilization* can be a misleading term and is very relative to the process and the conditions under which the beer has been brewed and will be stored. Quality control and consistency are of top priority to commercial brewers. They brew their beer under some of the most sanitary conditions in the food industry. Their beer is in perfect order when it is time to be bottled. Their need for filtration is greater than homebrewers' because, after leaving the brewery, their beers will be transported, stored and often handled under uncertain conditions. These conditions can be damaging to the charac-

Finished beer's long journey to clarity through enzinger filters at the Coors Brewing Co.

ter of the beer. Cold and sterile filtration can help stabilize the quality of their beer and minimize damage.

Most commercial brewers also pasteurize their beer before releasing it for consumption. Pasteurization is a process whereby the beer is heated in order to kill all living microorganisms in the beer. The beer can be pasteurized after it is bottled by passing row after row of bottles through hot water spraying in a tunnel-like oven. This is called *tunnel pasteurization* and is the most common means of pasteurization. The beer's temperature slowly rises and slowly cools. Properly done, pasteurization will only subtly change the flavor of the beer. If done improperly, it can give the beer an unpleasant cooked flavor. Keg beer cannot be tunnel-pasteurized because of its mass. That is why almost all commercially made keg beer is unpasteurized (there are a few exceptions) and must be properly refrigerated.

Flash pasteurization is a process whereby beer is passed in stainless plumbing through a heat exchanger, where it is quickly heated to pasteurization temperatures, and then flows on to become very quickly cooled. This process is considered less damaging to

beer's flavor than tunnel pasteurization, but there is an additional risk of recontamination during bottling or kegging. The pasteurized beer is fully carbonated then bottled or kegged.

It is very interesting to note here that a small amount of living yeast in finished and fully conditioned beer will *help* stabilize the flavor character of beer. Some commercial breweries are known to add the smallest amount of live yeast back into their fully filtered and/or pasteurized beer just before packaging.

Homebrewers have much more control over the storage conditions of their beer, so the need for filtration is not as urgent. Above all, filtration should never be a means to "fix" poorly brewed beer. Cleanly brewed beer should be much more of a priority than trying to stabilize an infected beer by removing bacteria or wild yeast through filtration. Forget it. You will not fix the beer, nor will you be able to brew a quality product. You may think filtration will extend the drinkable life of your beer by removing the inevitable few bacteria that are present in even the best-brewed beers. But in reality, other favorable beer characters are likely to change for the worse over that extension you thought you "bought." Furthermore, if your beer is that good, why not drink it or share it and brew some more? You and the world will be better off.

If removing tasteless chill haze is a concern, the beer must be chilled to 32 degrees F (0 C) in order to fully precipitate the chill haze. Beer freezes at about 28 degrees F (-2 C). Because chill haze molecules are so small, the tightest filtration is necessary. Unfortunately, with such tight filtration, other beer characters can be affected. Some hop flavor, bitterness, color, head retention and mouth feel will be lost in the process. In some cases it can leave the beer tasting empty, suggesting that something is missing. If character is removed to a degree that detracts from what you intended, you need to compensate by encouraging more of these characters during the brewing process. Experimentation with your particular system will determine to what degree you need to make adjustments.

If you've brewed a clean beer and have allowed the beer to settle its chill haze with cold lagering time, or if chill haze is not an issue for you (especially if you are brewing ales served at temperatures at which chill haze does not form), then a rough filtration will remove most of your yeast, while not affecting other beer characters.

It all may sound discouraging for the homebrewer, but it is admittedly a joy to be able to travel with sediment-free, clear beer. Filtration does have some legitimate uses for those special occasions.

FILTRATION EQUIPMENT

It's going to take some special equipment and a few extra dollars to put together your homebrew filtration system. If you hadn't figured that out by now, perhaps you're relaxing a bit too much. Never mind, though. Now you know. Have another homebrew and rest assured that if you really have the desire, it isn't all that complicated once you've invested the initial time in setting things up.

You'll need a filtering device, hoses to guide the flow of beer, stainless steel soda canister kegs to hold and receive the beer, and a carbon dioxide system to force the flow of the beer through your filtration system. There are two types of filtration systems that are reasonably accessible to homebrewers. They are plate-type filters and cartridge-type filters.

Plate-type Filters

Starting at a cost of about $100 for the smaller models, plate-type filters are available to homebrewers through homebrew supply stores and mail-order outlets. They are constructed of plates of plastic alternately arranged with filter pads. The plates and pads are fitted parallel to each other and then sealed together by means of tightening wing nuts. There are channels in the plastic plates through which beer is allowed to flow. The beer flows through a series of usually two to five filter pads and is forced through with 5 to 20 pounds per square inch of carbon dioxide pressure.

The filter pads are compressed cellulose material impregnated with diatomaceous earth (also referred to as d.e. or kieselguhr) and are offered in different porosity grades, depending on whether rough or tight filtration is desired. They are not reusable and must be replaced with new pads each time. Diatomaceous earth is calcified skeletons of microscopic-size diatoms. Their skeletal structure allows liquid to flow through, but not particulate matter.

Fossils and yeast. Diatamaceous Earth; microscopic skeletons of calcified diatoms provide barriers to yeast cells and bacteria while allowing beer to flow through. Trapped yeast are evident.

Attention to sanitation is imperative. The filter pads and system are sanitized before use by first passing a sanitizing solution of $\frac{1}{4}$ teaspoon (1.2 ml.) of household bleach diluted in 2 gallons (7.6 l.) of cold water through the system. Then about 1 gallon (3.8 l.) of hot boiled water is passed through to rinse off the sanitizing solution. It is important to use boiled deaerated water to rinse the sanitizing solution out of the system. Filter pads impregnated with aerated water will contribute undesirable dissolved oxygen to any beer that flows through the system.

Plate filtration systems are often wet and leaky and should be used in an area where wetness is not a problem. You must anticipate some beer loss. You'll need to discard the initial quart (0.95 l.) of beer flow, for it contains a higher proportion of rinsing water and possible paperlike flavors from the filter pads. Leaks and drips will take their toll during the process. Two quarts (1.9 l.) of beer loss is not too much to expect and is worth factoring into the overall efficiency of your brewing system. (Two quarts [1.9 l.] out of a 5-gallon [19-l.] batch is a 10 percent loss. If you were mashing and going to great lengths to achieve that extra 2 or 3 percent mashing efficiency, you may be compromising your earlier efforts during filtration.) You will increase your filtration efficiency as you increase the amount of beer you filter through this type of system. These systems have the potential of filtering more beer at one setup than the alternative system discussed later.

Beware of inexpensive plate-type filtration systems marketed as wine filters. Their design usually cannot withstand the higher pressures sometimes required to push beer through the system. Why? Wine is often quite clear by the time it goes through a filter. The system does not clog up as much and thus does not restrict flow and require additional pressure to push the liquid through. Wine filters or poorly constructed systems will rupture under excessive pressure.

FILTRATION RATINGS

Porosity	Type of Filtration	What's Filtered
<0.5 microns	sterile, very tight filtration	yeast, bacteria, chill haze
0.5 microns	tight filtration, nearly sterile	yeast, bacteria, most chill haze
0.5–1 microns	medium filtration	yeast, bacteria
1–5 microns	rough filtration	some or most yeast

Cartridge-type Filters

A cartridge filter system offers the most versatility and ease of operation for homebrewers who are only filtering one 5-gallon (19-l.) batch at a time. Beer is pushed through the cartridge-type system with carbon dioxide. The beer enters the sealed cylinder and passes through the outside surface of a cartridgelike filtration device into the core of the cartridge. Once the filtered beer has made its way into the core, the flow is directed out of the cylinder through internal plumbing and an attached hose.

The cartridge filters are not only replaceable but can also be cleaned, sanitized and reused several times. The cylindrical filter housing may cost $20 to $50, while the filters will range in cost from about $7 to $40, depending on the size of the system and the type of filter cartridge you use.

The cartridges are made of inert porous polypropylene plastic. There are two main types of cartridges. Spun polypropylene is the less expensive type and is essentially a string of polypropylene wrapped tightly around a core. The pleated cartridge is more expensive, but easier to use and clean, and it lasts longer. It is constructed with a polypropylene pad that is ridged like an accordion, surrounding a core.

Cartridges are available in various porosities, depending on how tight or rough your filtration requirements are. The systems are also rated for efficiency. If tight filtration is your goal, purchase systems that are rated at 99.9 percent efficiency.

The porosity of a cartridge rated for rough filtration can be made tighter with the addition of small amounts of a diatomaceous-earth-and-water/beer "slurry" in the entering beer stream. The tiny skeletons that make up the d.e. build up on the surface of the filtration cartridge and decrease the porosity. This method can also be used to increase the amount of beer you can filter through a limited system such as this. The surface pores of the main filter will eventually become clogged and restrict the flow of beer. If flow is allowed to continue, the filter will eventually become totally restrictive. The hazier the beer, the more quickly this will occur. By adding d.e. to the stream, you are slowly extending and building up the surface area. The cake of tangled microscopic skeletons allows less restrictive flow, while continuing to catch microscopic critters and chill haze molecules.

The system must be cleaned, sanitized and rinsed before and after every use. After each use, back-flush the system by forcing hot water through in a reverse direction. Remove the cartridge and in-

Cartridge Type Filter

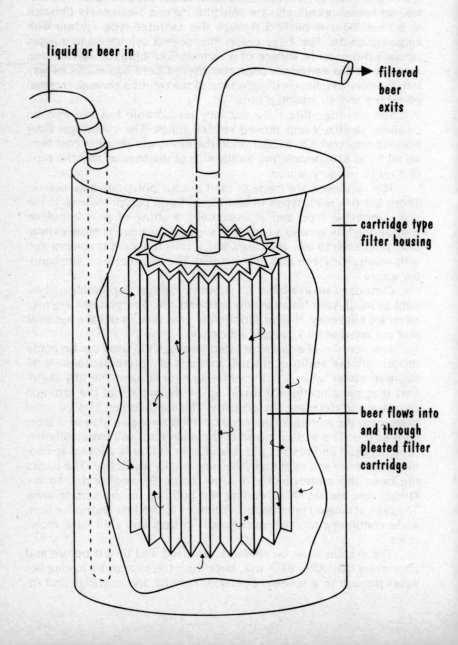

spect it. You may need a forceful jet of water to remove surface material. The cartridge itself should be cleaned by soaking overnight in a caustic lye solution. About 2 tablespoons per gallon of water should be adequate. **Caustic lye can be an extremely dangerous cleaner to work with, causing blindness and/or skin burns if not handled properly. Use protective rubber gloves and eye protection, and carefully read instructions on how to mix it. Never, ever add water to caustic. (The reaction is explosive.) Rather, add caustic to water, slowly and carefully to dissolve it. If you feel slipperiness on your skin when using caustic, that means that your skin is being eaten away!**

After the caustic cleaning, rinse completely with hot tap water and then immerse the cartridge in a weak sanitizing solution of household bleach and cold water. Rinse and store dry in an airtight container. Before using the cartridge, sanitize and rinse it once again.

Once the system is assembled for use, then sanitizing solution followed by boiled deaerated water must be flushed through the entire system to help assure sanitized conditions. As with the plate filters already discussed, there will be a small amount of beer waste as you will need to discard the first pint of filtered beer exiting the system.

The preceding is a relatively brief overview of how to filter your beer. The details are left up to your own ingenuity and inevitable trial, error and success. Recall how you felt when you brewed your first batch of beer. The process of filtration may seem rather intimidating and complex at first, but as with any new endeavor, your efforts will become second nature and will reward you with exactly the kind of beer you want.

Measuring Devices

There are hundreds of ways to measure the hundreds of variables during the beermaking process. Most homebrew supply shops will stock the essentials for what you need to measure. Here are a few additional hints to consider when measuring.

HYDROMETERS

Glass hydrometers measure specific gravity and/or degrees Balling/Plato. Most hydrometers are calibrated to be accurate at 60 degrees F (15.6 C). Readings must be adjusted if liquids are measured at warmer or cooler temperatures. The following table can be used as a reference.

HYDROMETER CORRECTION

Liquid Temperature Degrees F (C)	Correction to Specific Gravity (Degrees Balling)
50 (10)	− .0007 (negligible)
60 (15.6)	0
70 (21)	+ .001 (0.25)
78 (25.5)	+ .002 (0.5)
84.5 (29)	+ .003 (0.75)
90.5 (32.5)	+ .004 (1)
96 (35.5)	+ .005 (1.25)
101 (38)	+ .006 (1.5)
106 (41)	+ .007 (1.75)
110 (43)	+ .008 (2)
120 (49)	+ .010 (2.5)

For example, if your hydrometer indicated that wort at 100 degrees F was 1.030, you must add .006 to the reading to indicate the real 1.036 specific gravity.

Although conversions exist for temperatures above 120 degrees F (49 C), the measurement of hot liquid is neither practical nor safe with glass hydrometers. The temperature shock may stress the glass and cause it to crack. A more reliable and accurate means of measur-

ing the specific gravity of very warm or hot liquid is to pour a small amount in a saucepan, immerse the saucepan in a bath of cold water and swirl for a minute. The liquid should be cooled enough to pour into your hydrometer flask and be measured accurately.

THERMOMETERS

Thermometers are used and abused throughout the brewing process. Glass thermometers are prone to break and respond slowly to temperature changes. A probe thermometer with a dial or digital readout is your best investment. Look for accuracy, quick response and durability.

CHARISMATIC SPOONS AND DIPSTICKS

As if your brewing spoon weren't charismatic enough, it can also serve as a measuring device. For each brewpot you have in your galley, measure into it water in $\frac{1}{2}$-gallon (2-l.) increments. Immerse your spoon in the water and permanently mark (notch, carve, scratch or otherwise deface) levels at this and each additional $\frac{1}{2}$-gallon (2-l.) increment. You can notch a few scales on different sides of the spoon. If your spoon doesn't have a long enough handle, fashion yourself a dipstick. Wood is fine, but never use it to measure cooled wort.

This method of measurement comes in quite handy when estimating evaporation from boiling wort or trying to determine whether what you have in the pot will fit in your fermenter. The time you save by using this device is equivalent to the time it takes to drink one tall, cool glass of homebrew. Now.

Color

The exact color of beer is not of great concern if you are simply going to enjoy the process of making beer and drinking it. However, if you are fine-tuning your skills as a brewer and/or trying to match a beer or attempting to win in competitions, you may wish to consider measuring your beer color.

The color of beer is influenced by several factors during the brewing, fermenting and handling process. Malt usually has the most significant impact on the color of beer; a discussion of malt and its effect on color is found on page 39.

There are two standard color measurements used by professional brewers. One is the American Standard Reference Method (SRM, nearly identical to the older degrees Lovibond system), and the other is the European Brewing Convention (EBC). Each uses different analytical procedures. It should be noted that each system has its limitations and does not actually measure the color, but rather the intensity of certain types of light. The systems do not recognize the difference between a coppery red beer, an amber, a gold, yellow, or shades of redless brown.

There is not a dependably calculable relationship between EBC and SRM color units. However, the following relationship is reasonably accurate for gold- or straw-colored beers of about 4 degrees SRM or less. For colors darker than 4 degrees SRM, the relationship is an undependable and unscientific estimate, but something is better than nothing.

$$\text{degrees EBC} = (2.65 \times \text{degrees SRM}) - 1.2$$

or

$$\text{degrees SRM} = (0.377 \times \text{degrees EBC}) + 0.45$$

The equipment necessary to analyze color using standard methods is far from the means of even the above-average homebrewer. But a simple method of color analysis for beers whose color is less than or equal to 17 degrees SRM has been developed by Roger Briess and George Fix. Their method is outlined here with their permission. The standard for the method is Michelob Classic Dark, brewed

by Anheuser-Busch. It is generally widely available and its color is consistently 17 degrees SRM. The method is quite simple and compares the color of carefully measured dilutions of Michelob Dark to the beer being evaluated. The amount of distilled water it takes to dilute Michelob Dark to appear equal in color to the evaluated beer correlates to the color of beer in degrees SRM.

The authors of this method recommend that distilled water be used as the diluent. Both the Michelob standard and the test beer should be degassed by agitation because dissolved carbon dioxide

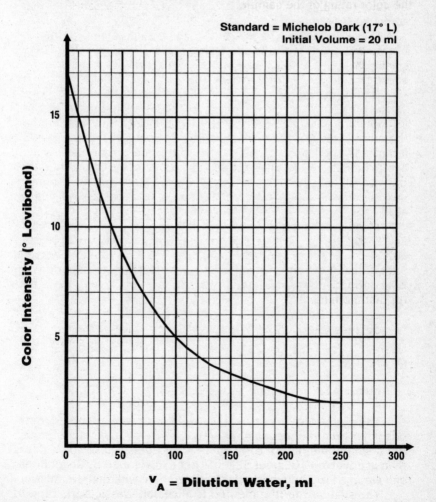

Standard = Michelob Dark (17° L)
Initial Volume = 20 ml

Color Intensity (° Lovibond)

v_A = Dilution Water, ml

can affect color. Reflected indirect light sources should be identical when observing samples.

Clear "white" glass long-necks are convenient vessels to use for making comparisons. Syringes or pipettes should be used to accurately measure volumes of liquid. For reference note that 1 cup = 8 fl. oz. = 237 ml., and 12 fl. oz. = 355 ml.

To make the evaluation, begin with 20 milliliters of degassed Michelob Dark. Add distilled water to the Michelob until it matches the color of the degassed sample. Refer to the chart to determine the color rating of the sample.

Beer Style Guidelines

From the brewhouse come centuries of mystery, folklore, tradition and the fine art of brewing, interpreted by each brewer. From modern brewing chemists come statistical and scientific data. Add to this spiritual alchemy the demands from commercial sales departments calling for a market-oriented product and the free spirit of the home-brewer. The vagaries of beer styles become apparent.

American brewers are in the middle of one of the most stylistically prolific periods ever. After a generation of simplicity in beer types, there is an outpouring of styles not seen in this country for decades. There are many reasons for American brewers to develop beer style guidelines, benchmarks, and a common language for measuring beer and communicating about brewing endeavors.

Some brewers and beer enthusiasts believe that styles are defined a bit more than necessary. But when staging a competition, standards must be established in order to define what the awards represent. Beer style guidelines serve as guideposts or targets to help us direct our brewing efforts and achieve the kind of beer we want.

Guidelines are just that: guidelines. They are a tool. They are not some kind of law or regulation. Their purpose is to help enhance the understanding and quality of our products. The art of establishing, changing and using guidelines is a game we all play. In the end it is our participation as spectators that makes it all worth the playful and meaningful consideration. Glasses full of brew and enjoyment.

Developing beer style guidelines is not a simple endeavor.

Generations of past brewers stand guard over the styles they created and popularized. Modern beer enthusiasts taste traditional styles without the benefit of broad cultural experience. Furthermore, each new American brewer has, by virtue of his or her travels and homebrewing or professional experimentation, developed a personal creative process of recipe formulation.

In a broad sense of the term, there are more than fifty distinctly different "classic" ale, lager and hybrid styles of beer popularly brewed in America. With well-researched information, guidelines serve to help brewers develop an understanding and appreciation for beer traditions. This knowledge can in turn enhance the beer's image and educate the consumer.

Furthermore, understanding beer styles is important to the brewer who endeavors to formulate recipes, to the salesperson who communicates beer traditions and culture to the customer, to the increasingly sophisticated consumer who develops an appreciation and respect for beer as an alcoholic beverage, and to federal and state regulatory agencies to help them make informed decisions and rules that are more consistent from state to state.

Each of the style descriptions included here reflects the elements of tradition and technique and is intended to aid brewers in formulating recipes and choosing appropriate ingredients, equipment and processes. The descriptions also are intended to guide the brewer and evaluator in assessing how well the final product matches the guidelines for the particular style.

There are many other factors not presented in the tables accompanying this chapter that can influence the character of beer, including esters, types of alcohol, sulfur compounds, variety of hops and yeast byproducts. These all create a range of complexity within each beer style. Therefore, a range of the attributes that generally define each "theme" or beer style is presented, not details of the complexities.

The data presented are a combination of objective and subjective observations. Valuable information and insight were gained from laboratory analyses of beer performed by others in the beer industry. However, without an indication of subjective sensory perception, most of the objective and analytical data are not useful when profiling the character of a beer style.

Technology offers the brewer the opportunity to assess specific attributes of a beer's profile in accurate detail, but human senses also are versatile tools for assessing qualities of beer. The combination of human senses and technology is synergistic in that the whole is greater than the sum of the parts. Both complement each other and

serve to enhance or confirm assessments that can be used to describe a beer style's profile.

DEFINITION OF TERMS

Ale

Ales are beers distinguished by the use of top-fermenting *Saccharomyces cerevisiae* yeast strains. These strains perform at warmer temperatures, the ferments are faster and fermentation byproducts are generally more evident. Ales tend to have a very pronounced palate where esters and fruitiness are a part of the character.

Apparent Degree of Actual Fermentation (or Attenuation)

Measured as a percent. This measures the degree to which the original extract has been converted to alcohol and other fermentation byproducts. It is a measure of the change in density. The *apparent degree* is not real, for the same reason apparent extract is not real extract (see below). A*pparent degree* of fermentation is more easily measured than real degree, and for the purpose of determining residual fermentation extract, it is sufficient.

Apparent Extract and Real Extract

Measured in degrees Balling (specific gravity). This is a measure of the final gravity or weight of the final extract. Because alcohol is lighter than water, the extract of finished beer will appear to be less if it is measured with the alcohol in it as it naturally occurs. A*pparent extract* is measured reasonably accurately with a hydrometer. To measure the real extract, one can boil off the alcohol and replace the lost volume with distilled water and then take a measurement. The *real extract* reading will be higher and will indicate true percentages.

Apparent Limit of Fermentation (or Attenuation)

Measured as a percent. This measures the absolute limit of fermentation. A portion of the wort used for brewing is subjected to ideal fermentation conditions and inoculated with more than enough yeast to assure maximum fermentation of the wort.

Bitterness (International Bitter Units [IBUs] or Bitter Units [BUs])

Measured as an amount of iso-alpha acid in solution. One IBU equals .000133 of an ounce (weight) of iso-alpha acid per U.S. gallon of solu-

tion or about 1 milligram per liter. Note: Its measurement is a helpful indication of bitterness, but there are other important factors that can contribute to the perception of bitterness that are not measured by IBUs.

Bitterness Perception

Measured subjectively: none, very low, low, medium, high, very high. Measures the actual degree of bitterness one is likely to perceive, relative to the overall bitterness range of all beer styles listed.

Body/Mouth feel

Measured subjectively: light, medium, full. Measures the sensation of viscosity, mouth feel or thinness or creaminess of the beer one is likely to perceive, relative to the overall intensity range of all beer styles listed.

Carbonation Level

Measured in volumes (i.e., percent carbon dioxide by volume).

Color

Describes actual color of the beer.

Color (SRM)

Measured in Standard Reference Method units, expressed as degrees SRM. For the purposes of general beer style guidelines, degrees SRM are assumed to be equivalent to degrees Lovibond. Also assumed is the general conversion of EBC color to SRM using the equation: $SRM = (0.375 \times degrees\ EBC) + 0.45$.

Diacetyl: ppm (perception)

Measured objectively in parts per million in solution. Measured subjectively: none, very low, low, medium, high, very high. Measures the degree of combined diacetyl aroma and flavor one is likely to perceive, relative to the overall intensity range of all beer styles listed.

Esters Perception

Also measured subjectively: none, very low, low, medium, high, very high. Measures the actual degree of combined ester aroma and flavor one is likely to perceive, relative to the overall intensity range of all beer styles listed.

Hop Aroma

Measured subjectively: none, very low, low, medium, high, very high. Measures the actual degree of hop aroma one is likely to perceive, relative to the overall aroma intensity range of all beer styles listed. A comment as to the character/variety may be included when appropriate for the style.

Hop Flavor

Measured subjectively: none, very low, low, medium, high, very high. Measures the actual degree of hop flavor one is likely to perceive, relative to the overall flavor intensity range of all beer styles listed. A comment as to the character/variety may be included when appropriate for the style.

Lager

Lagers are produced with bottom-fermenting *Saccharomyces uvarum* (or *carlsbergensis*) strains of yeast at colder fermentation temperatures than ales. This cooler environment inhibits the natural production of esters and other fermentation byproducts, creating a cleaner-tasting product.

Miscellaneous Comment

Comments that describe an important aspect of the style.

Mixed Style

These are beers fermented and/or aged with a mixed tradition of ale and lager techniques, or could be brewed as either ale or lager.

Original Extract

Measured in degrees Balling (specific gravity). This is a measure of the weight of fermentable and unfermentable extracts dissolved in solution as compared to the total weight of the solution.

Percent Alcohol

Measured in terms of percentage by weight (percentage by volume).

pH

An abbreviation for *potential hydrogen*, used to express the degree of acidity and alkalinity in an aqueous solution.

Residual Fermentation Extract

Measured as a percentage. This is a measure of the difference between the apparent limit of fermentation and apparent degree of fermentation. This is a measure of degree and not of content. (It is not to be confused with real extract.) This measurement can help give the brewer an indication of residual sweetness and body/mouth feel.

OUTLINE OF BEER STYLES

OUTLINE OF BEER STYLES (*continued*)

Type	Style	Substyle	Page
Lager	Bock	Traditional German	
		Dark	248
		Helles Bock	249
		Doppelbock	250
		Eisbock	250
Lager	Bavarian Dark	Munich Dunkel	251
		Schwarzbier	252
Lager	American Dark	American Dark	253
Lager	Dortmund/Export	Dortmund/Export	254
Lager	Munich Helles	Munich Helles	254
Lager	Classic Pilsener	German Pilsener	255
		Bohemian Pilsener	256
Lager	American Light	Diet/"Lite"	257
	Lager	American Standard	257
		American Premium	258
		Dry	259
Lager	Vienna/Oktoberfest/Märzen	Vienna	260
		Octoberfest/Märzen	261
Mixed Style	German Ale	Düsseldorf-style Altbier	261
		Kölsch	262
Mixed Style	Cream Ale	Cream Ale	263
Mixed Style	Fruit Beer	Fruit Ale or Lager	264
Mixed Style	Herb Beer	Herb Ale or Lager	265
Mixed Style	American Wheat	American Wheat Beer	265
Mixed Style	Specialty Beers	Ales or Lagers	266
Mixed Style	Smoked Beer	Bamberg-style Rauchbier	267
		Other styles	268
Mixed Style	California Common	California Common Beer	269
Mixed Style	German Wheat Beer	Berliner Weisse	269
		German-style Weizen	270
		German-style Dunkelweizen	271
		German-style Weizenbock	272

Type: Ale
Style: Barley Wine
Substyle: Barley Wine

Original Extract *Degrees Balling* (*specific gravity*):	22.5–30 (1.090–1.120)
Percent Alcohol *Weight* (*volume*):	6.7–9.6% (8.4–12%)
Apparent Extract *Degrees Balling* (*specific gravity*):	6–8 (1.024–32)
Real Extract:	—
Apparent Degree of Actual Fermentation (*percent*):	65–80%
Apparent Limit of Attenuation (*percent*):	70–82%
Residual Fermentation Extract (*percent*):	5–13%
pH:	4.1–4.6
Bitterness *International Bitter Units* (IBUs *or* BUs):	50–100
Bitterness Perception (*comment*):	medium–high
Hop Flavor (*comment*):	low–high
Hop Aroma (*comment*):	low–high
Esters Perception (*comment*):	medium–high
Diacetyl *ppm* (*perception*):	0.05–0.15 (low–medium)
CO_2 *Volumes*:	1.3–2.3
Body/Mouth Feel (*comment*):	full
Color (SRM):	14–22
Color Character:	copper–medium brown

Miscellaneous Comments: Characterized by a malty sweetness with evident alcohol flavor.

Type: Ale
Style: Belgian Specialty
Substyle: Flanders Brown

Original Extract *Degrees Balling* (*specific gravity*):	11–14 (1.044–56)
Percent Alcohol *Weight* (*Volume*):	3.8–4.2% (4.8–5.2%)
Apparent Extract *Degrees Balling* (*specific gravity*):	2–4 (1.008–16)

Real Extract: —
Apparent Degree of Actual 75–85%
 Fermentation (*percent*):
Apparent Limit of Attenuation 75–86%
 (*percent*):
Residual Fermentation Extract 0.5–1.0%
 (*percent*):
pH: 3.7–4.2
Bitterness International Bitterness 15–25
 Units (IBUs *or* BUs):
Bitterness Perception low–medium
 (*comment*):
Hop Flavor (*comment*): none
Hop Aroma (*comment*): none
Esters Perception (*comment*): medium
Diacetyl *ppm* (*perception*): 0.02–0.06 (none–low)
CO_2 *Volumes*: 1.9–2.5
Body/Mouth Feel (*comment*): light–medium
Color (SRM): 12–18
Color Character: copper–brown
Miscellaneous Comments: Characterized by a slight sourness and
 spiciness in flavor.

Type: Ale
Style: Belgian Specialty
Substyle: Dubbel

Original Extract *Degrees Balling* 12.5–17.5 (1.050–70)
 (*specific gravity*):
Percent Alcohol *Weight* 4.8–6% (6–7.5%)
 (*Volume*):
Apparent Extract *Degrees Balling* 3–4 (1.012–16)
 (*specific gravity*):
Real Extract: —
Apparent Degree of Actual 80–90%
 Fermentation (*percent*):
Apparent Limit of Attenuation 80–90%
 (*percent*):
Residual Fermentation Extract 0–2%
 (*percent*):
pH: 4.1–4.3
Bitterness International Bitterness 18–25
 Units (IBUs *or* BUs):

Bitterness Perception (*comment*):	low–medium
Hop Flavor (*comment*):	some okay
Hop Aroma (*comment*):	low
Esters Perception (*comment*):	high
Diacetyl *ppm* (*perception*):	0.05–0.15 (low)
CO_2 Volumes:	1.9–2.4
Body/Mouth Feel (*comment*):	medium–full
Color (SRM):	10–14
Color Character:	amber–brown

Miscellaneous Comments: Sometimes characterized by a spicy, phenolic, clove flavor. A banana ester is common. This beer has a sweet malty, nutty aroma with a slight sourness. Candi sugar is often used.

Type: Ale
Style: Belgian Specialty
Substyle: Trippel

Original Extract *Degrees Balling* (*specific gravity*):	17.5–24 (1.060–96)
Percent Alcohol *Weight* (Volume):	5.6–8% (7–10%)
Apparent Extract *Degrees Balling* (*specific gravity*):	4–6 (1.016–24)
Real Extract:	—
Apparent Degree of Actual Fermentation (*percent*):	79–87%
Apparent Limit of Attenuation (*percent*):	80–90%
Residual Fermentation Extract (*percent*):	0–3%
pH:	4.1–4.3
Bitterness *International Bitterness Units* (IBUs *or* BUs):	20–25
Bitterness Perception (*comment*):	low–medium
Hop Flavor (*comment*):	some okay
Hop Aroma (*comment*):	low
Esters Perception (*comment*):	high
Diacetyl *ppm* (*perception*):	0.05–0.15 (low)
CO_2 Volumes:	1.9–2.4
Body/Mouth Feel (*comment*):	medium–full

Cloning around. The possible effects of drinking Belgian Trippel at high altitudes as observed on Mt. Whitney, the highest point in the contiguous United States.

Color (SRM): 3.5–5.5
Color Character: light–pale
Miscellaneous Comments: Sometimes characterized by a spicy, phenolic, clove flavor . A banana ester is common. Usually a neutral, slight hop/malt balance. Some sourness is okay. Candi sugar is often used.

Type: Ale
Style: Belgian Specialty
Substyle: Belgian Ale

Original Extract *Degrees Balling* 11–13.5 (1.044–54)
 (*specific gravity*):
Percent Alcohol *Weight* 3.2–5% (4–6.2%)
 (*Volume*):
Apparent Extract *Degrees Balling* 2–3.5 (1.008–14)
 (*specific gravity*):
Real Extract: —
Apparent Degree of Actual 80–90%
 Fermentation (*percent*):

Apparent Limit of Attenuation (*percent*):	80–90%
Residual Fermentation Extract (*percent*):	0–1%
pH:	4.1–4.3
Bitterness *International Bitterness Units* (IBUs *or* BUs):	20–30
Bitterness Perception (*comment*):	low–medium
Hop Flavor (*comment*):	low–evident
Hop Aroma (*comment*):	low–evident
Esters Perception (*comment*):	low–medium
Diacetyl *ppm* (*perception*):	0.02–0.06 (none to low)
CO_2 *Volumes*:	1.9–2.5
Body/Mouth Feel (*comment*):	light–medium
Color (SRM):	3.5–12
Color Character:	light–amber

Miscellaneous Comments: Some sourness is okay. Caramel malt character is acceptable.

Type: Ale
Style: Belgian Specialty
Substyle: Belgian Strong Ale

Original Extract *Degrees Balling* (*specific gravity*):	16–24 (1.064–96)
Percent Alcohol *Weight* (*Volume*):	5.6–8.8% (7–11%)
Apparent Extract *Degrees Balling* (*specific gravity*):	3–6 (1.012–24)
Real Extract:	—
Apparent Degree of Actual Fermentation (*percent*):	80–90%
Apparent Limit of Attenuation (*percent*):	80–90%
Residual Fermentation Extract (*percent*):	0–2%
pH:	4.1–4.3
Bitterness *International Bitterness Units* (IBUs *or* BUs):	20–50
Bitterness Perception (*comment*):	low–high
Hop Flavor (*comment*):	very low
Hop Aroma (*comment*):	very low

Esters Perception (*comment*): medium to high
Diacetyl *ppm* (*perception*): 0.05–0.10 (low)
CO_2 Volumes: 1.9–2.4
Body/Mouth Feel (*comment*): medium–full
Color (SRM): 3.5–20
Color Character: pale to dark brown
Miscellaneous Comments: This beer is alcoholic and can be vinous; darker beers are typically colored with dark candi sugar.

Type: Ale
Style: Belgian Specialty
Substyle: White

Original Extract *Degrees Balling* (*specific gravity*): 11–12. 5 (1.044–50)
Percent Alcohol *Weight* (*Volume*): 3.8–4.2% (4.8–5.2%)
Apparent Extract *Degrees Balling* (*specific gravity*): 1.5–2.5 (1.006–10)
Real Extract: —
Apparent Degree of Actual Fermentation (*percent*): 75–85%
Apparent Limit of Attenuation (*percent*): 76–86%
Residual Fermentation Extract (*percent*): 1–2%
pH: 4.1–4.3
Bitterness *International Bitterness Units* (IBUs *or* BUs): 15–25
Bitterness Perception (*comment*): low–medium
Hop Flavor (*comment*): noble-type desired
Hop Aroma (*comment*): noble-type desired
Esters Perception (*comment*): low–medium
Diacetyl *ppm* (*perception*): 0.02–0.06 (none to low)
CO_2 Volumes: 2.1–2.6
Body/Mouth Feel (*comment*): light
Color (SRM): 2–4
Color Character: very pale, can be cloudy
Miscellaneous Comments: Unmalted wheat is used, and sometimes oats. Beer may be spiced with coriander seed and orange peel.

Type: Ale
Style: Belgian Specialty
Substyle: Lambic Gueuze

Original Extract Degrees Balling (specific gravity):	11–14 (1.044–56)
Percent Alcohol Weight (Volume):	4–5% (5–6%)
Apparent Extract Degrees Balling (specific gravity):	0–2.5 (1.000–1.010)
Real Extract:	2.2–4.5
Apparent Degree of Actual Fermentation (percent):	75–99%
Apparent Limit of Attenuation (percent):	75–99%
Residual Fermentation Extract (percent):	0%
pH:	3.2–3.5
Bitterness International Bitterness Units (IBUs or BUs):	11–23
Bitterness Perception (comment):	very low
Hop Flavor (comment):	none
Hop Aroma (comment):	none
Esters Perception (comment):	medium–very high
Diacetyl ppm (perception):	0.04–0.05 (very low)
CO_2 Volumes:	3.0–4.5
Body/Mouth Feel (comment):	light–dry
Color (SRM):	6–13
Color Character:	pale–amber

Miscellaneous Comments: Characterized by an intensely sour/acidic flavor. Unmalted wheat is used with malted barley and stale, aged hops.

Type: Ale
Style: Belgian Specialty
Substyle: Lambic Faro

Original Extract Degrees Balling (specific gravity):	—see gueuze for data
Percent Alcohol Weight (Volume):	—

Apparent Extract *Degrees Balling* —
 (*specific gravity*):
Real Extract: —
Apparent Degree of Actual —
 Fermentation (*percent*):
Apparent Limit of Attenuation —
 (*percent*):
Residual Fermentation Extract —
 (*percent*):
pH: —
Bitterness *International Bitterness* —
 Units (IBUs *or* BUs):
Bitterness Perception —
 (*comment*):
Hop Flavor (*comment*): —
Hop Aroma (*comment*): —
Esters Perception (*comment*): —
Diacetyl *ppm* (*perception*): —
CO_2 *Volumes*: —
Body/Mouth Feel (*comment*): —
Color (SRM): —
Color Character: —
Miscellaneous Comments: This beer is gueuze, flavored with sugar
 and/or caramel.

Type: Ale
Style: Belgian Specialty
Substyle: Lambic Fruit

Original Extract *Degrees Balling* 10–17.5 (1.040–72)
 (*specific gravity*):
Percent Alcohol *Weight* 4–5.6% (5–7%)
 (*Volume*):
Apparent Extract *Degrees Balling* 0–5 (1.000–1.020)
 (*specific gravity*):
Real Extract: 2.3–9.8
Apparent Degree of Actual 44–93%
 Fermentation (*percent*):
Apparent Limit of Attenuation 44–98%
 (*percent*):
Residual Fermentation Extract 0–5%
 (*percent*):

pH: 3.2–3.5
Bitterness *International Bitterness* 15–21
 Units (IBUs or BUs):
Bitterness Perception low
 (*comment*):
Hop Flavor (*comment*): none
Hop Aroma (*comment*): none
Esters Perception (*comment*): medium–very high
Diacetyl *ppm* (*perception*): 0.04–0.05 (very low)
CO_2 *Volumes*: 2.6–4.5
Body/Mouth Feel (*comment*): light–medium
Color (SRM): not applicable
Color Character: color of fruit
Miscellaneous Comments: Characterized by fruit flavor and aroma.
 The color is intense while sourness predominates. Raspberry,
 cherry, peach and cassis (black currant) are commonly used.

Type: Ale
Style: English Bitter
Substyle: English Ordinary

Original Extract *Degrees Balling* 8.5–9.5 (1.035–38)
 (*specific gravity*):
Percent Alcohol *Weight* 2.4–2.8% (3–3.5%)
 (*Volume*):
Apparent Extract *Degrees Balling* 2–3 (1.008–12)
 (*specific gravity*):
Real Extract: —
Apparent Degree of Actual 70–80%
 Fermentation (*percent*):
Apparent Limit of Attenuation 71–82%
 (*percent*):
Residual Fermentation Extract 1–2%
 (*percent*):
pH: 3.9–4.2
Bitterness *International Bitterness* 20–25
 Units (IBUs or BUs):
Bitterness Perception medium
 (*comment*):
Hop Flavor (*comment*): none–medium

Hop Aroma (*comment*):	none–medium
Esters Perception (*comment*):	low
Diacetyl *ppm* (*perception*):	0.05–0.10 (low–medium)
CO_2 Volumes:	0.75–1.3
Body/Mouth Feel (*comment*):	light–medium
Color (SRM):	8–12
Color Character:	gold–copper

Miscellaneous Comments: Characterized by low carbonation and low to medium maltiness.

Type: Ale
Style: English Bitter
Substyle: English Special

Original Extract *Degrees Balling* (*specific gravity*):	9.5–10.5 (1.036–42)
Percent Alcohol *Weight* (*Volume*):	2.8–3.6% (3.5–4.5%)
Apparent Extract *Degrees Balling* (*specific gravity*):	2–3 (1.006–12)
Real Extract:	—
Apparent Degree of Actual Fermentation (*percent*):	70–80%
Apparent Limit of Attenuation (*percent*):	71–82%
Residual Fermentation Extract (*percent*):	1–2.5%
pH:	3.9–4.2
Bitterness *International Bitterness Units* (IBUs *or* BUs):	25–30
Bitterness Perception (*comment*):	medium
Hop Flavor (*comment*):	none–medium
Hop Aroma (*comment*):	none–medium
Esters Perception (*comment*):	low
Diacetyl ppm (*perception*):	0.07–0.12 (low–medium)
CO_2 Volumes:	0.75–1.3
Body/Mouth Feel (*comment*):	light–medium
Color (SRM):	8–14
Color Character:	gold–copper

Miscellaneous Comments: Characterized by low carbonation and low to medium maltiness.

Type: Ale
Style: English Bitter
Substyle: English Extra Special

Original Extract *Degrees Balling* (*specific gravity*):	10.5–13.5 (1.042–55)
Percent Alcohol *Weight* (*Volume*):	3.6–4.4% (4.5–6%)
Apparent Extract *Degrees Balling* (*specific gravity*):	2–3.5 (1.008–14)
Real Extract:	—
Apparent Degree of Actual Fermentation (*percent*):	70–80%
Apparent Limit of Attenuation (*percent*):	71–83%
Residual Fermentation Extract (*percent*):	1–3%
pH:	3.9–4.2
Bitterness *International Bitterness Units* (IBUs *or* BUs):	30–35
Bitterness Perception (*comment*):	medium–high
Hop Flavor (*comment*):	none–medium
Hop Aroma (*comment*):	none–medium
Esters Perception (*comment*):	low–medium
Diacetyl *ppm* (*perception*):	0.07–0.15 (low–medium)
CO_2 Volumes:	0.75–1.3
Body/Mouth Feel (*comment*):	medium
Color (SRM):	8–14
Color Character:	gold–copper

Miscellaneous Comments: Characterized by low carbonation and low to medium maltiness.

Type: Ale
Style: Scottish Ale
Substyle: Scottish Light

Original Extract *Degrees Balling* (*specific gravity*):	7.5–9 (1.030–35)
Percent Alcohol *Weight* (*Volume*):	2.4–3.2% (3–4%)
Apparent Extract *Degrees Balling* (*specific gravity*):	1.5–2.5 (1.006–10)

Real Extract:	—
Apparent Degree of Actual Fermentation (*percent*):	70–80%
Apparent Limit of Attenuation (*percent*):	71–83%
Residual Fermentation Extract (*percent*):	1.5–2.5%
pH:	3.9–4.2
Bitterness *International Bitterness* Units (IBUs *or* BUs):	10–15
Bitterness Perception (*comment*):	low
Hop Flavor (*comment*):	none–low
Hop Aroma (*comment*):	none–low
Esters Perception (*comment*):	low
Diacetyl *ppm* (*perception*):	0.05–0.10 (low–medium)
CO$_2$ Volumes:	0.75–1.3
Body/Mouth Feel (*comment*):	medium
Color (SRM):	8–17
Color Character:	gold–dark amber/copper/brown

Miscellaneous Comments: Characterized by low carbonation and a slight sweet maltiness. A slight smokiness is okay.

Type:	Ale
Style:	Scottish Ale
Substyle:	Scottish Heavy

Original Extract *Degrees Balling* (*specific gravity*):	9–10 (1.035–40)
Percent Alcohol *Weight* (*Volume*):	2.8–3.2% (3.5–4%)
Apparent Extract *Degrees Balling* (*specific gravity*):	2.5–3.5 (1.010–14)
Real Extract:	—
Apparent Degree of Actual Fermentation (*percent*):	70–80%
Apparent Limit of Attenuation (*percent*):	71–83%
Residual Fermentation Extract (*percent*):	1.5–2.5%
pH:	3.9–4.2

Bitterness International Bitterness Units (IBUs or BUs):	12–17
Bitterness Perception (comment):	low
Hop Flavor (comment):	none–low
Hop Aroma (comment):	none–low
Esters Perception (comment):	low
Diacetyl ppm (perception):	0.05–0.10 (low–medium)
CO_2 Volumes:	0.75–1.3
Body/Mouth Feel (comment):	medium
Color (SRM):	10–19
Color Character:	gold–dark amber/copper/ brown

Miscellaneous Comments: Typically lightly carbonated. Characterized by sweet maltiness; a slight smokiness is okay.

Type: Ale
Style: Scottish Ale
Substyle: Scottish Export

Original Extract Degrees Balling (specific gravity):	10–12.5 (1.040–50)
Percent Alcohol Weight (Volume):	3.2–3.6% (4–4.5%)
Apparent Extract Degrees Balling (specific gravity):	2.5–4.5 (1.010–18)
Real Extract:	—
Apparent Degree of Actual Fermentation (percent):	70–80%
Apparent Limit of Attenuation (percent):	72–83%
Residual Fermentation Extract (percent):	2–3%
pH:	3.9–4.2
Bitterness International Bitterness Units (IBUs or BUs):	15–20
Bitterness Perception (comment):	low
Hop Flavor (comment):	none–low
Hop Aroma (comment):	none–low
Esters Perception (comment):	low–medium

Diacetyl *ppm (perception)*:	0.05–0.12 (low–medium)
CO_2 *Volumes*:	0.75–1.3
Body/Mouth Feel (*comment*):	medium–full
Color (SRM):	10–19
Color Character:	gold–dark amber/copper/ brown

Miscellaneous Comments: Typically lightly carbonated. Characterized by a sweet maltiness; a slight smokiness is okay.

Type: Ale
Style: Pale Ale
Substyle: Classic English Pale Ale

Original Extract *Degrees Balling* (*specific gravity*):	11–14 (1.044–56)
Percent Alcohol *Weight* (*Volume*):	3.6–4.4% (4.5–5.5%)
Apparent Extract *Degrees Balling* (*specific gravity*):	2.5–4 (1.010–16)
Real Extract:	4.1–4.9
Apparent Degree of Actual Fermentation (*percent*):	75–80%
Apparent Limit of Attenuation (*percent*):	78–83%
Residual Fermentation Extract (*percent*):	0–3%
pH:	4.0–4.2
Bitterness *International Bitterness* Units (IBUs *or* BUs):	20–40
Bitterness Perception (*comment*):	high
Hop Flavor (*comment*):	medium–high
Hop Aroma (*comment*):	medium–high
Esters Perception (*comment*):	low–medium
Diacetyl *ppm (perception)*:	0.02–0.09 (none to low)
CO_2 *Volumes*:	1.5–2.3
Body/Mouth Feel (*comment*):	medium
Color (SRM):	4–11
Color Character:	pale–deep amber/ copper

Miscellaneous Comments: Characterized by a low to medium maltiness; Goldings, Fuggles or other English-grown hops are essential.

Type: Ale
Style: Pale Ale
Substyle: India Pale Ale

Original Extract Degrees Balling (specific gravity):	12.5–15 (1.050–60)
Percent Alcohol Weight (Volume):	4–4.8% (5–6%)
Apparent Extract Degrees Balling (specific gravity):	3–4.5 (1.012–18)
Real Extract:	—
Apparent Degree of Actual Fermentation (percent):	70–80%
Apparent Limit of Attenuation (percent):	72–81%
Residual Fermentation Extract (percent):	0–1%
pH:	3.9–4.2
Bitterness International Bitterness Units (IBUs or BUs):	40–60
Bitterness Perception (comment):	very high
Hop Flavor (comment):	medium–high
Hop Aroma (comment):	medium–high
Esters Perception (comment):	low–medium
Diacetyl ppm (perception):	0.03–0.10 (none to low)
CO_2 Volumes:	1.5–2.3
Body/Mouth Feel (comment):	medium
Color (SRM):	8–14
Color Character:	pale–deep amber/copper

Miscellaneous Comments: Alcohol is evident. Characterized by medium maltiness.

Type: Ale
Style: Pale Ale
Substyle: American-style Pale Ale

Original Extract Degrees Balling (specific gravity):	11–14 (1.044–56)
Percent Alcohol Weight (Volume):	3.6–4.4% (4.5–5.5%)
Apparent Extract Degrees Balling (specific gravity):	2.5–4 (1.010–16)

Real Extract: —
Apparent Degree of Actual 75–80%
 Fermentation (*percent*):
Apparent Limit of Attenuation 75–84%
 (*percent*):
Residual Fermentation Extract 0–4%
 (percent):
pH: 4.0–4.2
Bitterness *International Bitterness* 20–40
 Units (IBUs *or* BUs):
Bitterness Perception high
 (*comment*):
Hop Flavor (*comment*): medium–high
Hop Aroma (*comment*): medium–high
Esters Perception (*comment*): low–medium
Diacetyl *ppm* (*perception*): 0.02–0.09 (none to low)
CO_2 Volumes: 2.26–2.78
Body/Mouth Feel (*comment*): medium
Color (SRM): 4–11
Color Character: pale–deep amber/red/
 copper

Miscellaneous Comments: Characterized by a low to medium
 maltiness; Cascade, Williamette, Centennial or other American
 hops are essential.

Type: Ale
Style: English and Scottish Strong Ale
Substyle: English Old Ale/Strong Ale

Original Extract *Degrees Balling* 15–19 (1.060–75)
 (*specific gravity*):
Percent Alcohol *Weight* 5.2–6.8% (6.5–8.5%)
 (*Volume*):
Apparent Extract *Degrees Balling* 3–5 (1.012–20)
 (*specific gravity*):
Real Extract: —
Apparent Degree of Actual 67–80%
 Fermentation (*percent*):
Apparent Limit of Attenuation 71–89%
 (*percent*):
Residual Fermentation Extract 4–9%
 (*percent*):

pH:	4.0–4.3
Bitterness *International Bitterness Units* (IBUs *or* BUs):	30–40
Bitterness Perception (*comment*):	medium
Hop Flavor (*comment*):	low–medium
Hop Aroma (*comment*):	low–medium
Esters Perception (*comment*):	low–medium
Diacetyl *ppm* (*perception*):	0.06–0.12 (low–medium)
CO_2 *Volumes*:	1.5–2.3
Body/Mouth Feel (*comment*):	medium–full
Color (SRM):	10–16
Color Character:	light–dark amber/copper

Miscellaneous Comments: A malty and alcoholic flavor is perceived.

Type: Ale
Style: English and Scottish Strong Ale
Substyle: Strong Scotch Ale

Original Extract *Degrees Balling* (*specific gravity*):	18–21 (1.072–84)
Percent Alcohol *Weight* (*Volume*):	5–6.4% (6.2–8%)
Apparent Extract *Degrees Balling* (*specific gravity*):	5–7 (1.020–28)
Real Extract:	7.5–8.5
Apparent Degree of Actual Fermentation (*percent*):	71–75%
Apparent Limit of Attenuation (*percent*):	85–88%
Residual Fermentation Extract (*percent*):	12–16%
pH:	4.1–4.3
Bitterness *International Bitterness Units* (IBUs *or* BUs):	25–35
Bitterness Perception (*comment*):	low–medium
Hop Flavor (*comment*):	low
Hop Aroma (*comment*):	low

Esters Perception (*comment*): medium
Diacetyl *ppm* (*perception*): 0.05–0.15 (low–high)
CO_2 Volumes: 1.5–2.3
Body/Mouth Feel (*comment*): full
Color (SRM): 10–47
Color Character: copper–black
Miscellaneous Comments: A definite alcoholic strength is perceived in this very malty-tasting beer.

Type: Ale
Style: Brown Ale
Substyle: English Brown Ale

Original Extract D*egrees Balling* (*specific gravity*): 10–12.5 (1.040–50)
Percent Alcohol W*eight* (*Volume*): 3.3–4.7% (4.1–5.9%)
Apparent Extract D*egrees Balling* (*specific gravity*): 1.5–3.5 (1.006–14)
Real Extract: —
Apparent Degree of Actual Fermentation (*percent*): 68–78%
Apparent Limit of Attenuation (*percent*): 70–80%
Residual Fermentation Extract (*percent*): 2–5%
pH: 4.0–4.3
Bitterness *International Bitterness Units* (IBUs *or* BUs): 15–25
Bitterness Perception (*comment*): low
Hop Flavor (*comment*): low
Hop Aroma (*comment*): low
Esters Perception (*comment*): low
Diacetyl *ppm* (*perception*): 0.05–0.12 (low–medium)
CO_2 Volumes: 1.5–2.3
Body/Mouth Feel (*comment*): medium
Color (SRM): 15–22
Color Character: medium–dark brown
Miscellaneous Comments: A sweet and malty, caramel-like flavor and aroma.

Type: Ale
Style: Brown Ale
Substyle: English Mild Ale

Original Extract *Degrees Balling* (*specific gravity*):	8–9 (1.032–36)
Percent Alcohol *Weight* (*Volume*):	2–2.8% (2.5–3.6%)
Apparent Extract *Degrees Balling* (*specific gravity*):	1.5–2.5 (1.006–10)
Real Extract:	—
Apparent Degree of Actual Fermentation (*percent*):	71–81%
Apparent Limit of Attenuation (*percent*):	70–80%
Residual Fermentation Extract (*percent*):	1–3%
pH:	4.0–4.2
Bitterness *International Bitterness Units* (*IBUs or BUs*):	14–20
Bitterness Perception (*comment*):	low
Hop Flavor (*comment*):	low
Hop Aroma (*comment*):	low
Esters Perception (*comment*):	very low
Diacetyl *ppm* (*perception*):	0.02–0.06 (none to low)
CO_2 Volumes:	1.3–2.0
Body/Mouth Feel (*comment*):	light
Color (SRM):	17–34
Color Character:	medium–dark brown

Miscellaneous Comments: This beer has a mild maltiness and a low alcohol flavor.

Type: Ale
Style: Brown Ale
Substyle: American Brown Ale

Original Extract *Degrees Balling* (*specific gravity*):	10–14 (1.040–56)
Percent Alcohol *Weight* (*Volume*):	3.3–4.7% (4.1–5.9%)
Apparent Extract *Degrees Balling* (*specific gravity*):	2.5–4.5 (1.010–18)

Real Extract:	—
Apparent Degree of Actual Fermentation (*percent*):	68–78%
Apparent Limit of Attenuation (*percent*):	70–80%
Residual Fermentation Extract (*percent*):	2–5%
pH:	4.0–4.3
Bitterness *International Bitterness* Units (IBUs *or* BUs):	25–60
Bitterness Perception (*comment*):	high
Hop Flavor (*comment*):	medium–high
Hop Aroma (*comment*):	medium–high
Esters Perception (*comment*):	low–medium
Diacetyl *ppm* (*perception*):	0.03–0.08 (none to low)
CO_2 *Volumes*:	1.5–2.5
Body/Mouth Feel (*comment*):	medium
Color (SRM):	15–22
Color Character:	medium–dark brown

Miscellaneous Comments: Characterized by a medium maltiness.

Type:	Ale
Style:	Porter
Substyle:	Robust Porter

Original Extract *Degrees Balling* (*specific gravity*):	11–15 (1.044–60)
Percent Alcohol *Weight* (*Volume*):	4–5.2% (5–6.5%)
Apparent Extract *Degrees Balling* (*specific gravity*):	2–4 (1.008–16)
Real Extract:	—
Apparent Degree of Actual Fermentation (*percent*):	75–80%
Apparent Limit of Attenuation (*percent*):	77–83%
Residual Fermentation Extract (*percent*):	2–6%
pH:	3.9–4.4
Bitterness *International Bitterness* Units (IBUs *or* BUs):	25–40

Bitterness Perception (*comment*):	high
Hop Flavor (*comment*):	none–medium
Hop Aroma (*comment*):	none–medium
Esters Perception (*comment*):	low
Diacetyl *ppm* (*perception*):	0.09–0.14 (low–medium)
CO_2 Volumes:	1.8–2.5
Body/Mouth Feel (*comment*):	medium–full
Color (SRM):	30+
Color Character:	black–opaque

Miscellaneous Comments: No roasted barley is used. A black malt bitterness as well as a malty sweetness are perceived.

Type: Ale
Style: Porter
Substyle: Brown Porter

Original Extract *Degrees Balling* (*specific gravity*):	10–12.5 (1.040–50)
Percent Alcohol *Weight* (*Volume*):	3.7–4.8% (4.6–6%)
Apparent Extract *Degrees Balling* (*specific gravity*):	1.5–2.5 (1.006–10)
Real Extract:	—
Apparent Degree of Actual Fermentation (*percent*):	75–80%
Apparent Limit of Attenuation (*percent*):	76–82%
Residual Fermentation Extract (*percent*):	1–5%
pH:	3.9–4.4
Bitterness *International Bitterness* Units (IBUs *or* BUs):	20–30
Bitterness Perception (*comment*):	medium
Hop Flavor (*comment*):	none–medium
Hop Aroma (*comment*):	none–medium
Esters Perception (*comment*):	low

Diacetyl *ppm (perception)*: 0.05–0.15 (low–medium)
CO_2 *Volumes*: 1.7–2.5
Body/Mouth Feel *(comment)*: light–medium
Color (SRM): 20–35
Color Character: medium–dark brown

Miscellaneous Comments: No roast barley or black malt bitterness is perceived; rather, there is a low to medium malty sweetness.

Type: Ale
Style: Stout
Substyle: Classic Dry Irish

Original Extract *Degrees Balling* (*specific gravity*): 9.5–12 (1.038–48)
Percent Alcohol *Weight* (*Volume*): 3–4% (3.8–5%)
Apparent Extract *Degrees Balling* (*specific gravity*): 2–3.5 (1.008–14)
Real Extract: 3.6–4.3
Apparent Degree of Actual Fermentation (*percent*): 78–84%
Apparent Limit of Attenuation (*percent*): 78–84%
Residual Fermentation Extract (*percent*): 0–0.5%
pH: 3.9–4.1
Bitterness *International Bitterness Units* (IBUs or BUs): 30–40
Bitterness Perception (*comment*): medium–high
Hop Flavor (*comment*): none
Hop Aroma (*comment*): none
Esters Perception (*comment*): very low
Diacetyl *ppm (perception)*: 0.10–0.15 (low–medium)
CO_2 *Volumes*: 1.6–2.0
Body/Mouth Feel (*comment*): light–medium
Color (SRM): 40 +
Color Character: black–opaque

Miscellaneous Comments: Characterized by roasted barley, caramel and sweet malt taste. Some slight acidity. Bitterness from the roasted barley may be perceived.

Type: Ale
Style: Stout
Substyle: Foreign Style

Original Extract Degrees Balling (*specific gravity*):	13–18 (1.052–72)
Percent Alcohol Weight (*Volume*):	4.8–6% (6–7.5%)
Apparent Extract Degrees Balling (*specific gravity*):	2–5 (1.008–20)
Real Extract:	3.6–4.3
Apparent Degree of Actual Fermentation (*percent*):	70–77%
Apparent Limit of Attenuation (*percent*):	70–77%
Residual Fermentation Extract (*percent*):	0–0.5%
pH:	4.0–4.5
Bitterness International Bitterness Units (IBUs or BUs):	30–60
Bitterness Perception (*comment*):	medium–high
Hop Flavor (*comment*):	none
Hop Aroma (*comment*):	none
Esters Perception (*comment*):	low–medium
Diacetyl ppm (*perception*):	0.05–0.15 (low–medium)
CO_2 Volumes:	2.3–2.6
Body/Mouth Feel (*comment*):	medium–full
Color (SRM):	40 +
Color Character:	black–opaque

Miscellaneous Comments: Characterized by roasted barley, caramel and sweet malt taste. Some slight acidity. Bitterness from the roasted barley may be perceived.

Type: Ale
Style: Stout
Substyle: Sweet Stout

Original Extract Degrees Balling (*specific gravity*):	11–14 (1.045–56)
Percent Alcohol Weight (*Volume*):	2.4–4.8% (3–6%)

Apparent Extract *Degrees Balling* (*specific gravity*):	3–5 (1.012–20)
Real Extract:	—
Apparent Degree of Actual Fermentation (*percent*):	62–70%
Apparent Limit of Attenuation (*percent*):	65–75%
Residual Fermentation Extract (*percent*):	3–7%
pH:	4.1–4.5
Bitterness *International Bitterness Units* (IBUs *or* BUs):	15–25
Bitterness Perception (*comment*):	very low–low
Hop Flavor (*comment*):	none
Hop Aroma (*comment*):	none
Esters Perception (*comment*):	very low
Diacetyl *ppm* (*perception*):	0.05–0.10 (low)
CO_2 *Volumes*:	2.0–2.4
Body/Mouth Feel (*comment*):	medium–full
Color (SRM):	40 +
Color Character:	black–opaque

Miscellaneous Comments: Characterized by mild roasted barley, caramel and very sweet malt taste. Bitterness from the roasted barley may be perceived.

Type: Ale
Style: Stout
Substyle: Imperial Stout

Original Extract *Degrees Balling* (*specific gravity*):	19–22.5 (1.075–90)
Percent Alcohol *Weight* (*Volume*):	5.6–7.2% (7–9%)
Apparent Extract *Degrees Balling* (*specific gravity*):	6–8 (1.024–32)
Real Extract:	—
Apparent Degree of Actual Fermentation (*percent*):	68–78%
Apparent Limit of Attenuation (*percent*):	70–80%
Residual Fermentation Extract (*percent*):	2–5%

pH:	4.0–4.5
Bitterness *International Bitterness Units* (IBUs *or* BUs):	50–80
Bitterness Perception (*comment*):	medium–very high
Hop Flavor (*comment*):	medium–high
Hop Aroma (*comment*):	medium–high
Esters Perception (*comment*):	medium–high
Diacetyl *ppm* (*perception*):	0.05–0.10 (low)
CO_2 *Volumes*:	1.5–2.3
Body/Mouth Feel (*comment*):	full
Color (SRM):	20+
Color Character:	dark copper–black

Miscellaneous Comments: Characterized by a rich maltiness and strong alcoholic taste with a roasted barley and caramel character.

Type: Lager
Style: Bock
Substyle: Traditional German Dark

Original Extract *Degrees Balling* (*specific gravity*):	16.5–18.5 (1.066–74)
Percent Alcohol *Weight* (*Volume*):	4.8–6% (6–7.5%)
Apparent Extract *Degrees Balling* (*specific gravity*):	4.5–6 (1.018–24)
Real Extract:	—
Apparent Degree of Actual Fermentation (*percent*):	72%
Apparent Limit of Attenuation (*percent*):	75%
Residual Fermentation Extract (*percent*):	3%
pH:	4.5–4.6
Bitterness *International Bitterness Units* (IBUs *or* BUs):	20–30
Bitterness Perception (*comment*):	low
Hop Flavor (*comment*):	noble type, low

Hop Aroma (*comment*): none
Esters Perception (*comment*): very low
Diacetyl *ppm* (*perception*): 0.07–0.14 (low–medium)
CO$_2$ *Volumes*: 2.2–2.7
Body/Mouth Feel (*comment*): full
Color (SRM): 20–30
Color Character: copper–dark brown
Miscellaneous Comments: Toasted malts give this beer its characteristic chocolaty aroma and flavor.

Type: Lager
Style: Bock
Substyle: Helles Bock

Original Extract *Degrees Balling* 16.5–17 (1.066–68)
 (*specific gravity*):
Percent Alcohol *Weight* 4.8–6% (6–7.5%)
 (*Volume*):
Apparent Extract *Degrees Balling* 3–5 (1.012–20)
 (*specific gravity*):
Real Extract: 5.7–6.5
Apparent Degree of Actual 75–81%
 Fermentation (*percent*):
Apparent Limit of Attenuation 77–87%
 (*percent*):
Residual Fermentation Extract 2–8%
 (*percent*):
pH: 4.5–4.7
Bitterness *International Bitterness* 20–35
 Units (IBUs *or* BUs):
Bitterness Perception low
 (*comment*):
Hop Flavor (*comment*): noble type, low–medium
Hop Aroma (*comment*): noble type, very
 low–medium
Esters Perception (*comment*): very low
Diacetyl *ppm* (*perception*): 0.07–0.10 (low)
CO$_2$ *Volumes*: 2.16–2.73
Body/Mouth Feel (*comment*): medium–full
Color (SRM): 4.5–6
Color Character: pale–gold
Miscellaneous Comments: Characterized by a malty aroma.

Type: Lager
Style: Bock
Substyle: Doppelbock

Original Extract Degrees Balling (specific gravity):	18.5–20 (1.074–80)
Percent Alcohol Weight (Volume):	5.2–6.4% (6.5–8%)
Apparent Extract Degrees Balling (specific gravity):	5–7 (1.020–28)
Real Extract:	6.8–8.5
Apparent Degree of Actual Fermentation (percent):	67–79%
Apparent Limit of Attenuation (percent):	76–82%
Residual Fermentation Extract (percent):	2.5–3%
pH:	4.5–4.6
Bitterness International Bitterness Units (IBUs or BUs):	17–27
Bitterness Perception (comment):	low
Hop Flavor (comment):	noble type, low
Hop Aroma (comment):	none
Esters Perception (comment):	low
Diacetyl ppm (perception):	0.07–0.1 (low)
CO_2 Volumes:	2.26–2.62
Body/Mouth Feel (comment):	full
Color (SRM):	12–30
Color Character:	amber–dark brown

Miscellaneous Comments: Characterized by malt sweetness in aroma and flavor. Alcohol is evident.

Type: Lager
Style: Bock
Substyle: Eisbock

Original Extract Degrees Balling (specific gravity):	23–29 (1.092–1.116)
Percent Alcohol Weight (Volume):	6.9–11.5% (8.6–14.4%)
Apparent Extract Degrees Balling (specific gravity):	NA

Real Extract:	8.2–12.2
Apparent Degree of Actual Fermentation (*percent*):	65–70%
Apparent Limit of Attenuation (*percent*):	70–76%
Residual Fermentation Extract (*percent*):	5–8%
pH:	4.4–4.7
Bitterness *International Bitterness Units* (IBUs *or* BUs):	26–33
Bitterness Perception (*comment*):	low
Hop Flavor (*comment*):	noble type, low
Hop Aroma (*comment*):	none
Esters Perception (*comment*):	low–medium
Diacetyl *ppm* (*perception*):	0.05–0.07 (low)
CO_2 *Volumes*:	2.37
Body/Mouth Feel (*comment*):	very full
Color (SRM):	18–50
Color Character:	deep copper–black

Miscellaneous Comments: A very alcoholic beer. Characterized by malty and sweet taste. Alcohol may be concentrated by freezing the finished beer.

Type: Lager
Style: Bavarian Dark
Substyle: Munich Dunkel

Original Extract *Degrees Balling* (*specific gravity*):	13–14 (1.052–56)
Percent Alcohol *Weight* (*Volume*):	3.6–4% (4.5–5%)
Apparent Extract *Degrees Balling* (*specific gravity*):	3.5–4.5 (1.014–18)
Real Extract:	4.7–5.8
Apparent Degree of Actual Fermentation (*percent*):	70.2–78.5%
Apparent Limit of Attenuation (*percent*):	71.6–83.6%
Residual Fermentation Extract (*percent*):	1.4–5.9%
pH:	4.3–4.5

Bitterness International Bitterness Units (IBUs or BUs):	16–25
Bitterness Perception (comment):	medium
Hop Flavor (comment):	noble type, low
Hop Aroma (comment):	noble type, low
Esters Perception (comment):	none
Diacetyl ppm (perception):	0.05–0.1 (low)
CO$_2$ Volumes:	2.21–2.66
Body/Mouth Feel (comment):	medium
Color (SRM):	17–23
Color Character:	deep copper–dark brown

Miscellaneous Comments: Characterized by a nutty, toasted, chocolaty malt sweetness in aroma and flavor.

Type: Lager
Style: Bavarian Dark
Substyle: Schwarzbier

Original Extract Degrees Balling (specific gravity):	11–13 (1.044–52)
Percent Alcohol Weight (Volume):	3–4% (3.8–5%)
Apparent Extract Degrees Balling (specific gravity):	3–4 (1.012–16)
Real Extract:	—
Apparent Degree of Actual Fermentation (percent):	72–78%
Apparent Limit of Attenuation (percent):	73–78%
Residual Fermentation Extract (percent):	1–2%
pH:	4.3–4.5
Bitterness International Bitterness Units (IBUs or BUs):	22–30
Bitterness Perception (comment):	low–medium
Hop Flavor (comment):	noble type, low
Hop Aroma (comment):	noble type, low
Esters Perception (comment):	none

Diacetyl *ppm* (*perception*):	0.03–0.10 (low)
CO_2 Volumes:	2.2–2.6
Body/Mouth Feel (*comment*):	medium
Color (SRM):	25–30
Color Character:	dark brown–black

Miscellaneous Comments: Characterized by a roast malt flavor but a low roast malt bitterness and low sweetness in aroma and flavor.

Type:	Lager
Style:	American Dark
Substyle:	American Dark

Original Extract *Degrees Balling* (*specific gravity*):	10–12.5 (1.040–50)
Percent Alcohol *Weight* (*Volume*):	3.2–4.4% (4–5.5%)
Apparent Extract *Degrees Balling* (*specific gravity*):	2–3 (1.008–12)
Real Extract:	—
Apparent Degree of Actual Fermentation (*percent*):	76–84%
Apparent Limit of Attenuation (*percent*):	77–85%
Residual Fermentation Extract (*percent*):	1.5–3%
pH:	4.2–4.4
Bitterness *International Bitterness Units* (IBUs *or* BUs):	14–20
Bitterness Perception (*comment*):	low
Hop Flavor (*comment*):	low
Hop Aroma (*comment*):	low
Esters Perception (*comment*):	none
Diacetyl *ppm* (*perception*):	0.01–0.07 (none–low)
CO_2 Volumes:	2.5–2.7
Body/Mouth Feel (*comment*):	light–medium
Color (SRM):	10–20
Color Character:	deep copper–dark brown

Miscellaneous Comments: Characterized by a low malt aroma and flavor.

Type: Lager
Style: Dortmund/Export
Substyle: Dortmund/Export

Original Extract Degrees Balling (specific gravity):	12–14 (1.048–56)
Percent Alcohol Weight (Volume):	3.8–4.8% (4.8–6%)
Apparent Extract Degrees Balling (specific gravity):	2.5–3.5 (1.010–14)
Real Extract:	4.2–4.5
Apparent Degree of Actual Fermentation (percent):	80–83%
Apparent Limit of Attenuation (percent):	80–87%
Residual Fermentation Extract (percent):	0–4%
pH:	4.4–4.5
Bitterness International Bitterness Units (IBUs or BUs):	23–29
Bitterness Perception (comment):	medium
Hop Flavor (comment):	noble type, low
Hop Aroma (comment):	noble type, low
Esters Perception (comment):	none
Diacetyl ppm (perception):	0.01–0.05 (none)
CO$_2$ Volumes:	2.57
Body/Mouth Feel (comment):	medium
Color (SRM):	4–6
Color Character:	very pale–golden

Miscellaneous Comments: Characterized by a medium malty sweetness.

Type: Lager
Style: Munich Helles
Substyle: Munich Helles

Original Extract Degrees Balling (specific gravity):	11–13 (1.044–52)
Percent Alcohol Weight (Volume):	3.6–4.4% (4.5–5.5%)
Apparent Extract Degrees Balling (specific gravity):	2–3 (1.008–12)

Real Extract:	3.6–4.1
Apparent Degree of Actual Fermentation (*percent*):	81–85%
Apparent Limit of Attenuation (*percent*):	83–87%
Residual Fermentation Extract (*percent*):	1.5–2.5%
pH:	4.4–4.6
Bitterness International Bitterness Units (IBUs *or* BUs):	18–25
Bitterness Perception (*comment*):	low
Hop Flavor (*comment*):	noble type, low
Hop Aroma (*comment*):	noble type, low
Esters Perception (*comment*):	none
Diacetyl *ppm* (*perception*):	0.05–0.10 (low)
CO_2 Volumes:	2.26–2.68
Body/Mouth Feel (*comment*):	medium
Color (SRM):	3–5
Color Character:	very pale–golden

Miscellaneous Comments: Characterized by medium malty sweetness.

Type:	Lager
Style:	Classic Pilsener
Substyle:	German Pilsener

Original Extract D*egrees Balling* (*specific gravity*):	11–12.5 (1.044–50)
Percent Alcohol W*eight* (*Volume*):	3.2–4.0% (4–5%)
Apparent Extract D*egrees Balling* (*specific gravity*):	2–3 (1.006–12)
Real Extract:	3.8–4.2
Apparent Degree of Actual Fermentation (*percent*):	76–83%
Apparent Limit of Attenuation (*percent*):	77–84%
Residual Fermentation Extract (*percent*):	0.5–1.5%
pH:	4.2–4.5
Bitterness International Bitterness Units (IBUs *or* BUs):	30–40

Bitterness Perception medium–high
 (comment):
Hop Flavor (comment): noble type, low–medium
Hop Aroma (comment): noble type, medium
Esters Perception (comment): none
Diacetyl ppm (perception): 0.03–0.08 (low)
CO_2 Volumes: 2.52
Body/Mouth Feel (comment): light–medium
Color (SRM): 2.5–4
Color Character: very pale–pale
Miscellaneous Comments: Characterized by low maltiness in aroma
 and flavor.

Type: Lager
Style: Classic Pilsener
Substyle: Bohemian Pilsener

Original Extract *Degrees Balling* 11–14 (1.044–56)
 (*specific gravity*):
Percent Alcohol *Weight* 3.2–4% (4–5%)
 (*Volume*):
Apparent Extract *Degrees Balling* 3.5–5 (1.014–20)
 (*specific gravity*):
Real Extract: —
Apparent Degree of Actual 65–75%
 Fermentation (*percent*):
Apparent Limit of Attenuation 67–78%
 (*percent*):
Residual Fermentation Extract 2–4%
 (*percent*):
pH: 4.4–4.6
Bitterness *International Bitterness* 35–45
 Units (IBUs *or* BUs):
Bitterness Perception medium–high
 (comment):
Hop Flavor (comment): noble type, low–medium
Hop Aroma (comment): noble type, low–medium
Esters Perception (comment): none
Diacetyl ppm (perception): 0.07–0.20 (low–medium)
CO_2 Volumes: 2.3–2.5
Body/Mouth Feel (comment): light–medium
Color (SRM): 3–5

Color Character: pale–golden
Miscellaneous Comments: Characterized by a low to medium maltiness in aroma and flavor.

Type: Lager
Style: American Light Lager
Substyle: Diet/"Lite"

Original Extract *Degrees Balling* (*specific gravity*) :	6–10 (1.024–1.040)
Percent Alcohol *Weight* (*Volume*):	2.4–3.4% (2.9–4.2%)
Apparent Extract *Degrees Balling* (*specific gravity*):	0.5–2 (1.002–8)
Real Extract:	1–3.9
Apparent Degree of Actual Fermentation (*percent*):	78–101%
Apparent Limit of Attenuation (*percent*):	78–101%
Residual Fermentation Extract (*percent*):	0%
pH:	4.3–4.5
Bitterness *International Bitterness Units* (IBUs *or* BUs):	8–15
Bitterness Perception (*comment*):	very low–low
Hop Flavor (*comment*):	none
Hop Aroma (*comment*):	none
Esters Perception (*comment*):	none
Diacetyl *ppm* (*perception*):	0.01–0.03 (none)
CO_2 *Volumes*:	2.57
Body/Mouth Feel (*comment*):	light
Color (SRM):	2–4
Color Character:	very pale

Miscellaneous Comments: This style has no malt aroma or flavor.

Type: Lager
Style: American Light Lager
Substyle: American Standard

Original Extract *Degrees Balling* (*specific gravity*):	10–11.5 (1.040–46)

Percent Alcohol Weight (Volume): 3.0–3.6% (3.8–4.5%)

Apparent Extract Degrees Balling (specific gravity): 1.5–2.5 (1.006–10)

Real Extract: 3.8–4.3

Apparent Degree of Actual Fermentation (percent): 77–88%

Apparent Limit of Attenuation (percent): 77–88%

Residual Fermentation Extract (percent): 0%

pH: 4.1–4.6

Bitterness International Bitterness Units (IBUs or BUs): 5–17

Bitterness Perception (comment): low

Hop Flavor (comment): very low

Hop Aroma (comment): very low

Esters Perception (comment): none

Diacetyl ppm (perception): 0.01–0.03 (none)

CO_2 Volumes: 2.57

Body/Mouth Feel (comment): light

Color (SRM): 2–4

Color Character: very pale

Miscellaneous Comments: Characterized by a low malt aroma and flavor.

Type: Lager
Style: American Light Lager
Substyle: American Premium

Original Extract Degrees Balling (specific gravity): 11.5–12.5 (1.046–50)

Percent Alcohol Weight (Volume): 3.4–4% (4.3–5%)

Apparent Extract Degrees Balling (specific gravity): 2.5–3.5 (1.010–14)

Real Extract: 4.1–4.5

Apparent Degree of Actual Fermentation (percent): 76–81%

Apparent Limit of Attenuation (percent): 77–81%

Residual Fermentation Extract (*percent*):	1–3%
pH:	4.4–4.5
Bitterness *International Bitterness Units* (IBUs *or* BUs):	13–23
Bitterness Perception (*comment*):	low–medium
Hop Flavor (*comment*):	low
Hop Aroma (*comment*):	low
Esters Perception (*comment*):	none
Diacetyl *ppm* (*perception*):	0.03–0.04 (none)
CO_2 *Volumes*:	2.57–2.73
Body/Mouth Feel (*comment*):	light–light medium
Color (SRM):	2–5
Color Character:	pale–golden

Miscellaneous Comments: Characterized by low malt aroma and flavor.

Type: Lager
Style: American Light Lager
Substyle: Dry

Original Extract *Degrees Balling* (*specific gravity*):	10–12.5 (1.040–50)
Percent Alcohol *Weight* (*Volume*):	3.6–4.5% (4.5–5.6%)
Apparent Extract *Degrees Balling* (*specific gravity*):	1–2 (1.004–8)
Real Extract:	—
Apparent Degree of Actual Fermentation (*percent*):	80–90%
Apparent Limit of Attenuation (*percent*):	80–90%
Residual Fermentation Extract (*percent*):	0–1%
pH:	4.2–4.5
Bitterness *International Bitterness Units* (IBUs *or* BUs):	15–23
Bitterness Perception (*comment*):	low–medium
Hop Flavor (*comment*):	low
Hop Aroma (*comment*):	low

Esters Perception (*comment*): none
Diacetyl *ppm* (*perception*): 0.02–0.03 (none)
CO_2 Volumes: 2.6–2.7
Body/Mouth Feel (*comment*): light
Color (SRM): 2–4
Color Character: pale–golden
Miscellaneous Comments: This style has no lingering aftertaste
 and low malt aroma and flavor.

Type: Lager
Style: Vienna/Oktoberfest/Märzen
Substyle: Vienna

Original Extract *Degrees Balling* 12–13.5 (1.048–55)
 (*specific gravity*):
Percent Alcohol *Weight* 3.6–4.7% (4.5–5.9%)
 (*Volume*):
Apparent Extract *Degrees Balling* 3–4.5 (1.012–18)
 (*specific gravity*):
Real Extract: —
Apparent Degree of Actual 74–83%
 Fermentation (*percent*):
Apparent Limit of Attenuation 75–85%
 (*percent*):
Residual Fermentation Extract 1–5%
 (*percent*):
pH: 4.3–4.6
Bitterness *International Bitterness* 22–28
 Units (IBUs):
Bitterness Perception low–medium
 (*comment*):
Hop Flavor (*comment*): noble type, low–medium
Hop Aroma (*comment*): noble type, low–medium
Esters Perception (*comment*): none
Diacetyl *ppm* (*perception*): 0.06–0.1 (low)
CO_2 Volumes: 2.4–2.6
Body/Mouth Feel (*comment*): light–medium
Color (SRM): 8–12
Color Character: amber–dark amber/
 copper
Miscellaneous Comments: Characterized by low malt sweetness
 and an evident toasted malt aroma.

Type: Lager
Style: Vienna/Oktoberfest/Märzen
Substyle: Oktoberfest/Märzen

Original Extract *Degrees Balling* (*specific gravity*):	13–16 (1.052–64)
Percent Alcohol *Weight* (*Volume*):	3.8–5.3% (4.8–6.6%)
Apparent Extract *Degrees Balling* (*specific gravity*):	3–5 (1.012–20)
Real Extract:	4.4–5.7
Apparent Degree of Actual Fermentation (*percent*):	72.9–84.3%
Apparent Limit of Attenuation (*percent*):	77.9–85.7%
Residual Fermentation Extract (*percent*):	1.4–11.6%
pH:	4.5–4.7
Bitterness *International Bitterness Units* (IBUs *or* BUs):	22–28
Bitterness Perception (*comment*):	low–medium
Hop Flavor (*comment*):	noble type, low
Hop Aroma (*comment*):	noble type, low
Esters Perception (*comment*):	none
Diacetyl *ppm* (*perception*):	0.06–0.1 (low)
CO_2 Volumes:	2.57–2.73
Body/Mouth Feel (*comment*):	medium
Color (SRM):	7–14
Color Character:	amber to dark amber/ copper

Miscellaneous Comments: Characterized by malty sweetness while toasted malt aroma and flavor are dominant.

Type: Mixed Style
Style: German Ale
Substyle: Düsseldorf-style Altbier

Original Extract *Degrees Balling* (*specific gravity*):	11–12 (1.044–48)
Percent Alcohol *Weight* (*Volume*):	3.5–4% (4.3–5%)

Apparent Extract Degrees Balling (specific gravity):	2–3.5 (1.008–14)
Real Extract:	3.9–4.5
Apparent Degree of Actual Fermentation (percent):	76–82%
Apparent Limit of Attenuation (percent):	77–83%
Residual Fermentation Extract (percent):	0–1%
pH:	4.2–4.6
Bitterness International Bitterness Units (IBUs or BUs):	25–35
Bitterness Perception (comment):	medium–high
Hop Flavor (comment):	very low
Hop Aroma (comment):	none
Esters Perception (comment):	low
Diacetyl ppm (perception):	0.02–0.06 (none–very low)
CO_2 Volumes:	2.16–3.09
Body/Mouth Feel (comment):	light–medium
Color (SRM):	11–19
Color Character:	dark amber–dark brown

Miscellaneous Comments: Typically fermented warm and aged cold.

Type: Mixed Style
Style: German Ale
Substyle: Kölsch

Original Extract Degrees Balling (specific gravity):	10.5–11.5 (1.042–46)
Percent Alcohol Weight (Volume):	3.5–4.0% (4.4–5%)
Apparent Extract Degrees Balling (specific gravity):	1.5–2.5 (1.006–10)
Real Extract:	3.65–4.1
Apparent Degree of Actual Fermentation (percent):	83–86%
Apparent Limit of Attenuation (percent):	83–86%
Residual Fermentation Extract (percent):	0.0–0.5%

pH:	4.4–4.6
Bitterness *International Bitterness Units* (IBUs *or* BUs):	20–30
Bitterness Perception (*comment*):	medium
Hop Flavor (*comment*):	low
Hop Aroma (*comment*):	low
Esters Perception (*comment*):	low
Diacetyl *ppm* (*perception*):	0.01–0.03 (none)
C0$_2$ *Volumes*:	2.42–2.73
Body/Mouth Feel (comment):	light–medium
Color (SRM):	3.5–5
Color Character:	pale gold

Miscellaneous Comments: Typically lager or ale yeast or a combination thereof is used; malted wheat is sometimes used. Characterized by a slightly winy flavor.

Type: Mixed Style
Style: Cream Ale
Substyle: Cream Ale

Original Extract *Degrees Balling* (*specific gravity*):	11–14 (1.044–55)
Percent Alcohol *Weight* (*Volume*):	3.6–5.6% (4.5–7%)
Apparent Extract *Degrees Balling* (*specific gravity*):	1–2.5 (1.004–10)
Real Extract:	—
Apparent Degree of Actual Fermentation (*percent*):	75–85%
Apparent Limit of Attenuation (*percent*):	75–85%
Residual Fermentation Extract (*percent*):	0–0.5%
pH:	4.3–4.6
Bitterness: *International Bitterness Units* (IBUs *or* BUs):	10–22
Bitterness Perception (*comment*):	low–medium
Hop Flavor (*comment*):	low
Hop Aroma (*comment*):	low
Esters Perception (*comment*):	low

Diacetyl *ppm (perception)*:	0.01–0.03 (none)
CO_2 *Volumes*:	2.6–2.7
Body/Mouth Feel *(comment)*:	light
Color (SRM):	2–4
Color Character:	very pale

Miscellaneous Comments: Lager, ale or a combination of yeasts can be used.

Type: Mixed Style
Style: Fruit Beer
Substyle: Fruit Ale or Lager

Original Extract *Degrees Balling* (*specific gravity*):	7.5–27.5 (1.030–110)
Percent Alcohol *Weight* (*Volume*):	2–9.6% (2.5–12%)
Apparent Extract *Degrees Balling* (*specific gravity*):	varies
Real Extract:	—
Apparent Degree of Actual Fermentation (*percent*):	varies
Apparent Limit of Attenuation (*percent*):	varies
Residual Fermentation Extract (*percent*):	varies
pH:	varies
Bitterness *International Bitterness Units* (IBUs or BUs):	5–70
Bitterness Perception (*comment*):	none–very high
Hop Flavor (*comment*):	none–very high
Hop Aroma (*comment*):	none–very high
Esters Perception (*comment*):	none–very high
Diacetyl *ppm (perception)*:	(low–medium)
CO_2 *Volumes*:	varies
Body/Mouth Feel (*comment*):	light–full
Color (SRM):	5–50
Color Character:	varies

Miscellaneous Comments: The character of fruit should typically be evident in color, aroma and flavor.

Type: Mixed Style
Style: Herb Beer
Substyle: Herb Ale or Lager

Original Extract *Degrees Balling* (*specific gravity*):	7.5–27.5 (1.030–110)
Percent Alcohol *Weight* (*Volume*):	2–9.6% (2.5–12%)
Apparent Extract *Degrees Balling* (*specific gravity*):	varies
Real Extract:	—
Apparent Degree of Actual Fermentation (*percent*):	varies
Apparent Limit of Attenuation (*percent*):	varies
Residual Fermentation Extract (*percent*):	varies
pH:	varies
Bitterness *International Bitterness Units* (IBUs *or* BUs):	5–70
Bitterness Perception (*comment*):	none–very high
Hop Flavor (*comment*):	none–very high
Hop Aroma (*comment*):	none–very high
Esters Perception (*comment*):	none–very high
Diacetyl *ppm* (*perception*):	(low–medium)
C0$_2$ *Volumes*:	varies
Body/Mouth Feel (*comment*):	light–full
Color (SRM):	5–50
Color Character:	varies

Miscellaneous Comments: The character of the herb or spice should typically be evident in color, aroma and flavor.

Type: Mixed Style
Style: American Wheat
Substyle: American Wheat Beer

Original Extract *Degrees Balling* (*specific gravity*):	7.5–12.5 (1.030–50)
Percent Alcohol *Weight* (*Volume*):	2.8–4% (3.5–5%)
Apparent Extract *Degrees Balling* (*specific gravity*):	1–4.5 (1.004–18)

Real Extract: —
Apparent Degree of Actual 76–84%
 Fermentation (*percent*):
Apparent Limit of Attenuation 77–85%
 (*percent*):
Residual Fermentation Extract 1–2.5%
 (*percent*):
pH: 4.1–4.4
Bitterness *International Bitterness* 5–17
 Units (IBUs *or* BUs):
Bitterness Perception low–medium
 (*comment*):
Hop Flavor (*comment*): low–medium
Hop Aroma (*comment*): low–medium
Esters Perception (*comment*): low–medium
Diacetyl *ppm* (*perception*): 0.02–0.06 (none–low)
CO_2 Volumes: 2.3–2.6
Body/Mouth Feel (*comment*): light–medium
Color (SRM): 2–8
Color Character: pale–amber

Miscellaneous Comments: This style can be either ale or lager and is usually characterized by low malt aroma and/or flavor.

Type: Mixed Style
Style: Specialty Beers
Substyle: Ales or Lagers

Original Extract *Degrees Balling* 7.5–27.5 (1.030–110)
 (*specific gravity*):
Percent Alcohol *Weight* 2–9.5% (2.5–12%)
 (*Volume*):
Apparent Extract *Degrees Balling* varies
 (*specific gravity*):
Real Extract: —
Apparent Degree of Actual varies
 Fermentation (*percent*):
Apparent Limit of Attenuation varies
 (*percent*):
Residual Fermentation Extract varies
 (*percent*):
pH: varies
Bitterness *International Bitterness* 5–70
 Units (IBUs *or* BUs):

Bitterness Perception (*comment*):	none–very high
Hop Flavor (*comment*):	none–very high
Hop Aroma (*comment*):	none–very high
Esters Perception (*comment*):	none–very high
Diacetyl *ppm* (*perception*):	(low–medium)
CO_2 *Volumes*:	varies
Body/Mouth Feel (*comment*):	light–full
Color (SRM):	5–50
Color Character:	varies

Miscellaneous Comments: Any beer brewed with unusual techniques or ingredients such as honey, maple syrup or hot rocks, which contribute to the unique overall character of the beer, in addition to or instead of malted barley.

Type:	Mixed Style
Style:	Smoked Beer
Substyle:	Bamberg-style Rauchbier

Original Extract *Degrees Balling* (*specific gravity*):	12–13 (1.048–52)
Percent Alcohol *Weight* (*Volume*):	3.5–3.8% (4.3–4.8%)
Apparent Extract *Degrees Balling* (*specific gravity*):	3–4 (1.012–16)
Real Extract:	4.7–5.8
Apparent Degree of Actual Fermentation (*percent*):	68–75%
Apparent Limit of Attenuation (*percent*):	68–81%
Residual Fermentation Extract (*percent*):	0–6%
pH:	4.4–4.5
Bitterness: *International Bitterness Units* (IBUs *or* BUs):	20–30
Bitterness Perception (*comment*):	low–medium
Hop Flavor (*comment*):	noble type, low
Hop Aroma (*comment*):	noble type, low
Esters Perception (*comment*):	none

Diacetyl ppm (*perception*):	0.05–0.07 (low)
CO$_2$ Volumes:	2.16–2.57
Body/Mouth Feel (*comment*):	medium
Color (SRM):	10–20
Color Character:	dark amber–deep brown

Miscellaneous Comments: This style is similar to Oktoberfest with a sweet, smoky aroma and flavor. The intensity of smoke is medium to high.

Type: Mixed Style
Style: Smoked Beer
Substyle: Other styles

Original Extract Degrees Balling (*specific gravity*):	—
Percent Alcohol Weight (Volume):	—
Apparent Extract Degrees Balling (*specific gravity*):	—
Real Extract:	—
Apparent Degree of Actual Fermentation (*percent*):	—
Apparent Limit of Attenuation (*percent*):	—
Residual Fermentation Extract (*percent*):	—
pH:	—
Bitterness International Bitterness Units (IBUs or BUs):	—
Bitterness Perception (*comment*):	—
Hop Flavor (*comment*):	—
Hop Aroma (*comment*):	—
Esters Perception (*comment*):	—
Diacetyl ppm (*perception*):	—
CO$_2$ Volumes:	—
Body/Mouth Feel (*comment*):	—
Color (SRM):	—
Color Character:	—

Miscellaneous Comments: The brewer specifies the style as long as smoke character is evident.

Type: Mixed Style
Style: California Common
Substyle: California Common Beer

Original Extract *Degrees Balling* (*specific gravity*):	10–14 (1.040–56)
Percent Alcohol *Weight* (*Volume*):	2.9–4% (3.6–5%)
Apparent Extract *Degrees Balling* (*specific gravity*):	3–4.5 (1.012–18)
Real Extract:	—
Apparent Degree of Actual Fermentation (*percent*):	75–85%
Apparent Limit of Attenuation (*percent*):	75–85%
Residual Fermentation Extract (*percent*):	0–1%
pH:	4.1–4.3
Bitterness *International Bitterness Units (IBUs or BUs)*:	35–45
Bitterness Perception (*comment*):	medium–high
Hop Flavor (*comment*):	medium–high
Hop Aroma (*comment*):	medium
Esters Perception (*comment*):	low
Diacetyl *ppm (perception)*:	0.03–0.1 (none–low)
CO_2 *Volumes*:	2.4–2.8
Body/Mouth Feel (*comment*):	medium
Color (SRM):	8–17
Color Character:	pale amber–deep amber

Miscellaneous Comments: Characterized by a toasted caramel-like maltiness in aroma and flavor. This beer is typically fermented warm with lager yeast and is aged cold.

Type: Mixed Style
Style: German Wheat Beer
Substyle: Berliner Weisse

Original Extract *Degrees Balling* (*specific gravity*):	7–8 (1.028–32)
Percent Alcohol *Weight* (*Volume*):	2.2–2.7% (2.8–3.4%)

Apparent Extract Degrees Balling (specific gravity):	1–1.5 (1.004–6)
Real Extract:	2.9
Apparent Degree of Actual Fermentation (percent):	75–77%
Apparent Limit of Attenuation (percent):	75–77%
Residual Fermentation Extract (percent):	0%
pH:	3.2–3.3
Bitterness International Bitterness Units (IBUs or BUs):	3–6
Bitterness Perception (comment):	none
Hop Flavor (comment):	none
Hop Aroma (comment):	none
Esters Perception (comment):	medium–high
Diacetyl ppm (perception):	0.02–0.03 (none)
CO_2 Volumes:	3.45
Body/Mouth Feel (comment):	light–dry
Color (SRM):	2–4
Color Character:	very pale–pale

Miscellaneous Comments: Characterized by sharp lactic sourness.
This style uses between 60 and 70 percent malted wheat. The
fermentation involves yeast and bacteria.

Type: Mixed Style
Style: German Wheat Beer
Substyle: German-style Weizen (Weissbier)

Original Extract Degrees Balling (specific gravity):	12–14 (1.048–56)
Percent Alcohol Weight (Volume):	3.8–4.3% (4.8–5.4%)
Apparent Extract Degrees Balling (specific gravity):	2.5–4 (1.010–16)
Real Extract:	4.0–4.9
Apparent Degree of Actual Fermentation (percent):	78–83%
Apparent Limit of Attenuation (percent):	78–84%
Residual Fermentation Extract (percent):	0–0.5%

pH: 4.2–4.4
Bitterness *International Bitterness* 10–15
 Units (IBUs *or* BUs):
Bitterness Perception low
 (*comment*):
Hop Flavor (*comment*): low
Hop Aroma (*comment*): low
Esters Perception (*comment*): medium
Diacetyl *ppm* (*perception*): 0.01–0.04 (none)
CO_2 *Volumes*: 3.6–4.48
Body/Mouth Feel (comment): light–medium
Color (SRM): 3–6
Color Character: pale–golden
Miscellaneous Comments: Typically 50 percent or more wheat malt
 is used. Often characterized by clovelike and mild bananalike
 character. A mild sourness is acceptable.

Type: Mixed Style
Style: German Wheat Beer
Substyle: German-style Dunkelweizen

Original Extract *Degrees Balling* 12–14 (1.048–56)
 (*specific gravity*):
Percent Alcohol *Weight* 3.8–4.3% (4.8–5.4%)
 (*Volume*):
Apparent Extract *Degrees Balling* 2.5–4 (1.010–16)
 (*specific gravity*):
Real Extract: —
Apparent Degree of Actual 75–82%
 Fermentation (*percent*):
Apparent Limit of Attenuation 75–83%
 (*percent*):
Residual Fermentation Extract 0–1%
 (*percent*):
pH: 4.1–4.4
Bitterness *International Bitterness* 10–15
 Units (IBUs *or* BUs):
Bitterness Perception low
 (*comment*):
Hop Flavor (*comment*): low
Hop Aroma (*comment*): low
Esters Perception (*comment*): medium
Diacetyl *ppm* (*perception*): 0.04–0.08 (low)
CO_2 *Volumes*: 3.6–4.48

Body/Mouth Feel (*comment*):	light–medium
Color (SRM):	17–22
Color Character:	dark copper–brown

Miscellaneous Comments: Typically 50 percent or more wheat malt is used. Often characterized by clovelike and mild bananalike character and chocolaty maltiness. A very mild sourness is acceptable for this style.

Type: Mixed Style
Style: German Wheat Beer
Substyle: German-style Weizenbock

Original Extract *Degrees Balling* (*specific gravity*):	16–18 (1.064–72)
Percent Alcohol *Weight* (*Volume*):	5.2–6% (6.5–7.5%)
Apparent Extract *Degrees Balling* (*specific gravity*):	4.5–7 (1.018–28)
Real Extract:	5.8–6.6
Apparent Degree of Actual Fermentation (*percent*):	75–80%
Apparent Limit of Attenuation (*percent*):	75–80%
Residual Fermentation Extract (*percent*):	0–1%
pH:	4.3–4.5
Bitterness: *International Bitterness Units* (IBUs *or* BUs):	10–15
Bitterness Perception (*comment*):	low
Hop Flavor (*comment*):	none
Hop Aroma (*comment*):	none
Esters Perception (*comment*):	medium
Diacetyl *ppm* (*perception*):	0.01–0.02 (none)
CO_2 *Volumes*:	3.71–4.74
Body/Mouth Feel (*comment*):	medium–full
Color (SRM):	7–30
Color Character:	amber–dark brown

Miscellaneous Comments: Typically 50 percent or more wheat malt is used. Often characterized by clovelike and mild bananalike character and chocolaty maltiness. A mild sourness is acceptable for this style.

BIBLIOGRAPHY OF RESOURCES FOR BEER STYLE GUIDELINES

American Homebrewers Association. *zymurgy*. Boulder, Colo.: 1979–1992.

Eckhardt, Fred. *Essentials of Beer Style*. Portland, Oreg.: Fred Eckhardt Associates, 1989.

Fix, Dr. George. *Vienna*. Boulder, Colo.: Brewers Publications, 1992.

Foster, Terry. *Pale Ale*. Boulder, Colo.: Brewers Publications, 1992.

Guinard, Jean-Xavier. *Lambic*. Boulder, Colo.: Brewers Publications, 1990.

Institute for Brewing Studies. *The New Brewer*. Boulder, Colo.: 1983–1991.

Jackson, Michael. *The Simon and Schuster Pocket Guide To Beer*. New York: Simon and Schuster, Inc., 1991.

————. *World Guide to Beer*. Philadelphia: Running Press, 1989.

Kieninger, Dr. Helmut. "The Influences on Beer Making," *Best of Beer and Brewing*, vol. 1–5. Boulder, Colo.: Brewers Publications, 1987.

Miller, Dave. *Continental Pilsener*. Boulder, Colo.: Brewers Publications, 1990.

Narziss, L. "Types of Beer." *Brauwelt International* II/1991.

Peindl, Professor Anton. From the series "Biere Aus Aller Welt." *Brauindustrie*. Schloss Mindelburg, Germany, 1982–1991.

Rajotte, Pierre. *Belgian Ales*. Boulder, Colo.: Brewers Publications, 1992.

Warner, Eric. *German Wheat Beer*. Boulder, Colo.: Brewers Publications, 1992.

Other Resources

J.E. Siebel and Sons, Chicago, Ill.

The American Homebrewers Association National Competition Committee.

Fred Scheer, Brewmaster, Frankenmuth Brewery, Frankenmuth, Mich.

The Great American Beer Festival[sm] Professional Tasting Panel.

BIBLIOGRAPHY OF RESOURCES FOR BEER STYLE GUIDELINES

Other Resources

BEER RECIPES

So tell me the truth, is this the first section you turned to upon first reviewing this book? Everyone appreciates recipes, even the master brewer. As it is with most master chefs, it is with master brewers—recipes serve as guidelines and a source of ideas. The skilled homebrewer will consult a recipe or perhaps a number of similar recipes and brew something that is actually an interpretation of the original.

By now we can all appreciate the incredible number of variables during the brewing and fermentation processes—ingredients, equipment, process and handling—that are absolutely different with every brewer. A recipe can offer a meaningful target, but the nuances of your homebrewing system must be taken into consideration. Yours will be a different, but similar beer.

If you've read this book from the beginning, you will read these recipes knowing how to tweak the hops, adjust the grind, control the temperature, culture your yeast or adapt your water in order to maximize the efficiency of whatever brewing system you've put together. More or less, higher and lower, shorter and longer, this for that—you'll be taking into consideration a lot of information and applying the invaluable asset of your own brewing experience.

Use the recipes as they are or feel free to adapt them to your own situation. Whatever you brew will certainly serve as a homebrewer's companion during your next brewing session.

TABLE OF RECIPES

(continued)

TABLE OF RECIPES (*continued*)

TABLE OF RECIPES (*continued*)

A FEW ASSUMPTIONS

- Whole hops are used in all recipes, unless otherwise specified. If using hop pellets, you may wish to reduce hop amounts 10 to 15 percent when considering bitterness contribution.

- Bitterness units will always refer to International Bitter Units and not Homebrew Bittering Units unless explicitly mentioned.

- A concentrated wort boil is done for all malt extract or mash-extract recipes. If a full wort boil is used, you may wish to reduce the hop rates to about 75 percent of the amount called for in the recipe when considering bitterness and hop utilization.

- Mashing systems are assumed to be about 80 to 90 percent efficient. For less efficient systems, more grain may be needed to match recipe yields. Extract ratings of your grain may vary from one purchase to another and especially from one crop to another. Anticipate a ±5 percent variation with small 5-gallon batch brewing.

- Dissolved minerals in brewing water can affect extract yield in mashing. Recipes assume the use of soft, noncarbonate water. Adjust amount of malt and lautering techniques if carbonate water is used.

- Dissolved minerals can affect the hop utilization and especially the perception of bitterness. Recipes assume the use of soft water unless otherwise noted. If minerals such as sulfate for Burton-type pale ales are added (or are present in your water), then adjust your hopping rates to compensate for the effect of the minerals.

- Relatively ideal fermentation temperatures are assumed in describing the character of beer resulting from each recipe. If you have less than ideal temperature control, you may wish to adapt by experimenting with yeast strains that minimize the effect of having less than ideal fermentation temperatures.

- A quality liquid culture of ale or lager yeast is always assumed. Sometimes a specific strain will be recommended, but you should use your own experience to determine which strain will work best for you.

- Color is indicated in degrees SRM.

- Original gravity (OG) and final gravity (FG) are in units of specific gravity (and degrees Balling).

HOP UTILIZATION BASED ON DENSITY OF BOILED WORT AND BOILING TIME

In Percent Utilization

(From *The New Complete Joy of Home Brewing*, Avon, 1991)

Approx. Specific Gravity of Boil (B)	1.040 (10)	1.070 (17.5)	1.110 (28)	1.130 (32.5)	1.150 (37.5)
Lbs. of Malt Extract per Gallon of Boiling Water	1	2	3	4	5
Time of Boil					
15 minutes	8%	7%	6%	6%	5%
30 minutes	15%	14%	12%	11%	10%
45 minutes	27%	24%	21%	19%	18%
60 minutes	30%	27%	23%	21%	20%

ALES

PALE ALES

Tits Up in the Mud Pale Ale (Malt Extract)

This one has to do with happy pigs, but everyone is entitled to his or her own vision; after all, that's what great beer is all about—vision, that is. Tits Up in the Mud Pale Ale is exactly what you've tasted fresh at the local pub somewhere in England. There's a definitive dose of the most excellent of English hops that contributes to the crisp, clean bite. It recalls the character of pale ales you're likely to find around London or in the southern hop-growing areas of England. The aroma, the appearance, the taste, the sound and the quench of a thirsty throat will warm the cockles of your heart. Surely shut your eyes and feel as happy as a pig lying tits up in the mud.

Ingredients for 5 gallons (19 l.)

5 lbs. (2.27 kg.) light dried English malt extract
0.4 lb. (0.18 kg.) 40 Lovibond dark crystal/caramel malt
$1\frac{1}{2}$ oz. (43 g.) Kent Goldings hops (boiling): 7 HBU
$\frac{1}{2}$ oz. (14.2 g.) Styrian Goldings hops (flavor): 2.5 HBU
$\frac{1}{2}$ oz. (14.2 g.) Kent Goldings hops (aroma)
$\frac{1}{2}$ oz. (14.2 g.) Kent Goldings hops (dry hop)
2 tbsp. (15.6 g.) gypsum (calcium sulfate)
$\frac{1}{4}$ tsp. (1 g.) powdered Irish moss
Ale yeast
$\frac{3}{4}$ c. (178 ml.) corn sugar or $1\frac{1}{4}$ c. (296 ml.) dried malt extract (for bottling)

BUs: 28
Color: 6–9
OG: 1.040–1.042 (10–10.5)
FG: 1.008–1.012 (2–3)

Add the crushed crystal malt to 2 gallons of 150-degree F (66 C) water and hold for 30 minutes. Remove the grains with a strainer and add malt extract, boiling hops and gypsum. Boil for 45 minutes, then add flavor hops and Irish moss and boil for an additional 15 minutes. Turn off heat. Add aroma hops and let steep for 2 to 3 minutes before sparging the hot wort into a fermenter partly filled with cold water. Pitch the yeast when cool. After primary fermentation is complete, transfer the beer into a secondary fermenter, add dry hops and allow beer to finish fermentation. Bottle when fermentation is complete. Avoid bottling spent aroma hops.

This style lends itself especially well to kegging. Use only $\frac{1}{3}$ cup corn sugar or $\frac{1}{2}$ cup dried extract if keg-conditioning.

Bababa Bo Amber Ale (Malt Extract)

Crazy. Just crazy. Crazy about brew.

So you like English-style ales? You like them bitter, mild, tawny or light. Pint after pint you've sampled the best, and there seems to be so much variation. You've come to the conclusion that you like them all; there isn't a best. It depends on your mood and the company. Indeed, there are so many great English bitters throughout the English countryside. Somewhere and sometime you'll come across an English bitter akin to Bababa Bo Amber Ale. Perhaps north of London in the midlands where they prefer their ales a bit more malty than in the South.

The bitterness level in this homebrewed pale ale is somewhat lower than in most traditional English bitters, but the lower bitterness is balanced nicely with excellent hop flavor and aroma. A good dose of crystal malt lends a fresh caramel character that increases Bababa Bo's drinkability. A favorite that you will brew more than once—I am sure.

Ingredients for 5 gallons (19 l.)

5 lbs. (2.27 kg.) light dried English malt extract
1.1 lbs. (0.5 kg.) 20 Lovibond dark crystal/caramel malt
0.2 lb. (0.09 kg.) chocolate malt
1.1 oz. (31 g.) Styrian Goldings hops (boiling): 5.8 HBU
0.4 oz. (11.3 g.) Styrian Goldings hops (flavor): 2.1 HBU

0.4 oz. (11.3 g.) Styrian Goldings hops (aroma)
0.2 oz. (5.7 g.) Cascade hops (aroma)
0.2 oz. (5.7 g.) Tettnanger hops (aroma)
2 tbsp. (15.6 g.) gypsum (calcium sulfate)
$\frac{1}{4}$ tsp. (1 g.) powdered Irish moss
Ale yeast
$\frac{3}{4}$ c. (178 ml.) corn sugar or $1\frac{1}{4}$ c. (296 ml.) dried malt extract (for bottling)

BUs: 22
Color: 8–12
OG: 1.040–1.042 (10–10.5)
FG: 1.010–1.014 (2.5–3.5)

Add the crushed crystal and chocolate malts to 2 gallons of 150-degree F (66 C) water and hold for 30 minutes. Remove the grains with a strainer and add malt extract, boiling hops and gypsum. Boil for 45 minutes, then add flavor hops and Irish moss and boil for an additional 15 minutes. Turn off heat. Add aroma hops and let steep for 2 to 3 minutes before sparging the hot wort into a fermenter partly filled with cold water. Pitch the yeast when cool, and bottle when fermentation is complete.

Jack Union's Classic Pale Ale (All Grain)

Let's wave the real flag of Great Britain. Fuggles and Goldings on a field of amber grain. Yes, that would be a flag we would all salute and respect, whether we're loyal, royal or Yank. A pint of tradition. True English malts and some of the finest varieties of hops blend to make Jack Union's Classic Pale Ale one of the most memorable English-style ales you'll ever brew. In the bottle call it a pale ale. On draft, let's call it something a little bit more than ordinary. I prefer special bitter because it's homebrewed and every bit as close as you could ever be to English soil.

Ingredients for 5 gallons (19 l.)

6 lbs. (2.7 kg.) English two-row pale ale malt
1 lb. (0.45 kg.) 40–50 Lovibond English crystal/caramel malt
1 oz. (28.4 g.) English Fuggles hops (boiling): 5 HBU
0.4 oz. (11.3 g.) English Kent Goldings hops (boiling): 2 HBU
0.4 oz. (11.3 g.) English Kent Goldings hops (flavor): 2 HBU
1 oz. (28.4 g.) English Kent Goldings hops (aroma)
2 tbsp. (15.6 g.) gypsum (calcium sulfate)

$\frac{1}{4}$ tsp. (1 g.) powdered Irish moss
Ale yeast
$\frac{3}{4}$ c. (178 ml.) corn sugar or $1\frac{1}{4}$ c. (296 ml.) dried malt extract (for bottling)

BUs: 34
Color: 7–12
OG: 1.045–1.049 (11–12)
FG: 1.010–1.014 (2.5–3.5)

Use a single-step infusion mash schedule for this recipe. Add gypsum to very soft water at a rate of 2 tablespoons (15.6 g.) per 5 gallons (19 l.) of water.

Add crushed malts to 1.75 gallons (6.7 l.) of 168-degree F (76 C) water. The mash will stabilize at 150 to 155 degrees F (66–67 C). Hold this temperature for 60 minutes.

Sparge with 4 to 4.5 gallons of 170-degree F (77 C) water. Add more water (do not oversparge) to brewpot to make an initial extract volume of 6 gallons (22.8 l.). Anticipate evaporation of 1 gallon (3.8 l.). Add boiling hops and boil for 75 minutes. Then add flavor hops and Irish moss and boil for an additional 15 minutes. Total boiling time is 90 minutes. Turn off heat. Add aroma hops and let steep for 2 to 3 minutes before removing hops and chilling the hot wort. Pitch the yeast when cool, and bottle when fermentation is complete.

BROWN ALES

Colorado Cowgirl's American Brown Ale (Malt Extract)

There are a lot of things American: apple pie, Thanksgiving, canyon-lands, hot dogs, baseball, Lyle Lovett and Nanci Griffith. I live in Colorado and I know that in the mountains and on the plains, Colorado cowgirls are out there. Doing what cowgirls do.

I sip my new brown ale. It's medium-bodied, brown, righteously bitter with a hoppy aroma and flavor. Nothing like an English-style sweeter brown ale. This is all-American to me. An invention of American homebrewers who know no limits when it comes to hops.

Its assertive bitterness will quench a dusty thirst.

Ingredients for 5 gallons (19 l.)

6.6 lbs. (3 kg.) Amber malt extract syrup
1 lb. (0.45 kg.) 20–80 Lovibond crystal/caramel malt
5 oz. (0.142 kg.) chocolate malt
2 oz. (57 g.) Williamette hops (boiling): 10 HBU
1 oz. (28.4 g.) Fuggles or Goldings hops (flavor): 5 HBU
$\frac{3}{4}$ oz. (21.3 g.) your favorite finishing hop for aroma
2 tbsp. (15.6 g.) gypsum (if your water is very soft)
Ale yeast
$\frac{3}{4}$ c. (178 ml.) corn sugar or $1\frac{1}{4}$ c. dried malt extract for bottle priming.

BUs: 42
Color: 15–20
OG: 1.045–1.049 (11–12)
FG: 1.010–1.014 (2.5–3.5)

Add crushed crystal and chocolate malts to 2 gallons of 150-degree F (66 C) water and hold for 30 minutes. Remove the grains with a strainer and add malt extract, boiling hops and gypsum. Boil for 30 minutes, then add flavor hops and Irish moss and boil for an additional 30 minutes. Turn off heat. Add aroma hops and let steep for 2 to 3 minutes before sparging the hot wort into a fermenter partly filled with cold water. Pitch the yeast when cool, and bottle when fermentation is complete.

Wait a couple of weeks or so and then relax, don't worry and toast a homebrew to some of the prettiest girls in all the land, Colorado cowgirls.

Saunders's Nut Brown Ale (Malt Extract)

My friend Michael Saunders once pleaded, "I want something like Samuel Smith's Nut Brown Ale. Can we make something like that?" "Of course."

Caramel-like sweetness, relatively low bitterness, and the gentle nuttiness of roasted malts and barley, but a wee bit on the alcoholic side for an everyday session beer, unless your day was like mine the

MIKE SAUNDERS FINALLY
FINDS HIS BEER...

other day. No complaints here, and I'm sure if you like nut brown ales, there'll be no complaints coming from your neck of the woods.

Ingredients for 5 gallons (19 l.)

6.6 lbs. (3 kg.) plain light English malt extract syrup
$1\frac{1}{2}$ lbs. (0.68 kg.) 40–80 Lovibond dark crystal/caramel malt
$2\frac{1}{2}$ oz. (70 g.) chocolate malt
$2\frac{1}{2}$ oz. (70 g.) roasted barley
1 oz. (28.4 g.) Styrian Goldings hops (boiling): 5 HBU
1 oz. (28.4 g.) Styrian Goldings hops (flavor): 5 HBU
$\frac{1}{2}$ oz. (28.4 g.) Styrian or Kent Goldings hops (aroma)
$\frac{1}{4}$ oz. (7 g.) Cascade hops (aroma)
$\frac{1}{4}$ tsp. (1 g.) powdered Irish moss
Ale yeast
$\frac{3}{4}$ c. (178 ml.) corn sugar or $1\frac{1}{4}$ c. (296 ml.) dried malt extract (for bottling)

BUs: 21
Color: 17–22
OG: 1.054–1.058 (13.5–14.5)
FG: 1.014–1.018 (3.5–4.5)

Add the crushed crystal malt, chocolate malt and roasted barley to 2 gallons of 150-degree F (66 C) water and hold for 30 minutes. Remove the grains with a strainer and add malt extract and boiling hops. Boil for 45 minutes, then add flavor hops and Irish moss and boil for an additional 15 minutes. Turn off heat. Add aroma hops and let steep for 2 to 3 minutes before sparging the hot wort into a fer-

menter partly filled with cold water. Pitch the yeast when cool, and bottle when fermentation is complete.

Buzzdigh Moog Double Brown Ale (All Grain)

Double brown does not refer to the color! This beer is brewed to the tune of English-style sweetness. Buzzdigh Moog Double Brown Ale is high in BUs but balanced with a lot of malt. The richness of Munich, Vienna and crystal malts combine for a deceivingly smooth and rich ale, complemented with the velvety chocolatelike character of roasted malts. The warmth of alcohol and fruitiness of a strong ale mingle with the barely perceived Cascade hop aroma. This ale ages nicely and may take 4 to 6 months in the bottle to reach its peak.

Double brown is to English brown ale as doppelbock is to German bock, but I doubt you'll ever see this available in England—unless, of course, they have a copy of this recipe.

And what about "Buzzdigh Moog"? My grandparents use to call my brothers and me that when we were very small. In Armenian it kind of means "small, playful imp". Strangely enough, this ale may make you feel impish.

Ingredients for 5 gallons (19 l.)

5 lbs. (2.3 kg.) American two-row lager malt
3 lbs. (1.36 kg.) Munich malt
2 lbs. (0.9 kg.) Vienna malt
$1\frac{1}{2}$ lbs. (0.68 kg.) 40 Lovibond crystal/caramel malt
$\frac{1}{4}$ lb. (113 g.) black-roasted malt
$\frac{1}{4}$ lb. (113 g.) chocolate-roasted malt
1 oz. (28.4 g.) English Fuggles hops (boiling): 4 HBU
1 oz. (28.4 g.) Williamette hops (boiling): 4 HBU
$\frac{1}{2}$ oz. (14.2 g.) Cascade hops (flavor): 2.5 HBU
1 oz. (28.4 g.) Cascade hops (aroma)
$\frac{1}{4}$ tsp. (1 g.) powdered Irish moss
Ale yeast; American Ale 1056 can be recommended
$\frac{3}{4}$ c. (178 ml.) corn sugar or $1\frac{1}{4}$ c. (296 ml.) dried malt extract (for bottling)

BUs: 38
Color: 25–30
OG: 1.068–1.072 (17–18)
FG: 1.018–1.022 (4.5–5.5)
Approximate alcohol: 6.5% by volume (5.2% by weight)

Using a protein-developing step mash, add 3 gallons of 130-degree F (54.4 C) water to the crushed malt. Stabilize at 122 degrees F (50 C) and hold for 30 minutes. Then add 1.5 gallons of boiling water. Stabilize at 148 to 150 degrees F (64.4–65.5 C) and hold for 60 minutes. Add heat and mash out to 165 degrees F (74 C).

Sparge with about 3 to 4 gallons (11.4–15.2 l.) of 170-degree F (77 C) water. Add more water (do not oversparge) to brewpot to make an initial extract volume of 6.5 gallons (24.7 l.). Anticipate evaporation of slightly more than 1 gallon (3.8 l.). Add boiling hops and boil for 75 minutes. Then add flavor hops and Irish moss and boil for an additional 15 minutes. Total boiling time is 90 minutes. Turn off heat. Add aroma hops and let steep for 2 to 3 minutes before removing hops and chilling the hot wort.

Note: To help minimize the ester and fusel alcohol production of this high-gravity beer, consider removing the hot trub from the wort before chilling. You may lose another 1 to 2 quarts of wort in this process and thereby reduce the overall efficiency of your system.

Pitch the yeast when cool, and bottle when fermentation is complete.

BELGIAN ALES

Belgian Tickle (Honey Ale) (Malt Extract)

The yeast makes every bit of difference in this formulation. This recipe could be a dandy strong English old ale if fermented with a typical ale yeast, but the use of a Belgian yeast culture will transform this wort into a romantically fruity and complex Belgian-style Dubbel. This ale ferments and ages well at room temperature of 70 degrees F (21 C). And the honey is our substitute for the Belgians' addition

of candi sugar (sucrose), a dose of which lightens the body while tickling the alcohol content.

Fruity esters can be quite dominant if the beer is drunk prematurely, but with age they'll mellow and blend with the malt and alcohol. With the correct Belgian yeast strains, this ale resembles full and fruity Belgian ales such as Chimay Red, brewed by Trappist monks. I use the word *resembles* because the finesse and character of Chimay is beyond duplication, unless, of course, you wish to take the same vows and become a monk, in which case perhaps there can be a similar movement of spirit. But then you may not be permitted to tickle. Belgian Tickle, anyone?

Ingredients for 5 gallons (19 l.)

5.5 lbs. (2.5 kg.) light dried English malt extract
2 lbs. (0.91 kg.) light honey
1 lb. (0.45 kg.) 40 Lovibond dark crystal/caramel malt
1 oz. (28.4 g.) Styrian Goldings hops (boiling): 5 HBU
$\frac{1}{2}$ oz. (14.2 g.) Kent Goldings hops (flavor): 2.5 HBU
$\frac{1}{2}$ oz. (14.2 g.) Kent Goldings hops (aroma)
$\frac{1}{4}$ tsp. (1 g.) powdered Irish moss
Belgian Ale yeast culture
$\frac{3}{4}$ c. (178 ml.) corn sugar or $1\frac{1}{4}$ c. (296 ml.) dried malt extract (for bottling)

BUs: 28
Color: 7–11
OG: 1.066–1.070 (16.5–17.5)
FG: 1.020–1.026 (5–6.5)

Add the crushed crystal malt to 2 gallons of 150-degree F (66 C) water and hold for 30 minutes. Remove the grains with a strainer and add malt extract and boiling hops. Boil for 60 minutes, then add flavor hops and Irish moss and boil for an additional 15 minutes. Turn off heat. Add aroma hops and let steep for 2 to 3 minutes before sparging the hot wort into a fermenter and cold water. Pitch the yeast when cool. Do not allow fermentation temperature to drop below 60 degrees F (15.5 C). Bottle when fermentation is complete. This beer lends itself best to bottle conditioning. Filtration and/or artificial carbonation will not yield similar or intended results.

"You'll See" Coriander Amber Ale (Mash-Extract)

Many Belgian ales rely on very special strains of yeast for their unique character. Here's an ale with the classic and refreshing character of

coriander seed. Some strains of Belgian yeast will contribute to this character, but you don't have to rely on the yeast for "You'll See," as you'll see. A relatively light and dry character is designed into the body of this brew, with hop bitterness taking a backseat to the zing of freshly crushed coriander seed. But as any occupant of the backseat knows, this blend of noble hops from Germany and Czechoslovakia is definitely there for the ride.

Purchase whole coriander seeds and crush or grind them yourself. One ounce (28.4 g.) is infused with the boil for deep flavor, and another $\frac{1}{2}$ ounce (14.2 g.) is added during secondary fermentation for aromatic effect.

Of all the coriander-flavored beers I've tasted over the years (both commercially made and homebrewed), I have observed hardly any oxidation even with three- or four-year-old beer. Might coriander have an unusual antioxidizing effect? I await research that might confirm my hunch.

Ingredients for 5 gallons (19 l.)

2 lbs. (0.91 kg.) pale malted barley
1 lb. (0.45 kg.) 40 Lovibond crystal/caramel malt
$\frac{1}{2}$ lb. (0.23 kg.) wheat malt
3.5 lbs. (1.6 kg.) light dried malt extract
$\frac{3}{4}$ oz. (21.3 g.) German Northern Brewers hops (boiling): 7 HBU
1 oz. (28.4 g.) Czech Saaz hops (flavor): 4 HBU
$\frac{1}{2}$ oz. (14.2 g.) German Hallertauer hops (aroma)
$\frac{1}{2}$ oz. (14.2 g.) Czech Saaz hops (aroma)
$1\frac{1}{2}$ oz. (42.6 g.) freshly crushed coriander seed
$\frac{1}{4}$ tsp. (1 g.) powdered Irish moss
Ale yeast; a neutral ale yeast such as American Ale 1056 does very well
$\frac{3}{4}$ c. (178 ml.) corn sugar or $1\frac{1}{4}$ c. (296 ml.) dried malt extract (for bottling)

BUs: 28
Color: 5–8
OG: 1.043–1.047 (11–12)
FG: 1.007–1.011 (2–3)

Use a single-step infusion mash schedule for this recipe.
Add crushed malts to 4 quarts (3.8 l.) of 168-degree F (76 C) water. The mash will stabilize at 153 to 158 degrees F (67–70 C). Hold this temperature at the high end for 60 minutes.

Sparge with about 1.5 gallons (5.7 l.) of 170-degree F (77 C) water. Add more water (do not oversparge) to brewpot if necessary to make an initial extract volume of about 2.5 gallons (9.5 l.). Anticipate evaporation of 0.5 gallon (1.9 l.). Add boiling hops and dried malt extract and boil for 60 minutes. Then add flavor hops and Irish moss and boil for an additional 15 minutes. Total boiling time is 75 minutes. Turn off heat. Add 1 ounce (28.4 g.) of crushed coriander and aroma hops and let steep for 2 to 3 minutes before removing hops. Transfer wort to a fermenter partly filled with cold water.

Pitch the yeast when cool. When primary fermentation is complete, add $\frac{1}{2}$ ounce (14.2 g.) crushed coriander to the fermenter and let it sit with the beer for at least one week before bottling. Crush seed in a manner that minimizes the risk of introducing contaminating microorganisms. (Do not use your malt mill.) Bottle when fermentation is complete . . . and you'll see.

The Horse You Rode In On (All Grain)

Yes, you and the horse you rode in on.

Now, after taking that, you deserve something very special! This has got to be one of my personal all-time favorites. Jointly brewed from a recipe formulated by brew pal Tracy Loysen (she deserves the creative kudos for this one), this has to be one of my all-time favorite fruit beers. If you enjoy the flavor and aroma of apricots and coriander, you will flip out over this indescribably amazing ale.

Light on the palate, light on the color, deceivingly but not devastatingly alcoholic, wondrously floral and fruity, blessedly acidic, per-

fectly balanced: malt, hop flavor, and bitterness and body and a colorful glow of gold. This ale will inspire the poet in you.

Ingredients for 5 gallons (19 l.)

7 lbs. (2.3 kg.) American two-row lager malt
$\frac{1}{2}$ lb. (0.23 kg.) Munich malt
1 lb. (0.45 kg.) wheat malt
$\frac{1}{4}$ lb. (0.11 kg.) 40 Lovibond crystal/caramel malt
$\frac{1}{2}$ c. (120 ml.) honey (for just because)
1.3 oz. (36.9 g.) German Hallertauer hops (boiling): 5.2 HBU
$\frac{1}{2}$ oz. (14.2 g.) German Hallertauer hops (flavor): 2 HBU
1 oz. (28.4 g.) American Tettnanger hops (aroma)
1 oz. (28.4 g.) freshly crushed coriander seed
7 lbs. (3.2 kg.) skinned fresh apricots
$\frac{1}{4}$ tsp. (1 g.) powdered Irish moss
Ale yeast; American Ale 1056 can be recommended
$\frac{3}{4}$ c. (178 ml.) corn sugar or $1\frac{1}{4}$ c. (296 ml.) dried malt extract (for bottling)

BUs: 25
Color: 4–6
OG: 1.049–1.055 (12–14)
FG: 1.008–1.014 (4.5–5.5)
Approximate alcohol: 5.5% by volume (4.4% by weight)

Using a protein-developing step mash, add 2.5 gallons (9.5 l.) of 130-degree F (54.4 C) water to the crushed malt. Stabilize at 122 degrees F (50 C) and hold for 30 minutes. Then add 1.25 gallons (4.8 l.) of boiling water. Stabilize at 148 to 150 degrees F (64.4–65.6 C) and hold for 60 minutes. Add heat and mash out to 165 degrees F (74 C).

Sparge with 3.5 to 4 gallons (13.3–15.2 l.) of 170-degree F (77 C) water. Add more water (do not oversparge) to brewpot if necessary to make an initial extract volume of 6.5 gallons (24.7 l.). Anticipate evaporation of slightly more than 1 gallon (3.8 l.). Add boiling hops and boil for 75 minutes. Then add flavor hops, honey and Irish moss and boil for an additional 15 minutes. Total boiling time is 90 minutes. Turn off heat. Add aroma hops and $\frac{1}{2}$ ounce (14.2 g.) crushed coriander seed and let steep for 2 to 3 minutes before removing hops and chilling the hot wort.

Note: To help minimize the ester and fusel alcohol production of this higher-gravity beer, consider removing the hot trub from the wort before chilling. You may lose another 1 to 2 quarts (0.9–1.9 l.) of wort in this process and thereby reduce the overall efficiency of your system.

Pitch the yeast when cool. When primary fermentation is finished (specific gravity will read approximately 1.020 to 1.024 [5–6 degrees B]), rack and transfer the fermenting beer to a secondary fermenter. Add 7 pounds (3.2 kg.) of skinned apricots and $\frac{1}{2}$ ounce (14.2 g.) freshly ground coriander seed. Fresh apricots are easily skinned if immersed in boiling water for 30 to 45 seconds. The skins will slip off. This process can be done ahead of time or during apricot season and the skinned fruit (pits removed) frozen in unused, new freezer bags until ready to use. Wash your hands thoroughly before handling the fruit.

Let the fruit and coriander sit with the beer for one to two weeks. Rack and bottle when fermentation is complete. You may notice wild "surface" yeast on your bottled beer. This will not usually affect the character of your beer. Don't worry. The acidity and alcohol of your beer will inhibit the microorganisms you've introduced into the secondary with the fruit. Relax.

BELGIAN LAMBIC

Frumentacious Framboise (Malt Extract)

In the tradition of a lightly hopped, fruit-flavored "wild" beer, Frumentacious Framboise takes the redness, fruitiness and acidity of raspberries and blends them with a minimally hopped wort, aged, and cultured and wild yeasts to produce a pungent, extremely estery, dry and acidic raspberry lambic-type ale.

This formulation is admittedly simplified: An all-barley-malt extract base is substituted for an all-grain mash of malted barley and

wheat. Even with this simplification, Frumentacious Framboise bears a strong resemblance to what one might be able to find in the small cafés of Brussels. The addition of *Brettanomyces lambicus* and *Brettanomyces bruxellensis* yeast cultures imparts most of the unique fermentation character. And of course, the raspberries come through exquisitely.

Ingredients for 5 gallons (19 l.)

4 lbs. (1.8 kg.) light dried malt extract
1 lb. (0.45 kg.) 20–40 Lovibond crystal/caramel malt
$\frac{3}{4}$ oz. (21.3 g.) Styrian Goldings hops (boiling): 4 HBU
8 lbs. (3.6 kg.) red raspberries (unsweetened)
Ale yeast culture; *Brettanomyces lambicus* and *Brettanomyces bruxellensis* yeast cultures
$\frac{3}{4}$ c. (178 ml.) corn sugar or $1\frac{1}{4}$ c. (296 ml.) dried malt extract (for bottling)

BUs: 15
Color: Just plain red
OG: 1.044–1.048 (11–12)
FG: 1.004–1.008 (1–2)

Add the crushed crystal malt to 2 gallons of 150-degree F (66 C) water and hold for 30 minutes. Remove the grains with a strainer and add malt extract and boiling hops. Boil for 60 minutes. Turn off heat. Remove as much of the spent hops with a strainer as possible (don't worry). Add crushed raspberries and allow to steep at about 150 to 160 degrees F (65.5–71 C) for 30 minutes to pasteurize the fruited wort. Add this concentrated fruit-wort to cold water to make a total volume of about 5.5 gallons (21 l.). If using glass fermenters, you will need to split the batch evenly between two 5-gallon fermenters for primary fermentation. Pitch both the ale and *Brettanomyces* yeast cultures when cool.

Allow to ferment with the fruit for one month. Siphon the fermentation to one secondary fermenter, leaving behind as much fruit as possible. The specific gravity may be as low as 1.010 (2.5 degrees B) at this point. Aging for seven to ten more months will allow the *Brettanomyces* to continue breaking down carbohydrates not normally fermentable by cultured ale yeast. A white film will cover the surface of your brew. Do not disturb this as it helps minimize any oxidation that could occur (but don't worry). Check your fermentation lock once a month to assure adequate water in the contraption.

Taste the brew after four or five months. If you wish the beer to be more acidic, you may add a *Lactobacillus* culture, but do so knowing that the results will be unpredictably good or perhaps not so good.

At bottling time, add priming sugar and a fresh slurry of ale yeast to help assure carbonation. Frumentacious Framboise is one beer that will stand up to years of aging. Bottling in small bottles helps preserve what will be a cherished stash.

PORTERS

Slanting Annie's Chocolate Porter (Mash-Extract)

First of all, I must confess: I cannot take credit for this sensuously creative and wonderfully balanced beer. I didn't brew it. But I watched it being brewed. I took care of it a little bit. I bottled it. But my brewing pal Tracy, inspired by her love of chocolate, waved the charismatic wooden spoon and created something that would endear itself to any chocolate lover: a chocolate-flavored porter.

Careful to take into consideration the bitterness of one pound of Baker's chocolate (unsweetened), the formulation compensates by adding a moderate amount of hops for bittering and using a not ordinary amount of crystal malt and a dose of wheat malt. The caramel-like sweetness of crystal and the maltiness of wheat malt enhance the chocolate.

The results filled the kitchen with the aroma of chocolate brownies baking in the oven. Five weeks later I had in hand a chilled mug of deep, velvety, rich chocolate porter. Slanting Annie's Porter, that is.

Slanting Annie? Oh yes, she's a legendary character out of the old West from the small town of Creede, Colorado. One leg was shorter than the other, but she sure could deal a deck of cards. Or so the story goes.

Ingredients for 5 gallons (19 l.)

$1\frac{3}{4}$ lbs. (0.8 kg.) pale malted barley
$2\frac{1}{4}$ lbs. (1 kg.) crystal/caramel malt
$2\frac{1}{4}$ lbs. (1 kg.) wheat malt
$\frac{1}{3}$ lb. (0.15 kg.) black roasted malt
$\frac{1}{3}$ lb. (0.15 kg.) chocolate roasted malt
3 lbs. (1.4 kg.) light dried malt extract
12 oz. (0.34 kg.) unsweetened Baker's chocolate*
$1\frac{1}{4}$ oz. (35.5 g.) Williamette hops (boiling): 7 HBU
$\frac{1}{2}$ oz. (14.2 g.) Williamette hops (flavor): 3 HBU
$\frac{1}{2}$ oz. (14.2 g.) Williamette hops (aroma)
$\frac{1}{4}$ tsp. (1 g.) powdered Irish moss
Ale yeast
$\frac{3}{4}$ c. (178 ml.) corn sugar or $1\frac{1}{4}$ c. (296 ml.) dried malt extract (for
 bottling)

BUs: 26
Color: >30
OG: 1.063–1.067 (16–17)
FG: 1.019–1.023 (5–6)

Using a protein-developing step mash, add 1 gallon (3.8 l.) of 130-degree F (54.4 C) water to the crushed malt. Stabilize at 122 degrees F (50 C) and hold for 30 minutes. Then add 2 gallons (7.6 l.) of boiling water. Stabilize at 154 to 157 degrees F (67.8–69.4 C) and hold for 60 minutes. Add heat and mash out to 165 degrees F (74 C).

Sparge with about 3 to 3.5 gallons (11.4–13.3 l.) of 170-degree F (77 C) water. Add more water (do not oversparge) to brewpot to make an initial extract volume of 6 gallons (22.8 l.). Anticipate evaporation of about 1 gallon (3.8 l.).

Prepare the chocolate by microwaving it in a saucer. This will soften the chocolate, making it easier to dissolve in the boil. Add the softened chocolate, malt extract and boiling hops and boil for 75 minutes. Then add flavor hops and Irish moss and boil for an additional 15 minutes. Total boiling time is 90 minutes. Turn off heat. Add aroma hops and let steep for 2 to 3 minutes before removing hops and chilling the hot wort. Pitch the yeast when cool.

During the primary fermentation you will notice very little if any

* You might substitute 3 level tablespoons of Baker's cocoa (powder) for each ounce of Baker's chocolate to avoid the concern about cocoa butter.

kraeusen (those mounds of fermentation foam). You will also note globs of ugly cocoa butter floating on the surface. The cocoa butter has congealed, resulting in an oily surface that inhibits bubble formation. Don't worry. After about five or seven days of primary fermentation, transfer the fermentation to a secondary fermenter, siphoning, naturally, below the surface of the beer. Let the brew sit in the secondary until fermentation has stopped and signs of clearing appear.

Bottle when fermentation is complete. When bottling, you will have siphoned a second time into your bottling vessel and a third time into your bottles, effectively siphoning oil-free beer from under the floating cocoa butter slick. Slanting Annie's Chocolate Porter will have a wonderful thick head, the rich aroma of chocolate, the subtle charm of hop flowers and the taste of porter—a wonderful porter.

STOUTS

Pelhourino Stout (Mash-Extract)

Not all stouts are created in the same image. Guinness comes to mind for most who know stout, and it is worthy of the highest esteem. Yet there are styles of stout, brewed even in Ireland, that are less pungent, less bitter and just as smooth and equally stout.

Pelhourino Stout is brewed with as much roasted barley punch as a Guinness, but with a higher proportion of caramelized malt and less bitterness, to create an Irish stout reminiscent of Ireland's Beamish and Murphy's Stout. It's a super stout for those looking for a tad less bitterness yet the full nourishment of a true stout.

Ingredients for 5 gallons (19 l.)

2 lbs. (0.91 kg.) pale malted barley
$1\frac{1}{2}$ lbs. (0.68 kg.) 40 Lovibond crystal/caramel malt
$\frac{3}{4}$ lb. (0.34 kg.) roasted barley
$\frac{1}{3}$ lb. (0.15 kg.) black roasted malt
3.5 lbs. (1.6 kg.) light dried malt extract
$\frac{3}{4}$ oz. (21.3 g.) Goldings hops (boiling): 3.8 HBU
$\frac{1}{2}$ oz. (14.2 g.) Goldings hops (flavor): 2.5 HBU
$\frac{1}{4}$ tsp. (1 g.) powdered Irish moss
Ale yeast; Irish Ale strains work well
$\frac{3}{4}$ c. (178 ml.) corn sugar or $1\frac{1}{4}$ c. (296 ml.) dried malt extract (for bottling)

BUs: 17
Color: >50
OG: 1.052–1.056 (13–14)
FG: 1.016–1.020 (4–5)

Use a single-step infusion mash schedule for this recipe.

Add crushed malts to $4\frac{1}{2}$ quarts (4.3 l.) of 168-degree F (76 C) water. The mash will stabilize at 155 to 158 degrees F (68–70 C). Hold this temperature at the high end for 60 minutes.

Sparge with about 1.5 gallons (5.7 l.) of 170-degree F (77 C) water. Add more water (do not oversparge) to brewpot if necessary to make an initial extract volume of about 2.5 gallons (9.5 l.). Anticipate evaporation of 0.5 gallon (1.9 l.). Add boiling hops and boil for 45 minutes. Then add flavor hops and boil for an additional 15 minutes. Then add Irish moss and boil another 15 minutes. Total boiling time is 75 minutes. Turn off heat. Strain and sparge hops out of wort and add to a fermenter partly filled with cold water to make 5 gallons.

Pitch the yeast when cool. Bottle when fermentation is complete.

Barrel of Monkeys Wheat-Oatmeal Nut Stout (All Grain)

If you're not careful to muster all your brewing skills and patience, your brewing session will not seem like a barrel of monkeys (i.e., not so fun). Oatmeal and wheat malt are notorious for contributing to frustrating stuck mashes. Stuck mashes are an experience every all-grain brewer goes through at least once. It's like having your pot of wort boil over, every once in a while. Kind of a ritual, a rite of passage.

On the other hand, oatmeal does lend a dreamy smoothness to stout, and wheat helps head retention as well as contributing to a fuller malt flavor. Take care and you'll have a brew worthy of celebrating with a barrel of monkeys. The bitterness units may appear to be

high on paper, but the blend of crystal, oatmeal, wheat and high-temperature mash brings out a fullness that pleasantly balances this nutlike stout. Especially terrific on draft!

Ingredients for 5 gallons (19 l.)

5 lbs. (2.3 kg.) pale two-row malt
2 lbs. (0.91 kg.) wheat malt
1 lb. (0.45 kg.) crystal/caramel malt
10 oz. (0.28 kg.) quick oatmeal
$\frac{1}{2}$ lb. (0.23 kg.) roasted barley
$\frac{1}{2}$ lb. (0.23 kg.) roasted black malt
2.5 oz. (71 g.) English Fuggles or Goldings hops (boiling): 12 HBU
$\frac{1}{2}$ oz. (14.2 g.) English Fuggles or Goldings hops (flavor): 2.5 HBU
$\frac{1}{2}$ oz. (14.2 g.) English Goldings hops (aroma)
4 tbsp. (31.2 g.) gypsum (calcium sulfate) if using very soft water
$\frac{1}{4}$ tsp. (1 g.) powdered Irish moss
Ale yeast
$\frac{3}{4}$ c. (178 ml.) corn sugar or $1\frac{1}{4}$ c. (296 ml.) dried malt extract (for bottling)

BUs: 56
Color: >50
OG: 1.053–1.060 (13–15)
FG: 1.016–1.020 (4–5)

Use a single-step infusion mash schedule for this recipe. Add gypsum to very soft water at a rate of 4 tablespoons per 5 gallons (19 l.) of water.

Add crushed malts to 2.5 gallons (9.5 l.) of 168-degree F (76 C) water. The mash will stabilize at 152 to 156 degrees F (67–69 C). Hold this temperature for 60 minutes.

Sparge and lauter slowly—*very slowly*—with 4 to 4.5 gallons (15.2–17 l.) of 170-degree F (77 C) water. If the runoff is done too quickly, you will increase the risk of a set or stuck runoff. If this is the case, here's what happened: The rate of the flow you were drawing off was quicker than the flow that could trickle through the grain bed. Whamo. You've got all the weight of the mash no longer floating and suspended in liquid. There is a vacuum in the false bottom, and the mash has compressed itself, compounding the situation. If this happens, it is an ideal time for a homebrew. Practice breathing deeply. Relax. Then develop a plan to salvage the brew. (In extreme situations I've been known to simply scoop the mash out and start

all over again, being more careful. The beer will still be very, very good, but your yield may suffer.)

When finished lautering, add more water (do not oversparge) to the brewpot to make an initial extract volume of 6 gallons (22.8 l.). Anticipate evaporation of 1 gallon (3.8 l.). Add boiling hops and boil for 45 minutes. Then add flavor hops and boil for an additional 15 minutes. Then add Irish moss and boil for a final 15 minutes. Total boiling time is 75 minutes. Turn off heat. Add aroma hops and let steep for 2 to 3 minutes before removing hops and chilling the hot wort. Pitch the yeast when cool, and bottle or keg when fermentation is complete.

Slickrock Imperial Stout (Malt Extract)

A potent elixir, not typical of most American Imperial-style stouts in that the hopping rate is much less, resulting in a smoother, less bitter, high-alcohol stout. Not only does it taste smoother, but it ages more quickly. Two to four months in the bottle and this hummer is black silk. Don't assume too much here—this stout still has plenty of pungent bitterness, but it is more in balance for those looking for something a bit less exclamatory.

Ingredients for 5 gallons (19 l.)

3 lbs. (1.36 kg.) plain dark malt extract syrup
2 lbs. (0.9 kg.) plain amber malt extract syrup
4 lbs. (1.82 kg.) Mountmellick brand Irish Stout kit malt extract syrup
1 lb. (0.45 kg.) 40–80 Lovibond dark crystal/caramel malt
$\frac{1}{2}$ lb. (0.23 kg.) black roasted malt
$\frac{1}{2}$ lb. (0.23 kg.) roasted barley
2.3 oz. (65.3 g.) Perle hops (boiling): 16 HBU
1.2 oz. (34 g.) Styrian Goldings hops (flavor): 6 HBU
1.5 oz. (42.6 g.) Cascades hops (aroma)
4 tbsp. (31.2 g.) gypsum (calcium sulfate) if soft water is used
$\frac{1}{4}$ tsp. (1 g.) powdered Irish moss
Ale yeast
$\frac{3}{4}$ c. (178 ml.) corn sugar or $1\frac{1}{4}$ c. (296 ml.) dried malt extract (for bottling)

BUs: 65
Color: >50
OG: 1.078–1.082 (19.5–20.5)
FG: 1.014–1.018 (3.5–4.5)

Add the crushed crystal malt, chocolate malt and roasted barley to 2 gallons (7.6 l.) of 150-degree F (66 C) water and hold for 30 minutes. Remove the grains with a strainer and add malt extract, gypsum (if using very soft water) and boiling hops. Boil for 60 minutes, then add flavor hops and Irish moss and boil for an additional 15 minutes. Turn off heat. Add aroma hops and let steep for 2 to 3 minutes before sparging the hot wort into a fermenter partly filled with cold water. Pitch the yeast when cool, and bottle when fermentation is complete.

Unspoken Passion Imperial Stout (Malt Extract)

Liquid sex in a bottle. This brew will leave you and your beer friends speechless. If you like the rich, creamy smoothness of a chocolate raspberry fudge cake or have ever imagined what raspberries dipped in semisweet chocolate could be like, then Unspoken Passion is an absolute winner.

In the tradition of Imperial Stout, this ale is brewed with an alcoholic strength of 7 percent by volume and enough bitterness to offset the rich, heavy body contributed by the generous amount of malt. A blend of roasted barley, chocolate malt, black patent malt and crystal malt contributes significantly to the character of the final brew.

The intensity of the raspberry flavor and acidity really comes through in the unfermented wort and at bottling, but with maturity the raspberry character softens and melts into the full-bodied texture of a brew that will simply amaze you and your friends.

Any bittering hop can be used, but high-alpha hops are most convenient since 35 homebrew bittering units are called for in the recipe. For finishing, Cascade hops were especially chosen because of their fruity/citrusy character, a perfect complement to this brew.

Dare to brew something different and very special.

Best put up in small bottles and served in stemmed glassware.

Serve cool in the winter months and, if it suits you (it certainly suits me), serve cold in warm weather as a rich, satisfying sipping refreshment.

The recipe is for $6\frac{1}{2}$ gallons (24.7 l.) because 5 (19 l.) just aren't enough and the beer ages extremely well.

Ingredients for $6\frac{1}{2}$ gallons (24.7 l.)

6 lbs. (2.7 kg.) plain light dried malt extract
8 lbs. (3.6 kg.) Mountmellick brand Irish Stout kit malt extract syrup or other stout kit
$1\frac{1}{4}$ lbs. (0.57 kg.) crystal/caramel malt
$\frac{1}{2}$ lb. (0.23 kg.) black roasted malt
$\frac{3}{4}$ lb. (0.34 g.) roasted barley
$\frac{1}{2}$ lb. (0.23 kg.) chocolate roasted malt
3 oz. (85.2 g.) Eroica hops (boiling): 30 HBU
2 oz. (56.8 g.) Cascades hops (aroma)
4 tbsp. (31.2 g.) gypsum (calcium sulfate) if soft water is used
11 lbs. (5 kg.) red raspberries (crushed, unsweetened)
Ale yeast
1 c. (237 ml.) corn sugar or $1\frac{1}{2}$ c. (355 ml.) dried malt extract (for bottling)

BUs: 90
Color: >50
OG: 1.076–1.086 (19–21.5)
FG: 1.022–1.030 (5.5–7.5)

Add the crushed crystal, black and chocolate malts and the roasted barley to 3 gallons (11.4 l.) of 150-degree F (66 C) water and hold for 30 minutes. Remove the grains with a strainer and add malt extract, gypsum (if using very soft water) and boiling hops. Boil for 60 minutes. Turn off heat. Use a strainer to remove most of the boiling hops from the hot concentrated wort. Then add room-temperature raspberries and Cascade hops. Without adding any more heat, let steep at about 145 to 165 degrees F (63–74 C) for 30 minutes.

Add 4 gallons (15.2 l.) of cold water to your sanitized fermenter(s). Add your hot wort, raspberries and finishing hops to the fermenter and top up with cold water to make a total volume of 8 (30.4 l.) gallons. A blow-off method of fermentation is not possible with this brew, so allow at least five inches of head space in your fermenter so that the foamy kraeusen does not reach the stopper. If you don't

have one vessel large enough, you can use two glass $6\frac{1}{2}$-gallon (25-l.) fermenters. Add 2 gallons (7.6 l.) of cold water to each and top with cold water to make two 4-gallon (15.2-l.) batches.

Pitch the yeast when cool and let ferment for seven days. You will notice that most of the raspberries and hops are pregnant with carbon dioxide and float to the surface. Do not disturb them.

On the seventh or eighth day siphon the fermentation to one $6\frac{1}{2}$-gallon (25-l.) fermenter. Insert the hose between the floating layer of spent fruit and hops and the bottom sediment. Relax. Don't worry about the few floating pieces of hops and fruit that may end up in your secondary.

Let fermentation go to completion, and bottle with one cup of corn sugar. Be patient; carbonation may take a little longer because of the strength of this brew.

Ohhh man, it's gonna be a good one!

The 3 Percent Factor—Guinness (Your Option)

The legendary Guinness Stout has a uniqueness all its own. There's good reason for this. Even though Guinness is brewed under contract by hundreds of breweries worldwide, there is one "secret" ingredient added to virtually every batch. This secret ingredient is soured double-strength Guinness. It is pasteurized before adding it to every batch at a rate of about 3 percent (sometimes up to 4 percent) of the total volume. Its addition helps assure a uniquely tangy Guinness character as well as a dense, creamy head.

How can you duplicate this process; or, rather, come close? Brew a 1.070 (17.5) batch of stout with 10 percent flaked barley as one of the ingredients. Fully ferment it and then add *Lactobacillus* and acetobacter ("vinegar") bacteria cultures. You will need to aerate the finished beer in order to provide necessary oxygen for the acetobacter to metabolize the beer and "vinegarize" some of the brew. These bacterial cultures are unpredictable, so you may have to experiment, but luckily you can do it with small batches.

Sound wretched? It will be. But you are going to add no more than $\frac{1}{2}$ quart (0.5 l.) to a 5-gallon (19-l.) batch of stout. And don't forget to pasteurize that 3 percent before adding it to your stout. Holding it at 170 degrees F (77 C) for 30 minutes will suffice.

BARLEY WINES

Here To Heaven Snow Angel Fest Wine Ale (Mash-Extract)

American-style barley wine ales are a feisty lot. Some, approaching $10\frac{1}{2}$ percent alcohol by volume, offer sipping pleasure for those who

enjoy the play of the intense bitterness of hops with the full-bodied sweetness of malt. Here To Heaven Snow Angel Fest Wine Ale is a slight departure from the Americanization of an English tradition, bringing into consideration the alacrity of Bavarian-style amber malts and a lower level of bitterness. The deep amber color reflects the warmth of the brewer's soul, as you will surely agree.

If bitterness units are calculated, one is led to believe there are about 130 units of bitterness in this brew. This will not be entirely accurate because of the very high gravity of the boiled wort and the great amount of hops called for. The bitterness is indeed very high, but with proper aging, a balance is achieved with the rich combination of Munich, Vienna, dextrine and crystal malts.

The actual original gravity will be slightly less than a calculated gravity due to the nonlinear nature of wort density measurements as wort becomes very high in gravity.

The recipe is for $6\frac{1}{2}$ gallons (25 l.). It is a patient beer that ages well. It is well worth having an extra $1\frac{1}{2}$ gallons (5.7 l.) of it.

Ingredients for $6\frac{1}{2}$ gallons (25 l.)

3 lbs. (1.36 kg.) pale malted barley
1 lb. (0.45 kg.) Munich malt
1 lb. (0.45 kg.) Vienna malt
$\frac{1}{2}$ lb. (0.23 kg.) dextrine malt
1 lb. (0.45 kg.) crystal/caramel malt
12 lbs. (5.5 kg.) light dried malt extract
5.5 oz. (156 g.) Eroica hops (boiling): 55 HBU
$1\frac{1}{2}$ oz. (43 g.) German Hallertauer hops (flavor): 6 HBU
$1\frac{1}{2}$ oz. (43 g.) Cascade hops (aroma)
$\frac{1}{4}$ tsp. (1 g.) powdered Irish moss
Ale yeast; American Ale 1056 strain works well
1 c. (237 ml.) corn sugar or $1\frac{1}{2}$ c. (355 ml.) dried malt extract (for bottling)

BUs: 100–130
Color: 14–20
OG: 1.098–1.108 (24.5–27)
FG: 1.028–1.032 (7–8)

Using a protein-developing step mash, add 6.5 quarts (6.2 l.) of 130-degree F (54.4 C) water to the crushed malt. Stabilize at 122 degrees F (50 C) and hold for 30 minutes. Then add 3.5 quarts (3.3 l.) of boiling water. Stabilize at 152 to 156 degrees F (67–69 C) and hold for 60 minutes. Add heat and mash out to 165 degrees F (74 C).

Sparge with about 3 gallons (11.4 l.) of 170-degree F (77 C) water. Add dried malt extract and more water (do not oversparge) to brew-pot if necessary to make an initial extract volume of about 4 gallons (15.2 l.). Anticipate evaporation of slightly more than 0.5 gallon (1.9 l.). Add boiling hops and boil for 75 minutes. Then add flavor hops and Irish moss and boil for an additional 15 minutes. Total boiling time is 90 minutes. Turn off heat. Add aroma hops and let steep for 2 to 3 minutes. Because of the high volume of concentrated boiled wort, immerse the pot of boiled wort in a tub of cold water for 20 to 30 minutes to help cool. Change water after the first 15 minutes. Then strain, sparge and transfer the wort to a fermenter partly filled with cold water.

Pitch yeast when wort is cooled, and bottle when fermentation is complete.

Gnarly Roots Lambic-style Barley Wine Ale (Mash-Extract)

Are you ready to try something really different? How about a strong, 10 percent copper-colored ale with enough of a wild, fruity and sour quirkiness to enhance the pleasure of an already wonderfully complex barley wine ale?

Using a barley wine ale recipe template and the introduction of active cultures of Brettanomyces Bruxellensis and Brettanomyces Lambicus one week after the initial cultured yeast is pitched creates a unique sensory experience.

The result is not a typical strongly soured Belgian lambic. Rather, the Belgian lambic character is obvious, but gentle. Because of the high alcohol content and the vigorous start of the cultured yeast, the Brettanomyces cultures are somewhat inhibited.

This high-gravity barley wine is strongly hopped, but because of the high alcohol and relatively high final gravity, the bitterness is nicely balanced by the sweetness of the malt and by the fruity acidity of the lambic-type yeast byproducts.

Let it age. Let it age. Let it age. Lagering at 60-to-70-degree F (15.6–21 C) cellar temperatures is perfect for this brew. It is best to rack the brew into a secondary closed fermenter because of the long storage time. The second fermenter is preferably glass so you can observe the disconcerting scum that forms on the surface of the beer as a result of the action of the *Brettanomyces* yeasts.

The *Brettanomyces* yeasts are wild and tend to break down and ferment some of the normally unfermentable carbohydrates. Be patient. I waited eight months to bottle my Gnarly Roots. And it tasted *soooo* incredibly good when I bottled it, I couldn't wait for it to carbonate. Unfortunately it may take several months to properly carbonate.

You will observe great clarity of the brew after eight months and wonder (don't worry) about the viability of the yeast. In order to minimize the possibility of worrying, add about 8 ounces of new freshly fermenting wort when bottling.

Since this is a long-lagered and well-aged brew, it is of utmost importance to reduce the risk of oxidation. When racking the brew from primary to secondary or from secondary to the bottling carboy, it helps to purge the air out of the receiving carboys with carbon dioxide. This can be accomplished with a ten- or fifteen-second shot of carbon dioxide from your CO_2 tapping system or a couple of gumball-size pieces of dry ice added to the receiving carboy. When bottling, be careful not to aerate or splash the beer. The use of oxygen-absorbing barrier bottlecaps should greatly enhance the life of this beer.

This is a batch for putting up in lots of small bottles.

Ingredients for $6\frac{1}{2}$ to 7 gallons (25–26.6 l.): because 5 gallons (19 l.) isn't enough.

4 lbs. (1.8 kg.) pale malted barley
1 lb. (0.45 kg.) crystal/caramel malt
15 lbs. (6.8 kg.) light dried malt extract
6 oz. (170 g.) Eroica hops (boiling): 60 HBU
$1\frac{1}{2}$ oz. (43 g.) Williamette hops (flavor): 7.5 HBU
$1\frac{1}{2}$ oz. (43 g.) Cascade hops (aroma)
$\frac{1}{4}$ tsp. (1 g.) powdered Irish moss

Ale yeast; American Ale 1056 strain works well
Cultures of *Brettanomyces Lambicus* and *Brettanomyces Bruxellensis*
1 c. (237 ml.) corn sugar or $1\frac{1}{4}$ c. (296 ml.) dried malt extract (for
 bottling)
Plus fresh yeast when bottling

BUs: 120–130
Color: 6–9
OG: 1.098–1.110 (24.5–27.5)
FG: 1.024–1.032 (6–8)

Using a protein-developing step mash, add 5 quarts (4.8 l.) of
130-degree F (54.4 C) water to the crushed malt. Stabilize at 122
degrees F (50 C) and hold for 30 minutes. Then add 3 quarts (2.9 l.)
of boiling water. Stabilize at 154 to 158 degrees F (67–69 C) and hold
for 60 minutes. Add heat and mash out to 165 degrees F (74 C).

Sparge with about 2 gallons (7.6 l.) of 170-degree F (77 C) water.
Add dried malt extract and more water (do not oversparge) to brew-
pot to make an initial extract volume of about 4 gallons (15.2 l.).
Anticipate evaporation of slightly more than 0.5 gallon (1.9 l.). Add
boiling hops and boil for 75 minutes. Then add flavor hops and Irish
moss and boil for an additional 15 minutes. Total boiling time is 90
minutes. Turn off heat. Because of the high volume of concentrated
boiled wort, immerse the pot of boiled wort in a tub of cold water
for 20 to 30 minutes to help cool it. Change water after the first 15
minutes. Then strain, sparge and transfer the wort to a fermenter
partly filled with cold water.

Pitch yeast when wort is cooled. After one week of primary fer-
mentation, add *Brettanomyces* yeasts to the fermentation. Rack into a
secondary after one month. Allow to slowly ferment for six to eight
months at cellar temperatures of about 60 to 70 degrees F (15.5–21
C). (Note, and avoid disturbing, the white scum covering the surface.
As a barrier, it helps prevent oxidation.)

Bottle after six to eight months in secondary bulk aging. When
siphoning, draw beer from beneath the surface scum and most of it
will remain behind or adhere to the sides of the fermenter, but don't
worry. At bottling time add a fresh slurry of active ale yeast to help
assure proper bottle conditioning.

Thoroughly sanitize all equipment that has come in contact with
this batch of beer. Use chlorine bleach as a sanitizer.

Relax. You're in for a real treat. And if you ever run into me

somewhere or someplace, I wouldn't turn down an offer to try your batch of Gnarly Roots Barley Wine Ale.

GERMAN ALES

Nomadic Kölsch (Mash-Extract)

Kölsch is a particularly refreshing pale, light-bodied, subtly fruity, balanced traditional ale of Cologne (Köln), Germany. If there were ever such a thing, you might describe Kölsch as a low-bitterness "Pilsener"-ale. Right. To some the mere inference that something could be a Pilsener-ale is blasphemous, but I'm enjoying my Kölsch no matter how I describe it. Are you?

Ale yeast is used for primary fermentation, with lager yeast added during cold lagering to help assure maximum attenuation.

Ingredients for 5 gallons (19 l.)

2 lbs. (0.91 kg.) pale malted barley
$\frac{1}{2}$ lb. (0.23 kg.) wheat malt
$\frac{1}{4}$ lb. (113 g.) dextrine or Cara-Pils malt
3.5 lbs. (1.6 kg.) light dried malt extract
0.7 oz. (19.9 g.) German Northern Brewers hops (boiling): 6 HBU
1 oz. (28.4 g.) German Hallertauer hops (flavor): 4 HBU
$\frac{1}{2}$ oz. (14.2 g.) American Spalt hops (flavor): 3.5 HBU
$\frac{1}{2}$ oz. (14.2 g.) German Hallertauer hops (aroma)
$\frac{1}{2}$ oz. (14.2 g.) Czech Saaz hops (aroma)
$\frac{1}{4}$ tsp. (1 g.) powdered Irish moss
Ale yeast; German Ale yeast. A Kölsch strain if you can find it.
Lager yeast
$\frac{3}{4}$ c. (178 ml.) corn sugar or $1\frac{1}{4}$ c. (296 ml.) dried malt extract (for bottling)

BUs: 30
Color: 4–5
OG: 1.042–1.046 (10.5–11.5)
FG: 1.008–1.012 (2–3)

Use a protein-developing step mash. Add 3 quarts (2.9 l.) of 130-degree F (54.4 C) water to the crushed malt. Stabilize at 122 degrees F (50 C) and hold for 30 minutes. Then add 1.5 quarts (1.4 l.) of boiling

water. Stabilize at 148 to 152 degrees F (64–67 C) and hold for 60 minutes. Add heat and mash out to 165 degrees F (74 C).

Sparge with about 1.5 gallons (5.7 l.) of 170-degree F (77 C) water. Add more water (do not oversparge) to brewpot to make an initial extract volume of 2.5 gallons (9.5 l.). Anticipate evaporation of about 0.5 gallon (1.9 l.).

Add the malt extract and boiling hops and boil for 60 minutes. Then add flavor hops and Irish moss and boil for an additional 15 minutes. Total boiling time is 75 minutes. Turn off heat. Add aroma hops and let steep for 2 to 3 minutes before removing hops and chilling the hot wort. Pitch the yeast when cool.

Traditional German brewing procedures would have you remove the trub. If you decide to go to the effort of removing your hot break trub, lower yield may result due to some loss of extract. Add an extra $\frac{1}{2}$ to 1 pound (0.23–0.45 kg.) of pale malt to the ingredients and adjust your procedures to adapt to the extra malt.

Pitch yeast when cool, and ferment in the primary at temperatures between 55 and 60 degrees F (13–15.6 C). After four to seven days, transfer the beer into a secondary fermenter, add an active culture of lager yeast and lager at 40 to 45 degrees F (4–7 C) for three to four weeks or until fermentation is complete.

SPECIALTY AND UNUSUAL BREWS

For Peat's Sake "Scotch" Ale (Mash-Extract)

By no stretch of the imagination does this ale resemble Scottish-style ales or strong Scotch ales. It is a very interesting experiment to introduce to your palate. Going to the edge. It is a brew possibly for those who enjoy their single-malt scotch rich and smoky (as with Laphroiag).

For Peat's Sake "Scotch" Ale is balanced as a malty export Scottish-style ale, with one very important difference. Almost 30 percent of the grain bill is peat-smoked malt. The result is an intensely smoke-flavored ale—not the mellow smoke flavor of a Bavarian Rauchbier, but an almost medicinal character unique to smoky peat moss. This ale mellows somewhat with age and will surely intrigue single-malt scotch enthusiasts. For those not quite as enthusiastic, the peat-smoked malt could be cut back to 5 percent and the difference made up with English pale ale malt. But for now let's go on an adventure . . . if you dare.

Ingredients for 5 gallons (19 l.)

2.2 lbs. (1 kg.) peat-smoked malted barley
1 lb. (0.45 kg.) crystal/caramel malt
1½ lbs. (0.68 kg.) Vienna malt
3 lbs. (1.4 kg.) light dried malt extract
1 oz. (28.4 g.) English or Styrian Golding hops (boiling): 5 HBU
1 oz. (28.4 g.) English Kent Golding hops (flavor): 5 HBU
¼ tsp. (1 g.) powdered Irish moss
Ale yeast
¾ c. (178 ml.) corn sugar or 1¼ c. (296 ml.) dried malt extract (for bottling)

BUs: 21
Color: 10–14
OG: 1.052–1.056 (13–14)
FG: 1.016–1.020 (4–5)

Use a single-step infusion mash schedule for this recipe.
Add crushed malts to 5 quarts (4.8 l.) of 168-degree F (76 C) water. The mash will stabilize at 153 to 158 degrees F (67–70 C). Hold this temperature at the high end for 60 minutes.
Sparge with about 2 gallons (7.6 l.) of 170-degree F (77 C) water. Add more water (do not oversparge) to brewpot if necessary to make an initial extract volume of about 2.5 gallons (9.5 l.). Anticipate evaporation of 0.5 gallon (1.9 l.). Add boiling hops and dried malt extract and boil for 45 minutes. Then add flavor hops and boil for an additional 15 minutes. Then add Irish moss and continue to boil for another 15 minutes. Total boiling time is 75 minutes. Turn off heat, remove hops and transfer to a fermenter partly filled with cold water.
Pitch the yeast when cool. Bottle when fermentation is complete.

Tim's Topple Over Anisethetic Brown Ale (Malt Extract)

This is quite a simple English-style brown ale but with a difference. Star anise is added to the boil, imparting a licoricelike anise flavor. It is not for those who don't appreciate anise flavor. For those who do, this malt-emphasized beer is a real treat and ages well as the anise melts into the malt sweetness. Bitterness is kept low intentionally. A combination of bitterness and licorice seems uninvitingly harsh. Yet the addition of wonderfully floral Mt. Hood hops for flavor and aroma complements the spiciness and cooling sensation of star anise.

Ingredients for 5 gallons (19 l.)

3.3 lbs. (1.5 kg.) plain light malt extract syrup
3.3 lbs. (1.5 kg.) plain dark malt extract syrup
1 oz. (28.4 g.) American Hallertauer hops (boiling): 4.5 HBU
$\frac{1}{2}$ oz. (14.2 g.) Mt. Hood hops (flavor): 2.5 HBU
$\frac{1}{2}$ oz. (14.2 g.) Mt. Hood hops (aroma)
2 oz. (56.8 g.) whole star anise
$\frac{1}{4}$ tsp. (1 g.) powdered Irish moss
Ale yeast
$\frac{3}{4}$ c. (178 ml.) corn sugar or 1$\frac{1}{4}$ c. (296 ml.) dried malt extract (for bottling)

BUs: 20
Color: >20
OG: 1.050–1.054 (12.5–13.5)
FG: 1.016–1.020 (4–5)

Add malt extract and boiling hops and boil for 45 minutes, then add whole star anise and continue to boil for 10 minutes. Then add flavor hops and Irish moss and boil for an additional 20 minutes. Turn off heat. Total boil time is 75 minutes. Add aroma hops and let steep for 2 to 3 minutes before sparging the hot wort into a fermenter partly filled with cold water. Pitch the yeast when cool, and bottle when fermentation is complete.

Turtles' Wheat Beer (Malt Extract)

You don't have to be an all-grain brewer to make a terrific wheat beer. There are some great wheat malt extracts that would make almost any fermenter happy to accommodate a 5-gallon (19-l.) batch. Traditional Bavarian or Berliner wheat beer styles are unique. What makes them especially distinctive is not any significant amount of so-called wheat character, but rather the unusual yeast or microbial fermentations. They are splendid beers for those who appreciate the style. But what about wheat malt?

Wheat malt and wheat malt extracts available in the United States and Canada add a distinct and pleasing toasted maltiness to beer. Their character is almost reminiscent of the type of malt toasti-ness one seeks with an Oktoberfest-style beer, but with a lighter body that results from more complete fermentation. In other words, wheat malts and wheat malt extracts of the light amber variety avail-able in America lighten the body of beers while contributing a toasted malt character.

Turtles' Wheat Beer is brewed straight from the can, with only

hops added. It couldn't be much simpler. The brand I happened to use is 55 percent wheat malt and 45 percent barley malt. Turtles' Wheat has a nonsweet malt flavor, light body, amber color, light bitterness, refreshing hop aroma and satisfying quenchability. It's a great warm-weather American-style wheat beer. The only drawback is a visual one. Chill haze is a problem you'll encounter often with homebrewed wheat beers. So you'll just have to shut your eyes, have a homebrew and bicycle with turtles.

Ingredients for 5 gallons (19 l.)

6.6 lbs. (3 kg.) Munton and Fison Wheat Malt Extract syrup
1 oz. (28.4 g.) American Hallertauer hops (boiling): 4.5 HBU
$\frac{1}{2}$ oz. (14.2 g.) Williamette hops (flavor): 2.5 HBU
$\frac{1}{2}$ oz. (14.2 g.) Williamette hops (aroma)
1 oz. (28.4 g.) Cascade hops (aroma)
$\frac{1}{4}$ tsp. (1 g.) powdered Irish moss
Ale yeast
$\frac{3}{4}$ c. (178 ml.) corn sugar or 1$\frac{1}{4}$ c. (296 ml.) dried malt extract (for bottling)

BUs: 20
Color: 8–10
OG: 1.046–1.050 (11.5–12.5)
FG: 1.008–1.012 (2–3)

Add malt extract and boiling hops and boil for 60 minutes, then add flavor hops and Irish moss and boil for an additional 15 minutes. Turn off heat. Total boil time is 75 minutes. Add aroma hops and let steep for 2 to 3 minutes before sparging the hot wort into a fermenter partly filled with cold water. Pitch the yeast when cool, and bottle when fermentation is complete.

Mr. Kelly's Coconut Curry Hefeweizen (All Grain with Honey)

If you like the tantalizing flavors of a spicy Indian curry, you are sure to find this beer intriguing. I did, and I liked it, too. This recipe is slightly adapted from brew pal Brian Kelly of Denver, Colorado. He's a curry freak and an expert brewer, winning awards with a beer brewed from this recipe, a recipe he says is based on a Sri Lankan crab curry recipe. My hat is off to Brian and his creative success.

The beer? Well, it's a light-bodied Bavarian-style wheat beer with all the excitement of ginger, cayenne, coriander seed, cinnamon, lime leaves and fenugreek. A refreshing pleasure—the heat of the cayenne is suggestive but not overwhelming. Gopher it.

Ingredients for 5 gallons (19 l.)

5 lbs. (2.3 kg.) malted wheat
1 lb. (0.45 kg.) American Victory malt
1 lb. (0.45 kg.) Munich malt
2 lbs. (0.91 kg.) wildflower honey
1 oz. (28.4 g.) German Hallertauer hops (boiling): 5 HBU
1 oz. (28.4 g.) Czech Saaz hops (boiling): 4 HBU
3 oz. (85 g.) freshly grated ginger
1 tbsp. ground cayenne pepper
1 tbsp. freshly crushed coriander seed
1 tbsp. ground fenugreek
3 inches (7.6 cm.) stick cinnamon
4 c. (950 ml.) dry unsweetened coconut
0.6 oz. (18 g.) lime leaves (or curry leaves)
$\frac{1}{4}$ tsp. (1 g.) powdered Irish moss
Wheat beer yeast; Bavarian-style wheat beer (Weissbier or Weizenbier) yeast
$\frac{3}{4}$ c. (178 ml.) corn sugar or $1\frac{1}{4}$ c. (296 ml.) dried malt extract (for bottling)

BUs: 33
Color: 5–9
OG: 1.050–1.054 (12.5–13.5)
FG: 1.004–1.008 (1–2)

Use a single-step infusion mash schedule for this recipe.

Add crushed malts to 7 quarts (6.6 l.) of 168-degree F (76 C) water. The mash will stabilize at 153 to 155 degrees F (67–68 C). Hold this temperature for 60 minutes.

Sparge with about 3 gallons (11.4 l.) of 170-degree F (77 C) water. Add more water (do not oversparge) to brewpot if necessary to make an initial extract volume of about 3.5 gallons (13.3 l.). Anticipate evaporation of 0.5 to 0.75 gallon (1.9–2.8 l.). Add boiling hops and honey and boil for 45 minutes. Then add the cayenne, coriander, cinnamon, lime leaves (or curry leaves), fenugreek, 1.5 ounces (43 g.) of the grated ginger and 2 cups (475 ml.) of the coconut and boil for an additional 15 minutes. Then add the remaining 2 cups (475 ml.) coconut and the Irish moss and boil for 15 more minutes. Total boiling time is 75 minutes. Turn off heat. Add the remaining 1.5 ounces of ginger (43 g.) and let steep for 2 to 3 minutes before straining hops and spices and transferring to a fermenter partly filled with cold water.

Pitch the yeast when cool. Bottle when fermentation is complete.

Cucurbito Pepo (Pumpkin) Ale (All Grain)

Pumpkin ale? Now, don't discount this one so quickly. Pumpkins were used in colonial days as an essential ingredient in many brews. With a bit of tradition and modern art you can brew something that is as American as apple pie. Cucurbito Pepo (Pumpkin) Ale is not too assuming. With a medium body, adequate bitterness, amber color, alcoholic warmth and reassuring spices, this beer will be an incredible contribution to your repertoire of accomplishments.

The spices that lend a typical pumpkin-pie character are not overdone, but they are optional if you choose to brew a simpler version. This is the kind of brew for which you invite friends over to help with the ceremonies of brewing. Surely a Thanksgiving or holiday season toast with Cucurbito Pepo Ale will be one of the most memorable. England, Belgium and Germany, eat your hearts out.

Ingredients for 5 gallons (19 l.)

10 lbs. (4.54 kg.) American six-row pale lager malt
1 lb. (0.45 kg.) 20–40 Lovibond crystal/caramel malt
7–10 lbs. (3.2–4.5 kg.) whole pumpkin
2 oz. (56.8 g.) Williamette hops (boiling): 10 HBU
$\frac{1}{2}$ oz. (14.2 g.) Cascade hops (boiling): 2.5 HBU
1 oz. (28.4 g.) Mt. Hood hops (aroma)
1 tsp. ground cinnamon
1 vanilla bean, chopped
$\frac{1}{2}$ tsp. freshly ground nutmeg
$\frac{1}{4}$ tsp. ground allspice
$\frac{1}{2}$ tsp. ground dried ginger
$\frac{1}{4}$ tsp. (1 g.) powdered Irish moss
Ale yeast
$\frac{3}{4}$ c. (178 ml.) corn sugar or $1\frac{1}{4}$ c. (296 ml.) dried malt extract (for
bottling)

BUs: 45–50
Color: 6–12 (and tawny)
OG: 1.066–1.070 (16.5–17.5)
FG: 1.016–1.022 (4–5.5)

Chill some homebrew the day before so that it's ready to enjoy on brew day. While the beer is chilling, slice the pumpkin in half and remove seeds and stringy "veins." Roast the pumpkin in a 350-degree F (177 C) oven for about 1 hour or until soft. The roasted pulp will be used in the mash.

Use a protein-developing step mash. Add 3 gallons (11.4 l.) of 130-degree F (54.4 C) water to the crushed malt. Stabilize at 122 degrees F (50 C) and hold for 30 minutes. Then add 1.5 gallons (5.7 l.) of boiling water and thoroughly mashed pumpkin pulp. Add heat if necessary and stabilize at 148 to 152 degrees F (64–67 C) and hold for 60 minutes. Add more heat and mash out to 165 degrees F (74 C).

Sparge with about 4 gallons (15.2 l.) of 170-degree F (77 C) water. Initial extract volume may be about 7 to 8 gallons (26.6–30.4 l.). Anticipate a long, vigorous boil and evaporation of 2 to 3 gallons (7.6–11.4 l.).

Add boiling hops and boil for 75 to 90 minutes or until volume of boiling wort approaches 5.5 gallons (21 l.). Then add cinnamon, nutmeg, allspice, ginger, vanilla and Irish moss and continue boiling

10 more minutes. Turn off heat. Add aroma hops and let steep for 2 to 3 minutes before straining hops and spices and chilling the wort.
Pitch the yeast when cool. Bottle when fermentation is complete.

Rye Not? (All Grain)

Rye malt is occasionally available to homebrewers. It's worth experimenting with, but be cautious. Too much rye malt will unbearably set your mash and stop runoff during the lautering. Attention must be given to flow from the lauter-tun. You may need a few glasses of homebrew for this one.

Rye contributes an austere crisp character to beer, but it is rather subtle. Now, how's that for describing something I really don't know how to describe? Rye Not? is a smooth lager complemented with plenty of caramel malt character and is not overly hoppy.

Ingredients for 5 gallons (19 l.)

4.5 lbs. (2.0 kg.) pale malted barley
1.2 lbs. (0.54 kg.) 20 Lovibond crystal/caramel malt
2 lbs. (0.91 kg.) rye malt
$\frac{3}{4}$ oz. (21.3 g.) American Hallertauer hops (boiling): 3 HBU
$\frac{1}{2}$ oz. (14.2 g.) American Hallertauer hops (flavor): 2 HBU
$\frac{3}{4}$ oz. (21.3 g.) Hersbrucker Hallertauer hops (flavor): 3 HBU
1 oz. (28.4 g.) Mt. Hood hops (aroma)
$\frac{1}{4}$ tsp. (1 g.) powdered Irish moss
Ale yeast
$\frac{3}{4}$ c. (178 ml.) corn sugar or $1\frac{1}{4}$ c. (296 ml.) dried malt extract (for bottling)

BUs: 20
Color: 6–10
OG: 1.044–1.048 (11–12)
FG: 1.014–1.018 (3.5–4.5)

Using a protein-developing step mash, add 2 gallons (7.6 l.) of 130-degree F (54.4 C) water to the crushed malt. Stabilize at 122 degrees F (50 C) and hold for 30 minutes. Then add 1 gallon (3.8 l.) of boiling water. Stabilize at 154 to 157 degrees F (67.8–69.4 C) and hold for 60 minutes. Add heat and mash out to 165 degrees F (74 C).

Sparge with about 3.5 gallons (13.3 l.) of 170-degree F (77 C) water. Add more water (do not oversparge) to brewpot to make an initial extract volume of 6 gallons (22.8 l.). Anticipate evaporation of about 1 gallon (3.8 l.).

Add the boiling hops and boil for 60 minutes. Then add the American Hallertauer hops and boil for an additional 15 minutes. Then add Hersbrucker Hallertauer hops and Irish moss and boil for another 15 minutes. Total boiling time is 90 minutes. Turn off heat. Add aroma hops and let steep for 2 to 3 minutes before removing hops and chilling the hot wort. Pitch the yeast when cool.

Transfer the fermenting beer to a secondary fermenter after four to seven days and lager at 40 to 50 degrees F (4–10 C) for three to five weeks.

Bottle when fermentation is complete.

ANCIENT SPECIALTIES

Speltbrau

A hybrid beer combining ancient grains with modern brewing techniques and recipe formulation. Spelt, also known as dinkel, is an ancient heirloom wheat. It is not currently available in malted form, but with a homebrewed determination, malted spelt and beer brewed from it can easily be made. Speltbrau may be an alternative beer for those who are allergic to barley and hybridized wheat. Consult your physician before consuming.

Ingredients for 2 gallons (7.6 l.)

4 lbs. (1.8 kg.) malted spelt
0.6 oz. (17 g.) Hallertauer hops (boiling): 2.25 HBU
$\frac{1}{8}$ tsp. (1 g.) powdered Irish moss
Ale or lager yeast
$\frac{1}{3}$ c. (79 ml.) corn sugar (for bottling)

BUs: 20
Color: 1.5–3
OG: 1.036–1.040 (9–10)
FG: 1.008–1.012 (2–3)

Begin by malting about 6 pounds (2.73 kg.) of spelt. Soak the spelt in fresh cool water for about 32 hours. Be sure to drain and change the water every 6 to 8 hours. After the soaking, drain and

rinse one final time and place in a container to germinate. While germinating, rinse the sprouting spelt with fresh water every 8 hours, or more frequently if desired. The spelt will develop rootlets and a growing acrospire. Sprouting will take place in two or three days, depending on conditions. Keep sprouting grains in a relatively cool and dark area. When the acrospire has reached a length equal to the length of the grain, it is time to dry the wet malt.

Rinse well before drying. The wet malt can be tied into a large sack and placed in a clothes dryer until dry. The malt may also be spread out on a flat surface and allowed to dry in a very warm area.

Finished malt should not be soft when chewed. It should be friably crunchy and have a slightly sweet flavor. The dried rootlets and shriveled acrospire will easily break off if the malt is roughly handled. They can be removed from the bulk of the malted kernel by pouring the grain from one container to another in the airstream of a fan—outdoors. Rubbing the grain over a wire screen will also serve to sieve off the dried rootlets and acrospire. But don't become worried about this.

Your spelt malt can be stored until you want to brew.

Using a protein-developing step mash, add 1 gallon (3.8 l.) of 130-degree F (54.4 C) water to 4 pounds (1.8 kg.) crushed malt. Stabilize at 122 degrees F (50 C) and hold for 30 minutes. Then add $\frac{1}{2}$ gallon (1.9 l.) of boiling water. Stabilize at 152–154 degrees F (66.7–67.8 C) and hold for 60 minutes. Add heat and raise temperature to 158 degrees F (70 C) and hold for 20 minutes. Then mash out to 165 degrees F (74 C).

Slowly lauter and sparge with about 2 gallons (7.6 l.) of 170-degree F (77 C) water. Because spelt does not have a husk, like barley, lautering will be difficult. If a 3- to 4-inch (7.6- to 10.2-cm) filter bed is maintained, the risk of grain bed compaction and stuck runoff can be minimized. This may necessitate a series of two or three lauterings. As an alternative, mix old hops having no bittering value to the mash during lautering. The hop cones will help create a more effective filter bed for the mashed spelt.

Initial extract volume should be about 2.5 gallons (9.5 l.). Anticipate evaporation of about $\frac{1}{2}$ gallon (1.9 l.).

Add the boiling hops and boil for 60 minutes. Strain out the hops and chill the hot wort. Pitch the yeast when cool.

Bottle when fermentation is complete.

Sikaru Sumerian Beer

> Let the heart of the gakkuo (fermenting) vat be our heart!
> What makes your heart feel wonderful,
> Makes also our heart feel wonderful.
> Our liver is happy, our heart is joyful.
> You poured a libation over the brick of destiny,
> You placed the foundations in peace and prosperity.
> May Ninkasi live together with you!
> Let her pour for you beer and wine,
> Let the pouring of the sweet liquor resound pleasantly for
> you!
> In the . . . reed buckets there is sweet beer,
> I will make cupbearers, boys, and brewers stand by,
> While I turn around the abundance of beer,
> While I feel wonderful, I feel wonderful,
> Drinking beer, in a blissful mood,
> Drinking liquor, feeling exhilarated,
> With joy in the heart and a happy liver—
> While my heart full of joy,
> And my happy liver I covered with a garment fit for a queen!

—A 5,000-year-old toast to a woman tavern keeper in ancient Mesopotamia. Translated by Miguel Civil of the Oriental Institute of the University of Chicago, 1964.

Sometime between 6,000 and 10,000 years ago the world's first grain-based beers may have been brewed. In what today is known as Iraq, Sumerians dwelled in an area referred to as Mesopotamia. Archaeologists, anthropologists and the Anchor Brewing Company of San Fran-

A *receipt that would fill your pocket. Held in hand, perhaps once a bill of sale, this original hardened clay tablet written in cuneiform by ancient Sumerians depicts the oldest recorded recipe in the world: A 5,000-year-old recipe for beer.*

cisco have done a great deal of investigative research to try to unravel the mysteries of what may have been man's first beer.

The earliest known recipe for beer is translated from Sumerian clay tablets dating back nearly 4,000 years ago. References to the joy of brewing and drinking were found on numerous other clay tablets inscribed in the hieroglyphiclike uniform written language of the Sumerians. Among these references is the "Hymn to Ninkasi." Ninkasi was the Sumerian goddess of brewing and a very revered deity.

In 1989 the Anchor Brewing Company endeavored to duplicate, as near as it could, a version of Sumerian beer. In the fall of 1989 they released the results of their first experiment. "Ninkasi" was the name they gave the beer. It was brewed from a combination of bappir, malt, dates, water and yeast. Bappir is a Sumerian bread. The Anchor Brewing Company's version included water, barley, malted barley, roasted barley and honey. It was twice baked in order that most of the moisture be removed. The resulting hard bappir bread could be stored indefinitely, as was likely the case 4,000 years ago.

Beer author Michael Jackson (left) and professor of anthropology at the University of Pennsylvania Dr. Solomon Katz view several ancient cuneiform tablets, some depicting beer recipes 5,000 years old.

Scholars surmise that bappir may have been one of the main ingredients in the brewing process, along with malted barley or spelt (an ancient wheat) and dates.

One part bappir was mashed with two parts malted barley and a quantity of dates for Anchor's Ninkasi beer. This mash was lautered and then brought to a temperature just shy of boiling, to authenticate what may have been actual procedures. The wort was pitched with cultured beer yeast, fermented and bottled without pasteurization. The result was a mild-tasting, low-alcohol, somewhat fruity-winelike beer, perhaps similar to the original 4,000-year-old version.

Here is a five-gallon (19-l.) recipe for a version of Sikaru that leaves much to your own imagination and creativity.

Ingredients for bappir

2 lbs. (0.9 kg.) crushed pale malted barley
2 lbs. (0.9 kg.) barley flour
$\frac{1}{2}$ lb. (0.23 kg.) crushed roasted barley
1 lb. (0.45 kg.) honey
adequate water

And on the first day they made bappir. Author Charlie Papazian participates with Anchor Brewing Company staff in preparing hundreds of loaves of bappir. Bappir, a twice-baked hard loaf of bread of barley, malt and honey, was later used as a main ingredient by the brewery in the making of an ancient Sumerian-style beer called Ninkasi.

Combine the dry ingredients with honey and enough water to make a stiff dough, roughly the consistency of oatmeal cookie dough, but slightly drier. Knead and then shape into 8-inch-diameter (20.3-cm.) patties about 1 inch (2.54 cm.) high. Bake in a 350-degree F (176 C) oven for about 1 hour. Remove and slice into $1\frac{1}{2}$-inch (3.8-cm.) strips. Let cool for 1 hour and then bake again until hard and dry. Your bappir may be stored in a cool, dry place for centuries and is ready for brewing when you are.

"Bappir will get you through times with no money better than money will get you through times with no bappir." Quote from my great, great, great, great, great, great, great, great . . . great-grand-mother.

Ingredients for five gallons (19 l.) of twenty-first-century Sikaru

> 3 lbs. (1.36 kg.) pale malted barley
> 2 lbs. (0.91 kg.) bappir
> 1 lb. (0.45 kg.) chopped and pitted dates
> ale yeast
> $\frac{2}{3}$ c. (156 ml.) corn sugar or 1 c. (237 ml.) dried malt extract (for bottling)

BUs: none
Color: varies
OG: 1.034–1.040 (8.5–10)
FG: 1.004–1.010 (1–2.5)

Add crushed malts and bappir to 1.5 gallons (5.7 l.) of 168-degree F (76 C) water. The mash will stabilize at 150 to 155 degrees F (66–67 C). Hold this temperature for 60 minutes.

Sparge with about 2–2.5 gallons (7.6- 9.5 l.) of 170-degree F (77 C) water. Add more water (do not oversparge) to brewpot to make initial extract volume of $5\frac{1}{2}$ gallons (21 l.). Add chopped dates. Anticipate evaporation of $\frac{1}{2}$ gallon (1.9 l.). Chill the hot wort with an immersion-type system. Transfer the cooled wort with the dates to your fermenter. When brewing 5 gallons (19 l.), a $6\frac{1}{2}$- to 7-gallon (25- to 26.5-l.) fermenter is necessary. Do not use a blow-off method of fermentation as the dates will clog the system. Pitch chosen yeast when cool and bottle when fermentation is complete.

Variations: For perhaps more authenticity, you may use spelt rather than barley. Malt the spelt as described in the recipe for Speltbrau. Grind and use unmalted spelt in place of barley flour. Roast a portion of unmalted spelt for coloring and as a substitute for roast barley. Keep in mind that your yields will be quite a bit less for home-malted spelt, so you may want to use 50 percent more malted ingredients in the final mash to compensate.

Want to try a yeast that may date back to Sumerian times? Write World Sourdoughs from Antiquity, P.O. Box 1440, Cascade, Idaho 83611, U.S.A., and order their Egyptian Red Sea Culture. Surely full of wild yeast and lactobacillus, this culture may produce a beer that, if consumed fresh, may be more similar to the original Sikaru. We can be quite certain that the original beers were drunk from non-pressurized containers, just as fermentation subsided.

LAGERS

LIGHT-BODIED LAGERS

Quarterbock Low Alcohol (Mash-Extract)

You'll not want to pass up handing this off to your light-drinking friends while you're rolling out another batch or running back to the center of town to buy ingredients for your next batch of beer. Quarterbock is one beer that won't get sacked as a tasteless second-string effort.

Now that I've fumbled that out of bounds, let's consider recovering with a winning, satisfyingly flavored 2 percent low-alcohol beer.

Quarterbock is a refreshing, light-bodied (but not watery) beer, light amber in color with a bitterness that complements yet doesn't linger. It's a great beer for occasions when you're thirsty, you want a beer and you want to minimize the effects of alcohol on your performance. It's a great starting point for your low-alcohol beer brewing efforts. Brew it. Taste it. Enjoy it. Then darken, lighten, hop or add body to it as suits your own taste with your next batch.

The secret? Well, it isn't really a secret but a trick some commercial breweries use to enhance their production. It's called high-gravity brewing, most often used to produce normal-strength beer by watering down higher-gravity beer during the packaging process. But none go the distance that you will.

The higher the beer gravity, the more esters and other fermentation byproducts that are produced. These "interesting" flavors are usually not desirable in commercially available, tasteless low-alcohol

beers. But for people like you and me who enjoy the flavors of beer, these characters are what we want.

We want to brew a very strong doppelbock with a starting gravity of 1.096 to 1.100 (24–25). Ferment out to completion (about 1.028 to 1.032 [7–8]), then add deaerated water at a ratio of three parts water to one part finished doppelbock. Result: a quarterbock that, after dilution, has a finished gravity of 1.008 to 1.010 (2–2.5). Brewing this as a straightaway run up the middle, you'd be brewing an original gravity of 1.025 (6), but it would be more likely to ferment down to 1.003 to 1.005 (1–1.5) and would be without esters and the complexity of flavor that higher-gravity brewing creates.

You can experiment and help predict what your fermentation will taste like by diluting 2 ounces (60 ml.) of your finished batch of doppelbock with 6 ounces (178 ml.) of chilled seltzer water.

Because of the very high gravity of the boiled wort and the great amount of hops called for, the original gravity and bitterness units cannot be accurately calculated, partially due to the nonlinear nature of high-wort-density measurements. Hop utilization is also decreased.

Ingredients for a final FOUR gallons (15.2 l.) of mash-extract brew, but actually you will brew one gallon (3.8 l.) of high-gravity beer and dilute with three gallons (11.4 l.) of deaerated water before bottling.

$8\frac{1}{2}$ oz. (241 g.) pale malted barley
$2\frac{1}{2}$ oz. (71 g.) Munich malt
6 oz. (170 g.) malted wheat
$2\frac{1}{2}$ oz. (71 g.) 40 Lovibond crystal/caramel malt
1 oz. (28.4 g.) roasted chocolate malt
1.9 lbs. (0.86 kg.) light dried malt extract
$\frac{1}{2}$ oz. (14.2 g.) German Northern Brewer hops (boiling): 4.5 HBU
$\frac{1}{5}$ oz. (5.7 g.) German Hallertauer hops (flavor): 1 HBU
$\frac{1}{5}$ oz. (5.7 g.) American Tettnanger hops (aroma)
Lager yeast
$\frac{2}{3}$ c. (158 ml.) corn sugar or 1 c. (237 ml.) dried malt extract (for bottling)

BUs: 100–130
Color: 14–20
OG: 1.096–1.106 (24–26.5)
FG (before dilution): 1.028–1.032 (7–8)
FG (after dilution): 1.008–1.010 (2–2.5)

Using a protein-developing step mash, add $5\frac{1}{2}$ cups (1.3 l.) of 130-degree F (54.4 C) water to the crushed malt. Stabilize at 122 degrees F (50 C) and hold for 30 minutes. Then add 3 cups (0.71 l.) of boiling water. Stabilize at 155 to 158 degrees F (68–70 C) and hold for 30 minutes. Add heat and mash out to 165 degrees F (74 C).

Sparge with about $2\frac{1}{2}$ quarts (2.4 l.) of 170-degree F (77 C) water. Add dried malt extract and boiling hops and boil for 45 minutes or until volume is 2 to 3 quarts (1.9–2.9 l.). Add flavor hops and boil for a final 15 minutes. Turn off heat, add aroma hops and let steep 2 to 3 minutes. Place the pot of hot wort in a tub of cold water for 15 to 20 minutes to help cool the wort. Then sparge, strain and add this warm wort to a sanitized 1-gallon (or larger) fermenter to which you have added 1 quart (0.95 l.) cold water. Top off the wort to achieve one gallon. Aerate the cooled wort. Add active yeast when cooled to about 70 degrees F (21 C).

When the beer is finished fermenting, prepare the deaerated dilution water. Boil 3 gallons (11.4 l.) of water and chill before adding to beer. If you have a 3-gallon (11.4-l.) or 5-gallon (19-l.) soda canister for your draft system, you can add boiled water or tap water to this container and bubble carbon dioxide through the water, releasing the air through one of the disconnect valves as you add carbon dioxide. This will purge oxygen from the water and replace it with a small amount of carbon dioxide. (Don't worry about the amount of carbon dioxide.) One last alternative is to use seltzer water as your dilution water, store-bought or homemade. Add vigorously to decarbonate it.

Add $\frac{2}{3}$ cup (158 ml.) corn sugar to finished and racked beer. Dilute 3:1 water to beer. Mix gently and bottle. It'll be yours within weeks. You won't want to have a Monday morning Quarterbock, but anytime after noon would be most appropriate.

There is no problem in actually brewing a 5-gallon (19-l.) batch of $10\frac{1}{2}$ percent alcohol doppelbock (using a recipe called Limnian Doppelbock featured in *The New Complete Joy of Home Brewing*). One gallon can go towards making 4 gallons (15.2 l.) of Quarterbock. The other 4 gallons (15.2 l.) of doppelbock? Well, you'll know what to do, won't you?

Shikata Ga Nai American Light Lager (Malt Extract)

Do you want to brew an extract-based light American lager? Well, *Shikata Ga Nai*, meaning "I'm sorry, there's nothing anyone can do about it. I can't do anything about it. There's nothing anyone can do

about it. But if there's something you can do about it, please let me know."

Well, it just so happens that there is something I can do about it, and so can you.

Keep in mind that there comes a time when the yard needs mowing, the sun is hot and the air is dry. Your thirst calls out for a cold, cold thirst-quenching beer—something simple, low in alcohol and effervescently refreshing. And just on the principle of the whole thing, you want it to be your homebrew. You know how much better your homebrew is than anything that could come out of a can.

Use a quality lager yeast and you'll be able to brew an American-style light lager, superlight in color, light in body, light in bitterness, light in alcohol, but with a fresh homebrewed flavor accented with a touch of German hop flavor and aroma.

The recipe calls for a 6-gallon (22.8-l.) batch because of the 4-pound (1.8-kg.) can of extract used. If you must brew 5 gallons (19 l.), substitute dry malt and cut back the recipe 16 percent all around.

Ingredients for 6 gallons (22.8 l.)

4 lbs. (1.8 kg.) Alexander's brand pale malt extract syrup, or substitute 3.2 lbs. (1.45 kg.) extralight dry malt extract

$1\frac{1}{2}$ lbs. (0.68 kg.) rice extract powder

$\frac{1}{2}$ oz. (14.2 g.) German Hersbrucker or Yakima Hallertauer hops (boiling): 2 HBU

$\frac{1}{2}$ oz. (14.2 g.) German Hersbrucker or Yakima Hallertauer hops (flavor, first addition): 2 HBU

$\frac{1}{2}$ oz. (14.2 g.) German Hersbrucker or Yakima Hallertauer hops (flavor, second addition): 2 HBU

$\frac{1}{2}$ oz. (14.2 g.) Czechoslovakian Saaz hops (flavor): 1.5 HBU
1 oz. (28.4 g.) American Tettnanger hops (aroma)
$\frac{1}{4}$ tsp. (1 g.) powdered Irish moss
Lager yeast; American Lager type
$\frac{3}{4}$ c. (178 ml.) corn sugar (for bottling)

BUs: 14
Color: 2–4
OG: 1.034–1.038 (8.5–9.5)
FG: 1.009–1.013 (2–3)

Bring 2 gallons (7.6 l.) of water to a boil with malt and rice extracts. Add $\frac{1}{2}$ ounce (14.2 g.) Hallertauer hops and boil 30 minutes, then add $\frac{1}{2}$ ounce (14.2 g.) more of Hallertauer hops. Boil for another 15 minutes, then add $\frac{1}{2}$ ounce (14.2 g.) more of Hallertauer and $\frac{1}{2}$ ounce (14.2 g.) Saaz hops and Irish moss. Boil for 15 more minutes. At the end of a total of 60 minutes of total boiling, add 1 ounce (28.4 g.) of Tettnanger hops and steep for two minutes.

Transfer the hot wort to a sanitized fermenter filled with 2 gallons (7.6 l.) of cold water. Strain out the hops. Top your fermenter with enough water to make 6 gallons (22.8 l.). When cool add yeast. Use a quality lager yeast, and after one week in a primary fermenter, secondary lager for three weeks at a temperature between 42 and 47 degrees F (5.6–8.3 C).

Bottle with corn sugar when fermentation is complete.
Shikata Ga Nai. Please let me know.

Get Rio (Malt Extract)

If you have friends who have American light lager tastes and have never had homebrew, this brew is light in color and not too bitter, but with great hop flavor and the malt character that'll suit your own preferences. It's a perfect beer to wean your friends from light light lagers to more flavorful brews. It is in the style of a premium all-malt American light lager, but with a pleasant fullness of hop flavor not found in beers on the store shelves.

Ingredients for 5 gallons (19 l.)

6.5 lbs. (3 kg.) Alexander's brand pale malt extract syrup, or substitute 5 lbs. (2.27 kg.) extralight dry malt extract
$\frac{3}{4}$ oz. (21 g.) German Hersbrucker hops (boiling): 2.3 HBU
$\frac{3}{4}$ oz. (21 g.) Czech Saaz hops (boiling): 2.4 HBU

$\frac{1}{5}$ oz. (5.7 g.) German Hersbrucker or Yakima Hallertauer hops (flavor): 0.5 HBU

$\frac{3}{4}$ oz. (21 g.) American Tettnanger hops (aroma)

$\frac{1}{4}$ tsp. (1 g.) powdered Irish moss

Lager yeast; American Lager type

$\frac{3}{4}$ c. (178 ml.) corn sugar or $1\frac{1}{4}$ c. (296 ml.) dried malt extract (for bottling)

BUs: 16
Color: 2–4
OG: 1.044–1.048 (11–12)
FG: 1.013–1.017 (3–4)

Bring 2 gallons (7.6 l.) of water to a boil with malt extract. Add boiling hops and boil 40 minutes. Then add Irish moss and flavor hops. Boil for another 20 minutes. At the end of a total of 60 minutes of total boiling, add aroma hops and steep for 2 to 3 minutes.

Transfer the hot wort to a sanitized fermenter filled with 2 gallons (7.6 l.) of cold water. Strain out the hops. Top your fermenter with enough water to make 5 gallons (19 l.). When cool add yeast. Use a quality lager yeast, and after one week in a primary fermenter, secondary lager for three weeks at a temperature between 42 and 47 degrees F (6–8 C).

Bottle when fermentation is complete.

Dutch Swing-top Lager (All Grain)

There are several brands of European continental light lagers that make their way to the American import beer market. Some of the best known are Dutch Heineken and Grölsch light lagers. Stylistically they might fall somewhere between an American light lager and a hoppy German Pilsener. Dutch Swing-top Lager is a cold-fermented lager brewed with corn to lighten the body and palate, while the use of adequate European hops gives it a distinctiveness similar to these Dutch beers.

Hot trub removal is recommended so a lower overall extract efficiency may result. This formulation is based on 80 percent overall extract/system efficiency.

Though I sincerely don't recommend it, you can add some real "imported green bottled beer" character by exposing a bottle of your own homebrew to direct sunlight for 5 minutes for that subtle light-struck "skunkiness."

Ingredients for 5 gallons (19 l.)

6.5 lbs. (3 kg.) American pale lager malt
$1\frac{1}{2}$ lbs. (0.68 kg.) flaked corn/maize (not the Kellogg's type)
0.6 oz. (17 g.) German Northern Brewers hops (boiling): 5 HBU
1 oz. (28.4 g.) German Hallertauer hops (flavor, first addition): 4 HBU
$\frac{1}{2}$ oz. (14.2 g.) German Hallertauer hops (flavor, second addition): 2 HBU
$\frac{1}{2}$ oz. (14.2 g.) German Hallertauer hops (aroma)
$\frac{1}{4}$ tsp. (1 g.) powdered Irish moss
Lager yeast; Pilsener type
$\frac{3}{4}$ c. (178 ml.) corn sugar or $1\frac{1}{4}$ c. (296 ml.) dried malt extract (for bottling)
Water used for this recipe should be very soft, low in carbonates, with about 50 ppm calcium ions.

BUs: 33
Color: 2–3
OG: 1.045–1.049 (11–12)
FG: 1.008–1.012 (2–3)

Use a protein-developing step mash. Add 2 gallons (7.6 l.) of 130-degree F (54.4 C) water to the crushed malt and flaked maize. Stabilize at 122 degrees F (50 C) and hold for 30 minutes. Then add 1 gallon (3.8 l.) of boiling water. Stabilize at 148 to 152 degrees F (64–67 C) and hold for 60 minutes. Add heat and mash out to 165 degrees F (74 C).

Sparge with about 3.5 to 4 gallons (13.3–15.2 l.) of 170-degree F (77 C) water. Add more water (do not oversparge) to brewpot to make an initial extract volume of 6 gallons (22.8 l.). Anticipate evaporation of about $\frac{3}{4}$ gallon (2.9 l.).

Add Northern Brewer boiling hops and boil for 30 minutes. Then add 1 ounce (28.4 g.) Hallertauer flavor hops and boil for another 15 minutes. Then add Irish moss and $\frac{1}{2}$ ounce (14.2 g.) more Hallertauer flavor hops and boil for an additional 15 minutes. Total boiling time is 75 minutes. Turn off heat. Add aroma hops and let steep for 2 to 3 minutes before removing hops and chilling the hot wort. Use your own preferred procedures to remove hot break trub before chilling or pitching yeast.

Pitch yeast when cool, and ferment at temperatures between 50 and 55 degrees F (10–13 C). After about four to seven days transfer the beer into a secondary fermenter and lager at 40 to 45 degrees F (4–7 C) for three to four weeks. Bottle.

St. Louis Golden Lager (All Grain)

Two of the classic American light lagers are formulated from only the best malted barley, the finest rice and the choicest hops. Different processes, yeast strains and fermentation temperatures create the variation from one brand of American light lager to another. Here's a basic recipe that will allow you to brew an American light lager unique to your brewery and lager yeast strain. Low in bitterness, malt flavor and body, this might be a beer you enjoy drinking because you made it. Of coors, it may make you weiser too.

Ingredients for 5 gallons (19 l.)

> 5 lbs. (2.3 kg.) two-row American pale lager malt
> 2 lbs. (0.91 kg.) white rice
> $\frac{1}{4}$ oz. (7 g.) American Perle hops (boiling): 2 HBU
> 0.3 oz. (8.5 g.) American Hallertauer hops (boiling): 1.5 HBU
> 0.2 oz. (5.7 g.) American Hallertauer hops (aroma)
> $\frac{1}{4}$ tsp. (1 g.) powdered Irish moss
> Lager yeast; American Pilsener type
> $\frac{7}{8}$ c. (207 ml.) corn sugar (for bottling)
> Water used for this recipe should be very soft, low in carbonates, with about 50 ppm calcium.

BUs: 15
Color: 2–3
OG: 1.040–1.044 (10–11)
FG: 1.006–1.010 (2.5–3.5)

Using a malt mill, adjust the grinder in order to crush the whole rice into small particles. The goal is to break the rice into pieces that are one-fourth to one-fifth the size of a whole grain. Combine the 2

pounds (0.91 kg.) of rice with 1 gallon (3.8 l.) water and boil for 15 to 20 minutes.

Using a protein-developing step mash, add 1 more gallon (3.8 l.) of water to the cooked rice in order to achieve a temperature of 130 degrees F (54.4 C). Then add the crushed malt, stabilize at 122 degrees F (50 C) and hold for 30 minutes. Then add 1.25 gallon (4.7 l.) of boiling water. Stabilize at 148 to 152 degrees F (64–67 C) and hold for 60 to 80 minutes or until conversion is achieved. Add heat and mash out to 165 degrees F (74 C).

Sparge with about 3.5 gallons (13.3 l.) of 170-degree F (77 C) water. Add more water (do not oversparge) to brewpot to make an initial extract volume of 6 gallons (22.8 l.). Anticipate evaporation of about $\frac{3}{4}$ gallon (2.9 l.).

Add boiling hops and boil for 45 minutes. Then add Irish moss and boil for an additional 15 minutes. Total boiling time is 60 minutes. Turn off heat. Add aroma hops and let steep for 2 to 3 minutes before removing hops and chilling the hot wort. Use your own preferred procedures to remove hot break trub before chilling or pitching yeast.

Pitch yeast when cool, and ferment at temperatures between 50 and 55 degrees F (10–13 C). After about four to five days transfer the beer into a secondary fermenter and lager at 40 to 45 degrees F (4–7 C) for three to four weeks. Bottle.

Dork's Torque Mexican Crown Lager (Your Choice)

If you enjoy the type of Mexican beer that is bottled in clear bottles, you can come close to duplicating it by combining the malt (reduce the amount by 1 pound), flaked corn and mashing procedures from the Dutch Swing-top Lager recipe with the hop ingredients and schedule from St. Louis Golden Lager. To assure authenticity, bottle in clear glass bottles and expose to sunlight for 30 minutes. Stuff a slice of lime into the bottle, hold your nose, smile and serve well chilled.

GERMAN- AND CZECHOSLOVAKIAN-STYLE PILSENER

Soiled Dove (Mash-Extract)

This is a malty, medium-bodied Czech-style Pilsener with the unique floral character of American Tettnanger hops and plenty of Czech hop character. It is golden in color. Soft water is essential to create the distinctive hop character of European Pilsener.

Ingredients for 5 gallons (19 l.)

3 lbs. (1.4 kg.) two-row lager barley malt
$\frac{1}{2}$ lb. (0.23 kg.) Munich malt
3.5 lbs. (1.6 kg.) light dried malt extract
1 oz. (28.4 g.) German Hallertauer hops (boiling): 4 HBU
1 oz. (28.4 g.) Czechoslovakian Saaz hops (boiling): 3.7 HBU
$\frac{1}{2}$ oz. (14 g.) German Hallertauer hops (flavor, first addition):
 2 HBU
$\frac{1}{2}$ oz. (14 g.) Czechoslovakian Saaz hops (flavor, first addition):
 1.8 HBU
1 oz. (28.4 g.) German Hallertauer hops (flavor, second addition):
 4 HBU
$\frac{1}{2}$ oz. (14 g.) Czechoslovakian Saaz hops (flavor, second addition):
 1.8 HBU
$1\frac{1}{2}$ oz. (43 g.) American Tettnanger hops (aroma)
$\frac{3}{4}$ oz. (21 g.) German Hallertauer hops (aroma)
$\frac{1}{4}$ tsp. (1 g.) Irish moss
Lager yeast
$\frac{3}{4}$ c. (178 ml.) corn sugar or $1\frac{1}{4}$ c. (296 ml.) dried malt extract (for
 bottling)

BUs: 40
Color: 4–5
OG: 1.046–1.050 (11.5–12.5)
FG: 1.010–1.014 (2.5–3.5)

Using a protein-developing step mash, add 1 gallon (3.8 l.) of 130-degree F (54.4 C) water to the crushed malt. Stabilize at 122 degrees F (50 C) and hold for 30 minutes. Add $\frac{1}{2}$ gallon (1.9 l.) of boiling water. Stabilize at 154 to 157 degrees F (68–69 C) and hold for 60 minutes. Add heat and mash out to 165 degrees F (74 C).

Sparge with about $1\frac{1}{2}$ gallons (5.7 l.) of 170-degree F (77 C) water. Add dried malt extract and boiling hops and boil for 45 minutes. Add $\frac{1}{2}$ ounce (14 g.) each of Hallertauer and Saaz flavor hops and boil for 15 minutes. Then add Irish moss, 1 ounce (28.4 g.) Hallertauer and $\frac{1}{2}$ ounce (14 g.) Saaz and boil for a final 15 minutes. Turn off heat, add aroma hops and let steep 2 to 3 minutes. Sparge, strain and add wort to your sanitized fermenter partly filled with cold water. Add active yeast when cooled to about 70 degrees F (21 C).

Continue primary fermentation at 50 to 60 degrees F (10–15.5 C). Transfer to a secondary fermenter and ferment at lager temperatures of 40 to 50 degrees F (4.4–10 C) for three to five weeks. Bottle with priming sugar.

A Fine Time to Be Me (All Grain)

A premium Czech-German-style Pilsener. The malt and body are in the style of Pilsner Urquell, and the hopping is a Germanic-Czech blend of European Saaz and Hallertauer. Use the best premium two-row Pilsener malt you can find, and accept no substitute for European-grown Saaz and Hallertauer hops if you want to achieve authenticity. Soft water is a must, but be sure your calcium ions are up to 50 ppm. A small amount of black roasted malt is added during the sparge to impart compounds that will help stabilize the flavor of this beer. As is the tradition in Europe, remove the trub to achieve a smoother, cleaner, crisper Pilsener. If Pils is one of your favorites, this recipe will become one of your favorites.

Ingredients for 5 gallons (19 l.)

7 lbs. (3.2 kg.) premium Pilsener two-row lager malt

$\frac{3}{4}$ lb. (0.34 kg.) premium two-row Vienna malt

$\frac{1}{2}$ oz. (14.2 g.) roasted black malt

1 oz. (28.4 g.) Czechoslovakian Saaz hops (boiling): 3.7 HBU

$\frac{3}{4}$ oz. (21 g.) German Hersbrucker Hallertauer hops (boiling): 2.3 HBU

$\frac{1}{2}$ oz. (14.2 g.) German Hallertauer hops (flavor, first addition): 2.3 HBU

$\frac{1}{4}$ oz. (7 g.) German Hersbrucker Hallertauer hops (flavor, first addition): 0.8

$\frac{1}{2}$ oz. (14.2 g.) German Hallertauer hops (flavor, second addition): 2.3 HBU

$\frac{3}{4}$ oz. (21 g.) Czechoslovakian Saaz hops (flavor, second addition): 3 HBU

$\frac{1}{2}$ oz. (14.2 g.) German Hallertauer hops (aroma)

$\frac{1}{4}$ oz. (7 g.) German Hersbrucker Hallertauer hops (aroma)

$\frac{1}{4}$ tsp. (1 g.) powdered Irish moss
Lager yeast; Pilsener type
$\frac{3}{4}$ c. (178 ml.) corn sugar or $1\frac{1}{4}$ c. (296 ml.) dried malt extract (for bottling)

BUs: 38
Color: 3–4
OG: 1.044–1.048 (11–12)
FG: 1.008–1.012 (2–3)

Use a protein-developing step mash. Add 2 gallons (7.6 l.) of 130-degree F (54.4 C) water to the crushed malt. Stabilize at 122 degrees F (50 C) and hold for 30 minutes. Then add 1 gallon (3.8 l.) of boiling water. Stabilize at 148 to 152 degrees F (64–67 C) and hold for 60 minutes. Add heat and mash out to 165 degrees F (74 C). Add crushed black malt to mash. Gently mix.

Sparge with about 3.5 to 4 gallons (13.3–15.2 l.) of 170-degree F (77 C) water. Add more water (do not oversparge) to brewpot to make an initial extract volume of 6 gallons (22.8 l.). Anticipate evaporation of about $\frac{3}{4}$ gallon (2.9 l.).

Add boiling hops and boil for 45 minutes. Then add $\frac{1}{2}$ ounce (14.2 g.) Hallertauer and $\frac{1}{4}$ ounce (7 g.) Hersbrucker flavor hops and boil for another 15 minutes. Add Irish moss, $\frac{1}{2}$ ounce (14.2 g.) more Hallertauer hops and $\frac{3}{4}$ ounce (21 g.) Saaz and boil for an additional 15 minutes. Total boiling time is 75 minutes. Turn off heat. Add aroma hops and let steep for 2 to 3 minutes before removing hops and chilling the hot wort. Use your own preferred procedures to remove hot break trub before chilling or pitching yeast.

Pitch yeast when cool, and ferment at temperatures between 50 and 55 degrees F (10–13 C). After four to seven days transfer the beer into a secondary fermenter and lager at about 40 to 45 degrees F (4–7 C) for four to six weeks. Bottle.

Creede Lily (All Grain)

The bitterness of a northern German Pils is a masterpiece of the brewer's art. German Pils such as Bitburger Pils is perfectly brewed in a way that pinpoints the sensation of hop bitterness on a specific area of the tongue. There are many kinds of sensations that bitterness can create; bitterness that lingers, bitterness that is assertive, over-powering, fleeting or soft, bitterness that is sensed on the center back of the tongue, on the roof of the mouth, on the sides. All of these sensations orchestrate and punctuate the other flavors of beer.

With a fine German Pils it becomes a dream symphony that creates a deep yearning for another and another.

Creede Lily was brewed with my German travels and the fresh taste, billowy head and hop fragrance of Bitburger Pils in mind.

Ingredients for 5 gallons (19 l.)

8 lbs. (3.6 kg.) premium Pilsener two-row lager malt
$\frac{1}{2}$ oz. (14.2 g.) Czechoslovakian Saaz hops (boiling): 2 HBU
1 oz. (28.4 g.) German Hersbrucker Hallertauer hops (boiling): 4 HBU
$\frac{1}{4}$ oz. (7 g.) Czechoslovakian Saaz hops (flavor, first addition): 1 HBU
$\frac{1}{2}$ oz. (14.2 g.) German Hersbrucker Hallertauer hops (flavor, first addition): 2 HBU
1 oz. (28.4 g.) Czechoslovakian Saaz hops (flavor, second addition): 4 HBU
$\frac{1}{2}$ oz. (14.2 g.) German Hersbrucker Hallertauer hops (flavor, second addition): 2 HBU
$\frac{3}{4}$ oz. (21 g.) German Hersbrucker Hallertauer hops (aroma)
1 oz. (28.4 g.) Tettnanger hops (aroma)
$\frac{1}{4}$ tsp. (1 g.) powdered Irish moss
Lager yeast; Pilsener type
$\frac{3}{4}$ c. (178 ml.) corn sugar or $1\frac{1}{4}$ c. (296 ml.) dried malt extract (for bottling)

BUs: 40
Color: 3–4
OG: 1.044–1.048 (11–12)
FG: 1.008–1.012 (2–3)

Use a protein-developing step mash. Add 2 gallons (7.6 l.) of 140-degree F (60 C) water to the crushed malt. Stabilize at 132 degrees F (50 C) and hold for 30 minutes. (The higher temperature will develop better foam stability.) Then add 1 gallon (3.8 l.) of boiling water. Stabilize at 148 to 152 degrees F (64–67 C) and hold for 60 minutes. Add heat and mash out to 165 degrees F (74 C).

Sparge with about 3.5 to 4 gallons (13.3–15.2 l.) of 170-degree F (77 C) water. Add more water (do not oversparge) to brewpot to make an initial extract volume of 6 gallons (22.8 l.). Anticipate evaporation of about $\frac{3}{4}$ gallon (2.9 l.).

Add boiling hops and boil for 45 minutes. Then add $\frac{1}{2}$ ounce

(14.2 g.) Hersbrucker and $\frac{1}{4}$ ounce (7 g.) Saaz flavor hops and boil for another 15 minutes. Add Irish moss, $\frac{1}{2}$ ounce (14.2 g.) Hersbrucker and 1 ounce (28.4 g.) Saaz and boil for an additional 15 minutes. Total boiling time is 75 minutes. Turn off heat. Add aroma hops and let steep for 2 to 3 minutes before removing hops and chilling the hot wort. Use your own preferred procedures to remove hot break trub before chilling or pitching yeast.

Pitch yeast when cool, and ferment at temperatures between 50 and 55 degrees F (10–13 C). After four to seven days transfer the beer into a secondary fermenter and lager at 40 to 45 degrees F (4–7 C) for four to six weeks. Bottle.

OKTOBERFEST AND VIENNA LAGERS

Autumnal Equinox Special Reserve (Mash-Extract)

Autumnal Special Reserve is an Oktoberfest-style lager, with less bitterness than is typical of the style. Noble varieties of Saaz, Hersbrucker Hallertauer and American-grown Mt. Hood hops are sparingly used to *barely* accent the mellow, rich roundness of malt. Regal maltiness is complemented with an almost opalescent amber glow from hints of wheat and Munich-style malt.

A Bavarian or Munich lager yeast should be used. They will perform best in contributing lager character even if cold lager fermentation temperatures cannot be totally achieved.

Because it matures well with the passing months, the recipe is for 10 gallons. Keg 5 gallons (19 l.) and reserve for a special occasion. Celebrate the other 5 gallons at your leisure.

Ingredients for 10 gallons (38 l.)

4 lbs. (1.8 kg.) two-row lager barley malt
$2\frac{1}{2}$ lbs. (1.14 kg.) Munich malt
3 lbs. (1.36 kg.) wheat malt
3 lbs. (1.36 kg.) light dried malt extract
6.6 lbs. (3 kg.) Ireks brand German Amber malt extract
$2\frac{1}{4}$ oz. (64 g.) Czechoslovakian Saaz hops (boiling): 9 HBU
4 oz. (114 g.) German Hersbrucker Hallertauer hops (flavor): 16 HBU
1 oz. (28.4 g.) Mt. Hood hops (aroma)
$\frac{1}{4}$ tsp. (1 g.) powdered Irish moss
Lager yeast; Bavarian- or Munich-type lager yeast
$\frac{3}{4}$ c. (178 ml.) corn sugar or $1\frac{1}{4}$ c. (296 ml.) dried malt extract for bottling 5 gallons (19 l.)
$\frac{1}{3}$ c. (78 ml.) corn sugar or $\frac{1}{2}$ c. (120 ml.) dried malt extract for kegging 5 gallons (19 l.)

BUs: 30
Color: 10–14
OG: 1.062–1.066 (15.5–16.5)
FG: 1.014 -1.018 (3.5–4.5)

Using a protein-developing step mash, add $2\frac{1}{2}$ gallons (9.5 l.) of 130-degree F (54.4 C) water to the crushed malt. Stabilize at 122 degrees F (50 C) and hold for 30 minutes. Add $1\frac{1}{4}$ gallons (4.8 l.) of boiling water. Stabilize at 158 degrees F (70 C) and hold for 30 minutes. Add heat and mash out to 165 degrees F (74 C).

Sparge with $3\frac{1}{2}$ to 4 gallons (13.3–15.2 l.) of 170-degree F (77 C) water. Collect about 5 gallons (19 l.). Add more water to the brewpot (do not oversparge) if necessary. Add dried malt extract and boiling hops and boil for 45 minutes. Add 2 ounces (57 g.) of Hallertauer flavor hops and boil for 15 minutes. Then add Irish moss and remaining 2 ounces (57 g.) Hallertauer and boil for a final 15 minutes. Turn off heat, add aroma hops and let steep 2 to 3 minutes. Sparge, strain and add wort to your sanitized fermenter partly filled with cold water. Add active yeast when cooled to about 70 degrees F (21 C).

Continue primary fermentation at 50 to 60 degrees F (10–15.6 C). Transfer to secondary fermenter and ferment at lager temperatures of 40 to 50 degrees F (4.4–10 C) for three to five weeks. Bottle and keg with appropriate amount of priming sugar.

If proper attention has been given to sanitation techniques, this beer will age wonderfully for eight to twelve months. When it reaches

its peak flavor is a matter of personal preference. I preferred the three- to six-month period, but this will vary with your techniques and yeast type.

Princess of Peace Märzen (Mash-Extract)

This rich amber beer expresses the essence of what beer means to me. The rich, warm and translucent color, the sweetly seductive aroma and flavor of toasted malt and the crisp bitterness of hops—a match made in beer heaven. Full-flavored, but not heavy. Clean yet expressive.

Sometime near the end of August and the first few weeks of September there is a trace of autumn that garnishes the air. It is time to brew the beer that captures the final warmth of summer to feed the soul during the shorter days and cooler nights that will come soon.

Princess of Peace is an Oktoberfest-Märzen that will warm your soul, complement your friends and inspire you to brew beer for the next fifty years. It's that good.

Ingredients for 5 gallons (19 l.)

$1\frac{1}{2}$ lbs. (0.68 kg.) two-row lager barley malt
2 lbs. (0.91 kg.) Munich malt
$\frac{1}{2}$ lb. (0.23 kg.) home-toasted pale malt
1 lb. (0.45 kg.) dextrine or Cara-Pils malt
3 oz. (85 g.) roast chocolate malt
$3\frac{1}{2}$ lbs. (1.6 kg.) light dried malt extract
1 oz. (28.4 g.) Perle hops (boiling): 8 HBU
$1\frac{1}{2}$ oz. (43 g.) American Tettnanger (flavor): 7 HBU
1 oz. (28.4 g.) Hallertauer hops (aroma)
$\frac{1}{4}$ tsp. (1 g.) Irish moss
Lager yeast; Bavarian- or Munich-type lager yeast
$\frac{3}{4}$ c. (178 ml.) corn sugar or $1\frac{1}{4}$ c. (296 ml.) dried malt extract (for bottling)

BUs: 35
Color: 10–14
OG: 1.052–1.056 (13–14)
FG: 1.015–1.019 (4–5)

Before you begin, toast your own malt by spreading $\frac{1}{2}$ pound of whole pale malt on a cookie sheet or screen and toasting in a 350-

degree F (177 C) oven for about 10 minutes. It is done when it smells wonderful and the insides turn a slight orange color. Allow it to cool before crushing.

Using a protein-developing step mash, add 5 quarts (4.75 l.) of 130-degree F (54.4 C) water to the crushed malt. Stabilize at 122 degrees F (50 C) and hold for 30 minutes. Add $2\frac{1}{2}$ quarts (2.4 l.) of boiling water. Stabilize at 158 degrees F (70 C) and hold for 30 minutes. Add heat and mash out to 165 degrees F (74 C).

Sparge with 2 to $2\frac{1}{2}$ gallons (7.6–9.5 l.) of 170-degree F (77 C) water. Collect about 3 gallons (11.4 l.). Add more water to the brewpot (do not oversparge) if necessary. Add dried malt extract and boiling hops and boil for 45 minutes. Add $\frac{3}{4}$ ounce (21 g.) of Tettnanger flavor hops and boil for 15 minutes. Then add Irish moss and remaining $\frac{3}{4}$ ounce (21 g.) Tettnanger and boil for a final 15 minutes. Turn off heat, add aroma hops and let steep 2 to 3 minutes. Sparge, strain and add wort to your sanitized fermenter and cold water. Add active yeast when cooled to about 70 degrees F (21 C).

Continue primary fermentation at 50 to 60 degrees F (10–15.5 C). Transfer to secondary fermenter and ferment at lager temperatures of 40 to 50 degrees F (4.5–10 C) for three to five weeks. Bottle.

GERMAN RAUCHBIER (SMOKED BEER)

Curly Whisper Rauchbier (Mash-Extract)

There is one small area of the world where smoke-flavored beer reigns supreme. It is in Bamberg, Germany. There, brewmasters continue to brew in the century-old tradition of using malt that has been kiln-dried over an open flame, imparting a mellow, smoky character to the malt and the beer. Of the four or five breweries in town that brew Rauchbier, the style varies from a light Märzen to an amber Oktoberfest, all, of course, with a soft, smoky character.

Curly Whisper Rauchbier is what I consider a very close match to some of the best of Bamberg. It has a tawny hue and malty sweetness balanced with German hops and an applewood-smoked flavor that matches the softness of German beechwood smoke. This is a must-brew if you enjoy smoke-flavored food.

Ingredients for 5 gallons (19 l.)

$1\frac{1}{2}$ lbs. (0.68 kg.) two-row lager barley malt
$1\frac{1}{4}$ lbs. (0.57 kg.) 40 Lovibond crystal/caramel malt
$\frac{3}{4}$ lb. (0.34 kg.) wheat malt

$1\frac{1}{2}$ lbs. (0.68 kg.) home-smoked pale malt
3 lbs. (1.36 kg.) light dried malt extract
0.4 oz. (11 g.) Perle hops (boiling): 3 HBU
0.4 oz. (11 g.) German Hallertauer hops (boiling): 1.5 HBU
0.2 oz. (5.7 g.) German Northern Brewers hops (boiling): 2 HBU
0.4 oz. (11 g.) Perle hops (flavor): 3 HBU
0.4 oz. (11 g.) German Hallertauer hops (flavor): 1.5 HBU
$\frac{1}{2}$ oz. (14 g.) German Hallertauer hops (aroma)
$\frac{1}{4}$ tsp. powdered Irish moss
Lager yeast; Bavarian- or Munich-type lager yeast
$\frac{3}{4}$ c. (178 ml.) corn sugar or $1\frac{1}{4}$ c. (296 ml.) dried malt extract (for bottling)

BUs: 26
Color: 10–17
OG: 1.046–1.052 (11.5–13)
FG: 1.015–1.019 (4–5)

Before you begin, soak $1\frac{1}{2}$ pounds (0.68 kg.) of whole pale malt in water for 5 minutes. You will need a Weber-type barbecue grill or similar barbecue in which you can cover hot charcoal briquettes and wood and encourage smoke. Spread the wet whole pale malt on a screen and place it on a clean grill over hot charcoal and pieces of applewood. (Hickory, beech, mesquite, will also do.) Cover the grill, allowing the grains to become smoky and dry. Stir the grains every 5 minutes to dry them evenly. Some darkening of the malt is to be expected. If you are enjoying a homebrew while doing this, you may blacken some of the malt. Don't worry. When the malt is dry, remove and allow it to cool before using.

Using a protein-developing step mash, add 5 quarts (4.75 l.) of 130-degree F (54.4 C) water to the crushed malt. Stabilize at 122 degrees F (50 C) and hold for 30 minutes. Add $2\frac{1}{2}$ quarts (2.4 l.) of boiling water. Stabilize at 158 degrees F (70 C) and hold for 30 minutes. Add heat and mash out to 165 degrees F (74 C).

Sparge with 2 to $2\frac{1}{2}$ gallons (7.6–9.5 l.) of 170-degree F (77 C) water. Collect about 3 gallons (11.4 l.). Add more water to the brewpot (do not oversparge) if necessary. Add dried malt extract and boiling hops and boil for 45 minutes. Then add Irish moss and flavor hops and boil for a final 20 minutes. Turn off heat, add aroma hops and let steep 2 to 3 minutes. Sparge, strain and add wort to your sanitized fermenter partly filled with cold water. Add yeast when cooled to about 70 degrees F (21 C).

Continue primary fermentation at 50 to 60 degrees F (10–15.5 C). Transfer to secondary fermenter and ferment at lager temperatures of 40 to 50 degrees F (4.5–10 C) for three to five weeks. Bottle.

MÜNCHNER LIGHT

Schwedagon Gold (All Grain)

Münchner light lagers are a pleasant memory for anyone who has ever been to Bavaria. Liter after liter of this beer made for heaven on earth can be some of the best beer drinking you'll ever do. Schwedagon Gold is a malty lager with excellent hop flavor and adequate background bitterness while the maltiness plays center stage.

Even though Munich water is naturally high in carbonates, Bavarian brewers of this traditional lager treat their water with acid rests or even the addition of acid mashes to reduce the carbonates to a level suitable for brewing this soft and mellow lager. Use soft water, the best German aromatic hops (and American Tettnanger for a floral American stroke), a touch of crystal malt for a golden glow, a high-temperature mash schedule for full malt body, and above all, your artistic sense of brewing a dream.

Note: Trub removal is recommended. Because of trub removal and the high temperature range, mash efficiency of your system may be as low as 75 percent. Recipe is based on 75 percent efficiency.

Hopheads: follow the numbers and not your instinct when hopping this brew. Excessive bitterness will result in an excellent brew but one that is out of class for this traditional south German session beer. Ahhh—the memories are as a temple of gold glistening under the blue skies of Rangoon. Liter after liter after liter after . . .

Ingredients for 5 gallons (19 l.)

$6\frac{1}{2}$ lbs. (3 kg.) two-row lager barley malt
1 lb. (0.45 kg.) Munich malt
$\frac{1}{4}$ lb. (114 g.) 20–40 Lovibond crystal/caramel malt
$\frac{1}{4}$ lb. (114 g.) dextrine/Cara-Pils/German light crystal malt
0.4 oz. (11.3 g.) German Mittelfrüh Hallertauer hops (boiling): 1.5 HBU
$\frac{1}{2}$ oz. (14.2 g.) German Hersbrucker Hallertauer hops (boiling): 2 HBU
1 oz. (28.4 g.) German Hersbrucker Hallertauer hops (flavor, first addition): 2 HBU

$\frac{1}{2}$ oz. (14.2 g.) German Mittelfrüh Hallertauer hops (flavor, first addition): 1 HBU

1 oz. (28.4 g.) German Hersbrucker Hallertauer hops (flavor, second addition): 2 HBU

$\frac{1}{2}$ oz. (14.2 g.) German Mittelfrüh Hallertauer hops (aroma)

$\frac{1}{2}$ oz. (14.2 g.) American Tettnanger hops (aroma)

$\frac{1}{4}$ tsp. powdered Irish moss

Lager yeast; Bavarian- or Munich-type lager yeast

$\frac{3}{4}$ c. (178 ml.) corn sugar or $1\frac{1}{4}$ c. (296 ml.) dried malt extract (for bottling)

BUs: 22
Color: 5–7
OG: 1.042–1.046 (10.5–11.5)
FG: 1.010–1.014 (2.5–3.5)

Using a protein-developing step mash, add 2 gallons (7.6 l.) of 130-degree F (54.4 C) water to the crushed malt. Stabilize at 122 degrees F (50 C) and hold for 30 minutes. Add 1 gallon (3.8 l.) of boiling water. Stabilize at 158 degrees F (70 C) and hold for 30 minutes. Add heat and mash out to 165 degrees F (74 C).

Sparge with $3\frac{1}{2}$ to 4 gallons (13.3–15.2 l.) of 170-degree F (77 C) water. Collect about 6 gallons (22.8 l.). Add more water to the brewpot (do not oversparge) if necessary. Add boiling hops and boil for 45 minutes. Then add 1 ounce (28.4 g.) Hersbrucker hops and boil for 15 minutes more. Then add Irish moss, $\frac{1}{2}$ ounce (14.2 g.) Mittelfrüh and 1 ounce (28.4 g.) Hersbrucker hops and boil for a final 15 more minutes. Turn off heat, add aroma hops and let steep for 2 to 3 minutes before removing hops and chilling the hot wort. Use your own preferred procedures to remove hot break trub before chilling or pitching yeast.

Pitch yeast when cool, and ferment at temperatures between 50 and 55 degrees F (10–13 C). After four to seven days transfer the beer into a secondary fermenter and lager at 40 to 45 degrees F (4–7 C) for four to six weeks. Bottle.

MÜNCHNER DUNKEL

Midnight on the Interstate (Malt Extract)

You'll always find company on the interstate, even at midnight. With this brew you'll never be without friends, even at midnight. It's a

good chocolaty mild German-style dark lager—no black malt bitterness and just enough roast character to back up its color and live up to its style: German Dunkel. Though traditional German Dunkel is not noted for its strong hop flavor or aroma, this version is because it is Midnight on the Interstate. And yes, that is Kent Goldings you see added as a flavor hop. I know German brewmasters at a very famous and very very big brewery located somewhere on the Mississippi River who indeed appreciated the unique earthy twist Goldings gave this German-style lager.

It's so simple, it almost seems ridiculous to include as a recipe, but anything and everything that is good is worth sharing, when it is Midnight on the Interstate.

Ingredients for 5 gallons (19 l.)

5 lbs. (2.3 kg.) plain dark dried malt extract
1 lb. (0.45 kg.) crystal/caramel malt
$\frac{1}{2}$ oz. (14.2 g.) Perle hops (boiling): 4 HBU
$\frac{1}{4}$ oz. (7 g.) Kent Goldings hops (flavor): 1 HBU
$\frac{1}{2}$ oz. (14.2 g.) German Hallertauer hops (aroma)
$\frac{1}{2}$ oz. (14.2 g.) English Kent Goldings hops (aroma)
$\frac{1}{4}$ tsp. (1 g.) powdered Irish moss
Lager yeast; Bavarian- or Munich-type recommended
$\frac{3}{4}$ c. (178 ml.) corn sugar or $1\frac{1}{4}$ c. (296 ml.) dried malt extract (for bottling)

BUs: 16
Color: 17–28
OG: 1.042–1.046 (10.5–11.5)
FG: 1.009–1.013 (2.5–3.5)

Add the crushed crystal malt to 2 gallons (7.6 l.) of 150-degree F (66 C) water and hold for 30 minutes. Remove the grains with a strainer and add malt extract and boiling hops. Boil for 45 minutes, then add flavor hops and Irish moss and boil for an additional 15 minutes. Turn off heat. Add aroma hops and let steep for 2 to 3 minutes before sparging the hot wort into a fermenter partly filled with cold water. Pitch the yeast when cool. Ferment at lager temperatures and bottle when fermentation is complete.

Benign Bruiser Dunkel (Malt Extract)

For a more traditional German Dunkel using malt extract as a base, try the following. It's worth taking the first exit off the highway for and spending the night wherever it is being served. The quality of premium dark 100 percent German barley malt extracts makes them really worth seeking out for this recipe. One sip and you will be forever Dunkel. True-to-style German hops are used—just a smidgen for flavor and aroma you'll hardly notice, but they set the tall, cool glass of dark nectar in perfect balance.

Ingredients for 5 gallons (19 l.)

6.5 lbs. (3 kg.) plain dark German-made malt extract syrup
1 oz. (28.4 g.) German Hersbrucker Hallertauer hops (boiling): 4 HBU
$\frac{1}{4}$ oz. (7 g.) German Hallertauer hops (flavor): 1 HBU
$\frac{1}{4}$ oz. (7 g.) German Hallertauer hops (aroma)
$\frac{1}{4}$ tsp. (1 g.) powdered Irish moss
Lager yeast; Bavarian- or Munich-type recommended
$\frac{3}{4}$ c. (178 ml.) corn sugar or $1\frac{1}{4}$ c. (296 ml.) dried malt extract (for bottling)

BUs: 16
Color: 17–28
OG: 1.046–1.050 (11.5–12.5)
FG: 1.014–1.018 (3.5–4.5)

Boil 2 gallons of water, malt extract and boiling hops for 45 minutes. Then add flavor hops and Irish moss and boil for an additional 20 minutes. Turn off heat. Add aroma hops and let steep for 2 to 3 minutes before sparging the hot wort into a fermenter partly filled with cold water. Pitch the yeast when cool. Ferment at lager temperatures, and bottle when fermentation is complete.

Jump Be Nimble, Jump Be Quick Dunkel (All Grain)

The rewards are great for brewing this nimbly dark lager. Roasted chocolate malt and other aromatic specialty malts all contribute to a spectacularly complex, nutty, velvety smooth German Dunkel. It is rich and malty yet punctuated with a balanced bitterness of roast malt and a whisper of hops. If you like dark lagers and you brew all grain, I guarantee pleasure with Jump Be Nimble, Jump Be Quick

Dunkel. Your German friends will wonder where you got your brew-master's degree.

Ingredients for 5 gallons (19 l.)

$5\frac{1}{2}$ lbs. (2.5 kg.) two-row lager barley malt
2 lbs. (0.91 kg.) Munich malt
$\frac{1}{2}$ lb (0.23 kg.) Aromatic, Biscuit or Victory malt
1 lb. (0.45 g.) 40–80 Lovibond crystal/caramel malt
$\frac{1}{3}$ lb. (0.15 kg.) roasted chocolate malt
$\frac{1}{8}$ lb. (57 g.) roasted black malt
$\frac{1}{2}$ oz. (14.2 g.) German Northern Brewer hops (boiling): 4 HBU
$\frac{1}{4}$ oz. (7 g.) German Hallertauer hops (boiling): 1 HBU
1 oz. (28.4 g.) German Hallertauer hops (flavor): 2 HBU
$\frac{1}{4}$ oz. (17 g.) German Hallertauer hops (aroma)
$\frac{1}{4}$ tsp. powdered Irish moss
Lager yeast; Bavarian- or Munich-type lager yeast
$\frac{3}{4}$ c. (178 ml.) corn sugar or $1\frac{1}{4}$ c. (296 ml.) dried malt extract (for bottling)

BUs: 27
Color: 20–30
OG: 1.050–1.054 (12.5–13.5)
FG: 1.010–1.014 (2.5–3.5)

Using a protein-developing step mash, add $2\frac{1}{2}$ gallons (9.5 l.) of 130-degree F (54.4 C) water to the crushed malt. Stabilize at 122 degrees F (50 C) and hold for 30 minutes. Add $1\frac{1}{4}$ gallons (4.75 l.) of

boiling water. Stabilize at 158 degrees F (70 C) and hold for 30 minutes. Add heat and mash out to 165 degrees F (74 C).

Sparge with about 4 gallons (15.2 l.) of 170-degree F (77 C) water. Collect about 6 gallons (22.8 l.). Add more water to the brewpot (do not oversparge) if necessary. Add boiling hops and boil for 30 minutes. Then add flavor hops and boil for 15 minutes more. Then add Irish moss and boil for 15 more minutes. Turn off heat, add aroma hops and let steep for 2 to 3 minutes before removing hops and chilling the hot wort. Use your own preferred procedures to remove hot break trub before chilling or pitching yeast.

Pitch yeast when cool, and ferment between 50 and 55 degrees F (10–13 C). After four to seven days transfer the beer into a secondary fermenter and lager at 40 to 45 degrees F (4–7 C) for four to six weeks. Bottle.

BOCKS AND DOPPELBOCKS

Tennessee Waltzer Dunkelweizenbock (Mash-Extract)

All beers are brewed because they are inspired by someone or some event. If there is no inspiration, there is no beer. I'm sure you understand this as a homebrewer. Tennessee Waltzer Dunkelweizenbock was inspired by and made for those who love beer but not bitter beer. In the tradition of southern Germany and big bocks, the signatures of this brew are its rich maltiness and low hop bitterness.

Here's a beer that has about 20 percent wheat malt, rather than a more traditional 40 to 50 percent base of wheat. Hey, I'm a homebrewer, so please allow me to design my own wheat beer. Your inspiration may motivate you to redesign a bit. Here is a deceptively

strong $5\frac{1}{2}$ percent alcohol lager, richly dark but not opaque, and immensely drinkable. Bavarians would suck this one up or down with no problem. You can add your favorite wheat beer yeast if you wish. Neutral ale yeast will result in a brew more reminiscent of lager bock rather than a spicy wheat beer. I don't care for that clovelike wheat beer character, but you might.

Ingredients for 5 gallons (19 l.)

1 lb. (0.45 kg.) lager barley malt
$1\frac{1}{2}$ lbs. (0.68 kg.) Munich malt
1 lb. (0.45 kg.) crystal/caramel malt
2 lbs. (0.91 kg.) wheat malt
$\frac{1}{4}$ lb. (114 g.) roasted chocolate malt
$\frac{1}{4}$ lb. (114 g.) roasted black malt
$3\frac{1}{2}$ lbs. (1.6 kg.) light dried malt extract or 4.5 lbs. (2 kg.) light German malt extract syrup
1 oz. (28.4 g.) Perle or Spalt hops (boiling): 9 HBU
$\frac{1}{2}$ oz. (14 g.) German or American Hallertauer hops (aroma)
$\frac{1}{4}$ tsp. (1 g.) Irish moss
Lager or ale yeast; Bavarian- or Munich-type lager yeast or American ale yeast
$\frac{3}{4}$ c. (178 ml.) corn sugar or $1\frac{1}{4}$ c. (296 ml.) dried malt extract (for bottling)

BUs: 30
Color: 17–25
OG: 1.062–1.064 (15.5–16.5)
FG: 1.015–1.019 (4–5)

Using a protein-developing step mash, add 6 quarts (5.7 l.) of 130-degree F (54.4 C) water to the crushed malt. Stabilize at 122 degrees F (50 C) and hold for 30 minutes. Add 3 quarts (2.9 l.) of boiling water. Stabilize at 152 to 155 degrees F (66.7–68.3 C) and hold for 60 minutes. Add heat and mash out to 165 degrees F (74 C).

Sparge with $2\frac{1}{2}$ to 3 gallons (9.5–11.4 l.) of 170-degree F (77 C) water. Collect $3\frac{1}{2}$ to 4 gallons (13.3–15.2 l.). Add dried malt extract and boiling hops and boil for 60 minutes. Then add Irish moss and boil for a final 15 minutes. Evaporate about 1 gallon (3.8 l.) during the initial boil. Turn off heat, add aroma hops and let steep 2 to 3 minutes. Sparge, strain and add wort to your sanitized fermenter partly filled

with cold water. Add yeast when cooled to about 70 degrees F (21 C).

If using lager yeast, continue primary fermentation at 50 to 60 degrees F (10–15.6 C). Transfer to secondary fermenter and ferment at lager temperatures of 40 to 50 degrees F (4.4–10 C) for three to five weeks. Bottle.

Mongolian Bock (Mash-Extract)

The Mongolians once conquered the Chinese. If they had done so with this bock, they could have conquered America. Mongolian Bock is an immensely drinkable session bock. It's lower in alcohol than its German counterpart, but it is rich in flavor and provides a bit more kick than a lighter-styled . . . oh, shall we call it American bock? It still reflects most of the malty traditions of dark German bock beer, but with a noticeable accent of hop bitterness and flavor, making it all the more refreshing and crisp. A terrific dark lager to introduce your friends to. And don't forget to invite Genghis if he's in your neighborhood.

Ingredients for 5 gallons (19 l.)

2 lbs. (0.91 kg.) lager barley malt
$1\frac{1}{2}$ lbs. (0.68 kg.) Munich malt
$1\frac{1}{2}$ lbs. (0.68 kg.) Vienna malt
$\frac{3}{4}$ lb. (0.34 kg.) crystal/caramel malt
$\frac{1}{3}$ lb. (0.15 kg.) roasted chocolate malt
$\frac{1}{8}$ lb. (57 g.) roasted black malt
$2\frac{1}{2}$ lbs. (1.14 kg.) light dried malt extract
$\frac{3}{4}$ oz. (21 g.) Perle or Spalt hops (boiling): 6 HBU
$\frac{1}{4}$ oz. (7.1 g.) Hallertauer hops (boiling): 1 HBU
$\frac{1}{3}$ oz. (9.4 g.) Hallertauer hops (flavor): 1.3 HBU
$\frac{1}{3}$ oz. (9.4 g.) American Tettnanger hops (flavor): 1.3 HBU
$\frac{1}{4}$ tsp. (1 g.) Irish moss
Lager yeast; Bavarian- or Munich-type lager yeast
$\frac{3}{4}$ c. (178 ml.) corn sugar or $1\frac{1}{4}$ c. (296 ml.) dried malt extract (for bottling)

BUs: 29
Color: 17–25
OG: 1.054–1.058 (13.5–14.5)
FG: 1.014–1.018 (4.5–5.5)

Using a protein-developing step mash, add 6 quarts (5.7 l.) of 130-degree F (54.4 C) water to the crushed malt. Stabilize at 122 degrees F (50 C) and hold for 30 minutes. Add 3 quarts (2.9 l.) of boiling water. Stabilize at 152 to 155 degrees F (66.7–68.3 C) and hold for 60 minutes. Add heat and mash out to 165 degrees F (74 C).

Sparge with $2\frac{1}{2}$ to 3 gallons (9.5–11.4 l.) of 170-degree F (77 C) water. Collect $3\frac{1}{2}$ to 4 gallons (13.3–15.2 l.). Add dried malt extract and boiling hops and boil for 60 minutes. Then add flavor hops and Irish moss and boil for a final 20 minutes. Evaporate 1 gallon (3.8 l.) during the initial boil. Turn off heat. Sparge, strain and add wort to your sanitized fermenter partly filled with cold water. Add yeast when cool.

Continue primary fermentation at 50 to 60 degrees F (10–15.5 C). Transfer to secondary fermenter and ferment at lager temperatures of 40 to 50 degrees F (4.5–10 C) for three to five weeks. Bottle.

Jah Mon Irie Doppelbock (Mash-Extract)

Jah, mon, ya wanna drink this one a up side a yo fronta da face, mon.

Jah Mon Irie Doppelbock is a potent bock that welcomes you to drink it. Yes, it's strong, but ohhh, is it smooth. This is a copper-garnet-colored lager with friendly malt tones and the hop balance you come to expect from a traditional German-style doppelbock. It is similar to the American-made Samuel Adams Doppelbock but with a bit more umph to it, and smoother and fresher because you made it. It's mashed on the low end for maximum fermentability and is lagered for good measure. This beer keeps very well with extended lagering or bottle conditioning.

Ingredients for 5 gallons (19 l.)

2 lbs. (0.91 kg.) lager barley malt
$1\frac{1}{2}$ lbs. (0.68 kg.) Munich malt
$1\frac{1}{2}$ lbs. (0.68 kg.) wheat malt
$\frac{1}{2}$ lb. (0.23 kg.) crystal/caramel malt
$\frac{1}{4}$ lb. (114 g.) roasted chocolate malt
5 lbs. (2.3 kg.) light dried malt extract
$1\frac{1}{4}$ oz. (36 g.) German Hallertauer hops (boiling): 5 HBU
$\frac{1}{2}$ oz. (14.2 g.) German Hersbrucker Hallertauer hops (flavor): 2 HBU
$\frac{1}{2}$ oz. (14.2 g.) German Hersbrucker Hallertauer hops (flavor): 2 HBU
$\frac{1}{4}$ tsp. (1 g.) Irish moss
Lager yeast; Well-attenuating lager yeast
$\frac{3}{4}$ c. (178 ml.) corn sugar or $1\frac{1}{4}$ c. (296 ml.) dried malt extract (for bottling)

BUs: 25
Color: 12–17
OG: 1.072–1.076 (18–19)
FG: 1.014–1.019 (3.5–5)

Using a protein-developing step mash, add 6 quarts (5.7 l.) of 130-degree F (54.4 C) water to the crushed malt. Stabilize at 122 degrees F (50 C) and hold for 30 minutes. Add 3 quarts (2.9 l.) of 185-degree F (85 C) water and stabilize at 140 degrees F (60 C) for 20 minutes. Add heat to raise temperature to 152 to 154 degrees F (66.7–67.8 C) and hold for 40 minutes. Then add heat to bring temperature to 160 degrees F (71 C) and hold for 10 minutes. Mash out to 165 degrees F (74 C).

Sparge with $2\frac{1}{2}$ to 3 gallons (9.5–11.4 l.) of 170-degree F (77 C) water. Collect $3\frac{1}{2}$ to 4 gallons (13.3–15.2 l.). Add dried malt extract and boiling hops and boil for 45 minutes. Then add $\frac{1}{2}$ ounce (14.2 g.) German Hersbrucker Hallertauer flavor hops and boil for an additional 15 minutes. Then add Irish moss and the remaining $\frac{1}{2}$ ounce (14.2 g.) German Hersbrucker Hallertauer flavor hops and boil for a final 15 minutes. Evaporate 1 gallon (3.8 l.) during the initial boil. Turn off heat. Sparge, strain and add wort to your sanitized fermenter partly filled with cold water. Add yeast when cool.

Continue primary fermentation at 50 to 60 degrees F (10–15.6 C). Transfer to secondary fermenter and ferment at lager temperatures of 40 to 50 degrees F (4.4–10 C) for five to eight weeks. Bottle. Jah Mon!

OH, HONEY! LET IT BE MEAD

Yes, a friend of mead *is* a friend indeed.

There are many things worth remembering in life. "Firsts" are always something special. Savoring the memory is sweet. I brewed my first mead on November 25, 1974. Little did I imagine what I was unleashing that fateful evening.

I had been brewing a mere four years, many batches of beer passed between my friends and me. Honey always intrigued me—right from the start. In fact, the fifth batch of beer I brewed in Colorado (please allow me to discount the countless dump-and-stir homebrews I made in college) was my first batch of the legendary Rocky Racoon's Honey Lager. (See *The New Complete Joy of Home Brewing* for the recipe.) That was on November 26, 1973.

In those dark days of homebrew knowledge, the mere thought of using honey was like jumping off into an unknown chasm hoping for a pool of homebrew at the bottom. There was virtually no discussion with regards to using honey in beer. There were some rare English winemaking books that discussed honey and a beverage called mead, but they were written in quite a discouraging tone.

The honey lager was the first step in acquiring the confidence to concoct a honey beverage that I could call mead. And so on that memorable and exciting evening in 1974, a mead was formulated called Barkshack Gingermead, named after an adventurous river on Vancouver Island's wild northwest coast, a place I had a habit of visiting frequently in those days. The recipe was formulated as though it were ginger-flavored beer; except honey was used instead of malt extract. It worked. Boy, did it ever work. It was a success beyond comparison. To all of us who enjoyed its truly wondrous spirit, it was mead—sparkling, 6 to 8 percent alcohol, hopped and ginger-flavored. It seemed that we had invented something very special. There were very few brewers who tasted this and did not brew at least one special batch of sparkling Barkshack Gingermead.

It has taken many miles of traveling and much effort to uncover mead lore and factual information about the tradition of meadmaking. Over the years I have grown to respect mead as incomparable to any other beverage. It is our roots. It was the original ale, long before wine or grain beers. Its history is inspirational. To make mead is indeed a very special privilege we have as homebrewers. Mead's magical powers and closeness to all things natural are best appreci-

ated through solemn and contemplative drinking experiences. Of course, another aspect of this special alcoholic beverage is the rousing camaraderie it inspires.

I rhapsodize. You've noticed. You will find yourself doing the same.

For over twenty years I've been making mead. The challenge of making the simplest traditional meads of water, yeast and honey—and nothing more—never diminishes. With the addition of fruits, spices and sparkle, the variation and challenge become unending. Mead has its own personality. It doesn't lend itself very well to commercialization. The quality of honey is extremely important in its influence on fermentation and flavor. Equally, the influence of different yeast strains, temperatures and creative extra ingredients is also key to mead's final character. There is very little that is consistent about mead from one batch to another, unless you are going to play doctor and aid the natural process with nutrients, acid blends and clarifiers. These meadmaking aids are all quite permissible, though the challenge and the rewards of making a natural mead are diminished in spirit if nothing else.

Regardless, the vagaries of fermentation do always end with one consistent truth. In the end you will have a mead that befits both the most ordinary and most special occasions. It may take one month or it may take two to three years. Patience and a sense of adventure are virtues that are well rewarded.

Generally speaking, meads with original gravities of less than 1.080 (20 degrees B) are quite predictable. They will usually ferment to completion within one to two months, given the proper conditions and care. Meads 1.100 (25 degrees B) and higher (usually up to 1.160 [40 degrees B]) become increasingly less predictable, except that with time and patience, they will eventually finish and become clear.

The recipes included in this section offer a place to start on your meadmaking adventures. The behavior of your particular concoction is likely to vary quite significantly from these recipes and even from one identical batch to another. When in doubt, let the mead stand at 70 to 75 degrees F (21–24 C) until there are no signs of fermentation and then let it sit for a few more weeks—or even a few months, in the case of very high-gravity still meads. When the mead is clear and still, it is ready to bottle. If it is a traditional unflavored mead, it is also ready to drink. Fruit-flavored mead may require aging to bring the flavors into balance.

Mead is very susceptible to oxidation damage. Take extra care in minimizing the introduction of oxygen during all transfer processes and check your water-filled air lock regularly.

GUIDELINES FOR FORMULATING RECIPES FOR DIFFERENT TYPES OF MEAD

Type of Mead	Lbs. per Gallon	Orig. Gravity	Final Gravity
Sparkling	2#	1.070–1.075	0.996
Dry (still)	2–2.5#	up to 1.110	1.000–1.010
Medium (still)	2.5–3#	1.110–1.120	1.010–1.015
Sweet (still)	3–4#	1.120–1.135	1.020–1.050

The addition of fruit may contribute to less predictable results.

Sugar content of honey will vary quite a bit from one type or batch to another. Here is a simple method of predicting original gravity with a very high degree of accuracy.

1 cup (237 ml.) of honey weighs about 11.5 ounces (326 g.). From this information we know that 11.5 ounces (326 g.) of honey plus 3 cups (711 ml.) of water make up one quart (950 ml.). From this we can figure that 11.2 fluid ounces or 1 pound (0.45 kg.) of honey plus about 117 fluid ounces (3.47 l.) of water make up one total gallon. What does all this background information mean? Well, it means that you can predict what specific gravity 1 pound (0.45 kg.) of honey will contribute to a total volume of 1 gallon (3.8 l.) of water and honey without actually having to mix the total volume. How? Mix and thoroughly dissolve $\frac{1}{4}$ cup (59 ml.) of honey with 21 fluid ounces (620 ml.) of water, and measure the gravity. Similarly, if you know what original

HONEY AND WATER: PREDICTING ORIGINAL GRAVITY

To Predict the Specific Gravity of Pounds of Honey per Gallon (Total Volume)	Mix this Amount of Honey:	With this Amount of Water:
1 lb.	$\frac{1}{4}$ cup (59 ml.)	21 fl. oz. (620 ml.)
$1\frac{1}{2}$ lbs.	$\frac{1}{4}$ cup (59 ml.)	13.2 fl. oz. (391 ml.)
2 lbs.	$\frac{1}{4}$ cup (59 ml.)	9.4 fl. oz. (279 ml.)
$2\frac{1}{2}$ lbs.	$\frac{1}{4}$ cup (59 ml.)	7.1 fl. oz. (211 ml.)
3 lbs.	$\frac{1}{4}$ cup (59 ml.)	5.6 fl. oz. (166 ml.)
$3\frac{1}{2}$ lbs.	$\frac{1}{4}$ cup (59 ml.)	4.5 fl. oz. (134 ml.)

. . . and measure the specific gravity.

American Homebrewers Association
Sanctioned Competition Program
MEAD SCORE SHEET

TYPE OF MEAD (check one or more as appropriate):

- ☐ Still
- ☐ Sweet
- ☐ Traditional
- ☐ Metheglin
- ☐ Sparkling
- ☐ Medium
- ☐ Melomel
- ☐ Pyment
- ☐ Dry
- ☐ Cyser

BOTTLE INSPECTION Comments _____

 Max. Score

BOUQUET/AROMA (as appropriate for style) **10** _____

Expression of Honey, Expression of other ingredients as appropriate

Comments _____

APPEARANCE (as appropriate for style) **5** _____

Clarity and Color as appropriate for style

Comments _____

FLAVOR (as appropriate for style) **25** _____

Expression of Honey (5), Balance of: acidity/sweetness, alcohol strength/body, carbonation
(if appropriate), other ingredients as appropriate (15), Aftertaste(5)

Comments _____

DRINKABILITY AND OVERALL IMPRESSION **10** _____

Comments _____

TOTAL (50 possible points): _____

Scoring Guide

Excellent (40-50):	Exceptionally exemplifies style, requires little or no attention
Very Good (30-39):	Exemplifies style well, requires some attention
Good (25-29):	Exemplifies style satisfactorily, but requires attention
Drinkable (20-24):	Does not exemplify style, requires attention
Problem (<20):	Problematic, requires much attention

gravity 1 pound per gallon will yield, then you know what 5 pounds per 5 gallons will yield. Refer to the chart Honey and Water: Predicting Original Gravity.

MEAD RECIPES

SPARKLING MEAD

There are several sparkling meads in the companion book *The New Complete Joy of Home Brewing,* but here are two that will effervesce your soul.

Waialeale Chablis Mead

Simply stated: a white mead champagne. The grace and delicacy of this brilliantly effervescent mead are reminiscent of the grace of the flower from which both the honey and grapes were conceived. For

those who harbor an enthusiasm for fine champagnes and for the liveliness of new endeavors, making a batch of Waialeale Chablis Mead can't miss. It is incredibly simple to make, and is dry, effervescent and refreshing. Serve chilled and when the mood suits you, because you're going to have 5 great gallons (19 l.) of the stuff. Your friends will never forget you or your skills as a master meadmaker with this honey of a mead. Waialeale is the rainiest place on the planet, but with a stash of this mead, it doesn't matter.

Ingredients for 5 gallons (19 l.)

> 5 lbs. (2.3 kg.) light honey (clover, alfalfa, orange blossom, Hawaiian wildflower)
>
> 26 fl. oz. (769 ml.) can of Chablis Grape Concentrate (found at beer- and winemaking shops)
>
> $\frac{3}{4}$ c. (178 ml.) corn sugar or $\frac{7}{8}$ c. (207 ml.) honey for carbonation
> wine or champagne yeast

OG: 1.048–1.052 (12–13)
FG: .996–1.000 (−1–0)

Combine honey with $1\frac{1}{2}$ gallons (5.7 l.) of water. Dissolve and bring to a boil for 10 minutes. Skim off the coagulated white albumin protein as it forms on the surface of the boil. Turn the heat off. Add the grape concentrate. Do not boil the fruit juice. Then add this concentrated honey "wort" to a sanitized fermenter partly filled with cold water and top up with additional cold water to make 5 gallons. Add yeast when cooled below 76 degrees F (24.4 C). Bottle when fermentation is complete and the mead is clear or almost clear. Prime with corn sugar or honey. Waialeale Chablis Mead is ready when clear and carbonated, though it may improve with three to eight months of aging, depending on your personal preference.

A Taste of Happiness Cyser

Apple juice and honey are a natural. We probably would have realized this as children, but what we didn't know then was that there was such a thing as yeast or fermentation. The quality of your Taste of Happiness Cyser will vary tremendously with the type of apples used for the juice and, of course, the type of honey. Light honey and your favorite apple juice are recommended for starters. If buying packaged juice, be sure that there are no preservatives added. Preservatives may inhibit or prevent fermentation.

A Taste of Happiness is a dry, sparkling cider with apple tones and an alcoholic punch that should be respected and enjoyed responsibly.

If you use freshly pressed, unpasteurized apple juice, you will have to decide whether or not you want to inhibit the effect of wild yeast that naturally occurs in apple juice by using metabisulphites or by pasteurizing at 140 degrees F (60 C) for 20 to 30 minutes.

Ingredients for 5 gallons (19 l.)

3 lbs. (1.36 kg.) light honey (clover, alfalfa, orange blossom, Hawaiian wildflower)

$4\frac{3}{4}$ gals. (18 l.) apple juice

$\frac{1}{3}$ tsp. sodium or potassium metabisulphite

$\frac{3}{4}$ c. (178 ml.) corn sugar or $\frac{7}{8}$ c. (207 ml.) honey for carbonation wine or champagne yeast

OG: 1.065–1.075 (16–19)
FG: .998–1.005 (0–1)

Combine honey with apple juice. Stir and dissolve well. Add sodium or potassium metabisulphite and let the cyser-wort rest for 24 hours. The metabisulphite will react with the acidic nature of the "wort" and release sulfur dioxide gas, killing most wild yeast and other microorganisms. The gas must be allowed to vent out of the fermenter. After 24 hours add yeast culture and ferment. Bottle when fermentation is complete and cyser is clear or almost clear. Prime with corn sugar or honey. A Taste of Happiness Cyser will improve with three to eight months of aging, depending on your personal preference.

STILL MEAD

Virgil, Plato, Plutarch, Zeus, Venus, Jupiter, Odysseus, Circe, the Argonaut, Beowulf, Aphrodite, Bacchus, Odin, Valhalla, the Sanskrit Rig-Veda, Thor, King Arthur, Queen Elizabeth, the French, Greeks, Mayans, Africans, English, Irish, Swedes, Poles, Hungarians, Germans and even the Australian aborigines all connected part of the enjoyment of life to mead. Man's and woman's first expression of interest in mead goes back 12,000 to 14,000 years. A cave drawing in Belgium depicts an early man gathering honey, and there at the foot of a ladder leading to the tree hives, mead's aphrodisiac effects are depicted between a man and woman.

The legend of mead lives on, but often not in its traditional simple formulation of honey, water and yeast. The variations have no boundaries. Here are a few recipes for uncarbonated still meads that offer some spectacular tasting excitement.

Prickly Pear Cactus Fruit Mead

Prickly Pear Mead is the most seductively delicious mead I have ever had—*ever*. Its color can be as dramatic as a sunset. The fluorescent crimson of ripe prickly pear fruit, the titillatingly soft character of light mesquite honey, a floral bouquet of the Sonoran desert freshly washed by rain, and finally the sweet delicate currant nature of the world's finest sherry all combine to stun your senses in appreciation of one of the greatest gifts to this world.

This recipe was inspired by Dave Spaulding's (Tucson, Arizona) award-winning mead in 1986. Since 1987 I have not let a year go by without brewing at least 5 gallons. At $14\frac{1}{2}$ percent alcohol, Prickly Pear Mead ages exceptionally well. Years bring out the best in it.

Prickly pear cacti grow in drier areas from Canada to the equator.

In North America each fall the plant produces dozens of fruits that ripen to a crimson red. The fruits are covered with fuzzy thorns and should be picked with tongs. They can be frozen until used. Their size varies from about 2 to 6 inches (5–15 cm.). The red color is sometimes difficult to maintain through the finish of the fermentation. Don't worry if your mead turns from red to deep gold. This mead will still take on all the character of the finest sweet mead you've ever made.

As you may have ascertained by now, I have a special place in my life for Prickly Pear Mead. There is a tradition I began in 1987, the year of my first Prickly Pear Mead. Each year I take at least one bottle of it up to Mead Mountain. (On a map it's really named something else, but I have renamed this peak Mead Mountain.) I have taken the liberty of burying these meads within 100 yards (91 m.) of the nearly 9,000-foot (2,743-m.) summit. There they have weathered temperature extremes from 40 degrees below zero F (− 40 C) to 80 degrees F (27 C). In October of 1992 two friends and I had the privilege of enjoying a bottle of Prickly Pear Mead that had been aged on a mountaintop. Among the clouds swirling around us, threatening rain and snow, we opened one well-aged bottle and cautiously sipped. There never has been a nectar tasting as close to godliness as that mead. Without any exaggeration, I must confide that we all agreed that this mead, on this day, on Mead Mountain, was unanimously "the best drink we had ever had." And as we felt the warmth of the alcohol reach our hearts, the clouds, which had enveloped us the entire day during our two-hour journey to the peak, parted. To the east we could clearly see our town 3,500 feet (1,066 m.) below. To the west a storm wall of clouds stood miles high, suspended over the continental divide. Pieces of clouds and misty vapors swirled around us.

Between Jeff, Chris and me, we shared 12 ounces of Prickly Pear Mead, but it felt like we had partaken of the mountain and all it had endured over the thousands of years it had been there. I will continue to bury more mead on that mountain as the years allow me. So far I have left far more than I have taken. I'll know when the time is right to open another bottle.

Ingredients for 5 gallons (19 l.)

20 lbs. (9.1 kg.) light honey (mesquite is preferred, but clover, alfalfa or other light honeys will produce superb results)
5–6 lbs. (2.3–2.7 kg.) red, ripe prickly pear cactus fruit
$\frac{1}{4}$ tsp. (0.6 g.) powdered yeast extract (nutrient)
1 tbsp. (8.1 g.) pectin enzyme (optional)

1 oz. (28.4 g.) dried and rehydrated sherry, wine or champagne yeast. Prise de Mousse Champagne yeast works very well in combination with sherry yeast.

Target OG: 1.130–1.150 (32.5–37.5)
FG: 1.025–1.050 (6–12.5)

Slice the fruit or chop in a food processor and boil with $2\frac{1}{2}$ gallons (9.5 l.) of water for 2 hours. Meanwhile combine the honey with 1 gallon (3.8 l.) of water and boil for 15 minutes. Skim off the coagulated white albumin protein as it forms on the surface of the boil. Turn the heat off. Strain the boiled juice of the fruit into the honey brewpot. Then add this concentrated honey "wort" to a sanitized fermenter and cold water to make 5 gallons. Add yeast and yeast nutrient when cooled below 76 degrees F (24.4 C). Ferment at temperatures between 70 and 77 degrees F ((21 and 25 C). Fermentation may last anywhere from three months to one year. Bottle when fermentation is complete and mead is clear. Fermentation may stop months before the mead clears. Rack the mead from a primary fermenter to a secondary fermenter when fermentation appears almost finished. Use carbon dioxide gas to purge the secondary carboy of oxygen before transferring the mead into it in order to minimize oxidation.

The type and batch of honey, the character of the fruit and the strain of yeast are but a few of several factors that affect the behavior and duration of fermentation. One batch of Prickly Pear Mead may take less than six months to finish and clarify, while another batch may take two years! Nevertheless, this mead always does clear and always is spectacular.

Note that there is good reason to boil the fruit, even though it sets the pectin in it and causes haze to form in the mead. Prickly pear fruit juice is very mucilaginous, and even more so if the juice is not boiled. The haze eventually settles out. You may add 1 tablespoon of pectin enzyme to the fermenter to aid in clarification.

When the mead is clear and fermentation has stopped, it is ready to drink and bottle. If you find that a batch of Prickly Pear Mead is too sweet for your taste, endeavor to make another batch of dry Prickly Pear Mead (see the following recipe for White Angel Mead) and blend the two batches at a ratio that suits your taste.

White Angel Mead A Savior Blend

This is a fully attenuated and dry mead. A batch of White Angel Mead is always handy to have around in a 5-gallon (19-l.) carboy waiting

to save that mysteriously stuck fermentation and very sweet mead. Usually completely fermented and clear within three to five months, White Angel can be brewed with prickly pears or any other flavors.

Ingredients for 5 gallons (19 l.)

12.5 lbs. (5.7 kg.) light honey
3 lbs. (1.4 kg.) red, ripe prickly pear cactus fruit (optional)
$\frac{1}{4}$ tsp. (0.6 g.) powdered yeast extract (nutrient)
1 oz. (28.4 g.) dried and rehydrated sherry, wine or champagne yeast. Prise de Mousse Champagne yeast works very well in combination with sherry yeast.

Target OG: 1.100–1.110 (25–27.5)
FG: .998–1.010 (0–2.5)

If using prickly pears, see recipe for Prickly Pear Mead for fruit preparation. Combine the honey with 1 gallon (3.8 l.) of water and boil for 15 minutes. Skim off the coagulated white albumin protein as it forms on the surface of the boil. Turn the heat off. Then add this concentrated honey "wort" to a sanitized fermenter and cold water to make 5 gallons. Add yeast and yeast nutrient when cooled below 76 degrees F (24.4 C). Ferment at temperatures between 70 and 77 degrees F (21 and 25 C).

Rack the mead from a primary to a secondary fermenter when fermentation appears almost finished. Use carbon dioxide gas to purge the secondary carboy of oxygen before transferring the mead. This will minimize oxidation.

When the mead is clear and fermentation has stopped, it is ready to blend with other sweeter meads or bottle as is. White Angel can be stored for one to two years in a carboy and combined with sweeter meads whenever the need arises. Care should be taken to maintain the water in an air lock.

Generally meads blended to a final gravity of 1.020 to 1.030 are preferred by most lovers of sweet mead, though a prickly pear mead of 1.050 will mature with many years of aging. It will be your special reserve.

Love's Vision—Honey and Pepper Mead

Love's Vision Honey and Pepper Mead is about love. Sweet and fiery. A blend of intrigue juxtaposed with familiarity. Laughing and crying. The sweet caress of honey. The uniquely mysterious and fiery passion of exotic peppercorns. The anxious spiciness of new love. The warm

intoxication of old love; trust, faith, devotion, caring and unending endearment. Surreal, soulful and sensual. Youthful and aged.

Love's Vision is about love.

Ingredients for 5 gallons (19 l.)

15 lbs. (6.8 kg.) light honey

2 tbsp. (30 ml.) whole black peppercorn (try to find aromatic varieties when possible)

6 tbsp. (90 ml.) whole (small black seeds and pods) Szechuan peppercorns (Note: These are not the same as dried red Szechuan chile peppers.)

$\frac{1}{4}$ tsp. (0.6 g.) powdered yeast extract (nutrient)

1 oz. (28.4 g.) dried and rehydrated sherry, wine or champagne yeast. Prise de Mousse Champagne yeast works very well in combination with sherry yeast.

Target OG: 1.120–1.130 (30–32.5)
FG: 1.020–1.035 (5–9)

Combine the honey with about 1 gallon (3.8 l.) of water and boil for 15 minutes. Skim off the coagulated white albumin protein as it forms on the surface of the boil. Turn the heat off. Then add this concentrated honey "wort" to a sanitized fermenter and cold water to make 5 gallons. Add yeast and yeast nutrient when cooled below 76 degrees F (24.4 C). Ferment at temperatures between 70 and 77 degrees F (21 and 25 C).

Rack the mead from a primary to a secondary fermenter when fermentation appears almost finished. Use carbon dioxide gas to purge the secondary carboy of oxygen before transferring the mead. This will minimize oxidation.

Grind the peppercorns to a coarse powder and add to the secondary and let age for at least three months. The pepper will eventually settle out. When the mead is clear and fermentation has stopped, it is ready to bottle. A new peppercorn can be added to each bottle at bottling time.

Love's vision? You tell me how real this mead is.

Aloi Black Raspberry Mead

A knockout of a mead as fine as an exquisite red zinfandel or cabernet sauvignon—but made with rich and fruity black raspberries, honey and water. Wine enthusiasts won't believe it when you tell them what it is. They will never be able to guess. Although this is well attenuated, the character of the black raspberries contributes a round, mellow and delicate sweetness. Deep purple and full-flavored, Aloi Black Raspberry Mead is a superb tribute to the fascination that is mead.

Ingredients for 3 gallons (11.4 l.)

10 lbs. (4.5 kg.) light honey
7 lbs. (3.2 kg.) ripe black raspberries
$\frac{1}{4}$ tsp. (0.6 g.) powdered yeast extract (nutrient)
1 oz. (28.4 g.) dried and rehydrated wine or champagne yeast. Prise de Mousse Champagne yeast works very well.

Target OG: 1.100–1.104 (25–27.5)
FG: .996–1.000 (0)

Combine the honey with 1 gallon (3.8 l.) of water and boil for 15 minutes. Skim off the coagulated white albumin protein as it forms on the surface of the boil. Turn the heat off, add crushed black raspberries and let steep for 20 minutes at about 160 to 170 degrees F (71–76.7 C). Then add this concentrated fruit and honey "wort" to a sanitized fermenter partly filled with cold water and add more cold water to make 4 gallons (15.2 l.). Add yeast and yeast nutrient when cooled below 76 degrees F (24.4 C). If you allow a good one gallon of air space in the carboy, you may ferment the fruit in a glass primary fermenter, otherwise you'll need to do your primary fermentation in a plastic fermenter. Ferment at temperatures between 70 and 77 degrees F (21 and 25 C).

Rack the mead from a primary to a secondary fermenter after fourteen days of fermentation, leaving the fruit behind in the primary. When fermentation appears almost finished, rack again and continue fermentation until clear. Use carbon dioxide gas to purge the second-

ary fermenters of oxygen before transferring the mead. This will mini-
mize oxidation. By the time you've racked three times, you will have
a yield of about $2\frac{1}{2}$ to 3 gallons (9.5–11.4 l.) of mead.

Time goes by as honey flows from a jar. Bottle when fermentation
is complete and the mead is clear. This mead will mature with age.

Ruby Hooker Raspberry Mead

A sweet and full-flavored raspberry mead. If you love the flavor, color
and aroma of red raspberries, then you'll love Ruby Hooker.

Ingredients for 5 gallons (19 l.)

18.5 lbs. (8.4 kg.) light honey
10 lbs. (4.5 kg.) ripe red raspberries
$\frac{1}{4}$ tsp. (0.6 g.) powdered yeast extract (nutrient)
1 oz. (28.4 g.) dried and rehydrated wine or champagne yeast

Target OG: 1.140–1.146 (35–36.5)
FG: 1.020–1.030 (5–7.5)

Combine the honey with 1 gallon (3.8 l.) of water and boil for 15
minutes. Skim off the coagulated white albumin protein as it forms
on the surface of the boil. Turn the heat off, add crushed red raspber-
ries and let steep for 20 minutes at about 160 to 170 degrees F
(71–76.7 C). Then add this concentrated fruit and honey "wort"
equally to two 5-gallon (19-l.) sanitized fermenters partly filled with
cold water and add more cold water to make a total of 6 gallons (22.8
l.) or 3 gallons (11.4 l.) in each of the two glass fermenters. Allow for
plenty of air space. Add yeast and yeast nutrient when cooled below
76 degrees F (24.4 C). Ferment the fruit in the glass primary ferment-

ers. Ferment at temperatures between 70 and 77 degrees F (21 and 25 C).

Rack the mead from the two primary fermenters to one secondary fermenter after fourteen days of fermentation, leaving the fruit behind. When fermentation appears almost finished, rack again and continue fermentation until clear. Use carbon dioxide gas to purge the secondary fermenters of oxygen before transferring the mead. This will minimize oxidation. By the time you've racked three times, you will have a yield of about 5 gallons (19 l.) of mead.

Bottle when fermentation is complete and the mead is clear. This mead will mature nicely with age.

Acermead

Although I've never tried this, the concept sounds so out of the ordinary, I'd like to inspire you. And besides, if this were ever made commercially, it would give tax collectors fits—after all, how do you tax alcohol made partially from tree sap?

Ingredients for 5 gallons (19 l.)

18 lbs. (8.2 kg.) light honey
4.6 gals. (17.5 l.) maple tree sap (substitute for water)
$\frac{1}{4}$ tsp. (0.6 g.) powdered yeast extract (nutrient)
1 oz. (28.4 g.) dried and rehydrated wine or champagne yeast

Target OG: 1.130–1.136 (32.5–34)
FG: 1.020–1.030 (5–7.5)

Combine the honey with tree sap and boil for 15 minutes. Skim off the coagulated white albumin protein as it forms on the surface of the boil. Turn the heat off. Chill the hot sap-honey "wort" before adding to the fermenter. Add yeast and yeast nutrient when cooled below 76 degrees F (24.4 C). Ferment at temperatures between 70 and 77 degrees F (21 and 25 C).

When fermentation appears almost finished, rack again and continue fermentation until clear. Use carbon dioxide gas to purge the secondary fermenters of oxygen before transferring the mead. This will minimize oxidation. Bottle when fermentation is complete and the mead is clear.

ROOT BEER

Roots, herbs and spices have always been ingredients in beer. Hops are a herbaceous ingredient that is certainly regarded as essential

in most beers brewed in the Western world, though they became a popular ingredient in beer only a century or two ago. Before that, all manners of herbaceous concoctions (sometimes called *gruit*) were added to beer to balance character. Roots, herbs and spices—fresh or dried—have been used to make all kinds of alcoholic and nonalcoholic beverages in virtually all cultures throughout the world.

American root beer, a nonalcoholic soft drink, surely had its origins in ancient beer recipes and emerged as a nonalcoholic beer centuries ago, when beer actually did taste like a fermented blend of herbs, spices and roots. Today root beer is an American commodity available as an alcohol-free soft drink. When mass-produced, it is artificially carbonated, with small amounts of preservative added to assure that a dangerously explosive fermentation does not occur in the package.

Most mass-produced root beer is conveniently made from extracts, artificial flavoring, water and sugar. Some small breweries have ventured into formulating natural recipes, producing some very delicious alcohol-free root beer. Homebrewers, as well, can make this delicious soft drink in an all-natural way or with more convenient extracts if they wish.

MacJack Root Beer

An exceptionally authentic-tasting all-natural root beer, with options to vary ingredients to individual taste preferences. MacJack Root Beer is not fermented, nor are there any preservatives added to inhibit fermentation. Extreme care must be taken to avoid fermentation. Fermentation may cause dangerous explosions. To help minimize this risk, artificial carbonation with a CO_2 system and keg is recommended.

There are some root beer recipes that recommend adding bread or ale yeast to the sweet root beer wort in order to carbonate it. This is an extremely dangerous mix and is as good as making a bomb. There is little reason why the sweet wort would not fully ferment in a bottle, causing foamy carbonation and exploding bottles. I know—I've been there! Sure, you could test the yeasted root beer after a few days and then refrigerate to inhibit yeast activity, but personally speaking, risking an eye and other vital parts of your body to such practices is simply not worth it.

Ingredients for 5 gallons (19 l.)

3 quarts (2.9 l.) brown molasses
2 oz. (57 g.) sassafras bark (Note: The U.S. government regards sassafras as having a degree of risk for being carcinogenic. Be advised and do not use if you are concerned.)
2 oz. (57 g.) Sarsaparilla (woody, shredded)
2 oz. (57 g.) wintergreen (herb)
$\frac{1}{2}$ oz. (14.2 g.) licorice bark or root (woody, shredded)
1 vanilla bean (chopped)
0–1 lb. (0–0.45 kg.) honey, corn or cane sugar to taste
Other optional flavoring that could be used: teaberry, dearberry, checkerberry, boxberry, spiceberry, clove, cinnamon, star anise, ginger, ginseng, juniper berries, malt extract

OG: 1.035–1.045 (9–11)

Add the herbs, roots, spices and molasses to 2 gallons of boiling water and immediately turn off heat. Let steep with lid on for 2 to 4 hours. Then strain the flavoring ingredients out of the root beer wort and add cold water to make 5 gallons (19 l.). Taste and add sugar to your preference. Transfer to a keg and chill to 33 to 45 degrees F (0–7 C). Force-carbonate with CO_2 until you achieve desired carbonation.

Always maintain the keg at cold temperatures. If storing for long periods of time, check pressure weekly. If there is pressure buildup, then release pressure and consume as soon as possible.

Naturally made MacJack Root Beer is a real treat for both kids and mature adults (and immature as well, I suppose).

It is always possible to ferment root beer as you would any other beer. If you wish to experiment, add and steep 2 to 3 pounds (0.9–1.4 kg.) of caramel/crystal malt in the wort in order to maintain some residual sweetness in the fully fermented beverage. Bottle with priming sugar when fermentation is complete.

NONALCOHOLIC BEERS:
HOW ARE THEY MADE?

If nonalcoholic beers could actually taste like their real counterparts, they might be an achievement worthy of a Nobel Prize. Unfortunately alcohol and the process of generating alcohol both contribute very significantly to the overall character of what most of us consider real beer. Consequently the character of commercially made nonalcoholic products requires a lot of imagination if you want to call it beer. Perhaps the success of nonalcoholic beers hinges on the success of marketing beer that is so light in character that it tastes nearly like water. I suppose nonalcoholic beer can approach that.

In the United States nonalcoholic "beer" cannot legally be called nonalcoholic "beer." It is considered a "malt beverage" and cannot exceed 0.5 percent alcohol. If you are looking for an alcohol-free malt beverage, seek a beverage whose label states "alcohol-free." Alcohol-free malt beverages are usually concoctions that are formulated from ingredients similar in taste to beer (at least that's the claim), carbonated and packaged. Unlike nonalcoholic malt beverages, alcohol-free brews do not go through any fermentation process whatsoever.

Nonalcoholic brews are most commonly produced using one of a few methods:

1) Distillation
2) Reverse osmosis
3) Yeast "management"
4) Special yeasts

The goal is to have less than 0.5 percent alcohol in the final product.

Distillation is a relatively simple process whereby beer is brewed and fermented, then subjected to a distillation process. Often a vacuum is pulled on the fermented beer, lowering the boiling point of water and alcohol. The beer is heated and the alcohol is evaporated and distilled off of the beer. There are two main drawbacks of this method. Heating alters the flavor of beer, and esters and other flavor compounds contributing to the character of beer are also evaporated off.

Freeze distillation might be worth consideration on a small-scale homebrewed level. Alcohol freezes at lower temperatures than water. If fully fermented beer were to be taken down to a few degrees below

freezing, a beer slush would be created. The liquid would be mostly alcohol, and the slush mostly nonalcoholic beer. You might have to go through a few stages of freezing and pouring as alcohol will be mixed in with the beer slush. Once the process has been finished, the reduced-alcohol beer can be force-carbonated or bottle-conditioned by priming with sugar and fresh yeast. There is a major problem with this method. It is illegal in the United States to distill, even if you intend to throw the alcohol away. Enough said about the freeze-distillation process.

Reverse osmosis is a method in which beer is passed by a filter membrane. Alcohol migrates through this membrane while the nonalcoholic solution flows on. The process is slow and expensive. Again, alcohol is an important part of the flavor of beer, and it is removed during the process.

Yeast management offers some unique methods of producing a brew that never kicks into the fermentation stage. Recall that when yeast is introduced into unfermented wort, it goes through a lag phase and respiration phase before it begins alcohol-producing fermentation. During the two initial cycles the yeast cells take up oxygen and reproduce. If conditions are controlled to force the yeast to extend its oxygen uptake and reproduction cycle (and what organism doesn't want to extend its reproduction cycle if given the opportunity?), then the carbohydrates are assimilated, and water, carbon dioxide and other flavor compounds are produced, with very little alcohol being made. Extra oxygen can be bubbled through the wort. Temperatures can be lowered. The yeast can be overpitched. Conditions can be controlled to extend these cycles, but the cycle can't last forever and must be arrested by removing the yeast before it begins fermentation. Some of the major problems with this method can be detected in the lack of flavors that alcohols and esters contribute, but more seriously this process can contribute high levels of undesirable characters such as diacetyl.

Researchers continue to genetically engineer *special yeasts* that do not have the capability to ever kick into a fermentation cycle. So far the results have been less than desirable, but continue to improve. Problems of high diacetyl and the production of other flavor compounds make these engineered yeasts not yet usable for production of a nonalcoholic malt beverage.

What can a homebrewer do if nonalcoholic beer is desired? For the time being, that's a tough question, a very tough question. Unfortunately the commercial choices are all brewed with the American superlight lager style in mind. Perhaps if fuller-flavored styles were to be considered, success at making a "near" beer could be approachable.

Most homebrewers do not have the sophisticated equipment to distill, manage yeast or perform reverse osmosis. But if you do, there is opportunity for experimentation. Producing a nonalcoholic beer (as homebrewers, we don't have to abide with the official government nomenclature) would be a new frontier: nonalcoholic full-flavored stout, bock, brown ale, Pilsener? You might be on to something a bit more palatable than what's available on the shelves.

MALTA—AN UNFERMENTED ALTERNATIVE MALT BEVERAGE

Malta has enjoyed popularity among the Puerto Rican community for decades. In recent years its popularity has grown throughout the Caribbean and other Latin American countries. Heineken, Guinness and Jamaican Red Stripe are but three of many popular brands available in the Caribbean.

What is malta? Essentially it is filtered, carbonated and pasteurized unfermented wort. All the Caribbean versions are dark, sweet and minimally bittered. Without alcohol, malta only slightly resembles the character of beer, but with a bit of creativity, a homebrewed formulation can reduce the sweetness and elevate the hop character of what one might call American Malta.

American Malta is a basic light wort. Of course, you can vary the formulation to suit your own preference for hops, malt and other flavorings. Your hop utilization will be greater (up to 35 percent) than fermented beer because you will not lose bittering units during fermentation and yeast sediment. Yet the degree of unfermented sweetness may require a greater amount of hop bitterness for balance.

American Malta

Basic formulation for 5 gallons (19 l.)

5.5 lbs. (2.5 kg.) two-row American pale lager malt, OR 3.75 lbs. (1.7 kg.) light dried malt extract.
$\frac{3}{4}$ oz. (21.3 g.) Hallertauer hops (boiling): 3 HBU
$\frac{1}{2}$ oz. (14.2 g.) Hallertauer hops (aroma)
$\frac{1}{4}$ tsp. (1 g.) powdered Irish moss
NO YEAST

BUs: 15
Color: 1.8–3
OG: 1.030–1.034 (7.5–8.5)

All-grain method: Use a protein-developing step mash. Add $5\frac{1}{2}$ quarts (5.2 l.) of 130-degree F (54.4 C) water to the crushed malt. Stabilize at 122 degrees F (50 C) and hold for 30 minutes. Then add $2\frac{1}{2}$ quarts (2.38 l.) of boiling water. Stabilize at 148 to 152 degrees F (64–67 C) and hold for 60 minutes. Add heat and mash out to 165 degrees F (74 C).

Sparge with 2.5 to 3 gallons (9.5–11.4 l.) of 170-degree F (77 C) water. Add more water (do not oversparge) to brewpot to make an initial extract volume of $5\frac{1}{2}$ gallons (21 l.). Anticipate evaporation of about $\frac{1}{2}$ gallon (3.8 l.).

If using malt extract, add the extract to 2 gallons of water and boil with hops.

Add boiling hops and boil for 45 minutes. Then add Irish moss and boil for an additional 15 minutes. Total boiling time is 60 minutes. Turn off heat. Add aroma hops and let steep for 2 to 3 minutes before removing hops and chilling the hot wort. Use your own preferred procedures to remove hot break trub before chilling. Do not add yeast.

Chill wort to 33 to 38 degrees F (0.6–3.3 C) in a glass carboy and allow cold break to settle. After about 24 hours siphon the clear wort into a keg. If you desire, you may pass this trubless wort through a filtration system to eliminate chill haze protein (see "Clear Beer with Filtration" section). Force-carbonate the wort with CO_2 and keep well chilled while serving on draft.

Yeast contamination is inevitable, and eventually American Malta will begin to ferment. Keeping homemade malta at temperatures near freezing will inhibit fermentation.

If you choose to force-carbonate and counterpressure-fill bottles, the malta can be pasteurized by holding the bottled malta at 150 degrees F (65.6 C) for 3 to 5 minutes or at 140 degrees F (60 C) for 15 to 30 minutes. Holding at either of these temperatures for the periods indicated will impart 15 to 30 pasteurization units to the malta. This should be adequate if sanitary conditions have been maintained throughout the brewing, filtering and packaging processes. Food additives/preservatives used to retard fermentation in soft drinks can also be added to malta to prevent fermentation.

Classic Beer Styles from Around the World

Let's not become so presumptuous as to believe that the beer styles we regard as "classic" are the complete outline of world beer traditions. The commercially marketable beer styles of Germany, England, Belgium, Ireland, Scotland, the United States, Czechoslovakia and France seem to us to take the forefront in today's world of beer. But in fairness to the rest of the world, we should appreciate that there are hundreds of millions of people who are enjoying beer styles that most Americans have absolutely no awareness of.

Traditional fermented beverages brewed from all manner of cereal grain, roots, herbs, milk, fruits and vegetables have been made for thousands of years throughout the world. Perhaps modern production, packaging and distribution technologies and modern marketing have not inspired their distribution. In some cases we can be reasonably assured that developing a taste for these beverages would be a significant and necessary first step.

Over a cool glass of Pilsener, stout, bock or pale ale we may incredulously review what's going on in the world of fermented beverages. Nevertheless, one should have a certain respect for these beverages, for some of them have been enjoyed by far more people and for a much longer time than our so-called classic beers. Our beer world and perspective is but one, just as American-style light lager beer was at one time America's only perspective.

If the beer revolution in America is going to continue, homebrewers will be on the frontier. For the last 5,000 years they always have been.

INDIGENOUS BEERS AND FERMENTED BEVERAGES OF THE AMERICAS

Algarroba—Brewed by Central and South American Indians from ripe fruit of carob, mesquite or other leguminous trees.

Balché (mead)—A Mayan Indian honey mead flavored with bark from the balché tree.

Camass Beer—Western North American Indians made a fermented and alcoholic brew from the bulbous root of the common camass

(*Camassia quamash*), not to be confused or mistaken for the death camas, which has whitish to cream-colored flowers. (The common camass has blue flowers.) The onionlike bulbs could be boiled or roasted to develop sugars. Lewis and Clark mention this brew in their journals.

Chicha—Corn beers of the South American high country. Corn is boiled, then "mashed" by women who chew corn and spit the juice into a fermentation pot. Enzymes in saliva are similar to the enzymes in a mash, breaking down starch to sugar.

Kentucky Sour Mash Beer—Malted wheat and/or barley beer brewed from a mash that has been soured by primarily *Lactobacillus* bacteria.

Manioc Beer—Common throughout the world. Brewed from the starchy root of the manioc plant (also known as cassava, manioca, tapioca, massato). Manioc is often "mashed" by chewing and spitting the juice into a fermentation pot. Enzymes in saliva are similar to the enzymes in a mash, and break down starch to sugar. Arawaks, the native Caribbeans, had a version of manioc beer to which they added chile pepper and fish bones.

Mescal Beer—Brewed from the juice of the mescal plant in Mexico.

Piva—Aleutian Island brew of potatoes, raisins and sugar.

Pulque—A beerlike beverage made from the sap of several species of agave plant growing in Mexico. Sometimes called *maguey* or *pita*.Up to one ton of juice may be tapped from one plant, yielding 6 to 8 quarts (6–8 l.) per day. Pulque can be naturally fermented to about 6 percent alcohol.

Tahamara Corn Beer—Corn beer brewed by Tahamara Indians of Central America.

Tiswin (Apache Indian "beer")—Made from malted corn, wheat and jimsonweed (*Datura stramonium*). Jimsonweed has a druglike effect that

can be violent and can be toxic to some individuals. Experimentation is not recommended.

INDIGENOUS BEERS AND FERMENTED BEVERAGES OF ASIA

Chong/Chang/Janr—Millet, rice, maize or barley beer of the Himalayas and surrounding area. It has the consistency of gruel. The liquid is drunk through straws.

Chiu—Wheat beer of ancient China.

Chung—Tibetan barley beer.

Kaoliang—Sorghum beer made in the ancient Szechuan province of China.

Li—Ancient Chinese rice beer.

Makkolli/Takju/Yakju—Homebrewed rice beer of Korea. Alelike and unlike sake.

Pachwaï—Type of northern India *Cannabis sativa* sake.

P'ei—Ancient grain-based beer of China.

Sake—Japanese rice brew. A complex process using enzymes, bacteria and yeast is used.

Shoto Slake—Japanese fermented sugarcane juice.

Tuak/Arak—Indonesian brew made from fermented sap of a particular palm tree.

INDIGENOUS BEERS AND FERMENTED BEVERAGES OF AFRICA

Bantu/Keffir/Kaffir—Fermented mare's milk. Mare's milk will not curdle like cow's milk as the acidity of bacterial and yeast fermentation increase. Similar to Russian *Koumiss/Kumis*.

Boza/Bosa/Bouza/Booza—Made from malted millet bread, wheat or corn. Beer of ancient Babylonia, Egypt, Turkey and Ethiopia.

Bilbil—Once brewed in northern Egypt from malted durra, a type of sorghum/millet.

Dolo—Millet/sorghum beer of parts of Africa flavored with bitter plants, sometimes including the toxic jimsonweed (see American *Tiswin*).

Khadi—Berry honey mead of Botswana.

Korma—Egyptian barley wine beer flavored with ginger.

Mealie—South African beer made from maize and/or sorghum and flavored with plants.

Pombe ya Ndizi—Beer brewed by the Wachagga tribe on Mt. Kilimanjaro, made from mashed bananas and malted millet (indigenous grain called mbegi).

Sorghum Beer—Brewed from a grain of which millet is a variety. *Lactobacillus* bacteria souring and yeast fermentation produce a cloudy, acidic brew very popular especially in southern Africa.

Soubya—Egyptian rice beer.

Talla—Ethiopian beer brewed from sorghum/millet, roasted barley and sometimes corn/maize. Often flavored with herbs.

Tej—Ethiopian honey mead, often flavored with herbs.

INDIGENOUS BEERS AND FERMENTED BEVERAGES OF OCEANIA

Cassava/Manioc Beer—Brewed from the starchy root of cassava/manioc/tapioca. Cane sugar is commonly used in great quantities.

Okole—Brewed by the ancient Hawaiians from the roasted root of the ti plant. The root when roasted caramelizes to a molasseslike substance.

Topuy—Filipino rice beer.

INDIGENOUS BEERS AND FERMENTED BEVERAGES OF EUROPE

Brumalis Canna—Medieval French brew made from fruit and ginger.

Imiak—Malt beer homebrewed in Greenland.

Kiesel—Russian rye and oat beer.

Kvass—A low-alcohol Russian beer brewed from dark rye bread, sometimes malted barley and/or rye and sugar. Yeast and bacterial fermentation is encouraged. *Lablochny*, kvass with apples. *Malinovi*, kvass with raspberries.

Mum(m)—Sometimes called Braunschweiger Mumme, brewed in old Germany and currently a specialty product. Ingredients include wheat and barley malt, field beans, inner bark of blue spruce trees, buds of blue spruce trees, buds from birch trees, dried karbo-benedictine weed, sunflower seeds, bibernell, betonica, marjoram, benedictine spice, bee pollen, juniper berries, thyme, cardamom, bay

leaves, black burgundy, parsley, horseradish and ten unbroken, un-
cracked freshly laid eggs.

Roggenbier—German beer made with malted rye.

Sahti—From Finland, a brew made from barley, rye, juniper berries
and other flavorings.

Shekar—A Hebrew beer brewed from corn, dates, honey and other
flavorings.

Sicera—A strongly hopped beer brewed by the Jews when captive
in Babylon.

Sikaru—Brewed 6,000 to 10,000 years ago by Sumerians of Mesopo-
tamia. Made from ancient wheat called spelt (still available today as
dinkel or spelt) or barley. Grain was malted and mashed; the wort
was flavored with spices and fruits. Grains were roasted for variety
and flavor.

INDIGENOUS BEERS AND FERMENTED BEVERAGES OF THE AFTERWORLD

Stelae—Although Germans sing a song with the words "In heaven
there is no beer. That's why we drink it here," sources and emissaries
tell us that there is beer in the afterlife called Stelae. If this is indeed
true, I'll meet you at the tap, sometime.

Beer Worlds:
Origin of Species and
the Big Bang Theory

Have you ever thought about what it would be like to brew beer in outer space? I have.

My friends kid me with smiles as though to tell me, "You're not serious, but yes, I do wonder what would happen."

Can you imagine an experiment on board a future space mission, a container full of wort pitched with yeast once weightlessness has been achieved? It gives you something to wonder about as you watch those bubbles in your pale ale, doesn't it?

WhaBang! Literally hundreds of thousands of tiny worlds would be created—beer worlds. (Photograph of actual beer bubbles greatly magnified.)

Where would the bubbles go? It would be a pity if some unimaginative scientist (who drank traditional beer and didn't know a drop about how it was made) created an artificial gravity for the fermentation by revolving the primary fermenter to create a gravitational pull, much like being on a whirling merry-go-round. The bubbles could sense "up" and "down" and migrate to a fermentation lock. Pretty nifty, but not very imaginative.

What would I propose? I'd place the wort in a tightly sealed, sanitized plastic bag. When weightlessness was achieved I'd inoculate the wort with beer yeast, tie it shut and let the bag drift in a room by itself. Conditions would be near perfect, and the yeast, I'm sure, would begin to metabolize sugar into alcohol, carbon dioxide and the flavor of beer. Where would the gas go? There would be no up or down. I don't know the answer, but I'm sure it would go somewhere.

I imagine pressure building within the plastic bag, expandable only to a limit, then: BANG. Thousands, literally hundreds of thousands, of tiny worlds would be created—beer worlds.

Wouldn't it be grand to be able to monitor all those beer worlds and see the fermenting beer explode in such a grand fashion! The walls of the room, of course, would be specially treated material so liquid would not adhere, only bounce off. After a given time, equilibrium would be reached and the once large mass of beer would break down into small cohesive worlds of fermentation held together only by their own surface tension.

No, I've never had a graduate physics course called Bubbles 501. But this whole notion intrigues me, especially as I enjoy my current glass of Belgian-style ale.

Imagine—a dark room full of tens of thousands of beer worlds, tiny droplets each initially inhabited by life and all of the other ingredients for a classic Pilsener. Now each of these respectable worlds would be teeming with a living wort. Still, where would the bubbles go? Perhaps they would be confused at first, but eventually they would be drawn to the surface of these tiny beer spheres, even creating a minuscule layer of atmosphere, while most of the gas may just drift away.

It would be a shame if our experiment got this far and it was time to go home to Earth. After these fermentations were complete, it would be most unfortunate indeed if our on-board scientist gathered up all these worlds into one keg and returned to Earth to sample the results as "Fermentation of Classic Pilsener in Outer Space," amen.

Me? What would I propose? Give me a cosmic boat and shrink me down to size. Beer worlds, here I come.

I'm serious, you know I am, but wait as I pour myself some Derailed Ale.

Within the weightlessness of this room I would maneuver to the center and quietly observe. Worlds colliding and merging, evaporating, shrinking in size, concentrating their bitterness units. Some worlds would drift towards one wall behind which ran a heating duct for the spacecraft. Those warmer worlds would experience quicker fermentation. Meanwhile the yeasts on the worlds closer to the hull of the spacecraft would experience a greater rate of mutation, being bombarded by cosmic rays. Someone forgot to replace the protective cover on the heating coil at the bottom corner of the room. Every now and then an entire "planet" would drift upon the red-hot element, sizzle and send an asteroidlike cloud of black carbonized malt into this neatly closed galaxy. This dust would invariably find worlds to darken.

Nothing is exactly as it should seem to be—there are strange red planets, blue fuzzy worlds and even a few ghostly, hellish spheres

In outer space, bubbles don't always rise to the surface, for nothing is as you'd expect it to be. Beer worlds; there would be red planets, blue fuzzy worlds and even a few ghostly hellish spheres reeking ominously of diacetyl and dimethyl sulfide. (Photograph of actual beer bubbles greatly magnified.)

reeking ominously of diacetyl, dimethyl sulfide; the cold appearance of a pulsating liquidlike snowball. The yeast culture must have been slightly contaminated or maybe crafty bacteria were hiding in some crevice in the room—bacteria, wild yeasts, microscopic cling-ons, cosmic ray mutations. I could never know for sure, though there would be one thing for certain, these aliens found homes. They always do.

I'd power my cosmic boat gently through this finite galaxy. Hovering just above a beer world, I would pierce the surface with my flexible, specially designed, self-sterilizing straw, discovering wonderful differences and inspiring similarities.

I would not be alone. There would be many of us. You and I each with cosmic boats, able to explore our own corners of the galaxy. Knowing human nature, I bet that, depending on your taste preferences, some of you would quaff warm-brewed Duct Ale, others would enjoy a finely evolved Coil Stout, others would sample condensed-planet Very Bitter Celebration Ale, while a few weirdos would hang out on the red planets drinking Wild Lager. As for me, I'd sample along the way in search of the Galactic Pilsener, taking notes so that when the mission was over, we could compare.

Another glass of chilled Derailed Ale makes me feel as though I actually can recollect this imagined journey.

It was strange how we all communicated. Different areas of the room seemed to create distinctly unique beer worlds. We all noted how beers in a particular area may have seemed similar, but always a slight variation of one another. Of course, we all discussed the strange, bizarre and occasional exceptions. I was particularly intrigued by the corners of the room (where three wall joints met)—there would be the wildest, weirdest beer planets. They always seemed to hang out in corners, except the one cold corner.

Well, I'll tell you, to begin with, you and I were classic Pilsener scientists. We had a tough time communicating our experiences and discoveries. Out of necessity we tried to categorize various solar systems. We returned with names like Bock (near the back wall), Bitter (very bitter beers), Porter (the black beers by the heating coil manufactured by Porter and Sons, Inc., of Marion, Ohio), and there were many others. They were all new to us, except for the classic Pilsener, of which we found many worlds that were similar. They appeared everywhere—ubiquitous yet with variation.

It was a very informative experience, this Big Bang Beer Worlds phenomenon. There were many different worlds, you and I discovered. In describing our tastings to classic Pilsener brewers around the world when we returned, I think we turned a few heads, raised

Pulsating atmospheres, some cohesive, others bursting to contaminate other beer worlds. Their surfaces teeming with fermentation activity and dangerous carbon dioxide gas. (Photograph of actual beer bubbles grealy magnified.)

a few eyebrows, changed a few minds and even established a few traditions.

Didn't we?

Our generation is earthbound—the bubbles in our beer always rise to the surface. As I relax, do not worry and finish off my glass of Derailed Ale, I hope I have a say in the Beer Experiment someone may be planning for the space shuttle. It would be a real shame if they combined all those wonderful little beer worlds into a single container and declared it "Classic Pilsener Brewed in Outer Space."

BEER EVALUATION:
IS IT ANY GOOD?

BEER EVALUATION:
Is It Any Good?

Did you like it? You've planned for, brewed, fermented, packaged, waited for your beer to be ready. A chilled bottle is uncapped and poured into your favorite glass. Of course, your favorite glass is always the one that has your beer in it—always. Isn't it? It's a matter of personal preference whether you've poured the beer down the side of the glass or straight down the middle, but practically speaking, you've probably started out by pouring it down the side and watching how lively the beer becomes as the barley and hop nectar begins to express itself. If the beer needs more head, you'll likely begin to pour it down the middle, creating the amount of foamy topping that suits your preference. So far you've given it your best shot.

You look at it, there in the glass. You smell it and then taste it. Is it any good? Well, the answer to that is quite simple. If *you* like it, then it *is* good, and nobody should ever convince you otherwise. The simple pleasures of enjoying great beer must never be forgotten.

Simple pleasure is quite enough reason to make and appreciate your own beer. However, an understanding of the basic principles of beer evaluation can offer any brewer an enhanced appreciation for beer character and can help improve or maintain quality.

BEER CHARACTER: THE DYNAMICS OF CHANGE

Beer Is A Food

From the moment we first brew our beer to when it is consumed, beer undergoes continual change. Flavors, aromas, sights and sensations are layered on one another. What one perceives is the net effect. There are hundreds of different compounds that contribute to the quality of beer. Some are not perceived at all, while others may be highlighted, but what is primarily being perceived is characters that are enhanced or suppressed by the interaction of the combination of everything beer is.

As beer ages, its character will change. Certain characters will be perceived to a greater or lesser degree, or perhaps not at all. Because of the layering of so many stimulating compounds in beer, it is quite possible that the perceived development of a specific character might be something new created in the beer during the aging process or something that has been there all along, but has been suppressed by the dominance of other characters. For example, the bitterness

of a beer might be perceived to increase over a period of time, not because bitter compounds are increased, but rather because malty sweetness and body are being reduced, giving a perception of increased bitterness.

Other characters that are perceived may not each exist as a single character, but may be a synergistic combination of two or more factors that creates a unique perception all its own. This synergy may also have the effect of increasing the intensity of each factor involved.

Beer changes. What we perceive in those changes is not always a clear indication of what's really happening, though often it is.

Buns and Alligators: How fresh is fresh and how long will beer last?

Ponce de Leon searched for the fountain of youth, but only found himself up to his buns in alligators. Moral of the story: There is no simple answer to the question of age.

Commercially made beer is said to be *brewery fresh* just after it has been packaged and leaves the brewery. For most beer styles and at this time, the beer generally will be perceived as being at its best by most consumers. Some special styles of commercially made beer will be perceived as being enhanced in character with some age, but these styles are generally very strong beers with live yeast still in the bottle.

Homebrewed bottle-conditioned beer is quite another matter, but first let's examine what is happening with commercially made beer. The most significant flavor changes that will come about in sterile-filtered or pasteurized commercial beer are usually the result of time and oxidizing reactions. This is assuming that the beer is not contaminated with significant amounts of beer spoilage microorganisms. There are countless other reactions that can also affect flavor, but the biggies are caused by oxidation—the reaction of oxygen with flavor compounds. This reaction is encouraged by heat, light and agitation. The character of old commercial beer is often described as tasting like wet cardboard, wet paper or rotten pineapple, or as winy, sherrylike, skunky and other not-so-wonderful adjectives.

Even if oxidation is minimal, there can be other flavor changes that are not considered true to the intent of the brewer and thus "not fresh-tasting."

Now then, bottle-conditioned beer is still alive in the true sense of the word. If you've brewed cleanly, then what you have is a well-brewed beer with yeast still living in the bottle. That yeast can produce both desirable and undesirable characters. Obviously desirable

is the carbon dioxide that adds effervescence. The presence of yeast can reduce some of the dissolved oxygen in the beer, helping minimize future oxidation reactions. Yeast can also reduce the diacetyl (buttery or butterscotch) character of a beer with age (though it cannot adequately reduce bacterially produced diacetyl). When yeast undergoes refermentation in the bottle, it will produce a small amount of undesirable byproducts. Normally many of these byproducts are released to the air in primary, secondary and lagering fermentation, but when sealed in a bottle, these undesirables are captured and must be aged out with some time. Bottle-conditioned beer may improve with some aging. As it reaches its peak flavor, one might consider homebrew to be "fresh" and as it was intended to be.

Now then, about that harshly bitter brew that seemed to get better with age. If you hadn't put so many hops in to begin with, you wouldn't have had to age it so long to mellow it out. Yes, the perception of bitterness is often diminished with age in a very hoppy beer. The beer's bitterness will be perceived as becoming more balanced, but in the meantime, other age reactions occur, detracting from the balance. The skill to acquire is getting your bitterness proportioned correctly to begin with, so you can drink the beer sooner.

How long will homebrew maintain its fresh and intended character? It has so very much to do with how contaminant-free the beer is, as well as what temperature it is stored at and the type of beer it is. For beers in a range of 3 to $5\frac{1}{2}$ percent alcohol, one can reasonably expect a fresh flavor to remain stable for one to three months if the beer is kept at temperatures below 60 degrees F (15.5 C). After three months, the beers will change, but if there is no bacterial or wild yeast activity, homebrew will keep for a year or two (sometimes more). However, oxidation and air ingress will eventually take their toll and the beer's character may become no better than that of an old and tired commercially brewed beer.

One final thought on this subject before I open one of my seven-year-old barley wine ales: If your beer tastes good, it can never be beyond its time.

BEER CHARACTER DESCRIPTORS

Before we can begin to discuss beer character in any detail, a language must be developed. Over many years many of the following descriptor definitions and possible sources have been developed and utilized by the American Homebrewers Association for home-

Desirable or undesirable? Can you recognize 17 different flavors or aromas often present in beer?

brew competitions and educational purposes. They represent the most common attributes related to the character of homebrewed beers.

Acetaldehyde—Green applelike aroma; byproduct of fermentation. Can be perceived as breadlike or solventlike at high concentrations. Can be caused by low yeast levels and influenced by yeast strain.

Alcoholic—The general effect of ethanol and higher alcohols. Feels warming. Tastes sweetish.

Astringent—Drying, puckering (like chewing on a grape skin); feeling often associated with sourness. Tannin. Most often derived from boiling of grains, long mashes, oversparging or sparging with excessively hot or alkaline water. Metal ions in water or excessive trub in fermentation can contribute.

Bitter—Basic taste associated with hops; *braunhefe* or malt husks. Sensation is experienced on back of tongue.

Body—The mouth feel sensation of beer. Full or heavy body is more creamlike in consistency, while light-bodied or dry beer is thinner.

Cheesy—Old, stale, rancid hops and sometimes (in rare cases) old malt can cause this character.

Chill Haze—Haze caused by precipitation of protein-tannin compounds at cold temperatures. Does not affect flavor. Reduction of proteins or tannins in brewing or fermenting will reduce haze.

Chlorophenolic—Caused by chemical combination of chlorine and organics. Detectable at one to three parts per billion. Aroma is unique but similar to plasticlike phenolic. Avoid using chlorinated water.

Clean—Lacking off-flavors.

Cooked Vegetable/Cabbagelike—Aroma and flavor often due to long lag times and wort-spoilage bacteria that later are killed by alcohol produced in fermentation. The character persists as a by-product.

Diacetyl—Described as buttery, butterscotch. Sometimes caused by abbreviated fermentation or bacteria.

DMS (dimethyl sulfide)—A sweet-cornlike aroma/flavor. Can be attributed to malt, short or nonvigorous boiling of wort, slow wort chilling or, in extreme cases, bacterial infection.

Estery-Fruity—Similar to banana, raspberry, pear, apple or strawberry flavor; may include other fruity-estery flavors. Often accentuated with higher-temperature fermentations, stirred or agitated fermentation, high pitching rates, fermentation of higher gravity beer, excessive wort aeration and certain yeast strains.

Fatty-Soapy—A lardlike, fatty or soapy character contributed by the autolyzation of yeast. Dormant yeast cells explode their fatty acids and lipids into the beer.

Fusel—Refers to higher alcohols and some esters. Sometimes referred to as fusel oils because of their oily nature as a compound (see **Solventlike**). Also can be roselike and floral. High levels of amino acid protein in wort, high temperatures, high-gravity wort, agitated wort during fermentation, great yeast growth, all can contribute to higher levels of fusels.

Grainy—Raw grain flavor. Cereal-like. Some amounts are appropriate for some beer styles. Beers with high pH tend to have grainier flavors.

Hoppy—Characteristic odor or the essential oil of hops. Does not include hop bitterness.

Husky—see **Astringent**.

Light-struck—Having the characteristic smell of a skunk, caused by exposure to light whose wavelength is blue-green at 520 nanometers. Some hops can have a very similar character.

Metallic—Possibly caused by exposure to metal or by fatty acid reactions. Also described as tinny, coins, bloodlike. Check your brewpot and caps.

Moldy-Musty—Character may be contributed by water source containing algae, or by moldy hoses or plumbing. Common with corked beer.

Nutty—As in Brazil nut, hazelnut or fresh walnut; sherrylike.

Oxidized-Stale—Develops in the presence of oxygen as beer ages or is exposed to high temperatures; wet cardboard, papery, rotten vegetable or pineapple, winy, sherry, uric acid. Often coupled with an increase in sour, harsh or bitter flavors. The more aeration in bottling, filtering and transferring or the more air in the headspace, the more quickly a beer oxidizes. Warm temperatures dramatically accelerate oxidation.

Phenolic—Can be any one or a combination of a medicinal, plastic, electrical fire, Listerine-like, Band-Aid-like, smoky or clovelike aroma or flavor. Most often caused by wild strains of yeast or bacteria. Can be extracted from grains (see **Astringent**). Sanitizing residues left in equipment can contribute.

Salty—Flavor associated with table salt. Sensation experienced on sides of tongue. Can be caused by presence of too much sodium chloride, calcium chloride, or magnesium sulfate (Epsom salts).

Soapy—See **Fatty.**

Solventlike—Flavor and aromatic character of certain alcohols, often caused by high fermentation temperatures. Like acetone, lacquer thinner.

Sour-Acidic—Pungent aroma, sharpness of taste. Basic taste is like vinegar or lemon; tart. Typically associated with lactic or acetic acid. Can be the result of bacterial infection through contamination or the use of citric acid. Sensation experienced on sides of tongue. Acetic acid (vinegar) is usually only a problem with wooden fermenters and introduction of oxygen.

Sweet—Basic taste associated with sugar. Sensation experienced on front tip of tongue.

Sulfurlike (H_2S; Hydrogen Sulfide)—Rotten eggs, burning matches, flatulence. A byproduct with certain strains of yeast. Fermentation temperature can be a big factor. Diminishes with age. Can be more evident with bottle-conditioned beer.

Worty—The bittersweet character of unfermented wort. Incomplete fermentation.

Yeasty—Yeastlike flavor. Often due to strains of yeast in suspension or beer sitting on sediment too long.

WHY EVALUATE BEER?

Accurately evaluating beer does not come easy. It takes dedication, training, years of practice and a very wide variety of beer experiences. As homebrewers, you have an advantage—you know the process and understand where flavors can originate once you learn how to identify them.

If you want to learn how to evaluate beer, you have your wort cut out for you. There are more than 850 chemical compounds that occur naturally in the fermentation process. Many hundreds of these compounds remain in the beer or change to something else with time and condition. These compounds titillate the tens of thousands of taste buds in our mouths. The resulting symphony is the taste we nonchalantly identify as beer.

We find ourselves attempting to isolate and identify one or a few flavors among hundreds. How our brains manage to do this is a wonder still not fully understood. With desire we can train ourselves: first, how to recognize a type of character; and second, how to perceive various intensities or particular characters. The final test, and the most difficult, is to recognize, perceive and isolate a number of characters among many in our glass of beloved beer.

Let's consider the reasons why brewers would want to know how to evaluate beer.

Quality Control and Consistency. Every large brewery in North America has a regular program for evaluating its beer for the sole purpose of ascertaining that its quality is consistent from batch to batch. The breweries are not necessarily trying to detect unusual flavors in order to identify their origins. Instead, beer evaluators usually are specially trained to evaluate just one style of beer—the brewery's own brand.

To Be Able to Describe a Given Beer. How does your beer taste? "This beer tastes good (or bad)." "It's a party beer." "It's less filling." "The one beer to have when you want more than one." These generic descriptions just don't cut it anymore if you want to identify for yourself or communicate to other beer enthusiasts your beer's character.

Because of the proliferation of beer styles being brewed in North America, a language has developed over the last decade that effectively communicates the characteristics of beer. If you can evaluate your beer's strong or weak points and describe them accurately, you may be able to improve the character of your beer and make exactly what you want.

To Score And/Or Judge in a Competition. Beer competitions are becoming more and more popular. Hundreds of beer enthusiasts and brewers are spending a great deal of time learning to evaluate beer

and determine a winner in a contest. This is a specialized perspective on the art and science of evaluation, and one that has taken the direction of blending objectivity with subjectivity. The evaluators or judges use scientific and technical terms in objectively assessing beer qualities, and their subjective senses to assess the beer's drink-ability and appropriateness to a style.

To Define Styles. For every beer you brew, there is born a style. The skill of the brewer, combined with the tools at his or her disposal, makes for the individuality of any glass of beer. So why do definitions of styles emerge when we take pride in our own uniqueness? One reason is to develop traditions, enthusiasm and reasons to argue about better or worse, too malty or bitter; to create identity.

To Detect Problems and Improve Your Own or Someone Else's Beer. This is perhaps the most challenging of all the reasons to evaluate beer. Not only do you need to identify any one of hundreds of characters, but you also need to identify the source of the character. If you are able to evaluate a beer's flavor, aroma, appearance, mouth feel and aftertaste—and then identify the source of these char-acters—you can control, adjust and improve the quality of your brew.

SIX SENSES FOR EVALUATION

Sophisticated equipment can be used to measure, right down to the last little molecule, the kinds and amounts of constituents that could be in your beer. Technological evaluation may augment the objective and subjective findings of a trained evaluator, but it can never replace them.

The human senses of taste, smell, sight, hearing and touch can be trained as very effective tools to evaluate beer. But it takes pa-tience and development of confidence, time and, above all, humility. It takes practice. I know. I have watched hundreds of beer enthusiasts and brewers improve their evaluation skills over the years, to such a degree that they enjoy beer more and brew better beer.

Sight. You can tell a lot about a beer by just looking at it while it's in the bottle or glass. Excessive headspace in the bottle is an indica-tion that air content may be high. This tells you that oxidized flavor and aroma characters may follow. A surface deposit ringing the inside of the bottle's neck is a clear indication of bacterial or wild yeast contamination. In this case, sourness and excessive acidity may re-sult. Gushing (another visual experience) also may be the result of bacterial or wild yeast contamination.

BOTTLE INSPECTION Comments _____

Max. Score

BOUQUET/AROMA (as appropriate for style) **10** _____

Malt (3), Hops (3), Other Aromatic Characteristics (4)

Comments _____

APPEARANCE (as appropriate for style) **6** _____

Color (2), Clarity (2), Head Retention (2)

Comments _____

FLAVOR (as appropriate for style) **19** _____

Malt (3), Hops (3), Conditioning (2), Aftertaste (3), Balance (4), Other Flavor Characteristics (4)

Comments _____

BODY (full or thin as appropriate for style) **5** _____

Comments _____

DRINKABILITY & OVERALL IMPRESSION **10** _____

Comments _____

TOTAL (50 possible points): _____

Scoring Guide

Excellent (40-50): Exceptionally exemplifies style, requires little or no attention
Very Good (30-39): Exemplifies style well, requires some attention
Good (25-29): Exemplifies style satisfactorily, but requires attention
Drinkable (20-24): Does not exemplify style, requires attention
Problem (<20): Problematic, requires much attention

It's a rough job, but someone's got to do it. Judging and evaluating beer is
serious business, demanding time, patience, training, practice and humility.
But keep in mind, beer judges don't spit it out.

Sediment in a filtered, yeast-free beer may indicate an old, stale beer. Watch out for gushing. Sediment also may indicate precipitation of oxalates, a result of the brewing water lacking appropriate brewing salts—a sure cause of gushing.

Hazy beer can be the result of bacterial or yeast infection. Chill haze, a precipitate of a tannin-protein compound, doesn't affect the flavor, but it can be remedied when identified.

When poured into a brandy snifter, high-alcohol beers such as doppelbocks and barley wines verify their strength by showing their legs on the sides of the glass. *Legs* refers to a coating of liquid that concentrates into streams as it runs down the side of a glass.

The complete lack of foam stability in a glass of newly poured beer (assuming the glass is beer-clean) is an indication that the beer may be stale, old and oxidized.

Hearing. It takes a lot of attention, but for an experienced evaluator, that sound upon opening—of gas escaping from a bottle—is music with specific tones for different volumes of carbon dioxide.

Smell. The most sensitive and the most telling of our senses is our sense of smell. Assessing a beer's aroma should be a quick experience. Our smell detectors quickly become anesthetized to whatever we are smelling. For example, you may walk into a room and smell the strong aroma of coffee perking. Five minutes later, the smell lingers just as strongly, but you don't notice it any longer.

Our smell detectors reside in a side pocket of dead air along our nasal passage. In order to assess aromas, we must take air into this side pocket. The most effective way of doing this is to create a lot of turbulence in the nasal passage. Several short, strong sniffs or long, deep sniffs help get the aromatic molecules of vaporized beer smells into this pocket. Then our memory and current experience combine to identify what we smell.

Getting the aromas out of the beer doesn't happen so easily. It is best done with beers warmed to at least 45 to 50 degrees F (7 to 10 degrees C) so that volatiles and aromatic compounds will change form from liquid to gas. Swirl a half-full glass of beer to release the carbon dioxide bubbles into the air, carrying with them other aromatic gases.

Note that some constituents of beer flavor and aroma are so volatile that they virtually disappear from beer within a matter of a few minutes. This is the case with some sulfur-based compounds like DMS (a sweet-cornlike aroma), giving the beer an entirely different smell and taste after it has sat out for a time.

Taste. The tongue is the main flavor assessor in the mouth. It is mapped out in four distinct areas. Bitterness is experienced at the

back of the tongue, sweetness at the front tip of the tongue, and saltiness and sourness on the sides of the tongue. It is interesting to note that 15 to 20 percent of Americans confuse sour with bitter and vice versa. Clarify this for yourself by noting where on the tongue you are experiencing the taste sensation.

"Chew" the beer when evaluating. Because different areas of the tongue experience various flavors, you must coat all of your tongue and mouth with the beer *and then swallow*. Beer evaluators—don't spit it out! It is important to assess the experience of swallowing beer for its aftertaste and so that all parts of the mouth are exposed. There are flavor receptors on the sides, back and roof of the mouth independent of the tongue.

Touch and Feel. Your mouth, most of all, senses the texture of the beer. Often called *body*, the texture of beer can be full-bodied or light-bodied as extremes. Astringency (also related to huskiness and graininess) can also be assessed by mouth feel. It is not a flavor, but rather a dry, puckery feeling, exactly like chewing on the skin of a grape. This astringent sensation most often comes from tannins excessively extracted from grains as a result of oversparging, sparging with overheated water or having a high pH. Sometimes astringency can be the result of milling your grains too finely.

Other sensations that can be felt are oily, cooling—as in menthol-like—burning and hot or cold.

Pleasure. This is our sixth sense. This is the close-your-eyes drinkability, the overall impression, the memorableness of the beer. No evaluation is complete without this final assessment. Is the beer pleasurable? Would you want another? This is the assessment and the evaluation that turned you into a homebrewer, isn't it?

Our senses, like a $100,000 machine plugged into the electric socket, are sensitive to power surges, brownouts and other ups and downs that influence the "show." Our own genetic makeup can affect our ability to detect certain chemical compounds' aromas and flavors. Also, our health is a very significant factor. Two to three days before we show the first outward symptoms of a cold or flu, our taste buds may go completely haywire. Taste panels that make million-dollar decisions consider this and do not rely on just one taster but on several in order to account for temporary inaccuracies of perception.

Finally, the environment in which we assess should be comfort-

ing and not distracting. Smoke, loud music and unusual lighting should be avoided.

SOME FACTORS INFLUENCING THE CHARACTER OF BEER

Here is a thumbnail sketch of some of the more common factors influencing the character of beer.

INGREDIENTS

Malt—influences color, mouth feel, sweetness, level of astringency, alcohol strength.

Hops—influences bitterness level, flavor, aroma (can be citrusy or floral), and sometimes can contribute to a metallic character.

Yeast—strains and environment can affect diacetyl (buttery-butterscotch) levels; hydrogen sulfide (rotten egg smell), particularly in bottle-conditioned beer; phenolic character, including clove; plasticlike aroma and flavor; fruitiness and esters. Release of fatty acids from within cell walls can contribute to soapy or lardlike flavor.

Water—chlorinated water can result in harsh chlorophenolic (plasticlike) aroma and flavor. Saltiness results from excess of certain mineral salts. High pH can result in harsh bitterness from unwanted extraction of tannin from grain and/or hops. Algae in water source can contribute moldiness or mustiness.

PROCESS

Milling—grain too finely crushed can result in husky-grainy and/or astringent character.

Mashing—temperature can affect level of sweetness, alcohol, body or mouth feel, astringency.

Temperature—during fermentation it can affect level of estery-fruitiness and level of fusel and higher alcohols; slow chilling of wort can increase DMS (sweet-cornlike character) levels.

Lautering—temperature and alkalinity of sparge water can affect level of tannins and subsequent phenols detected in finished beer.

Boiling—short boiling times or nonvigorous boils can result in high DMS levels; vigorous boiling precipitates proteins out of solution. Also extracts hop flavors.

Fermentation—High temperatures can cause fusel alcohols and/or solventlike characters; cooling regime can elevate or decrease diacetyl levels in finished beer.

EQUIPMENT

Sanitation—lack of sanitation can result in bacterial or wild yeast contamination, causing unusual effects on flavor, aroma, appearance, texture; residues of sanitizer can contribute to medicinal-phenolic character.

Design—design of equipment—kettles, fermenters and plumbing—can grossly affect boiling regime, fermentation cycles, cleanability; the same combination of ingredients can be affected by different configurations and sizes of equipment.

Scaling batch size up or down can have significant and unforeseen effects on character of beer.

HANDLING

Temperature—warm temperatures grossly affect the freshness of beer; warm temperatures speed up the oxidation process.

Oxygen—more than anything else, oxygen destroys the flavor of finished beer; oxygen combines with beer compounds and alcohol to produce negative flavors and aromas described as winy, stale, sherrylike, papery wet cardboard, rotten vegetables, rotten pineapple.

Light—blue-green wavelengths at 520 nanometers photochemically react with hop compounds to produce a light-struck skunky character. Green and clear class offer no protection.

Agitation—rough handling enhances the oxidation process.

TRAINING CAMP!

Becoming a knowledgeable beer drinker takes practice. It begins with tasting and observing your beer from its inception. Taste, smell, feel and look at your ingredients. Watch your brewing process. Taste the liquids that are being transformed into beer as you progress. Taste the wort, taste the various rackings of fermented beer. Note appearances; note how vigorous the fermentation is and how quickly it

clears. Taste the beer as you bottle it, then taste it after one week, two weeks, three weeks and a month. Accompany the beer along its way with your senses. Knowing and feeling the soul of your beer takes time and practice. Don't expect an "aha" phenomenon to occur with every batch. Your knowledge and understanding are cumulative. Use your senses more than anything else. These perceptions are your foundation for further training and development of beer awareness.

With cumulative experience and knowledge you will begin to be able to predict the outcome of your beer and how it will change before it is ready to drink. As the beer matures, you'll recognize what kind of sulfur characters come and go with age. You'll know that some phenolic characters are likely to get worse with age, and some can diminish. You'll observe the rise and fall of bitterness, diacetyl. Some esters will increase with age, and others will be perceived to diminish. You'll be able to gauge the potential of your beer. Homebrewing is different from commercial brewing. Many commercial brewing principles and theories can be appropriately applied to homebrewing, but there are exceptions. If you brew enough and use your senses, you will discover the delightful uniquenesses of homebrew.

Limber up that elbow. Taste beer. Yours, others'—commercial and homebrewed.

Serve samples at a temperature no cooler than 50 degrees F (10 C), preferably 50 to 60 degrees F (10–15.6 C) for ales. Serve in an environment that is comfortable, well lit, odor-free and quiet, for maximizing your sense of perception.

Training Aids. Here is a table of substances you can add to 12 ounces (355 ml.) of light-flavored beer in order to help you learn how to identify particular aroma or flavor characters.

Some of these samples are difficult to make and depend on their strength because many of these aromas are very volatile and unstable. Make these doctored beer samples only 12 to 24 hours before they are actually sampled. Otherwise, many of them are so volatile and unstable that their propensities will diminish.

You may find some of the samples will be too strong, and some much too weak, as far as your senses are concerned. Individual perception thresholds are different.

Some of the chemicals are intensely pungent in their concentrated form and will require a well-ventilated mixing area. A vented hood with strong fans is mandatory for chemicals such as diacetyl, ethyl acetate and acetaldehyde. Use safety glasses to protect your eyes if handling concentrated lactic acid.

Note that lactic acid does not have an aroma in and of itself. Other byproducts produced by bacteria produce aromatics in beer.

TROUBLESHOOTER'S CHART
A Homebrewers Guide to Better Beer

This chart is intended for use by brewers as a guide in helping to identify the causes of certain more commonly occurring beer flavors. It is not intended to represent a complete compilation of beer flavors or their origins. Published by the American Homebrewers Association.

Profile Descriptor	Ingredients	Process	Equipment	Handling and Processing
Alcohol (ethanol)—a warming prickly sensation in the mouth and throat.	High: increase fermentable sugars through use of malt or adjuncts. NOTE: use of corn, rice, sugar, honey adds alcohol without adding body. High: healthy and attenuative yeast strains.	High: within the general 145 to 158 degree F range of mashing temperatures the lower mash temperature produce more fermentables, thus more resulting alcohol. High: aeration of wort before pitching aids yeast activity. High: fusel (solvent-like) alcohols are produced at high temperatures.		Age and oxidation will convert some of the ethanol to higher solvent-like alcohols.
Astringent—(see Husky/ Grainy)				
Bitter—a sensation generally perceived on the back of the tongue, and sometimes roof of the mouth, as with caffeine or hop resin.	High: black and roasted malts and grains. High: great amounts of boiling hops. High: alkaline water can draw out bitter components from grains.	High: effective boiling of hops. Low: high fermentation temperatures and quick fermentation rates will decrease hop bitterness.	Low: filtration can remove some bitterness.	
Body—not a flavor but a sensation of viscosity in the mouth as with thick (full-bodied) beers or thin (light-bodied) beers.	Full: use of malto-dextrin, dextrinous malts, lactose, crystal malt, caramel malt, dextrine (Cara-Pils) malt. Thin: use of highly fermentable malt. Thin: use of enzymes that break down carbohydrates in mash, fermentation of storage.	Full: high-temperature mash. Low: low-temperature mash.		Low: age will reduce body. Low: wild yeast and bacteria may reduce body by breaking down carbohydrates.

Profile Descriptor	Ingredients	Process	Equipment	Handling and Processing
Clarity—visual perception of the beer in the bottle and after it is poured.	High: use of protein reducing enzymes (papain). Low: chill haze more likely in all malt beers because higher protein than malt and adjunct beers. Low: wheat malt and unmalted barley cause more chill haze than malted barley and corn and rice adjuncts. Low: poor flocculant wild yeast may cause poor sedimentation. Low: bacteria causes cloudiness and haze. High: use of polyclar or activated silica gel.	Low: overmilling/grinding grain. High: long, vigorous boil and proper cooling.	Low: bacteria from dirty plastic equipment, especially siphon and blow-out hoses, scratched fermenter. High: filtration can help clear.	Low: unclean bottles can cause bacterial haze.
Color—visual perception of beer color.	Dark: dark malts (crystal, Munich, chocolate, roasted barley, black patent). Light: exclusive use of lighter malts and starch adjuncts.	Dark: scorching. Dark: caramelization with long boil.	Low: filtration can reduce color.	
Degree of Carbonation	High: bacteria and wild yeast may break down carbohydrates not normally fermentable and create overcarbonation and gushing. High: over priming. NOTE ON GUSHING: excessive iron content causes gushing; malts containing Fusarium (mold) from wet harvesting of barley causes gushing; precipitates of excess salts in bottle cause gushing.	Low: cold temperatures inhibit ale yeast. Low: long lagered beer may not have enough viable yeast for bottle conditioning (carbonating) properly.	High: unsanitary equipment can introduce bacteria which can cause overcarbonation and gushing.	High: unclean bottles can cause bacterial growth and gushing. High: overpriming kegs; prime kegs at one-third normal rate. High: agitation. Low: improper seal on bottle cap.

(continued)

TROUBLESHOOTER'S CHART (*continued*)

Profile Descriptor	Ingredients	Process	Equipment	Handling and Processing
Diacetyl—butter or butterscotch flavor.	High: unhealthy, non-flocculating yeast. High: not enough soluble nitrogen-based yeast nutrient in wort. High: not enough oxygen in wort when pitching yeast. High: bacterial contamination. High/Low: yeast strain will influence production of diacetyl. High: excessive use of adjuncts such as corn or rice, deficient in amino acid (soluble nitrogen based nutrients).	High: chilling fermentation too soon. High: high-temperature initial fermentation. High: premature fining takes yeast out of suspension too soon. Low: agitated extended fermentation. Low: high temperature during extended fermentation. Low: kraeusening.	High: bacteria from equipment. High/Low: configuration and size of fermenting vessel will influence production.	
Dimethylsulfide (DMS)—cooked cabbage or sweet corn-like.	High: high-moisture malt, especially 6-row varieties. High: bacterial contamination of wort. Low: use of 2-row English malt. High: under pitching of yeast (lag time). High: bacterially infected yeast slurry.	Low: longer boil will diminish DMS. High: oversparging at low temperatures (especially lower than 160 degrees F).	High: bacteria from equipment.	High: introduction of unfiltered CO_2 produced by fermentation. Bottle priming will produce small amounts.

Profile Descriptor	Ingredients	Process	Equipment	Handling and Processing
Fruity/Estery—flavors similar to fruits such as: strawberry, banana, raspberry, apple, pear.	Yeast strains produce various esters. High: loaded with fruit.	High: excessive trub. High: warm fermentation. High: high pitching rates. High: high gravity wort. High: high aeration of wort. Low: opposite of above.		Low: age will reduce esters to closely related fusel alcohols and acids (solventlike qualities).
Head Retention— physical and visual degree of foam stability.	Good: high malt content. Poor: use of overmodified or underkilned malt. Good: mashing in of barley flakes. Good: licorice, crystal malt, dextrine (Cara-Pils) malt, wheat malt. Good: high bittering hops in boil. Poor: hard water. Poor: germ oil in whole grain. Poor: elevated volumes of higher alcohols. Good: high nitrogen content.	Low: oversparging (releases fatty acids). Low: high aeration of wort before pitching. Low: extended enzymic molecular breakdown of carbohydrates in mashing. Low: fatty acid release during yeast autolysis. Low: high fermentation temperatures (production of higher alcohols). High: good rolling boil in kettle.	Poor: cleaning residues, improper rinsing of fats, oils, detergents, soaps. Poor: filtration can reduce head retention.	Low: oxidation/aging breaks down head stabilizing agents. Low: dirty bottles, improperly rinsed. Low: improperly cleaned glasses.
Husky/Grainy (Astringent bitter)—raw grainlike flavor, dry, puckerlike sensation as in grape tannin.	High: alkaline or high sulfate water. High: stems and skins of fruit. High: 6-row more than 2-row malt.	High: oversparging grains. High: boiling grains. High: excess trub. High: poor hot break (improper boiling). High: overmilling/grinding. High: high temperature (above 175 degrees F) sparge water.		Low: aging reduces astringency.
Light struck (skunky)—like a skunk (the British describe this character as "catty" because there are no skunks in the U.K.).	High: some varieties of hops.		High: fermenting beer in glass carboy in bright light.	High: light striking beer through green or clear glass and over a prolonged time through brown glass. NOTE: effect is instantaneous with clear or green glass.

(continued)

TROUBLESHOOTER'S CHART (continued)

Profile Descriptor	Ingredients	Process	Equipment	Handling and Processing
Metallic—tinny, coinlike, bloodlike.	High: iron content in water.		High: mild steel, aluminum, cast iron. High: cleaning stainless steel or copper without subsequently oxidizing surfaces to form a protective layer of oxide on metal.	
Oxidation—paper or cardboardlike, winey, sherrylike, rotten pineapple or rotten vegetables.	Low: addition of ascorbic acid (Vitamin C).	High: aeration when siphoning or pumping. High: adding tap or aerated water to finished beer.	High: malfunction airlock.	High: too much air space in bottle. High: warm temperatures. High: age.
Phenolic—medicinal, Band-Aid-like, smoky, clovelike, plasticlike.	High: chlorinated (tap) water. High: wild yeast. High: bacteria. High: wheat malt (clovelike) or roasted barley/malts (smoky).	High: oversparging of mash. High: boiling grains.	High: cleaning compound residue. High: plastic hoses and gaskets. High: bacterial and wild yeast contamination.	High: defective bottlecap linings.

Profile Descriptor	Ingredients	Process	Equipment	Handling and Processing
Salty—sensation generally perceived on the sides of the tongue as with table salt (sodium chloride).	High: brewing salts, particularly those containing sodium chloride (table salt) and magnesium sulfate (Epsom salts).			
Sour/Acidic—sensation generally perceived on the sides of the tongue as with lemon juice (citric acid).	High: introduction of lactobacillus, acetobacter and other acid-forming bacteria. High: too much refined sugar. High: addition of citric acid. High: excessive ascorbic acid (Vitamin C).	High: mashing too long promotes bacterial growth and acid byproducts in mash. High: bacteria in wort, fermentation. High: excessive fermentation temperatures promote bacterial growth. Low: sanitize all equipment.	High: bacteria harbored in scratched surfaces of plastic, glass, stainless, improper welds, valves, spigots, gaskets, discolored plastic. High: use of wooden spoon in cooled wort or fermentation.	High: storage at warm temperatures. High: unsanitary bottles or kegs.
Sulfur—sulfur dioxide, hydrogen sulfide (rotten eggs), see DMS, see light struck, yeastlike flavor.	High: various yeast strains will produce byproducts. High: malt releases minor amounts.	High: yeast autolysis: sedimented yeast in contact with beer in fermenter too long. High/Low: yeast strains will influence.		
Sweet—sensation generally perceived on the tip of the tongue as with sucrose (white table sugar).	High: high malt content. High: crystal malt, Munich malt and toasted malt create sweet malt flavor. High: low hopping. High: licorice. High: low attenuation or unhealthy yeast strains.	High: within the general 145 to 150 degree F range of mashing temperatures the higher mash temperatures produce more unfermentable carbohydrates.		Low: aging reduces sweetness.

BEER AROMA/FLAVOR RECOGNITION

Substances used to duplicate various beer characters

(Much of this information is based on Dr. Morton Meilgaard's work on the subject and my own and Greg Noonan's experience with handling samples)

Meilgaard Ref. No.	Term Descriptor	Substance Used for Recognition	Concentration in 12-oz. Beer	Concentration in One Quart Beer
0110	Alcoholic	Ethanol	15 ml.	40 ml.
0111	Clove/Spicy/DO NOT DRINK	Eugenol	100 mcg.	265 mcg.
		Allspice	2 g.	5 g.
		Cloves	(marinate 2 or 3 cloves in beer)	
0112	Winy/Fusely	Chablis wine	1 fl. oz.	2.7 fl. oz.
0123	Solventlike/DO NOT DRINK Acetone	Laquer thinner	.03 ml.	.08 ml.
0133	Estery, Fruity, Solventlike/DO NOT DRINK	Ethyl acetate	.028 ml.	.076 ml.
0150	Green Apples/DO NOT DRINK	Acetaldehyde	.016 ml. or 16 mg.	.040 ml. or 40 mg.
0220	Sherry	Sherry	1.25 fl. oz.	3.25 fl. oz.
0224	Almond, Nutty/DO NOT DRINK	Benzaldehyde	.002 ml. or 2 mg.	.005 ml. or 5 mg.
		Almond extract	4 drops	11 drops
0503	Medicinal, Band-Aid-like, Plasticlike/DO NOT DRINK	Phenol	.003 ml. or 3 mg.	.010 ml. or 10 mg.
0620	Butter, Butterscotch/DO NOT DRINK	Diacetyl	.00005 ml.	.00014 ml.
		Butter-flavor extract	4 drops	11 drops

Meilgaard Term Ref. No.	Descriptor	Substance Used for Recognition	Concentration in 12-oz. Beer	Concentration in One Quart Beer
0710	Sulfury/Sulfitic/DO NOT DRINK	Sodium or Potassium Metabisulfite	20 mg.	50 mg.
	Sulfur dioxide/DO NOT DRINK			
0721	Skunky, Light struck	Beer exposed to sunlight for 1 hour		
0732	Sweet corn, DMS/DO NOT DRINK	Dimethylsulfide/DMS (note: unstable)	.00003 ml. or 30 mcg.	.0001 ml. or 100 mcg.
	Cabbage/DO NOT DRINK			
0800	Stale, Cardboard, Oxidation	Open bottle. Recap. Heat sample for one week at 90–100°F, or marinate cardboard in beer		
0910	Sour/Vinegar/Acetic (acid)	White vinegar	7.5 ml.	25 ml.
0920	Sour/Lactic (acidic) flavor only	Lactic acid	0.4 ml. of 16% solution	1.1 ml. of 16% solution
1000	Sweet flavor only	Sucrose sugar	5.3 g.	14 g.
1100	Salty flavor only	Table salt (NaCl)	1.2 g.	3.2 g.
1200	Bitter flavor only	Isohop extract	.0015 ml.	.004 ml.
—	Hop Aroma	hop oil	one drop	2 drops

NOTE: As indicated, some of these substances are toxic and should not be tasted.

Savor the
Flavor—Responsibly

Drinking beer is a privilege. Drinking beer intelligently is an art.

Quality, not quantity, is what beer should be all about. Homebrewing is an endeavor that most of us pursue because we enjoy the flavor of beer and enjoy the process as a hobby and as an opportunity to improve the quality of our lives.

As homebrewers, we each must take individual responsibility for our behavior when consuming beer as an alcoholic beverage. Some may consider homebrewing a right, while others consider it a privilege. Regardless, unless we take it upon ourselves to exercise individual responsibility, then choices may be made by others. Part of the freedom of choice and of brewing one's beer is taking on this important responsibility. Savor the flavor and do so responsibly is the policy of the Association of Brewers and its American Homebrewers Association division.

Drinking any amount of alcohol can impair your ability to perform certain tasks. Driving is one of them. Chemical tests can determine your blood alcohol concentration (BAC). BAC is a helpful indication of your impairment. For example, five parts of alcohol in 10,000 parts of blood is shown as 0.05 percent BAC.

In many states, a driver of an automobile with a BAC between 0.05 and 0.09 percent is presumed to be driving while his or her ability to drive is impaired (DWAI). A driver with a BAC of 0.10 percent or more is presumed to be driving under the influence (DUI). Laws and BAC limits change often and vary from state to state. Both DWAI and DUI convictions may mean mandatory penalties, sometimes including a jail term, a fine, public service and possibly surrender of one's driving license.

The alcohol concentration in your body depends on several factors, some of which are:

- Your weight (see chart on page 413).
- The amount of food in your stomach. Food postpones alcohol absorption but will not keep you from increasing BAC, though the peak level may be less as your body begins to metabolize alcohol already in your blood. Fats and proteins delay alcohol

uptake by the body more than when carbohydrates are ingested.

- The concentration of alcohol in the beverage you are consuming.
- The length of time during which you consume alcohol (see chart).
- The period of time since your last drink. It takes about one hour for your body to metabolize the alcohol in 12 ounces of $3\frac{1}{2}$ to $4\frac{1}{2}$ percent alcohol beer.
- The ability of your digestive system to produce enzymes that help break down and metabolize alcohol.

Be aware that the degree of intoxication you may develop is not a matter of how much of an alcohol-containing beverage you drink, but rather, how much alcohol you drink. One type of drink is often not equal to another kind of drink. Twelve ounces (355 ml.) of a beer that's 4 percent alcohol by volume contains 0.48 fluid ounces (14.2 ml.) of pure alcohol. A 6-ounce (178-ml.) serving of wine that's 12 percent alcohol by volume contains 0.72 fluid ounces (21.4 ml.) of pure alcohol. One ounce of 80 proof (40 percent) distilled liquor mixed with any mixer contains 0.40 fluid ounces (11.9 ml.) of pure alcohol. These differences are very significant, and variation from the above can have a dramatic effect on how well you will be able to control the intoxicating effect of alcohol-containing beverages.

A specialty strong beer containing 6 percent alcohol by volume will have 50 percent more alcohol than a 4 percent beer. Studies have been made implying that, for example, two beers at 6 percent will increase the potential for higher peak BAC more so than if three beers at 4 percent were drunk during the same period.[9]

Keep in mind that the concentration of alcohol in your drink has an influence on how quickly you will feel the effects of alcohol. A 1-ounce (30-ml.) shot of 80 proof liquor will affect you more quickly than when combined with 11 ounces (327 ml.) of a mixer.

There are several scales of proof for liquor. The American scale defines 100 percent alcohol as 200 proof, thus 80 proof would be 40 percent alcohol. There is a British scale that defines 100 percent alcohol as 175 proof, thus 80 proof would be 45 percent alcohol. A Canadian scale defines 100 percent alcohol as 75 overproof. And if

[9] "How the Blood Alcohol Curve Develops After Drinking Light Beer," by Anton Piendl, *Brauwelt International*, 1993/II.

all this were not confusing enough, there is a French scale that defines 100 percent alcohol as 100 proof.

The alcoholic content of beer is not normally indicated in terms of the proof scale, but keep these scales in mind when discussing alcohol by volume of beer and proof of distilled spirits. Pacing yourself with a 12-ounce (355-ml.) bottle of beer can be done.

Know Your Limit.

Your life and the lives of others depend on it.

Be careful driving BAC to .05% [] Do not drive .10% and up [▒] Driving impaired .05% to .09% [▒]

1 Drink = 12 oz. beer, 4 oz. wine or 1 1/4 80proof liquor

After hours	1 Drink				2 Drinks				3 Drinks				4 Drinks			
Weight	4	3	2	1	4	3	2	1	4	3	2	1	4	3	2	1
100	–	–	–	.03	–	.02	.04	.06	.05	.07	.08	.10	.09	.10	.12	.13
120	–	–	–	.03	–	–	.03	.05	.03	.04	.06	.08	.06	.08	.09	.11
140	–	–	–	.02	–	–	.02	.05	.02	.03	.05	.07	.04	.06	.08	.09
160	–	–	–	.02	–	–	.02	.04	.01	.02	.04	.06	.03	.04	.06	.08
180	–	–	–	.01	–	–	.01	.04	–	.02	.03	.05	.02	.04	.05	.07
200	–	–	–	–	–	–	.01	.03	–	.01	.03	.05	.01	.03	.04	.06
220	–	–	–	–	–	–	–	.03	–	–	.01	.04	–	.01	.03	.06

KNOW YOUR LIMITS

After hours	5 Drinks				6 Drinks				7 Drinks				8 Drinks			
Weight	4	3	2	1	4	3	2	1	4	3	2	1	4	3	2	1
100	.13	.14	.16	.17	.16	.18	.19	.21	.20	.22	.23	.25	.24	.25	.27	.28
120	.09	.11	.13	.14	.13	.14	.16	.17	.15	.17	.19	.20	.19	.20	.22	.23
140	.07	.09	.10	.12	.10	.12	.13	.15	.13	.14	.16	.17	.15	.17	.18	.20
160	.06	.07	.09	.10	.08	.09	.11	.13	.10	.12	.13	.15	.13	.14	.16	.17
180	.04	.06	.07	.09	.06	.08	.09	.11	.09	.10	.12	.13	.11	.12	.14	.15
200	.03	.04	.06	.08	.05	.07	.08	.10	.07	.09	.10	.12	.09	.10	.12	.13
220	.01	.03	.05	.07	.04	.06	.07	.09	.05	.07	.08	.11	.06	.08	.10	.12

Note: This blood alcohol concentration (BAC) chart is only a guide and not sufficiently accurate to be considered legal evidence. The figures you calculate are averages. Individuals may vary somewhat in their personal alcohol tolerance. Food in the stomach slows the rate of absorption. Medication, health, and psychological conditions are also influencing factors.

Beer and Nutrition

Although beer contains elements of nutrition and can promote some positive physiological and psychological effects, let's face it, we drink beer because we enjoy the flavor and we enjoy the effect that alcohol has on our bodies and minds, hopefully in moderation. In today's culture we don't drink beer because of its nutritional value, though in olden times beer was most purposefully brewed and consumed for health and nutritional value. But one must take this into perspective since healthy food options were limited in centuries past.

Regardless of the reasons we drink beer—beer continues to have some nutritional value when consumed in moderation. For most people, alcohol when consumed in moderation can provide limited nutritional value. As an energy source, it is much more readily assimilated by the body than sugar, but it is a depressant, and as the intake increases, it can have a debilitating and toxic effect. Toxicity is indicated by dose and not by substance.

Beer provides varying amounts of nutrition, including calories, protein, carbohydrates, vitamins and minerals. Fat and cholesterol are totally absent in most styles of beer. The amounts of some nutrients can vary quite drastically with the style of beer. A high-gravity beer, for example, may have an overall higher rating of the above nutrients. An unfiltered beer and especially bottle-conditioned beer will have a much greater amount of B vitamins. Let it suffice to say that nutritional value will vary with beer style.

Hops and other herbs can contribute added health benefits. Hops are a soporific and diuretic, helping create a relaxed mode, promoting sleep and enhancing appetite, digestion and water transport from the body. Alcohol is also a diuretic, and taken in excess, it can lead to dehydration.

There are many special interest groups that promote the healthful aspects of beer, while other special interest groups promote the unhealthful aspects of beer. Just as we must take individual responsibility to enjoy beer sensibly and with respect, we must individually take the responsibility for assessing the "facts" and "studies" for what they are. Take all that you read and learn into perspective, be wary, be smart, make your own beer, appreciate beers that others make and think about what you are being told, who is telling you and why.

Perspective and moderation are important keys in assessing the

value of the 10,000-year-old tradition of brewing and of your own enjoyment of beer. If you realize you don't have the ability to moderate your own consumption, respect yourself and consider alternatives. There is nothing wrong with appreciating and respecting beer while not being able to drink it.

ONE 12-OUNCE SERVING OF BEER

Nutrient	Typical American Light Lager	German Wheat Beer with Yeast	German Doppelbock	U.S. RDA (Recommended Daily Allowance) for Healthy Males 25–50
Kilocalories	148	179	273	—
Protein	0.94 g.	2.09	3.39	75 g.
Thiamine (B$_1$)	0	.044	0.170	1.5 mg.
Riboflavin (B$_2$)	.07 mg.	0.164	0.206	1.7 mg.
Niacin	1.8 mg.	3.03	6.3	20 mg.
Pantothenic Acid	0.169 mg.	0.77	0.765	10 mg.
Pyridoxine (B$_6$)	0.18 mg.	0.153	429	2.0 mg.
Folic Acid	20 mcg.	—	—	400 mcg.
Vitamin C	0	—	—	65 mg.
Calcium	14 mg.	5.5	6.7	1,000 mg.
Copper	0.292 mg.	.047	.008	2 mg.
Iron	0.11 mg.	.043	0.11	18 mg.
Magnesium	35 mg.	30.8	44.2	400 mg.
Phosphorous	50 mg.	12.6	212	1,000 mg.
Zinc	0.18 mg.	.003	.039	15 mg.

Data for American light lager taken from U.S. Department of Agriculture, Human Nutrition Service, listing in September 1981 "Provisional Table on the Nutrient Content of Beverages." Data for RDA taken from *The Essential Guide to Vitamins and Minerals,* copyright 1992 by Health Media of America, HarperCollins Publishers, New York, NY. Data for German Doppelbock and Wheat Beer taken from "Biere Aus Aller Welt," by Professor Anton Piendl, *Brauindustrie,* Schloss Mindelburg, Germany.

ALLERGIES AND BEER

There are many reasons why people can develop allergies to beer. If allergies do develop, they are often allergies to one or a combination of the following:

yeast
barley
corn
wheat
rice
hops
alcohol

If yeast is the cause of an allergy, then filtering beer using a filter with a porosity of less than 0.5 micron will enable the brewer to eliminate yeast from the final product, but often compounds from within the yeast cell walls will dissolve into solution if yeast cells burst or autolyze due to adverse situations. Consult your physician if you are allergic to yeast. Consider yourself fortunate if you are not allergic to yeast.

Barley, corn, wheat and rice are the most common ingredients in commercially available beer and most homebrewed beer. If these grains or other modern cultivated cereal grains cause allergic reactions, consult with your doctor about the possibility of tolerating ancient nonhybridized grains such as spelt (also known as kamut or dinkel). Beers made from these home-malted grains may afford an alternative.

Not to worry is the homebrewer or the lover of beer who develops an annoying allergy to hops. Remember beers were made with many different kinds of bitter herbs and plants before hops became popular about 100 to 200 years ago. This is an allergy that can be most easily circumvented.

If you are allergic to alcohol, well, relax, don't worry and don't have a homebrew. Find other passions in life that will allow you similar satisfaction and pleasure. They do exist.

Gone With the Wind

FLATULENCE AND BEER

Have you ever been with a group of people touring a small brewery and sampling *zwickelbier*, the good stuff out of the tanks before the yeast has settled or the beer's been filtered? It's funny, but not funny, if you know what I mean.

Without professing to be a doctor of flatulence, I can say with confidence that yeasted homebrew can cause flatulence. We are all sensitive to yeast to a small or large degree. When flatulence becomes a common occurrence after one consumption of yeasty beer, it often, though not always, indicates an imbalance of digestive tract microflora. The wrong kind of or the lack of certain kinds of bacteria in your gut may promote a fermentation of the undesirable sorts in your gut. Voilà—flatulence (i.e., farting).

Sometimes imbalances are the result of having taken antibiotics. Some antibiotics can wipe out much of your digestive bacteria, creating an environment for other bacteria and even certain kinds of yeast to take hold and ferment in your gut. Consult your medical doctor or a holistic minded physician for foods and supplements you may be able to take to get your system back in balance, thus minimizing the effect that naturally made unfiltered beer will have on your system.

One simple step is to avoid yeasty, cloudy beer and let someone else cut the cheese.

Beer and Food

Let's hope that the definition of an American gourmet seven-course meal doesn't become a six-pack and a cheeseburger.

Meals can be an adventure. The food and beer you enjoy are a reflection of the people who made them and those who had a hand in producing, growing or harvesting the ingredients. And as well, meals can be a reflection of your own adventurous spirit.

We are at the beginning of an American adventure—appreciating our own unique heritage of fine food and beer. I predict that years from now we will recall how American homebrewers and beer enthusiasts popularized the practice of enhancing food with beer.

Since prehistoric times, people have been enjoying beer with food in more ways than one. Preparing food with beer (both while drinking it and using it in the recipe) is one more versatile way to enjoy your homebrew.

Food cooked with beer and food accompanied by beer are an adventure worth discovering.

A FEW WORDS ABOUT COOKING WITH BEER

Essentially beer can be substituted for liquid in most recipes, in varying proportions. The finesse is using beer to enhance the flavor of the dish, not to take center stage. In this regard and considering that foods have varying degrees of flavor character and strength, it is all too obvious that the choice of beer style used in cooking is an important one. The right beer wonderfully contributes to the flavor of the food being prepared. Here are some general guidelines:

> lighter foods—light beers
> more robust foods—dark beers
> sweet foods—maltier, stronger beers
> fruity foods—mildly bittered fruity ales
> sour foods and sauces—acidic beers
> smoky foods—smoky beers.

The following section on food types is excerpted from "Cooking with the Brewgal Gourmet," by Candy Schermerhorn, in the book Brew Free or Die. *Candy is a culinary consultant and instructor at Kitchen Classics, Phoenix, Arizona. She is a regular food columnist for* zymurgy *magazine and author of the highly acclaimed book* The Great American Beer Cookbook, *Brewers Publications, 1993.*

In Breads . . .

"The best reason to add beer to your bread recipe is that the yeast, malt and hops of beer impart a wonderful, full flavor and aroma. The final product is indescribable, and should be experienced at least once in a lifetime!"

In Soups . . .

"Soup recipes can be modified to include beer, in several different ways. Beer can be used to make broth or stock—just add a few cups of beer to the water that bones or vegetables will be simmered in. Alternatively, beer can replace part of the stock called for in a recipe. A basic guideline of two cups of broth to one cup of beer is a good starting point."

On Meats . . .

"No matter how you cook meat, you can add beer to it.

"Because beer is acidic, it works as a natural tenderizer on meat. This makes it perfect for marinades. Beer-based sauces and braising liquids can also enhance the flavor of meats."

On Poultry . . .

"Because of the 'modern' methods employed in raising most commercial poultry, much of it lacks depth of flavor. By adding beer to basting sauces, marinades and stuffings, you will heighten the final flavor and expand your recipe repertoire."

On Seafood . . .

"Fish and shellfish can benefit greatly from the addition of beer, but use a subtle touch; fish is easily overwhelmed by powerful flavors. Marinating, steaming, poaching and boiling are wonderful ways to incorporate beer into your seafood cooking."

On Desserts . . .

"When it comes to combining beer and desserts, the sky is the limit. When substituting beer in a dessert recipe, it is important to remember that texture will play a big role in the amount of beer you can substitute. When a recipe calls for water, it is easy. You can substitute all or a part of the water with beer. When a recipe calls for fruit juice, substitute two-thirds of the amount with beer and the remaining one-third with frozen, undiluted fruit juice concentrate.

"Dairy products are used to add tenderness and flavor and often are used as a form of leavening. It is important to know the function of each dairy product in a recipe before substituting beer in its place. As an example, you may substitute one cup of milk with $\frac{3}{4}$ cup beer mixed with $\frac{1}{2}$ cup powdered milk.

"Some examples of desserts made with beer: Imperial stout chocolate sour cream cake, chocolate doppelbock mousse, home-made kriek (cherry beer) and cherry ice cream, strawberries with a topping of honey mead blended with honey and sour cream."

For a more comprehensive treatment of cooking with beer, Candy Schermerhorn's *The Great American Beer Cookbook* (Brewers Publications, 1993) is an indispensable adventure in cooking and beer enjoyment.

CHOOSING BEER TYPES TO ACCOMPANY A MEAL

Here are a few simple guidelines that can be considered when designing a meal.

The beginning of a meal sets the mood. Choosing a lively, bubbly and unusual beer greets the palate and inspires conversation. Belgian-style fruit beers such as peach (Pêche), cherry (Kriek) or raspberry (Framboise) beer or even a champagnelike Berliner Weiss (a sour wheat beer) are great starters.

Salads or seafood cocktails are well matched with winelike light sour beers such as Belgian lambic gueuze.

If you serve steamers, mussels or oysters, dry stout is an excellent accompaniment. Shellfish, fish and poultry main courses go well with light yet hoppy German Pilseners or Dortmunder styles. Their pleasant bitterness and delicate hop character refresh the palate.

Beef dishes go well with heartier brews such as robust Belgian Trappist ales and English pale ales.

Between the main course and dessert, a small glass of a maltier brew such as bock, Oktoberfest or English brown ale makes you feel like you're at a carnival and the cotton candy is just around the corner.

Some beers go exceedingly well with dessert; pie, fruit, ice cream, sherbet, torte and cakes. One of my favorites is a Belgian-style Grand Cru Reserve, a light-colored, alcoholic beer with the refreshing palate-cleansing zestiness of hops, coriander and orange curaçao. Dry stouts and porters can complement very sweet desserts well.

After-dinner drinks? Bring out the cognac glasses, but hold the cognac. How about a malt "liqueur" such as sweet stout, a barley-wine-style ale, a sweet doppelbock or a rare honey mead?

AN EIGHT-COURSE BANQUET

Here's a banquet that is a proven success. Beers are chosen and combined with recipes provided by Candy Schermerhorn.
Reception: Hoppy, dry, appetite-arousing pale ale (serving—12 ounces).
Appetizer: Italian Seasonal Fruit Salad with figs marinated in hard cider and/or Bavarian-style Weizen (wheat) beer. Serve with a dollop of sauce made from cream cheese, sour cream, cinnamon and beer. Top with toasted almonds. Serve with a fruity and acidic Belgian-style cherry beer (serving—4 ounces).

Soup: Brie and Norwegian Shrimp Soup prepared with American light lager. Serve with a lightly to medium-hopped American-style wheat beer (serving—6 ounces).

Salad: Green Salad garnished with fresh Kent Golding hops (on the side) with a "vinaigrette" dressing of oil, sour raspberry beer, crushed raspberries and herbs. Serve with a medium-body, deep amber to brown, malty-sweet, balanced bittered German-style Munich Dunkel lager (serving—4 ounces).

Dinner: Roasted Turkey Breast (this is marinated with a light hoppy Pilsener beer, olive oil, herbs, spices, then wrapped with corn husks and roasted), with a gravy made from smoke-flavored beer (German Rauchbier style). Serve in a pastry on a bed of beer pilaf (use Munich Helles-style lager) accompanied by carrots glazed in English-style brown ale. Serve with Märzen/Oktoberfest; the rich toasted malt flavor and German hop flavor and bitterness complement the roasted and smoky flavors in the food (serving—6 ounces).

Dessert: *Crème Brûlée* made with a combination of malt extract and Lyles Golden syrup as bottom sauce. Serve with a dark, rich American-style porter (serving—4 ounces).

Finish: Chocolate Truffles made with stout. Served with Belgian-style ale flavored with apricots, coriander or peaches (serving—4 ounces).

Encore: Coffee and after-dinner drink: homemade vintage sweet prickly pear cactus fruit honey mead (serving—2 ounces).

Bibliography of Resources

BOOKS

Briggs, Hough, Stevens and Young. *Malting and Brewing Science*. Vols. 1–2. New York: Chapman and Hall, 1971.

Daniels, Steve. "Beer Filtration for Homebrewers." *Just Brew It: Beer and Brewing*. Vol. 12. Boulder, Colo.: Brewers Publications, 1992.

Eckhardt, Fred. *The Essentials of Beer Style*. Portland, Oreg.: Fred Eckhardt Associates, 1989.

Fink, Dan. "Fermentation and Beyond: Gadgets for the Homebrewer." *Brew Free or Die: Beer and Brewing*. Vol. 11. Boulder, Colo.: Brewers Publications, 1991.

Fix, Dr. George. *Principles of Brewing Science*. Boulder, Colo.: Brewers Publications, 1989.

———. *Vienna*. Boulder, Colo.: Brewers Publications, 1992.

———. "Quality Control in Small Scale Brewing." *Beer and Brewing*. Vol. 6. Boulder, Colo.: Brewers Publications, 1986.

———. "Hop Flavor in Beer." *Beer and Brewing*. Vol. 8. Boulder, Colo.: Brewers Publications, 1988.

Forget, Carl. *Dictionary of Beer and Brewing*. Boulder, Colo.: Brewers Publications, 1988.

Foster, Dr. Terry. *Pale Ale*. Boulder, Colo.: Brewers Publications, 1990.

———. *Porter*. Boulder, Colo.: Brewers Publications, 1992.

———. "Hops, Beer Styles and Chemistry." *Best of Beer and Brewing*. Boulder, Colo.: Brewers Publications, 1987.

———. "Clear Beer Please." *Beer and Brewing*. Vol. 9. Boulder, Colo.: Brewers Publications, 1989.

Gordon, Dan. "Effect of Trub on Flavor and Fermentation." *Brewery Operations*. Vol. 7. Boulder, Colo.: Brewers Publications, 1991.

Gruber, Mary Anne. "Crack It Up: Understanding the Physical Properties of Malt." *Quality Brewing/Share the Experience; Brewery Operations*. Vol. 9. Boulder, Colo.: Brewers Publications, 1992.

Guinard, Jean-Xavier. *Lambic*. Boulder, Colo.: Brewers Publications, 1990.

Jackson, Michael. *The Simon and Schuster Pocket Guide To Beer*. New York: Simon and Schuster, Inc., 1991.

――――. *The New World Guide to Beer*. Philadelphia: Running Press, 1989.

Kieninger, Dr. Helmut. "The Influences on Beer Making." *Best of Beer and Brewing*. Vols. 1–5. Boulder, Colo.: Brewers Publications, 1987.

Klimovitz, Ray. "Is This the Malt You Ordered?" *Quality Brewing/Share the Experience; Brewery Operations*. Vol. 9. Boulder, Colo.: Brewers Publications, 1992.

Konis, Ted. "Origins of Normal and Abnormal Flavor." *Evaluating Beer*. Boulder, Colo.: Brewers Publications,1993.

Master Brewers Association of the Americas. *The Practical Brewer*, first and second editions. Madison, Wis., 1946, 1977.

Miller, Dave. *Continental Pilsener*. Boulder, Colo.: Brewers Publications, 1990.

Narziss, Prof. Ludwig P. *Die Technologie der Würzebereitung*. Stuttgart: Ferdinand Enke Verlag, 1985.

Noonan, Greg. *Brewing Lager Beer*. Boulder, Colo.: Brewers Publications, 1986.

――――. "Water: Its Effects on Hop Bitternes and Beer Flavor," *Beer and Brewing*. Vol. 6. Boulder, Colo.: Brewers Publications, 1986.

――――. "Water Workshop,"*Brew Free or Die: Beer and Brewing*. Vol. 8. Boulder, Colo.: Brewers Publications, 1988.

Palamond, Dr. Raoul. "Training Ourselves in Flavor Perception and Tasting." *Evaluating Beer*. Boulder, Colo.: Brewers Publications, 1993.

Papazian, Charlie. *The New Complete Joy of Home Brewing*. New York: Avon Books, 1991.

Rajotte, Pierre. *Belgian Ales*. Boulder, Colo.: Brewers Publications, 1992.

Remi, Bertrand. *Home Brew*. Katmandu, Nepal: Sahayogi Prakashan, 1976.

Scheer, Fred. "Diacetyl—a Quality Control Parameter." *Quality Brewing/ Share the Experience; Brewery Operations*. Vol. 9. Boulder, Colo.: Brewers Publications, 1992.

Schermerhorn, Candy. "The Brewgal Gourmet Cooks with Beer." *Brew Free or Die: Beer and Brewing*. Vol. 11. Boulder, Colo.: Brewers Publications, 1991.

Shelton, Ilse. "Flavor Profiles." *Evaluating Beer*. Boulder, Colo.: Brewers Publications, 1993.

Thomas, David. "The Magic of Malt." *Beer and Brewing*. Vol. 6. Boulder, Colo.: Brewers Publications, 1986.

Warner, Eric. *German Wheat Beer*. Boulder, Colo.: Brewers Publications, 1992.

Wood, Rebecca. *Quinoa the Supergrain*. Tokyo: Japan Publications, 1989.

PERIODICALS

Ballard, Melissa. "Tuak: Toddy of the Rice Farmers." *Zymurgy* (Fall 1986).

Bauer, Gary. "Raw Materials." *Zymurgy* (Fall 1990).

Clack, Johnny. "Apache Beer: Indigenous Beer of American Indians." *Zymurgy* (Winter 1984).

Cribb, Stephen. "Beer and Rocks." *Zymurgy* (Special 1985).

Fix, Dr. George. "Cereal Grains." *Zymurgy* (Special 1985).

———. "Yeast Cycles." *Zymurgy* (Special 1985).

———. "Detriments of Hot Side Aeration." *Zymurgy* (Fall 1992).

———. "Sulfur Flavors in Beer." *Zymurgy* (Winter 1992).

———. "A Simple Technique for Evaluating Beer Color." *Zymurgy* (Fall 1988).

Great Western Malt Staff. "A Malt Primer." *Zymurgy* (Special 1985).

Guinard, Jean-Xavier; Miranda, Mary; and Lewis, Professor Michael. "Yeast Biology and Beer Fermentation." *Zymurgy* (Special 1989).

Kane, Ken. "Low Alcohol Beers: Brewing Fad or Future." *Zymurgy* (Fall 1989).

Katz, Dr. Solomon. "Beer and the Origin of Cereal Grain Agriculture." *Zymurgy* (Summer 1988).

Klisch, Russel. "Proteins in Beer." *Zymurgy* (Special 1985).

Kowaka, K., Fukuoka, Kawasaki and Asano. "The True Value of Aroma Hops in Brewing." *European Brewing Convention Congress* 1983, *Lecture No. 7* (1983).

Millspaw, Micah, and Jones, Bob. "Beer Stability." *Zymurgy* (Winter 1992).

Morris, Rodney. "Beer Filtration for the Homebrewer." *Zymurgy* (Summer 1990).

Narziss, L. "Types of Beer." *Brauwelt International* II/1991.

———. "Special Malts for Greater Beer Type Variety." *Brauwelt International* IV/1991.

Noonan, Greg. "Decoction Mashing." *Zymurgy* (Special 1985).

O'Neil, Pat. "The Mystery of Malt Extract." *Zymurgy* (Summer 1985).

Peindl, Professor Anton. From the series "Biere Aus Aller Welt." *Brauindustrie* (1982–1991).

———. "How the Blood Alcohol Curve Develops After Drinking Light Beer." *Brauwelt International* II/1993.

Richman, Darryl. "Water Treatment: How to Calculate Salt Adjustments." *Zymurgy* (Winter 1989).

Rodin, Colin, and Colon-Bonet, Glenn. "Beer From Water: Modify Minerals to Match Beer Styles." *Zymurgy* (Winter 1991).

Schisler, Ruocco and Mabee. "Wort Trub and its Effects on Fermentation and Beer Flavor." *American Society of Brewing Chemists.* Vol. 40 (1982).

Segal, Doralie Denenberg. "Beer and Nutrition." *Zymurgy* (Winter 1984).

Singleton, Jill. "Kvass: Back in the USSR." *Zymurgy* (Summer 1986).

Taylor, David. "The Importance of pH Control During Brewing." *Master Brewers Association of the Americas Technical Quarterly.* Vol. 27 (1990).

Taylor, Ken. "Effects of Water." *Zymurgy* (Special 1985).

Tierney, Michael. "How to Keep Skunks Out of Your Homebrew." *Zymurgy* (Fall 1989).

Winship, Kihm. "Black Patent Malt and the Evolution of Porter." *Zymurgy* (Summer 1987).

Wright, Morgan. "How to Make Maple Sap Beer." *Zymurgy* (Winter 1988).

OTHER LITERATURE (PAMPHLETS, BROCHURES, ETC.)

The Great American Beer Festival Program Guide—1992. Boulder, Colo.: Association of Brewers.

Hops From Germany. Bonn, Germany: Centrale Marketingesellschaft der deutschen Agrarwirtschaft, mbH, 1992.

Hop Variety Specifications. Yakima, Wash.: Hop Union U.S.A., Inc., 1983.

INDIVIDUALS, ASSOCIATIONS, INSTITUTES AND BUSINESSES THAT PROVIDED TECHNICAL ASSISTANCE AND INFORMATION FOR THIS BOOK

Bass Export Limited, Glasgow, Scotland. Arthur Seddon, Master Brewer; Jane Milroy, Brand Manager.

Beverage Consult International, Inc., Evergreen, Colorado. Finn Knudsen, Director.

Brother Adam, Bee Breeder and Meadmaker, Buckfast Abbey, Buckfast Leigh, Devon, England.

Kinny Baughman, Brewer, Boone, North Carolina. Beer is his business and he's late for work.

Briess Malting Company, Chilton, Wisconsin. Mary Anne Gruber, Director of Brewing Services; Roger Briess, President.

Cellite Corporation, Wayne, New Jersey. Ed Busch, Senior Technical Sales Representative.

Coors Company, Golden, Colorado. Willis Lyford, Corporate Communications Manager; Dave Thomas, Department Head—Malting R & D.

Crosby and Baker, Westport, Massachusetts. Seth Schneider, General Manager.

Dr. George Fix, Author, Brewing Consultant and Brewer, Arlington, Texas.

Phil Fleming, Editor and Homebrewer, Broomfield, Colorado.

Frankenmuth Brewery, Frankenmuth, Michigan. Fred Scheer, Brewmaster.

Lt. Col. Robert Gayre, Mead Historian and Meadmaker; **Reinhold and Marion Gayre**, Minard Castle, Argyll, Scotland.

Great Western Malting Co., Vancouver, Washington. Bryan Thoet, Vice President, Sales and Services.

Guinness Ireland Limited, Guinness Brewing Worldwide Research Centre, St. James Gate, Dublin. Dr. Eddie Collins.

Hopunion U.S.A. Inc., Yakima, Washington. Dr. Gregory K. Lewis, Vice President and Technical Director; Ralph Olson, Vice President of Operations.

Michael Jackson, World Beer Journalist and Author, London, England.

Labatts Brewing Co. Ltd., London, Ontario, Canada. Dr. Inge Russel, Research Manager; Dr. Graham Stewart, Director of Technical Affairs.

Michael Lewis, Professor, Food Science and Technology Department, University of California, Davis, California.

Liberty Malt Supply, Seattle, Washington. Charles Finkel, President.

Tracy Loysen, Editor, Homebrewer and Creative Thinker, Alameda, California.

The Miller Brewing Co., Milwaukee, Wisconsin. Gary Luther, Senior Staff Brewer.

Rodney Morris, Homebrewer, College Station, Texas.

Munton & Fison, P.L.C., Stowmarket, England. Andy Janes, Marketing Manager.

Greg Noonan, Author, Brewmaster and Owner of Vermont Pub and Brewery of Burlington, Vermont.

Joseph L. Owades & Co., Sonoma, California. Dr. Joseph Owades, Director.

Schenk Filterbau GMBH, Waldstetten, Germany. Tom Thilert, U.S. Representative, Baltimore, Maryland; Josef Neubauer, Waldstetten.

S.S. Steiner, Inc., Yakima, Washington. Herbert Grant, Technical Consultant.

Schrier Malting Co., Sheboygan, Wisconsin. Keith Gretenhart, Vice President, Sales and Technical Services.

Siebel and Sons, Chicago, Illinois. Ron Siebel, Director.

Siebel Institute of Technology, Chicago, Illinois. Bill Siebel, Director.

Stroh Brewing Co., Detroit, Michigan. Ray Klimovitz, Director of Brewing Development.

Tabernash Brewing Company, Denver, Colorado. Eric Warner, President and Brewmaster.

Rebecca Wood, Natural Foods Authority and Great Person, Albuquerque, New Mexico.

ADDITIONAL TECHNICAL READINGS AND RESOURCES FOR THE HOMEBREWER (NOT MENTIONED IN BIBLIOGRAPHY)

Books

American Homebrewers Association. *Victory Beers*. Boulder, Colo: Brewers Publications, 1994.

Eckhardt, Fred. *Sake*—U.S.A. Portland, Ore.: Fred Eckhardt Communications, 1992.

Gayre, Lt. Col. Robert, and Papazian, Charlie. *Brewing Mead*. Boulder, Colo: Brewers Publications, 1986.

Jackson, Michael. *Michael Jackson's Beer Companion*. Philadelphia: Running Press, 1993.

————. *The Simon and Schuster Pocket Guide To Beer*. New York: Simon and Schuster, 1994.

————. *The Great Beers of Belgium*. Cooperstown, N.Y.: Vanberg & DeWulf, 1991.

Miller, Dave. *The Complete Handbook of Home Brewing*. Pownal, Vt.: Garden Way Publishing, 1988.

Morse, Roger. *Making Mead*. Ithaca, N.Y.: Wicwas Press, 1980.

Neve, R. A. *Hops*. New York: Chapman and Hall, 1991.

Noonan, Greg. *Scotch Ale*. Boulder, Colo: Brewers Publications, 1993.

Reed, Gerald, and Nagodawithana, Tilak W. *Yeast Technology*. New York: Van Nostrand Reinhold, 1991.

Richman, Darryl. *Bock Beer*. Boulder, Colo: Brewers Publications, 1994.

Rybacek, Valclav, ed. *Hop Production*. New York: Elsevier, 1991.

Schermerhorn, Candy. *The Great American Beer Cookbook*. Boulder, Colo: Brewers Publications, 1993.

See Bibliography for additional books not listed above.

Periodicals

Brewing Techniques. Box 3222, Eugene, Oreg. 97403.

The New Brewer (for microbrewers and pub brewers). Institute for Brewing Studies, Box 1679, Boulder, Colo. 80306.

zymurgy. American Homebrewers Association, P.O. Box 1679, Boulder, Colo. 80306–1679.

Of Special Interest:

1985 *Special All-Grain Brewing Issue*
1986 *Special Malt Extract and Recipe Issue*
1987 *Special Troubleshooting Issue*
1988 *Special Brewers and Their Gadgets Issue*
1989 *Special Yeast and Beer Issue*
1990 *Special Hops and Beer Issue*
1991 *Beer Styles Issue*
1992 *Gadgets and Equipment*
1993 *World Beer Traditions: Britain, Germany and the United States*
1994 + *Forthcoming*

Associations

American Society of Brewing Chemists, 3340 Pilot Knob Road, St. Paul, Minn. 55121

Association of Brewers, Box 1679, Boulder, Colo. 80306–1679

Has four divisions:

1. The American Homebrewers Association; activities include:
 Annual National Homebrewers Conference
 Annual National Homebrewers Competition
 National Beer Judge Certification Program
 Sanctioned Competition Program
 Publisher of *zymurgy* magazine
2. The Institute for Brewing Studies; activities include:
 Annual National Microbrewers and Pub-brewers Convention and Trade Show
 Publisher of *The New Brewer* magazine
 Editors of *The North American Brewers Resource Directory*
 Brewers for Hire Program
 additional services
3. Brewers Publications; publishes books on beer and brewing
4. The Great American Beer Festival[sm]; annual festival of American beers held each October

Master Brewers Association of the Americas, 2421 North Mayfair Road, Suite 310, Milwaukee, Wisc. 53226

ACKNOWLEDGMENTS

Photo on page 227 by John Abbott, Chico, California.

Scoresheets appearing on pages 356 and 395 courtesy of the American Homebrewers Association, Boulder, Colorado.

Photo on page 323 courtesy of the Anchor Brewing Company, San Francisco, California.

Tables and charts on pages 184 and 215 and excerpts from the book *Brew Free or Die* on pages 418 to 422 appear courtesy of Brewers Publications, Boulder, Colorado.

Photo on page 174 appears courtesy of Bass Export Limited, Glasgow, Scotland.

Photo (bottom) on page 207 appears courtesy of Cellite Corporation, Wayne, New Jersey.

Photos on pages 32, 33 and 204 courtesy of Coors Brewing Company, Golden, Colorado.

Chart on page 413 courtesy of The Great American Beer Festival[sm], Boulder, Colorado.

Illustrations and charts by Vicki Hopewell appear on the following pages: 132, 134, 135, 146, 147, 156, 158, 159, 175, 186 and 210.

Photos by Gregory O. Jones on pages 380, 382 and 384.

Photos on pages 88 and 89 courtesy of Labatt's Brewing Company, London, Ontario, Canada.

Illustrations by Steve Lawing appear on the following pages: 9, 10, 25, 29, 52, 55, 58, 59, 61, 70, 73, 81, 82, 86, 87, 107, 111, 124, 136, 161, 168, 217, 282, 285, 289, 292, 294, 296, 299, 302, 306, 313, 315, 319, 325, 328, 332, 335, 338, 347, 348, 351, 357, 359, 360, 364, 366, 368, 375, 376, 377, 378 and 379.

Photos by Michael Lichter appear on the following pages: 92, 95, 105, 133, 172, 390, 396 and 418.

Photos by Charles Matzen appear on page 196.

Photos by Charlie Papazian appear on pages: 69, 84, 150, 321 and 322.

Photo on page 191 by Loran Richardson.

Photos (top and middle) on page 207 courtesy of Schenk Filterbau GMBH, Waldstetten, Germany.

Illustration on page 98 by Brent Warren.

Charts appearing on pages 402–408 courtesy of *zymurgy* magazine, American Homebrewers Association, Boulder, Colorado.

Index

All recipe names are indexed under the Recipe listing.

SPECIAL
OFFER FOR
HOMEBREWERS

From the American Homebrewers Association
The AHA brings you:

- Five issues of *zymurgy* magazine each year packed with recipes, homebrew tips, information on equipment and brewing events.
- The AHA National Homebrew Competition.
- The AHA National Conference.
- Beer Judge Certification Program
- AHA Sanctioned Competition Program
- AHA Registered Club Program
 Satisfaction guaranteed or your money back.

YES! I want to take the steps toward better homebrewing

❏ Please send me a free catalog

❏ Enclosed is $9 for a sample *zymurgy* issue plus information about the AHA.

❏ Enclosed is $29 ($34 Canada; $44 Foreign) for one-year membership to the AHA (includes subscription to *zymurgy*).

Name_____

Address _____

City _____State/Country_____Zip/Postal Code _____

Daytime phone number___()___-_____

Send check or money order (U.S. funds only) to *zymurgy*,
PO Box 1510, Boulder, CO 80306-1510 or call (303) 546-6514;
FAX (303) 447-2825 for Visa/MasterCard orders. Prices subject to change

CP 0894